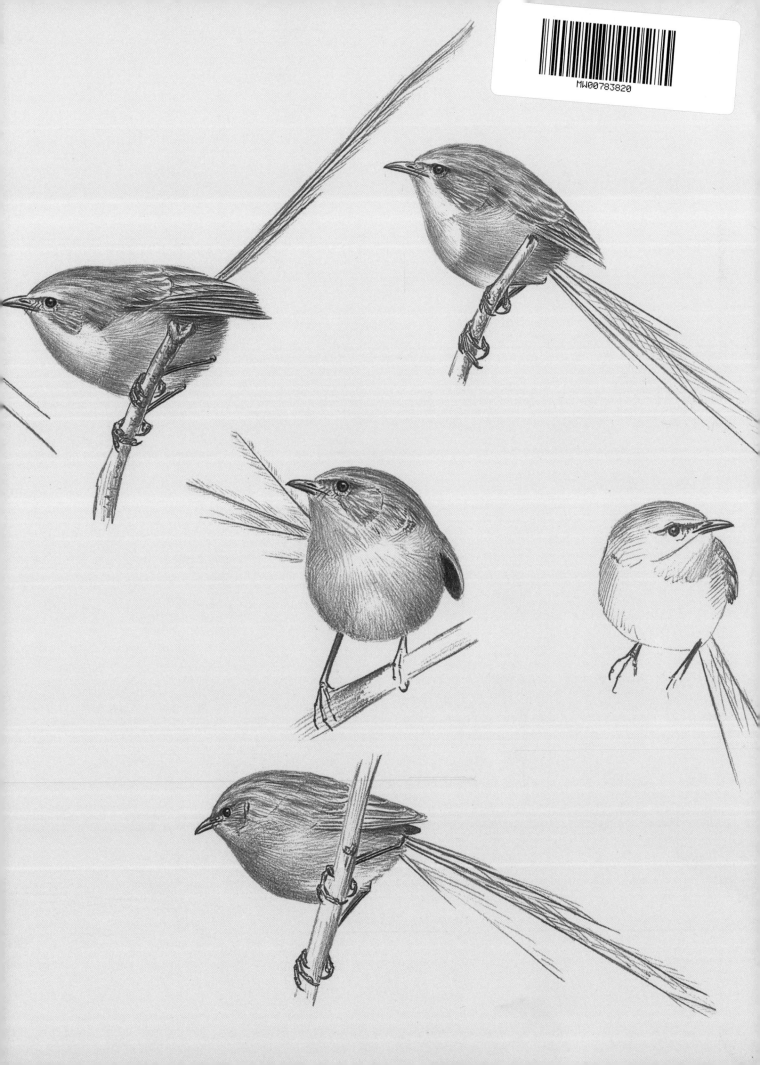

A Brush
with
Birds

RICHARD WEATHERLY

Emus on the Western Plains, pp. 254–5, courtesy Hamilton Gallery, Hamilton, Victoria.

South Polar Skuas, Emperor Penguins, Elephant Seals, krill, Weddell Seal and Crabeater Seals illustrations, pages 224, 228, 229, 232, 237, Commission for the Conservation of Antarctic Marine Living Resources & Weatherly, Richard, 1947– *Conserving Antarctic marine life : CCAMLR the Commission for the Conservation of Antarctic Marine Living Resources – its origins, objectives, functions and operation,* The Commission, Hobart, 1991

Published in 2020 by Hardie Grant Travel, a division of Hardie Grant Publishing

Hardie Grant Travel (Melbourne)
Building 1, 658 Church Street
Richmond, Victoria 3121

Hardie Grant Travel (Sydney)
Level 7, 45 Jones Street
Ultimo, NSW 2007

www.hardiegrant.com/au/travel

A catalogue record for this
book is available from the
National Library of Australia

Hardie Grant acknowledges the Traditional Owners of the country on which we work, the Wurundjeri people of the Kulin nation and the Gadigal people of the Eora nation, and recognises their continuing connection to the land, waters and culture. We pay our respects to their Elders past, present and emerging.

A Brush with Birds
ISBN 9781741176445

10 9 8 7 6 5 4 3 2

Publisher
Melissa Kayser
Senior editor
Megan Cuthbert
Project editor
Nan McNab
Proofreader
Penny Mansley
Internal design
Peter Dyson at desertpony
Cover design
Gayna Murphy
Index
Nan McNab

Colour reproduction by Splitting Image Colour Studio

Printed and bound in China by LEO Paper Products LTD.

The paper this book is printed on is from FSC®-certified forests and other sources. FSC® promotes environmentally responsible, socially beneficial and economically viable management of the world's forests.

CONTENTS

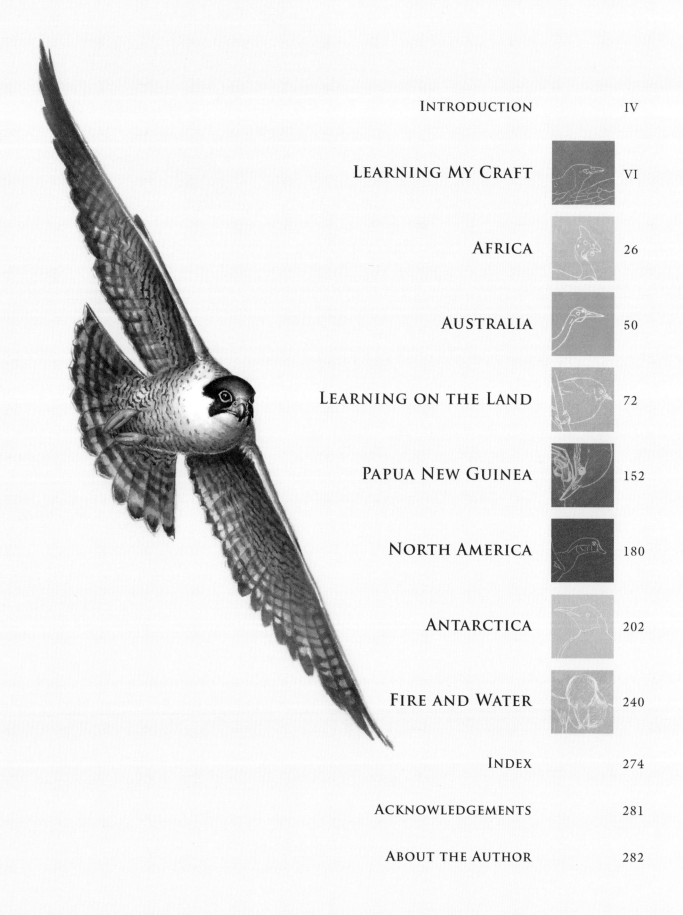

INTRODUCTION

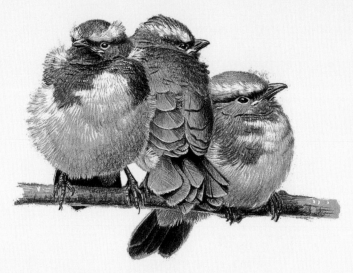

The fault is great, in Man or Woman,
Who steals a Goose from off a Common;
But, who can plead that Man's excuse,
Who steals the Common from the Goose!!!

Anon. c.1800

WHEN I ANSWERED the phone, a woman introduced herself as a senior editor and said, 'Would you be interested in writing a book about Australian birds?'

'No,' I answered truthfully.

I am not an ornithologist; I am not a specialist of any kind and have not really been trained for any of the pursuits I have followed during my life. Indeed, my mother argued that I was not even house-trained!

At university I studied history – an excellent mind-trainer – but I did not pursue it. Somewhere I read that 'An eagle may soar, but a weasel is seldom sucked into a jet engine.' I have not soared in any particular field, I have remained a generalist, eschewing the specialist training so beloved of the modern era. I am an interested naturalist.

A strong fascination with both science and art has complicated matters. The discipline of science can inhibit creativity, whereas the creativity of art can be an impediment to sound science. But both seek answers, and search for a deeper truth.

If I were to paint wildlife, then it was imperative that I learn some science. I have worked with bushmen and boffins, and each has increased my understanding. As a boy, one of my first paintings was of a little brown bird, identified by a neighbouring farmer who was one of many amateur naturalists who contributed brilliantly to the science of natural history. Increasingly these 'amateurs' were sidelined as science withdrew into professional institutions. But good science is based on good questions and good observations,

and 'citizen scientists' are once more increasingly involved in research.

I have been involved in research projects on different continents, studied birds and their habitat, and spent time with some fine ornithologists and scientists. This naturally developed my interest in conservation, sustainability and the resilience of ecosystems. For four decades I was involved in farming, an industry integral to sustainability. Ably supported by my wife Jenny, I planned to incorporate habitat within our farm, so that the farm became the ecosystem and benefitted from ecosystem services. We ran a revegetation company based on direct-sowing of native seeds, helped develop revegetation techniques, planted trees from Tasmania to Queensland, and were part of community efforts to establish corridors and connections throughout the broader landscape. Our farm was too small to become a sustainable ecosystem, but by joining with others we could establish larger connections over greater distances, forging new friendships and a larger and more resilient ecosystem.

I was fortunate to learn from artists who emphasised the need to draw, to get to know and understand one's subject and its character, and to commit to memory its particular features. This instruction has been a blessing, training my visual memory and leading me to spend more time in the field observing and learning. Digital photography and the internet allow an artist to copy a photograph, sometimes with amazing technical skill, but without subtlety or understanding: the result is a crow, but not 'crowmanship'.

Most of the images in this book have been drawn from a body of work dating back to the 1960s. They are the culmination of many, many drawings, of days and sometimes months spent in the wild. I have benefitted from the generous help and advice of good people from six continents, all of whom have wittingly or unwittingly assisted my better understanding of the Australian environment and its birds.

However, this not a Bird Book. It is a book about birds, and animals and people. It contains the observations, experiences and adventures of a life spent watching birds. It is also an account of learning to portray birds for illustrations and exhibitions throughout the world, and of the mentors who have guided me. Nor could the book be limited to birds. Birds exist as part of a complex ecosystem and to watch them and understand them requires an interest in plants, animals, insects and geology.

Making art is a selfish pursuit, often done in isolation, with great concentration and occasional deprivation. But it brings great rewards, great

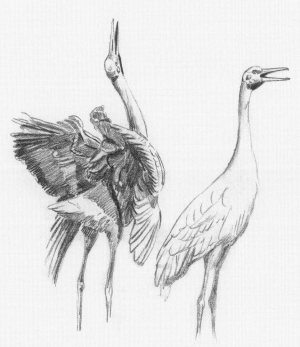

friendships and extraordinary experiences and opportunities. These often lead to a story, sometimes a humorous one, and add to the joyful experience of what we regard as 'the wild'.

I agreed to write this book so I could tell of extraordinary experiences in unlikely places, many of which I can never revisit because they are forever changed – by human intervention, natural catastrophe or crime. Within these pages, should you choose to accompany me, are stories about individual birds, about species, about people and places. We will wander in Europe, Africa, America, Antarctica, Papua New Guinea and many parts of Australia. We will find bird species that are seldom encountered, and even describe a species new to science. We will be held at gunpoint by a couple of Mexican bandits in the remote mountains of Sonora and meet a man who is moved to tears by an exhibition of paintings.

We will watch as a mother Black Duck defends her ducklings against a determined attack from a harrier and see how she triumphs, even after the harrier turns on her. We will share the frustration of a tiny thornbill as it fails at aerobatics and retires in disgust. And we will watch, and probably laugh, as a falcon humiliates his trainer in a demonstration of falconry. We will ricochet between science and art, fear and bravery, pathos and humour.

Throughout we will keep an eye to the future and examine some of the many serious conservation issues, searching for solutions in an increasingly bleak world. We need to learn to live on the land without plundering or despoiling it.

I hope we can rekindle that marvellous sense of wonder that we so enjoyed when we were young: 'Look, a feather! Isn't it beautiful,' and the cascade of questions that follow, 'What part of the bird might it have come from?' and 'What kind of bird?' and 'Where and how does it live?'

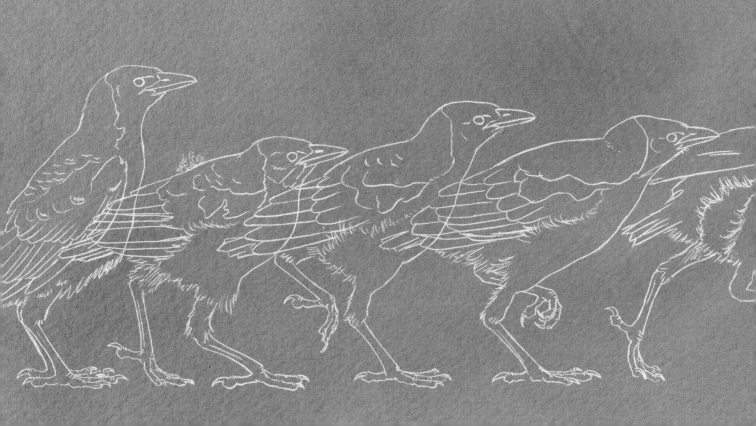

LEARNING MY CRAFT

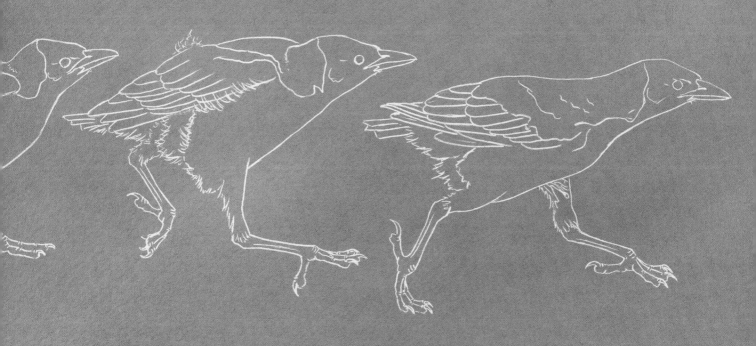

CHILDHOOD

THE BANTAMS BELONGED to my sister. She had been given them by a benign uncle and she adored them. They were wily, wiry, diminutive chooks of enormous individual character.

The hen was soft and fluffy, greyish, with a cascade of glorious golden hackles centred with black strips on her nape. Her back was pencilled with the finest vermiculations, as though a bored telephonist had doodled restlessly with grey-lead on each feather. The black feathers of her quirky little tail were arranged vertically, quite different to the horizontal tail-structure of most birds, and she was friendly, confiding and totally unafraid.

With her came two cockerels, clearly derived from the wild stock of Asia's red jungle fowl. They were fighting birds, each dressed in resplendent military uniform of glossy rich colours. Shining purples and greens glowed from near-black

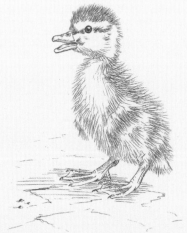

PREVIOUS Pencil sketches of a running baby Magpie (*Cracticus tibicen*)
ABOVE Pen and ink sketch of duckling
RIGHT *Crooked Creek*, gouache, 47 × 63 cm
A backwater on the Crooked Creek at Buttabone Stud Park, Warren, New South Wales

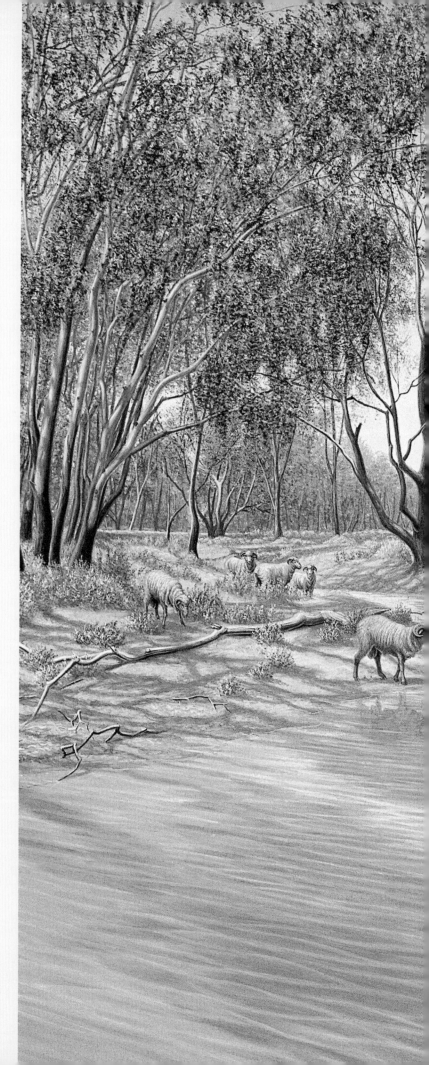

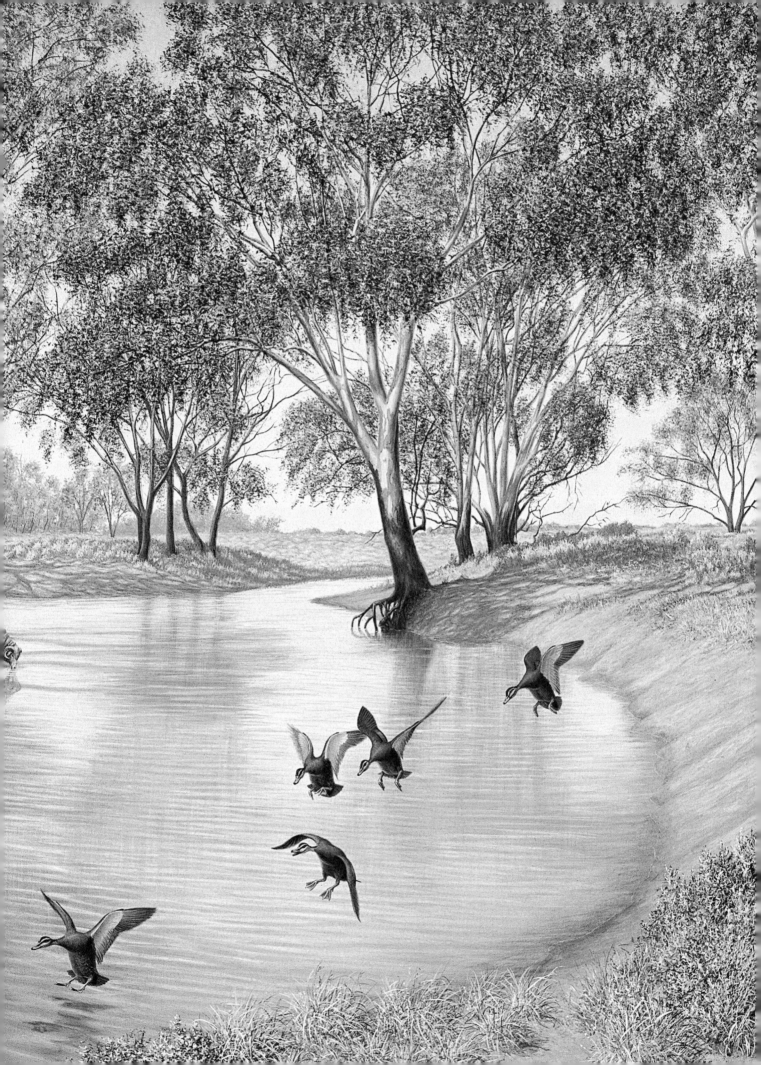

feathers and were enhanced by gleaming bronze hackles and back feathers, russet epaulettes and golden wings.

It would be wrong to assume that these roosters were friends. One, who was presumptuously named Monsieur le Coq, was wily, lean and conniving. His rival, the arrogant Chanticleer (a name featured in Aesop's fables and dating back to Chaucer's stories) seemed aware of his natural authority. In short, they loathed each other.

Two roosters and a hen. There were other hens, less memorable than the favourite, who was unimaginatively named 'Speckledy', rather than the traditional name of Chanticleer's mate, Pertilote. Speckledy had a problem: she would lay numerous eggs, but nothing could induce her to begin incubation until she had twenty-one gathered in her nest. It was as if she could count. As this large clutch required sitting alternate days on each half, since she could not cover them all, her hatching rate was disappointing to say the least. Nevertheless, there were constant gains in bantam numbers from other less fastidious hens and their numbers increased abruptly until a paternal decree: the feed bill was too great, so bantam numbers must diminish.

Natural attrition might have resolved the problem, but the bantams lived securely in a large fox-proof cage which was roofed with pig-netting. This netting had sufficiently wide apertures for a reasonably large bird to drop through, but prevented such immigrants from escaping, as they could not fly out with their wings spread.

One day, a young Brown Goshawk (*Accipiter fasciatus*) slipped through this netting in pursuit of the bantams, but brave Monsieur le Coq launched a savage attack to protect his wives. Making good use of his spurs, he had the goshawk on its back, battling for survival,

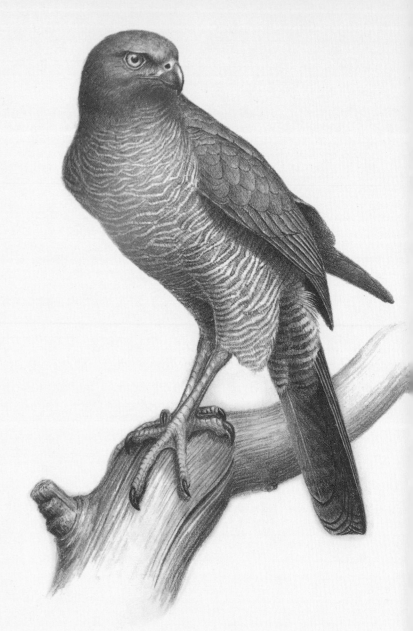

while Chanticleer alerted all the world to the outbreak of hostilities. Before this duel could end, I intervened and rescued the goshawk. No bird can have such a fierce, penetrating stare as a goshawk. Never had I seen one so close and I found it fascinating. Holding it at arm's length by the carpal joints of each wing in my left hand, I set off to our house to share what I had caught with my parents.

The chookyard was fenced, and featured a large, five-barred wooden gate secured by a chain. This was simple to latch with one's left hand, but that hand was holding a wild bird. Stretching to reach the pin with the chain, my concentration wavered and – Whack! – the goshawk's rapier claws shot out and clawed my left eye. Fortunately, the powerful hind talon snagged on my cheekbone

ABOVE Pencil study of a Brown Goshawk, Connewarran, Mortlake; originally drawn for the CSIRO publication *Wild Places of Greater Melbourne*, by Robin Taylor
OPPOSITE Pencil sketches of Plumed Whistling Ducks (*Dendrocygna eytoni*), Connewarran, Mortlake

and its opposing front toe caught on my eyebrow, so my eye was protected.

But how to escape its pulsating clutch? I dared not let it go lest it turn and attack my face with both feet. My left hand was occupied keeping it far enough away, now at its arm's length, to protect my right eye from its other foot. Each time I tried to reach up and extricate myself from its grasp, it snatched my hand with its free foot. Eventually, I loosened its hind claw from my cheek and managed to free myself and make my way to the house, where I remember a family more interested in my welfare than in the goshawk!

Monsieur le Coq had triumphed. Sadly, flushed with his success he over-reached. He challenged Chanticleer and the challenge was accepted. There was a bitter fight to the death. Both birds were evenly matched and blood and feathers flew until each had lost; they both died.

I am reminded of the words of an elderly station hand who was attempting to convince a young Dutchman of the danger of snakes.

'They eat each other, you know, Hans.'

'No. They vould not do that!'

'Yes, I put a couple in a box one day, and when I came back, they'd both gone.'

FROM AN EARLY age, I have been fascinated by birds. Possibly because I am short-sighted, I enjoyed stalking them; the closer I could get,

the more clearly I could see them. I recall stalking a Pacific Black Duck (*Anas superciliosa*) preening on the shoreline of a large swamp. I was about five or six and the reflection from its brilliantly coloured wing was enthralling. I walked amongst some dairy cows that were approaching the swamp to drink until I could gain the cover of some reeds and worm my way ever closer. Eventually I was within two or three metres, and had a clear view. I lay there, entranced by the beauty and proximity of something so wild. I have always liked ducks.

I was fortunate to grow up on Woolongoon, a large Australian cattle and sheep property in the Western District of Victoria, near Mortlake, with good wetlands and sufficient habitat to attract a wide range of bird species. My older sister, Penelope, known to the world as 'Toot', was my close companion; an intelligent, creative and adventurous girl, she was ideal company for a small boy. We had great freedom, and a pony each, which allowed us to explore. There was a large lake on our doorstep, where we learnt to swim, to sail and eventually to waterski behind my uncle's boat. Television had not arrived in our lives – electricity was still generated by a big old diesel engine – so it was an energetic, active, outdoor life.

A creek with plenty of yabbies and fish ran close to the house and fed a large, shallow dam

that was home to a great array of waterbirds. My father, William, knew most of these birds and encouraged me to explore their behaviour. Such comments as, 'I wonder why all those birds are gathered in a flock. Let's try to see what they are feeding on,' would be followed by a more careful inspection and more intimate observation.

My mother, Patricia, also was alert to any strange bird call and was keen to identify all that she saw. Thus, I had role models who encouraged observation and curiosity.

Even as a very young child, I was drawn to books about birds, and swiftly wore out my treasured copy of Neville Cayley's *What Bird is That?*, one of the few Australian bird guides available at the time. I loved the books illustrated by such hallowed names as Sir Peter Scott, George Lodge and Winifred Austin. I remember being much influenced by the paintings of A. W. Seaby in *British Birds*, a book by F. B. Kirkman and F. C. R. Jordain, and I loved to leaf through *Morning Flight*, lavishly illustrated with Sir Peter Scott's paintings, which showed a fundamental understanding of the species of waterfowl he depicted. The pictures were so delightful, I can't remember even looking at the text.

Gradually, as I perused the illustrations of Scott and Seaby, I began to nurture what I considered to be an impossible dream. Wouldn't it be wonderful to grow up to be an artist and to paint pictures of birds. I had a little box of watercolour paints, as did my sister. We enjoyed using them and every year I did a few paintings, nearly always of birds. They were not very good.

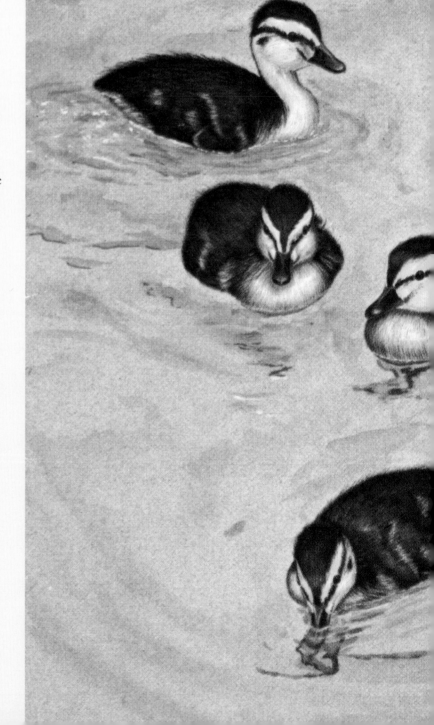

RIGHT *Responsibilities*, watercolour
The first painting I ever sold at a commercial gallery (The Mall Galleries, London, 1970), it was reproduced by the Medici Society as a card in 1971

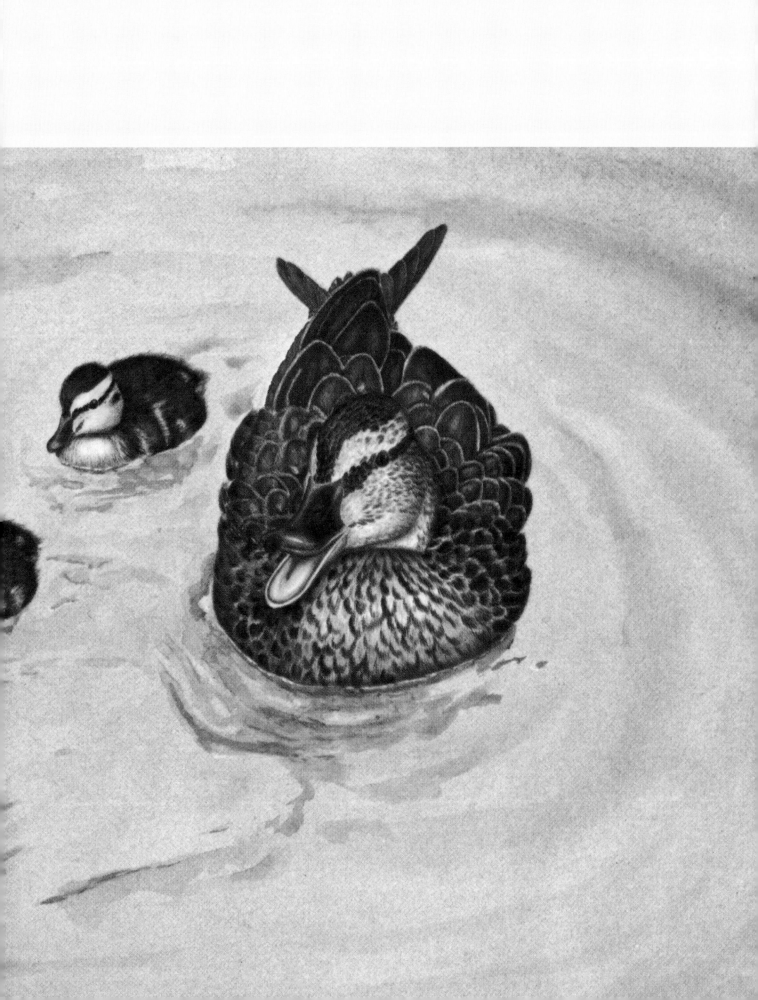

Around about my seventh or eighth birthday, I was offered a half-holiday from my schooling, so long as I sat on the lawn and drew the birds there. 'The birds there' were Yellow-rumped Thornbills (*Acanthiza chrysorrhoa*), a species that is tiny, mobile and wary of close approach. Thankfully, no drawing from that exercise has survived, for, in retrospect, it may have been one of the most miserable experiences of my artistic career. The thornbills darted about, far too distant for me to see them well enough to draw, and I became more and more frustrated and dispirited.

Very good homeschooling had advanced me by a year, so that, when I started school, I won academic prizes without effort and developed habits of intellectual laziness that lasted for years; then reality struck. I sank to the bottom of the class and became a problem child.

Then I went to Timbertop. I had spent my life on the grassland plains of western Victoria, but now I found myself in the bush, very close to the property where my mother had been raised. It was the saving of me.

Timbertop challenged us, physically and mentally, which was just what I needed. While I had been in bushland before, to live in it was totally new. The birds were different, the trees were different, the plants were different and the topography was steep and rugged. I loved the rivers and the opportunity to learn fly-fishing. I liked the hiking, the independence and the challenges.

Here were birds that I knew only from books. Early on in the year I saw my first Superb Lyrebird (*Menura novaehollandiae*). It was feeding on the fringes of bushland on the flats of the Howqua River outside the Eight Mile Hut as

we approached to camp there for the night. By the end of that year, I could recall days when I saw seven or eight lyrebirds.

Outside the same hut next morning I encountered my first Satin Bowerbird (*Ptilonorhynchus violaceus*), and I remember a pair of Sacred Kingfishers (*Todiramphus sanctus*) in a manna gum watching us at breakfast. Gradually it dawned on me that differing habitats were home to vastly different fauna and I began to take a much more focussed interest in my surroundings.

Early one morning, when I was fishing on the Howqua River, an exquisite Rufous Fantail (*Rhipidura rufifrons*) landed on my fly-rod to use it as a vantage point for its next foray. I froze lest I disturb it and was rewarded by its return to perch, and briefly preen, before fluttering into the bush.

Such encounters must surely shape a young mind, and I was thrilled by the proximity of such a beautiful little bird.

MENTORS

When my brother James married (he was six years older than I), he and his bride received as a wedding present an original illustration from *Birds of Australia* by John Gould: the Southern Emu-wren (*Stipiturus malachurus*), depicted by Elizabeth Gould, one of the most delicate and beautiful illustrations by an artist renowned for such delicacy of treatment. Shortly afterwards I had a bad accident and my massive concussion required total and prolonged rest. While recuperating,

ABOVE Pencil sketches of Yellow-rumped Thornbills
RIGHT *Spirit of Howqua*, oil on linen, 59 × 90 cm Loosely based on the slopes of Mt Buller with a young Wedge-tailed Eagle (*Aquila audax*); I was exploring the colour palettes of the Heidelberg painters

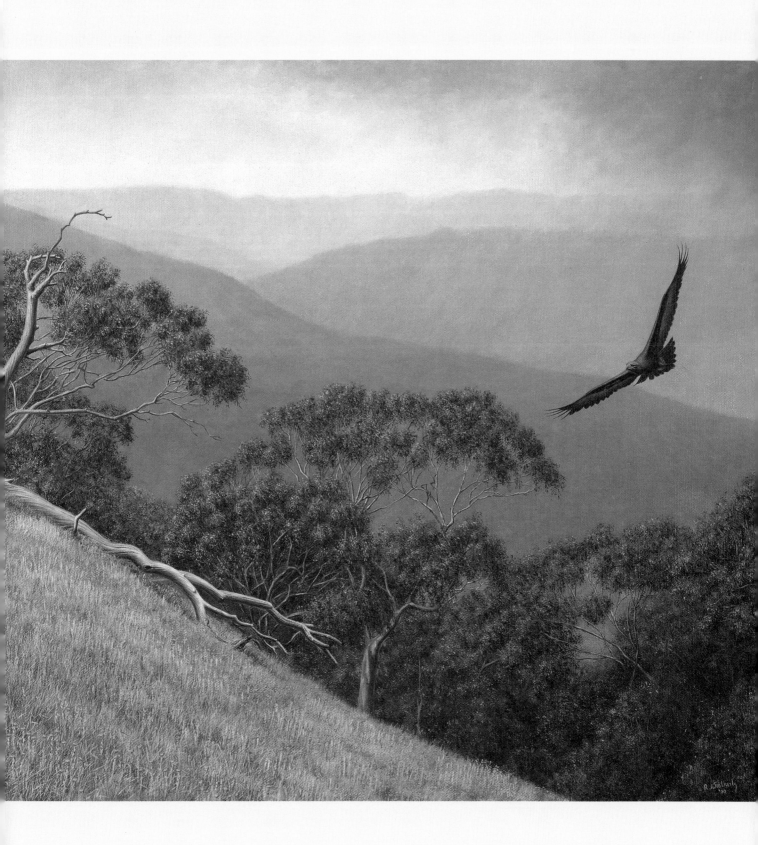

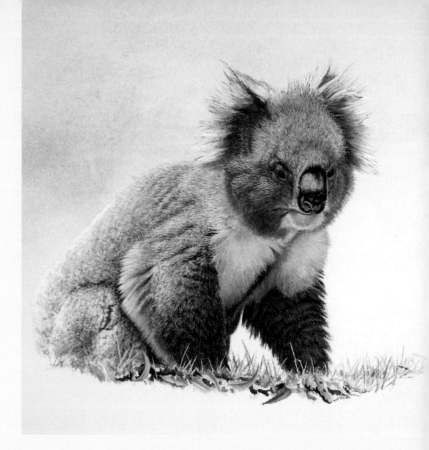

I decided to paint a pair for this picture, the only wedding present that I could afford.

As it happened, I found a dead bird not dissimilar to the emu-wren. This was my opportunity. Very carefully, I drew, designed and painted my picture. But under each of Gould's plates is written the name of the bird; I would have to identify my subject.

Tentatively, I telephoned Mr Sandford Beggs, a huge, gentle farmer of great kindness and humour who lived nearby and was a serious authority on birds. Mr Beggs pointed out that my specimen was a Little Brown Bird, and therefore an object of mystery to all but the more specialised professional ornithologists. He recommended that I should consult Mr Allan McEvey BA, the Curator of Ornithology at the then National Museum of Victoria. The BA proved to be Bachelor of Arts, not Bird Authority.

By this time the bird's remains were beginning to take on a character of their own. Caching the little corpse in a disused spectacles box, I travelled to Melbourne, and with the bird in my pocket, I took a crowded tram to the museum. I did notice that I seemed to have a remarkable amount of space around me!

Inside the door of the museum was a little glass window with a bell alongside which one could ring for assistance. This I did, and was soon attended to by a kindly young lady, who proved to be Mr McEvey's assistant. Having learnt of my mission, Belinda sniffed audibly and enquired, 'You have the bird with you, do you, sir?' She then led me down to the bowels of the museum, amongst long lines of formal-looking cabinets and piles of official-looking boxes.

Pinned to the wall was a copy of Hilaire Belloc's poem about the Common Cormorant, or Shag, laying eggs inside a paper bag. My terror

diminished, and when a small, smiling man, puffing actively on a pipe, emerged from beyond some bookshelves and greeted me warmly, I began to think that ornithology was a science that I could embrace.

Mr McEvey swiftly identified my specimen as a Striated Fieldwren (*Calamanthus fuliginosus*) and expressed interest in seeing my painting. By the time I returned with the painting, I knew that I had been speaking to a man who was internationally recognised as the southern hemisphere's greatest expert on the work of John Gould, and who was publishing a book on Gould's contribution to British art.

Again, I received an equally warm reaction from Allan, and also from Robin Hill, who was working in the basement of the Department of Ornithology illustrating his forthcoming book, *Australian Birds.* Robin looked pale and anaemic, as though he had seen little sunlight for a long time, which should have been a warning to me about producing books, but he had retained his renowned sense of humour.

Allan McEvey was enthusiastic in his encouragement, and when he learnt that I had been accepted by Cambridge University to read history and would shortly be travelling to

England, he gave me the contact details for Robert Gillmor, a proficient and well-known painter of wildlife who was art master at Reading School. It was years later, after I had left Cambridge to live in London, that I met Robert.

In 1969, my final year at university, an acquaintance had broken an old gun stock, leaving two gloriously grained pieces of seasoned walnut wood. He willingly gave them to me, and I set to work with a sharp pocketknife to make a small wooden sculpture from each. I had spent some time in Papua New Guinea, where wood carvings made from black palm had impressed me greatly. However, because of the nature of the wood's grain, they were very linear in form, lacking the grace and flow of their natural subjects. I set myself the task of attempting to carve similar subjects, avoiding the stiff, 'wooden', linear forms that I had seen.

The results were a shark and a dolphin, which took pride of place on the dashboard of my Mini Minor. The walnut timber had polished to a wonderful finish, deep and rich in colour and glossy-smooth.

COMING OF AGE IN LONDON

MOVING TO LONDON at the end of my studies gave me access to a wide variety of art of the highest quality. Many considered London to be the cultural capital of the world, and the music, literature, ballet, painting, sculpture and theatre were a new drug for me. Having come from an isolated rural background, I had been only dimly aware of these art forms, so I drank deeply from the cup of creativity.

On a visit to the Moorland Gallery in Cork Street, I fell into conversation with the director of the gallery, Major MacDonald Booth. At that time in London, a gang of Australian criminals had achieved some success, and I suspect that my accent may have aroused suspicion in the major. He followed me outside to my car, where he spied my carvings.

'What are those?' he enquired.

'Wood carvings,' I stammered.

'Would you like to sell them?' he asked.

Pound signs flashed before my eyes – here was an opportunity! So I left the sculptures with him and shortly afterwards they were sold. Asked if I would produce sculptures for the gallery's spring exhibition I readily agreed; I would be amongst artists who had inspired me for years, painters such as J. C. Harrison and Archibald Thorburn and sculptors Ernest Dielman, Trevor Faulkner and the Canadian Anita Mandl.

I dressed in my best suit for this, my first professional exhibition, and so polished did I look that a very posh young lady assumed I must be a gallery assistant. Expressing interest in my sculptures, she went over them in detail with me, explaining exactly what was wrong with each one.

At first I thought, 'I must introduce myself,' but she was so confident and verbose that she allowed me little opportunity, so eventually I fell in with the embarrassing deceit.

Later, this lady approached the sales desk to discuss one of my sculptures. 'Oh,' said the sales assistant, 'the artist is here. Would you like to meet him?' She pointed me out and the purchaser turned on me. 'You bastard!' she said, in her polished English accent. But she bought the sculpture!

The owner of another West End gallery, Sladmore Gallery in Bruton Place, saw the preliminary sketches I had done of my sculptures and invited me to put together an exhibition of paintings. I was easily persuaded; sculptures were not especially lucrative – one had taken weeks and sold for about forty guineas, but the sketch for it, which had taken about thirty minutes, sold for thirty-eight guineas. It seemed that I might yet become an artist.

There remained one problem. How could I learn to paint to the required standard? I have met artists who say that they are 'self-taught', and in general that is readily discernible and nothing to boast about. It was time to seek assistance.

Learning to paint is like learning a language: one is limited by the 'vocabulary' one has acquired – the technique and experience. At this point, the only thing that I knew was that I knew nothing.

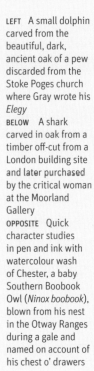

LEFT A small dolphin carved from the beautiful, dark, ancient oak of a pew discarded from the Stoke Poges church where Gray wrote his *Elegy*
BELOW A shark carved in oak from a timber off-cut from a London building site and later purchased by the critical woman at the Moorland Gallery
OPPOSITE Quick character studies in pen and ink with watercolour wash of Chester, a baby Southern Boobook Owl (*Ninox boobook*), blown from his nest in the Otway Ranges during a gale and named on account of his chest o' drawers

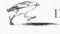

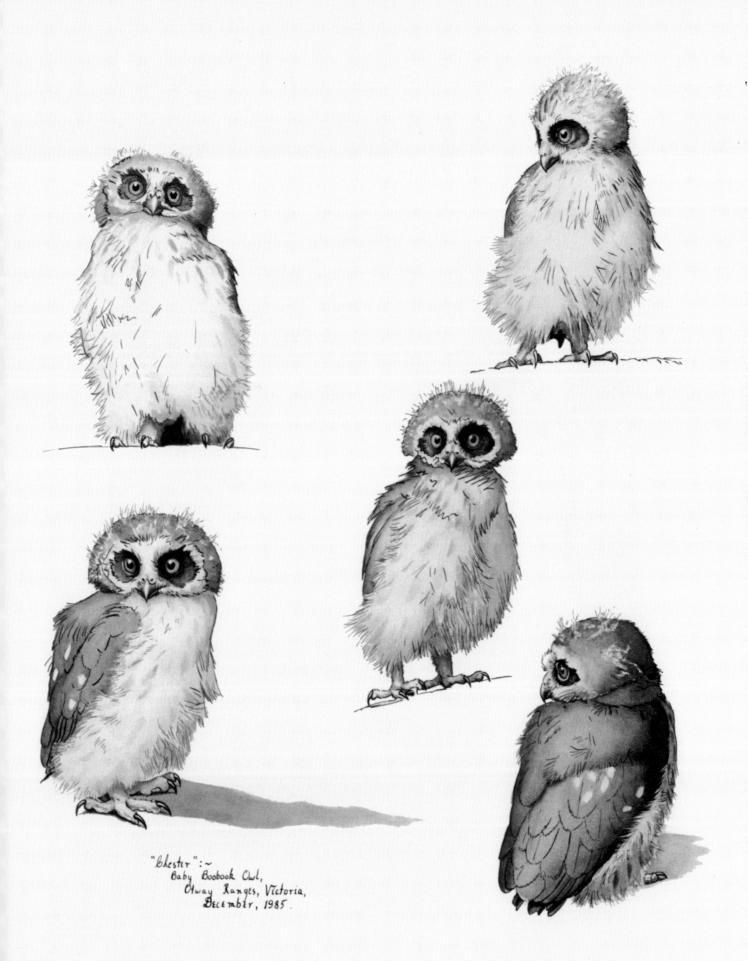

"Chester":—
Baby Boobook Owl,
Otway Ranges, Victoria,
December, 1985.

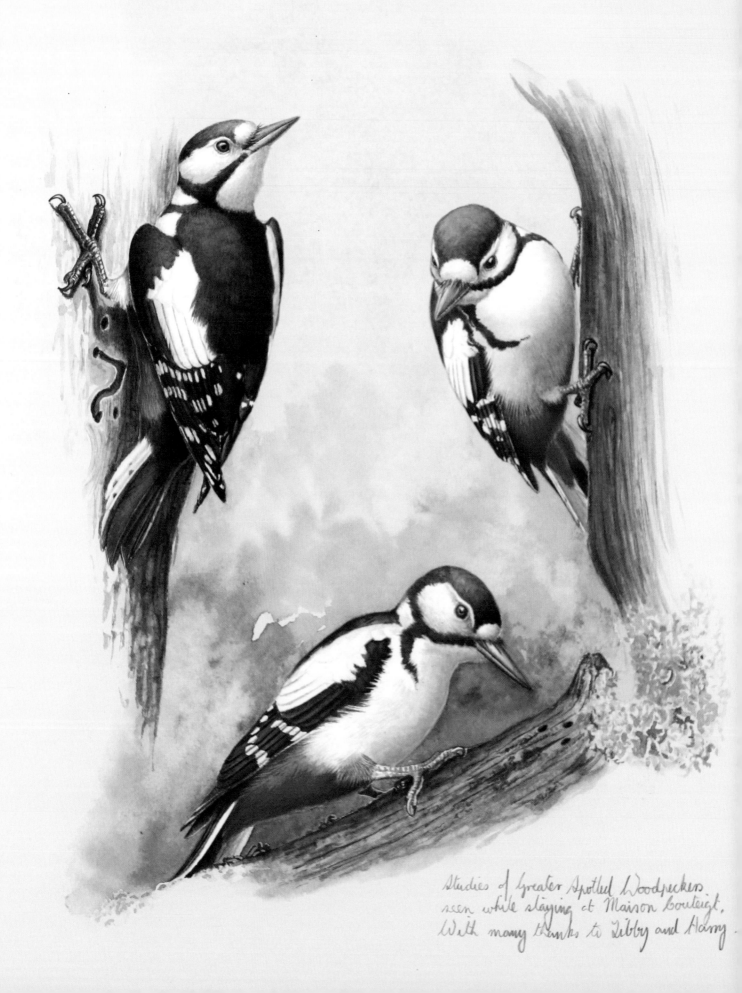

Studies of Greater Spotted Woodpeckers
seen while staying at Maison Bouteigt.
With many thanks to Libby and Harry.

TEACHERS

FRANTICALLY I SEARCHED my scattered possessions for the note from Allan McEvey with contact details for Robert Gillmor. Perhaps he could be my lifeline.

Professor Robert Goodden, then Deputy Director of the Royal College of Art in London and a gentle, kindly man, had quietly discussed with me the positives and negatives of attending art school. He concluded that I would derive little benefit; my skills and drawing were quite good, I was already an exhibiting artist, so I should just carry on. I wonder how different my life, and my art, would have been if he had reached the opposite conclusion. There are many aspects of art which I have learnt slowly from experience which I might have learnt quickly at an art school. However, working beside masters such as Robert Gillmor and David Reid-Henry, almost in the manner of the old guild system, has probably taught me a great deal more than years at the Royal College of Art.

Professor Goodden did recommend attending many galleries, finding artists whose work I really admired and seeking them out for advice or help. So I telephoned Robert Gillmor.

ROBERT GILLMOR

Robert was an immensely cheerful and likeable person with a broad smile and a ready wit. He was also a highly respected and experienced wildlife artist, a foundation member of the Society of Wildlife Artists of Great Britain and a busy art teacher at Reading School. He suggested that I bring my work to Reading.

Robert had grown up in an atmosphere of art; his grandfather was A. W. Seaby, my childhood inspiration as a painter of birds, who had also been the art master at Reading School before Robert. He was used to nurturing young minds to produce art.

Robert passed on the advice he had received when he started painting: choose a small number of inspiring and interesting species and work only on them, until you are familiar with every aspect of their structure, character and behaviour. At that time, several years into his own career, he had only ever painted seven species: these included the Lapwing (*Vanellus vanellus*), Black-winged Stilt (*Himantopus himantopus*), Pied Avocet (*Recurvirostra avosetta*), Kittiwake (*Rissa tridactyla*), Blackbird (*Turdus merula*) and Puffin (*Fratercula arctica*). He suggested I start at the London Zoo and return in a month's time.

I chose owls. Owls like to sit still for prolonged periods; during the day they are

OPPOSITE Watercolour impressions of Great Spotted Woodpeckers (*Dendrocopos major*), a gift for a couple who generously loaned us their house in southern France for a week
RIGHT Pen and ink drawing of David Reid-Henry's Southern White-faced Owl (*Ptilopsis granti*), named Chippy because his alarm call sounded like a carpenter using a handsaw; Chippy was referred to as male for twenty-seven years, whereupon he laid his first egg!

half-asleep, a condition with which, as an ex-student, I had great empathy. They have strong and endearing characters and they have distinctive shapes that are easily captured with line drawings.

Equipped with a sketchpad and pencil, I attended the zoo and went to work. Immediately, there was a nudge on my elbow. 'What ya doin', mister?' 'C'n oi 'ave a look?' 'Cor, come'n 'ave a look at this one, Emm! E's drawin' the birds!' 'Eh! Throw a stone at 'em Johnnie and see if you can make 'em move.'

Silently, I swore that I would never have children. Gradually, I resolved to restrain myself from throttling the children of others. My concentration level, of necessity, increased immeasurably.

Robert and I would lunch together, laughing uproariously most of the time, then scramble to look at my sketches before Robert returned to work. I would go back to London chastened, but determined to improve. Robert was always benign and constructive in his criticism, but I recall him characterising some rocks and grass as 'exploding tortoises'.

On one visit, Robert took me to an exhibition of the work of David Reid-Henry at Sladmore Gallery. I had never heard of him, but was immediately spellbound. Never, in my limited experience, had I ever seen an artist so technically skilled at painting birds. Clearly, David was the supreme bird illustrator of his era.

Robert introduced me to David, and in the half-minute available, David said, 'Australian, eh? Well if you want to talk to me about painting birds, come and see me.'

DAVID REID-HENRY

I was there at 7.30 the next morning. Several things impressed me. Surprisingly, David had no studio. He painted on the kitchen table, and when it came to mealtimes, his wife, with a sweep of her arm, removed everything, painting, brushes and paints, to make space to eat. Around the room were drawings and half-finished paintings in a variety of media.

Eventually, at about 1.00 am, I left. Poor David; he must have been exhausted after the opening of his exhibition. I returned at 8.30 the same morning, a willing sponge to soak up any information I could. I was introduced to a male Merlin (*Falco columbarius*), Britain's tiniest falcon, which lived in David's bedroom and was part of the reason his wife slept elsewhere. Tiddlywinks was a tiny, feathery bundle of enchantment and became the subject of my first attempt to use gouache, under David's supervision. He also showed artistic taste, for, just as I was nearing completion of his portrait, he hopped down from his block (the falconry term for perch) and regarded the painting quizzically with head tilted, before defecating on it. Art critics can be so cruel! Thereafter I used a falconry 'hood' to restrict his movement, despite the fact that, traditionally, it is rare for Merlins to be hooded.

On that first day, David demonstrated how to create a smoothly blended wet wash using gouache, a form of opaque watercolour, and then how to add, while the paper was still wet, brush strokes that suggested water, or grass, or clouds, or any number of effects. He soaked the paper for ten minutes in clean water, then laid it on a smooth board, carefully brushing out any air bubbles beneath it.

Next, he laid a thick layer of white paint evenly across the paper, before either blending in an even colour across the page, or selecting a number of colours to blend into each other.

Finally, he demonstrated how to use fan brushes to remove any trace of brush strokes. At this point, prior to the paper drying, he showed me how to use brush marks to indicate out-of-focus leaves, or mist, or distant bushes, or waves, for a softer, more subtle background to the intended painting. I started nearly every painting with this technique for twenty years, and people often asked if I used an airbrush, which I did *not* have.

David also gave me plenty of instruction on pencil drawing, at which he was superbly skilled. He was a master at suggesting detail by creating texture, and his tonal control was outstanding.

OPPOSITE ABOVE
White-headed Stilts (*Himantopus leucocephalus*), gouache, 44 × 62 cm
Sketched at Inglewood, Queensland, and developed into a gouache painting
OPPOSITE BELOW
Pencil drawing of a male Blackbird, from Graham Pizzey's book *A Garden of Birds*
RIGHT My first painting in gouache, under the tutelage of David Reid-Henry, was of his jack (male) Merlin, Tiddlywinks

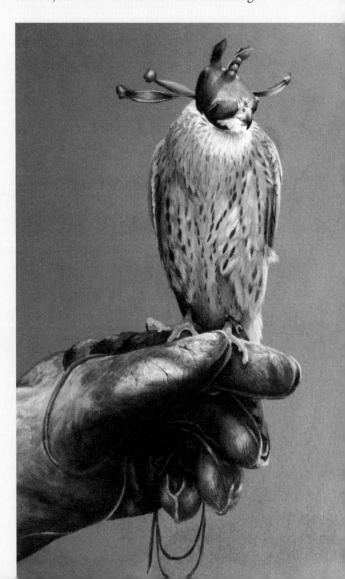

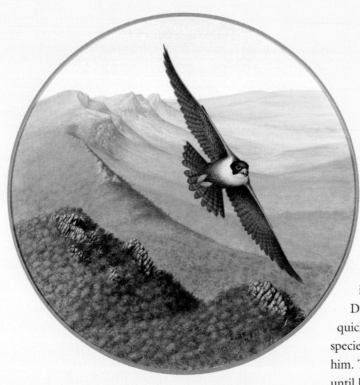

His drawings were a revelation to me and assisted my artistic development enormously.

David strongly suggested using gouache to paint birds, rather than watercolour: its softness better suits plumage, its opacity allows over-painting, and it can achieve effects unobtainable with watercolour. Since the Renaissance, gouache has been made by grinding pigments in watercolour medium, obtaining opacity by adding material such as chalk or *blanc fixe*. Watercolour is translucent, allowing light to pass through and reflect off the paper, providing an inner glow. With gouache the pigment reflects light, not the paper, and its inherent softness lends itself to sketching or illustrating birds.

Occasionally, David would demonstrate a technique he was employing in one of his own works. Once he had almost completed a painting of a Gyrfalcon (*Falco rusticolus*) in an Arctic landscape, with a clear blue sky; he decided a cloudy grey sky and dull light would be preferable. He showed me how he could go back to basics and do a totally different wet wash over much of it. This he achieved with a loaded wet brush, repeatedly brushing the back of the painting until water soaked through to the front without disturbing the paint. Then, turning the page over, he used the side

of a wet brush to add low clouds and mist.

David was a stickler for careful drawing to prepare for a painting and would occasionally paint over a pencil drawing with translucent tempera, somewhat like the technique used later by Raymond Harris Ching, who claimed that it was derived from Vermeer's technique. David would survey a whole collection of quick, linear drawings that he had done of a species before selecting the one that best pleased him. This he would then redraw and redraw until he was satisfied. Many of his sketches are scribbled darkly on the reverse side where he has transferred them onto a new sheet of paper to redraw the mirror image. Meanwhile, outdoors, I was still attempting to resolve how to battle with windblown paper, spectacles, binoculars, flies and sweat in a dispiriting attempt to record my observations. I needed to develop my sketching and drawing skills with some urgency.

David Reid-Henry encouraged me to do quick, linear drawings – essentially character sketches – to prepare for each subject. I would then select sketches that caught something of the essence of the subject, and work them up into more finished drawings, refining light and shade to add form, or researching details I could not see sufficiently clearly by revisiting the subject or looking at bird skins in museums.

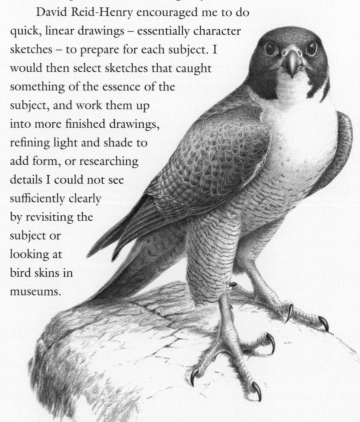

Gradually, I developed a manner of working that can best be described as 'in stages'. I would see a bird or an incident in the wild that would inspire me: it could be the behaviour of the subject, the way the light fell, or an action or interaction – many things or anything.

First I would draw a layout design for the painting, looking for balance in colour and tone, for positive and negative space, for flow in the design. Next, I would do linear sketches of the subject – many, many sketches – until I began to know the bird, to 'feel' the bird, almost to get into its mind. If the opportunity arose, I might do hundreds of sketches, but if the bird was rare, or in a remote location, then I learnt to make do with what I could get, sometimes a meagre few sketches.

I would then select four or five of what I considered to be the sketches with the most life, movement or character and draw more careful drawings from these, working out some of the details, proportions or markings.

From these, I might use one or two on which to base a careful study, either in colour or in black and white, sometimes loosely, sometimes in careful detail. When I am painting, I prefer to know what I am trying to achieve. These studies are, mostly, to remove areas of doubt. However, I am not constricted by the preliminary drawings, as sometimes I might change complete sections of a painting midway to completion, or even change the subject completely.

Occasionally, but not often, I will complete the entire painting on a small scale, a finished painting in itself, which may be changed or unchanged for the larger final work. Sometimes these smaller preparatory studies will be purchased by a client before I have completed the final version and on these occasions I may decide that I have already said what I wished to say on that idea and not complete the final painting, even painting over what had been done for another work. Thus, there may be a painting in Canada that hides behind it an Australian desert scene (and in fact there is!), or some totally unrelated artwork.

Of course, the weakness in this process is that the drawings most likely to reflect the energy and character of the subject are the sketches. They tend to have movement and immediacy which are easily watered down at each stage as it moves away from the original observations. I try to remain conscious of that, but also to spend as much time in the field as possible, to retain the sense of awareness gained by direct observation.

Over the years, with experience, one starts to observe elements that one overlooked in earlier years. This is when it becomes tempting to draw what one 'knows' rather than what one sees. David was rigorous in the use of 'indicator marks' for details he could not see sufficiently – a dot for an eye, a straight line for a bill – implicit reminders to research further at a later time to confirm that detail. He continuously urged me to step out of my comfort zone and try new ideas, to never 'paint from recipe', as he called it, meaning repeating a technique or ideology formed and practised in previous paintings.

HARRY HORSWELL

Harry Horswell, of the Sladmore Gallery, noticed that I was keen to learn from David Reid-Henry, and it appeared that David was keen to teach me. Harry invited us both to stay at his home, Sladmore Farm, at Cryer's Hill in Buckinghamshire. Harry, I think, saw an opportunity to control David's wandering interests and induce him to paint more productively, and he placed great faith in my capacity to develop under David's tutelage. He was not slow, either, to utilise my skills with handling horses, tacking on a horseshoe or remedial hoof-trimming, for his four children all had horses and were keen members of the pony club.

Sladmore Farm was a wonderful place for an aspiring artist with an interest in ornithology. Harry had his own vast collection of birds in a network of aviaries, so that David and I could wander a few yards to check on plumage or behaviour at any time. We were allocated a large, glass-fronted room for our studio, which had originally been built as a gallery, and we would paint alongside each other at our desks. David was constantly available to instruct me if needed, and he would frequently call me across to demonstrate some new technique. An able raconteur, he was a constant source of stories, of growing up in Sri Lanka (then Ceylon, where his father was Curator of Entomology at the Colombo Museum), of his time spent in Africa, of his adventures in the war, of working with the great artist and falconer George Lodge, and many other subjects, normally punctuated with hoots of laughter.

I was fascinated by Tomboy, his Peregrine Falcon, and by his Prairie Falcon (*Falco mexicanus*) and Mr Bumps, a Common Buzzard (*Buteo buteo*). All of these were available to me as models to develop my skills and I began to accumulate some simple understanding of

both drawing and how a bird of prey should be handled. David's drawings of raptors were world-renowned and immensely valuable. Once, in gratitude to a gamekeeper for obtaining a buzzard for him, he had done a very highly finished drawing of a Peregrine Falcon, almost the most valuable thing he could create. He gave this to the gamekeeper, who thanked David profusely, before folding the drawing carefully in half, creasing it closed, and then folding it again before placing it in his pocket. I was aghast. 'That is so sad, David, to waste a drawing like that.'

'Not at all,' said David. 'I drew it to thank him. He was grateful and if that is what he wants to do with it, then that is his business. He was happy; it achieved its purpose.'

The Horswell family were extraordinarily hospitable. Jane Horswell, a shy, highly strung woman with a heart of gold, was an expert on animalier art, and Sladmore Gallery was really

ABOVE My early attempt in pencil at drawing David Reid-Henry's Mediterranean Peregrine Falcon Tomboy
OPPOSITE *Steve's Bird*, gouache, 26 × 21 cm An American Peregrine owned and flown by Steve Sherrod, of the George Miksch Sutton Avian Research Center at Bartlesville, Oklahoma

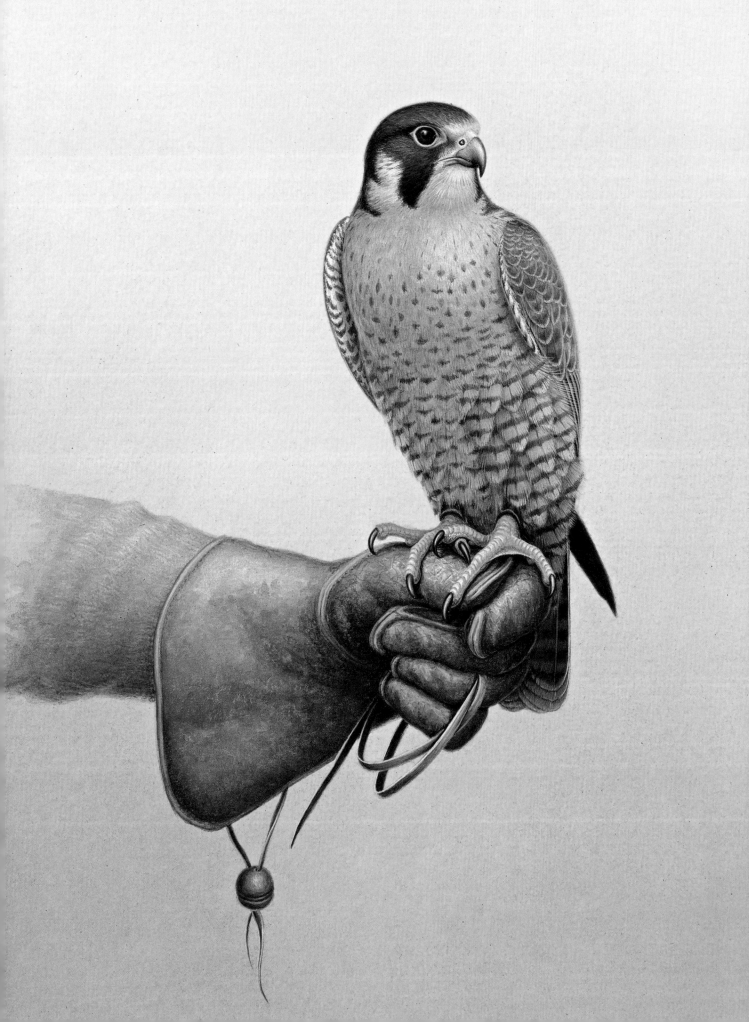

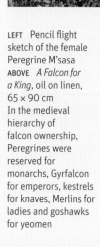

intended to display and trade her collection of sculptures and to communicate with other experts. I gradually accumulated some knowledge of animalier sculpture from her, becoming familiar with the work of P. J. Mene, Antoine Louis Barye, Rosa Bonheur and Rembrandt Bugatti, whose sculptures I found absolutely brilliant. Once, a casting of Bugatti's immensely valuable *Panther* was lost. When the children were home it could be like cyclone central, and concern was veering towards panic until the sculpture was discovered under a heap of discarded gumboots and macs near the back door.

Edward, the youngest, had a girlfriend but no driver's licence. At fifteen, he was a seething cauldron of catalytic hormones. Occasionally I would be co-opted to transport him to his girlfriend's house, where I would sit chatting to her father while Edward and she cavorted elsewhere. Her father was Roald Dahl, one of the most fascinating raconteurs that one could ever hope to meet and a constant source of wisdom and entertainment. I thoroughly enjoyed transporting Edward.

PAINTING BIRDS

The technique of sketching forces one to look carefully, and to learn about the subject; nothing could impose better discipline than to impress the image on one's memory. The artist observes, and learns, nuances of light, form and character almost subconsciously. Each drawing teaches a little more, until the artist begins to feel an intimate understanding of the subject. A little like an actor, the artist can come so close that it's almost possible to see things from the bird's point of view, not as an observer, but as a participant.

David Reid-Henry was a brilliant draftsman and drew frequently, but mostly

LEFT Pencil flight sketch of the female Peregrine M'sasa
ABOVE *A Falcon for a King*, oil on linen, 65 × 90 cm
In the medieval hierarchy of falcon ownership, Peregrines were reserved for monarchs, Gyrfalcon for emperors, kestrels for knaves, Merlins for ladies and goshawks for yeomen

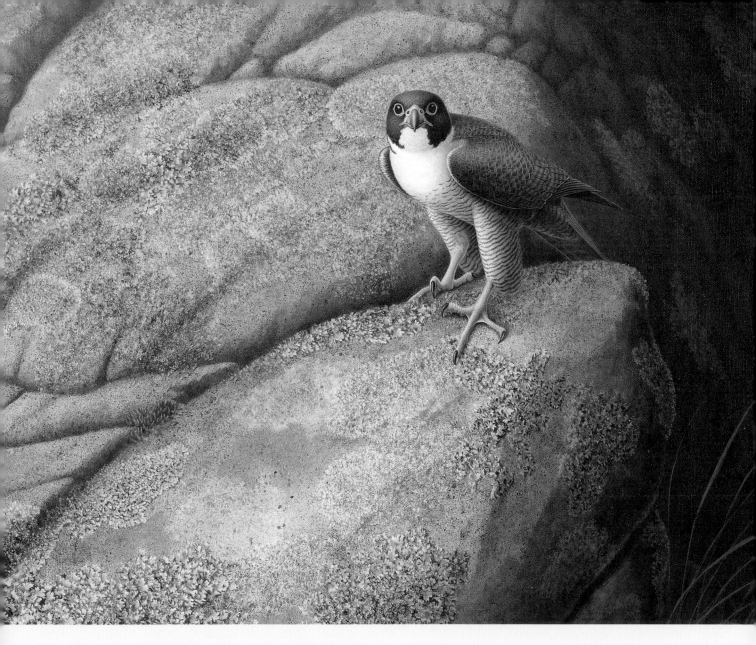

from his mind. He seldom sketched in the field and I only saw him drawing from a live bird once, a tiny, thumbnail sketch of a White-faced Whistling Duck (*Dendrocygna viduata*) asleep. He possessed the most astonishing visual memory of anyone that I have ever encountered. Often, relaxing after dinner, he would pull out a sheet of paper and draw a study of a bird, say a Golden-backed Woodpecker (*Dinopium benghalense*), which he had seen in the Ceylon jungle some forty years before. He would normally draw the head first then add the body. He did not use an eraser, but sometimes would draw a second head in an entirely different attitude on the same body to change the posture and character of his subject. Of course, what made David's drawing look so easy was long

practice, the training of his mind over decades to memorise what he saw: he had been drawing some of these birds for forty years and was entirely familiar with them. Also, his frequent drawing exercised and improved his abilities. Most of us can achieve an excellent visual memory if we continually practise; it becomes easier with time. Drawing birds from life is as astonishing to the unpractised bystander as is riding a bicycle, or being able to swim. What appears impossible can be perfected by practice.

Pablo Picasso once said, 'Painting is a blind man's profession. He paints not what he sees, but what he feels, what he tells himself about what he has seen.' Perhaps, by drawing from memory, David was recording the impact the bird had on his mind, not a merely physical form.

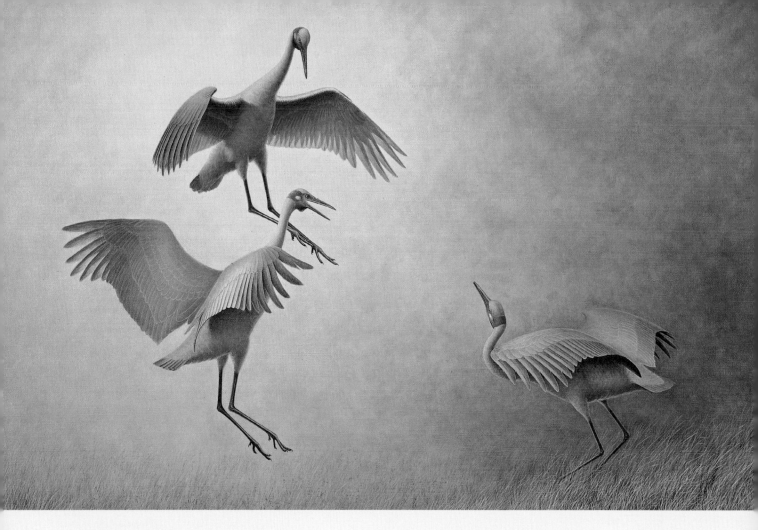

Today, through the internet and digital photography, it is easy for aspiring artists to find photographic references for their art. In many genres this has become a preferred method; it is faster and easier and helps artists make a living from their art. Quite apart from the fact that such facilities were not available to me, I was strongly discouraged from using photographic references by nearly all the people influencing my development. Foremost amongst the reasons offered was that, if I were to produce a painting, I should think about what I was trying to say. Surely it should offer some insight into the subject, to make a point or tell a story?

The silversmith Leslie Durban explained this best to me. He said, 'You are not trying to draw a crow; you are trying to draw "crowmanship". Think of the cave paintings of men running,' he said. 'They don't look like men, but they are running like no man has ever run before; and the water in traditional Chinese paintings – it doesn't look like water, but it is deep and flowing in a way that a photographic imitation could not achieve.'

Working from photographs damages an artist's visual memory. Photography inserts a mechanical apparatus between artist and subject, which induces a kind of visual laziness. The exercise becomes merely technical – the copying of a photograph as faithfully as possible. Gradually their mind becomes lazier, limiting the care with which observations are made and diminishing the ability to draw effectively from memory. It also diminishes the confidence, even certainty, that comes from frequent drawing and may limit the expression of character and understanding that gives life and character to the subject.

Many bird paintings emanate from a form of avian portraiture, either of an individual or of a species, possibly due to their origin in book illustration. There are so many indicators of expression in the human face, but the avian form is more limited. The main sources of expression are the eyes, followed by the feet and then the wings. Beyond that, attitude or posture becomes critical, and the various sources of expression need to match. There is no merit in drawing a bird in a

ABOVE *Dancers of the Dawn*, oil on linen, 105 × 137 cm An attempt to catch the backlighting of a misty dawn, with the low sun shining through the feathers of dancing Brolgas (*Grus rubicunda*), a painting as much about mood as about these glorious, athletic birds OPPOSITE Loose study of Burdekin Ducks (*Radjah radjah*) in pen and ink with watercolour, attempting to catch their smart cleanliness

totally relaxed posture with a look of panic in its eyes, or vice versa. Instead of thinking, 'That looks like a crow,' ideally a viewer should think instead, 'Isn't it interesting how crows always sit like that?'

In the art establishment, there are brilliant artists responding to the environment in ways that science finds uncomfortable. In scientific illustration, we have extraordinary artisans who are increasingly obsessed with technique, but who have little to say artistically. Here is the dichotomy between art and science at its extreme. Illustrative wildlife art is not accepted by the art establishment. Art is not admired by the scientific community. One aspect of learning to paint wildlife is the inherently schizophrenic necessity to be two incompatible intellects simultaneously: one an artist, the other a scientist, a battle between two sides of the brain. However, in both painting and science, is not the intention to add to the sum of knowledge of the subject; to inform or show character, as in a good portrait; to reveal some greater truth?

An added burden for the wildlife artist is that the viewing public are becoming further removed from the reality of wildlife, by absorbing vicarious experience and knowledge from their television sets.

The gulf between those who compose their artwork through a camera lens and those who develop their ideas through direct experience, knowledge, familiarity and draftsmanship will widen. When an artist paints, it is not just to create a pretty picture, but normally to convey a message, tell a story or make a statement. For the wildlife artist, this can be difficult if the message depends on a more subtle knowledge of the subject than the viewer can understand.

In Europe at the time I was learning, there were a number of remarkable artists painting wildlife and showing their drawing skills, and it was still possible to occasionally find exquisite drawings by Wilhelm Kuhnert – I was fortunate to see sketches by him of an elephant shrew, or 'sengi', from Africa. The woodblock prints of Robert Hainard were widely admired, and watercolourists like Eric Ennion and John Busby were masters at capturing character.

It seems almost unfair to single out artists, as they nearly all drew well. It was only later that other options became truly viable, though early examples of photographic references do exist, surprisingly in some of the works by Bruno Liljefors, amongst others.

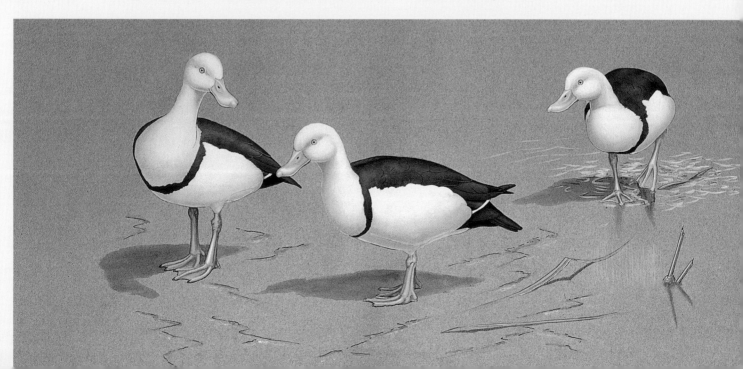

AFRICA

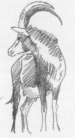
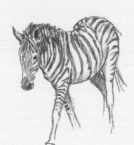
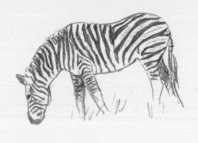

FIELD SKETCHING CAUSED me great angst. I could draw subjects that were relatively immobile and easily visible, but wild birds, particularly small ones, caused me immense difficulty. I could not see sufficiently well to draw, and became entangled in spectacles and binoculars while holding down the windblown pages of the sketchbook. When David Reid-Henry announced that he was returning to Rhodesia (now Zimbabwe), I seized the opportunity to work with him in the field and develop my skills further.

My father had learnt to fly aircraft in Rhodesia under the Empire Training Scheme during the Second World War, and I'd been enthralled by his photographs and stories. Two of his uncles farmed tobacco there, and he clearly loved their farm.

Uncle Griff and Uncle Jack returned to Australia in 1959, having foreseen the violence and bloodshed ahead. Their exotic stories of wild animals and colourful birds, their collection of assegais, fly whisks made from a Blue Wildebeest's tail, bracelets of elephant hairs, and their enormous personal energy were most exciting for a small boy thirsting for adventure.

So it was with enormous enthusiasm and no plan at all that I set out for Rhodesia on a charter aircraft that was to land at Johannesburg. I took my paints, which were so heavy in their leaden tubes I had to carry them in my sportscoat pockets, forever saggy thereafter.

The three-day train journey from Johannesburg to Salisbury (now Harare) was at times so sluggish that I could hop off and walk alongside it. I journeyed with my nose pressed against the window, searching for the mythological Africa about which I had read so much, and regaled with stories from fellow passengers of leopards in the sitting room, elephants in the vegetable garden and Black Mambas rearing their heads to look into passing cars!

I am astonished that I arrived with no book of African birds. Field guides for any country were less usual in that period, before Roger Tory Peterson's innovations, comparing birds with similar birds in similar attitudes, generally organised in taxonomic groups. Earlier field guides could be difficult and confusing, and growing up with Cayley's *What Bird is That?* did not induce total reliance on the guide. Often the question remained – what bird *is* that? I had survived four years in England having never felt the need for a field guide to British birds, as my childhood years spent studying books of European avifauna had left me familiar with British species.

PREVIOUS Pencil layout sketch of Helmeted Guineafowl (*Numida meleagris*)
ABOVE Pencil sketches of Sable Antelope (*Hippotragus niger*) and Plains Zebra (*Equus quagga*) in a small, private wildlife park in Zimbabwe
BELOW Quick pencil sketch of very aggressive and dangerous African elephants in the Gonarezhou, prior to its declaration as a national park
OPPOSITE Gouache study, 28.5 x 21.5 cm, of a Lilac-breasted Roller (*Coracias caudatus*); this brilliant jewel of the African veldt perches on vantage points in savannah woodland throughout Sub-Saharan Africa to watch for its prey of insects, small reptiles, scorpions or centipedes, which it eats on the ground

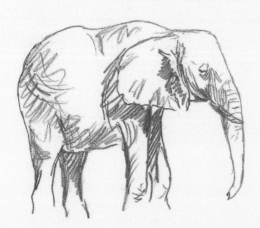

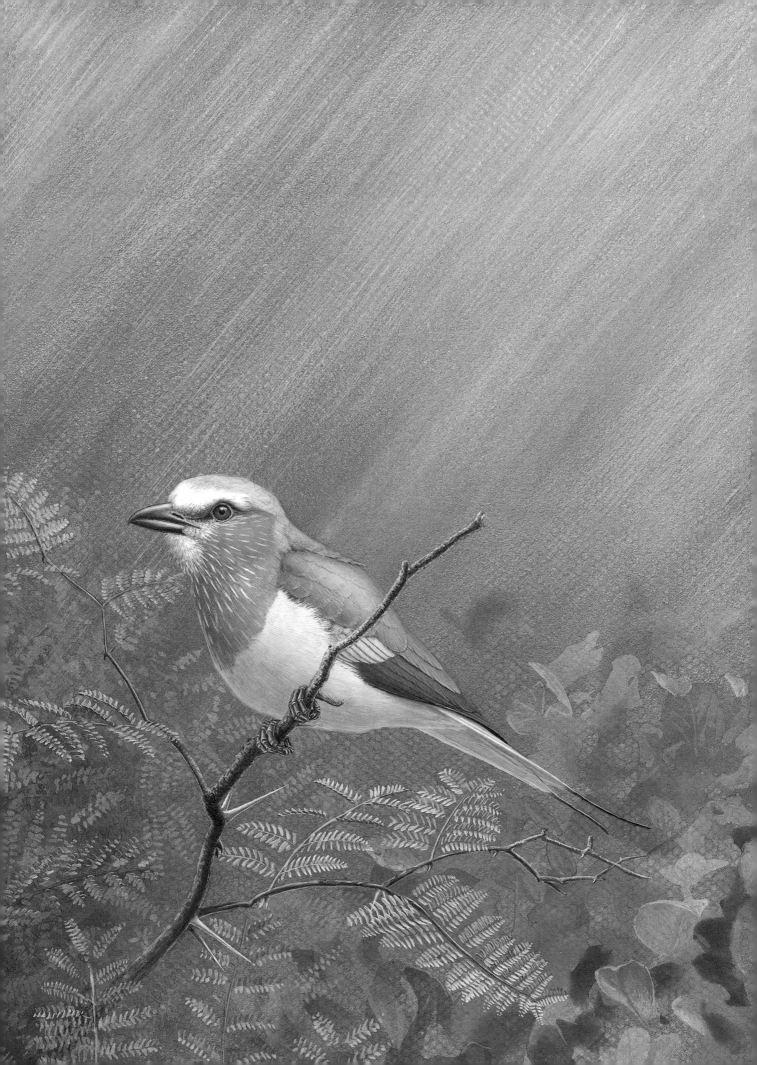

Suffice to say, I was a stranger in a strange land and bravely unprepared.

Through friends of a friend I was introduced to Dr John Condy, the Chief Veterinary Officer for Rhodesia, a superb bushman and naturalist, who was engaged in foot-and-mouth research with native animals. John was generous in including me in some of his bush trips and probably taught me more about tracking and bushcraft than anyone.

John took me to the Gonarezhou, a Shona word meaning 'elephant's tusk', which is in the remote south-east of Rhodesia, four years before it was declared a national park. It was wonderfully wild country, full of elephants renowned for their aggression and resentment of human interference. In preparation for the declaration of the park, the Mkwasini communities who lived close to the Lundi and Sabi rivers were being evacuated to preserve the integrity of the park. Sadly, this had an enormously deleterious effect. Elephants also used the rivers and would travel silently through the dark, sometimes from as far as thirty or more kilometres away, to drink and bathe. Before first light, they would retreat to their feeding grounds, well away from the threat of humans and hence well away from the rivers.

When the people left, there was no cause for them to retreat, and so they remained to feed and lounge around. This dramatically increased the grazing pressure along the riverbanks. Elephants can be destructive feeders, pushing over trees to reach their foliage, hauling down and breaking off branches that are just within reach of their trunks and gouging great holes in the baobab trees with their tusks to reach the soft, moist, fibrous tissue beneath the bark.

Soon the river flats began to resemble a bomb site, and with pressure from grazing animals like Impala and browsing animals like kudu, the vegetation began to disappear completely for a

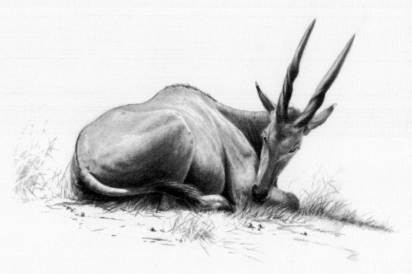

kilometre or so back from the riverbanks. How this problem has been managed since I have no idea, but when we were there it was a vista of destruction.

At the junction of the Lundi and the Sabi rivers stand the spectacular Chilojo Cliffs, known then as Clarendon Cliffs, rising a hundred metres vertically above the floodplain, in alternate layers of pink and white sandstone, which flared brilliantly in the evening sunlight. By late afternoon each day, a variety of doves would hurtle over the brink of these cliffs and dive down to the water below for

ABOVE Pencil study, 15 × 22 cm, of an Eland (*Taurotragus oryx*) cow resting on a private farm near Mazowe in Zimbabwe
LEFT Small sculpture of a kudu bull carved from a single block of pear wood; the disparity between the price of this sculpture and its study drawing convinced me to turn to painting
OPPOSITE ABOVE Field sketch in pencil of a Southern Red Bishop (*Euplectes orix*), Savuti, Botswana
OPPOSITE BELOW Pencil sketch of African Wild Dogs (*Lycaon pictus*) in Botswana

their evening drink. Poised on dead branches and rock clefts at the top of the cliffs waited Lanner Falcons (*Falco biarmicus*), and as the doves hurtled past, the falcons would stoop (dive) after them in spectacular chases, attempting to catch them before they reached the safety of the scrub below. Laughing Doves (*Spilopelia senegalensis*), Cape Turtle Doves (*Streptopelia capicola*), even the diminutive Namaqua Dove (*Oena capensis*), the smallest in the region, would run the gauntlet each night.

WEAVERS

My interest in stalking creatures constantly landed me in trouble. In the Gonarezhou, with John Condy, I attempted to reach a buffalo weavers' nesting colony. These birds build a huge communal nesting structure, an untidy mess of sticks, generally in a large tree. This one was at the end of a massive low branch, which overhung a donga. The branch was broad and strong enough that I could easily balance on it, but by the time I was over the donga, I was six metres above the ground. Having walked along the branch, I turned to walk back. It was then that I noticed a rotten hollow in the branch, over which I had stepped on my way out. Curled in the hollow was a very large snake, gleaming black, with narrow untidy white bands at intervals along its body. It appeared to be very alert.

I assessed a jump of about six or more metres, and considered how many hours I was

from medical assistance. I thought I should attempt to identify the snake, so I called, 'Hey, John, does a Black Mamba have white stripes around its body?'

'No,' came John's reply, 'no, that would be a Banded Cobra.' And then, as the implications of my question sank in, he turned a pallid shade of green. A discussion ensued and we decided that I must step back over the snake, as I had when I disturbed it on the way out. I dared not look down, but stepped boldly over it. John said that the snake's head followed my leg over, but it didn't strike!

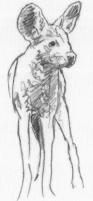

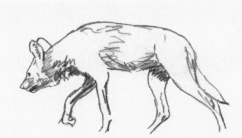

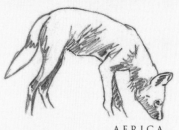

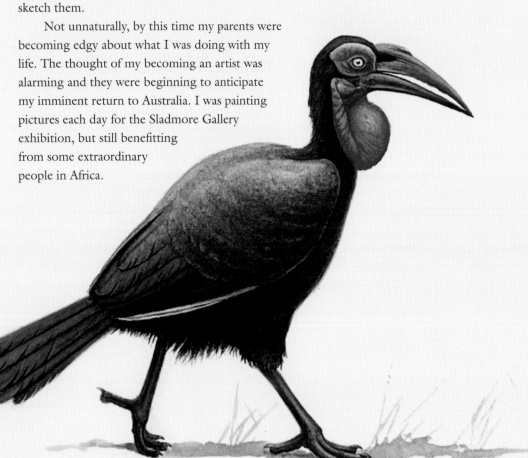

HORNBILLS

The following morning seven stately Southern Ground Hornbills (*Bucorvus leadbeateri*) were stalking through the short, dense grass near the track. These sombre black birds, with their conspicuous red face patches and scarlet throats, are as large as a turkey, but more erect, and resemble funeral directors, until they take to the air, revealing large, white, terminal wing patches. They mostly eat insects, but will take frogs, birds, snakes and even tortoises. The largest species of hornbill, they are threatened in many parts of their range, so it was a great opportunity to sketch them.

Not unnaturally, by this time my parents were becoming edgy about what I was doing with my life. The thought of my becoming an artist was alarming and they were beginning to anticipate my imminent return to Australia. I was painting pictures each day for the Sladmore Gallery exhibition, but still benefitting from some extraordinary people in Africa.

ABOVE Female Red-billed Hornbill (*Tockus rufirostris*) in the Okavango, one of a number of small pen and ink drawings in a bird list for tour groups I was leading
LEFT Gouache study, 21 × 30 cm, of a Southern Ground Hornbill, seen near the Gonarezhou in Zimbabwe
OPPOSITE Gouache study, 21 × 30 cm, of a Southern Ground Hornbill, depicting their habitual tall posture, reminiscent of a funeral director

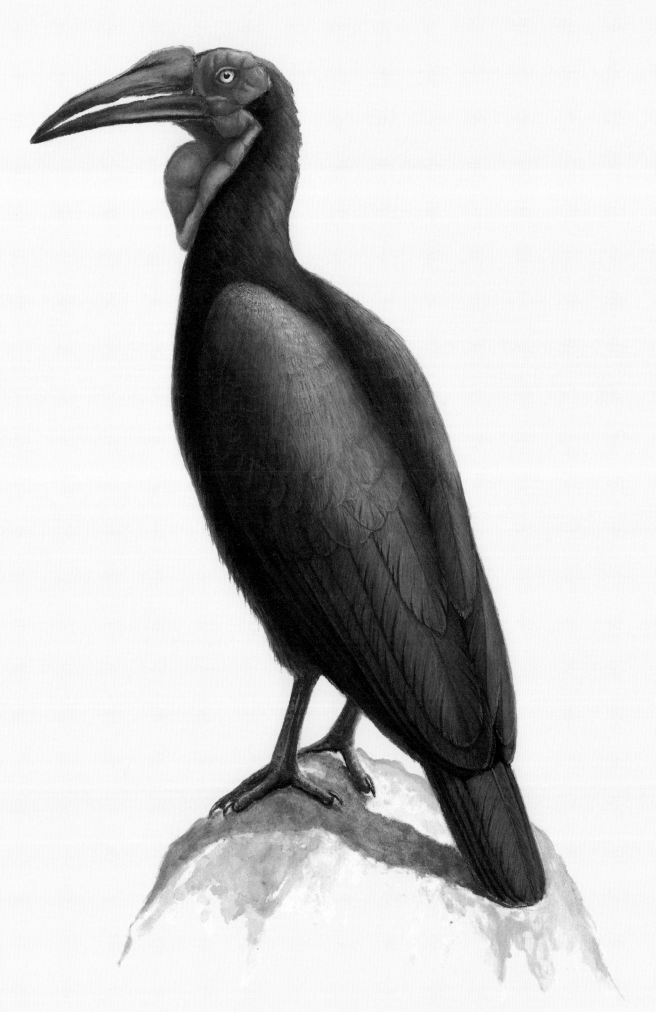

FALCONRY

WHEN I WAS eight or nine years old, I had found a sick Brown Falcon (*Falco berigora*) which I had ached to train, but without any clue as to how to start, I eventually released it.

John Condy was an experienced falconer, and one morning he left camp intending to trap a falcon. To my astonishment, he returned with an adult female Lanner Falcon, which he handed to me to train under his tutelage. She was a beautiful bird, perfect in feather and physique, totally fierce and wild. I could scarcely believe my good fortune. Immediately, we broke camp, packed the vehicle and drove home to Salisbury, this glorious falcon sitting on my gloved fist, hooded to keep her quiet, for if she could see nothing, then she need fear nothing.

Throughout the long drive I studied the bird closely. Her back was a pale steely blue, each feather delicately marked with darker grey barring, forming the chain mail of a hardened warrior. Her tail, longer and more slender than that of a Peregrine Falcon, was the same pale steel grey fading to a blush of salmon at the tip, and there were parallel dark bands evenly spaced along each feather. Her underparts, throat, breast, belly and vent were clothed in softer feathers of subtle pale salmon pink, with sparse and delicate darker arrow shapes on some feathers. She sat, balancing on my hand, but if we hit a bump or went round a tight corner, she would grip my fist with her bright yellow feet. Gradually, she relaxed, as a child will settle into sleep in its car seat.

Different species of falcons react to capture differently: Lanner Falcons are normally co-operative, but individuals vary greatly. A falcon trapped in the morning will usually be handled

for the first time that evening, and this should occur in a quiet, dimly lit room, where one can be undisturbed for an hour or so. Of course, at the time I knew none of this. When we arrived back at the Condy home in Salisbury, John found some food for the falcon, which I had named Awala, after a Papuan village where I had a friend. I was attracted by the onomatopoeic qualities of the name, suggesting rushing wind and speed.

Seated in his sitting room, with dogs and children all around, I took off the hood in the hope that she would accept her surroundings and eat. I expected her eyes to dart around the room, before she flattened her feathers in fear, leapt frantically from my fist to hang bating from the jesses (bating means beating her wings, and jesses are restraining straps).

ABOVE Preparatory pencil drawing of a Brown Falcon subduing a mantid OPPOSITE Gouache study, 21 × 30 cm, of my Lanner Falcon, Awala, trapped by John Condy in the Gonarezhou

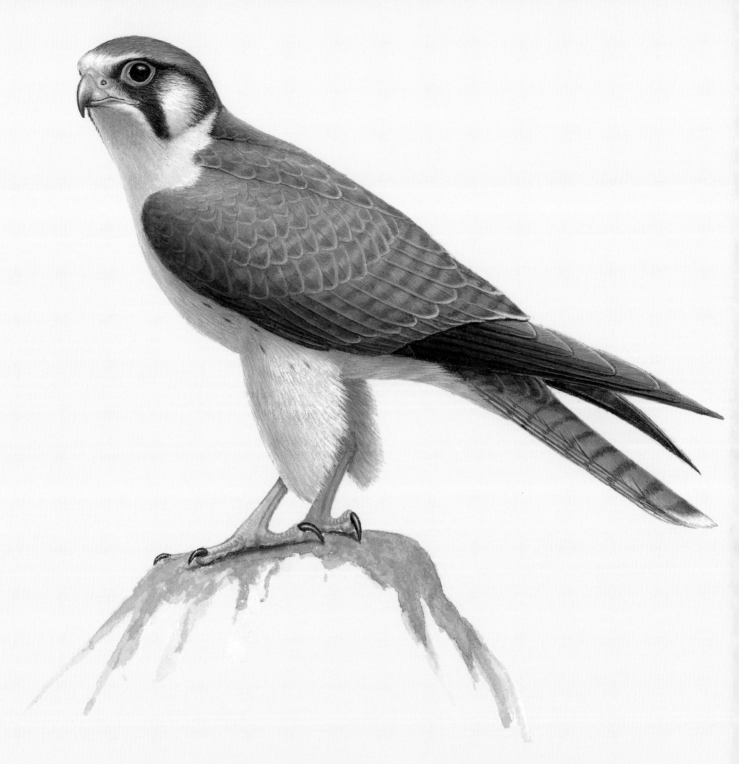

To my astonishment, she glanced around the room, roused her feathers and, in response to my tickling her talons, looked down at the food I was holding. To put her head down to eat would be intensely risky, for then she would be less aware of her surroundings and temporarily off balance for any desperate getaway. After a couple of false starts, she leant forward and quickly picked at the meat; then, settling, she started to tear off small portions and consume them ravenously.

Thus began the training of my first falcon, one of the most amenable and best performing birds that I have ever trained. There were trials and tribulations, but she survived them all without mishap. Eventually, when I returned to London, I left her with John Condy, who took her to Scotland to hunt grouse with elite Peregrines trained by the legendary falconer Stephen Frank.

To stalk birds, to paint birds, it helps to understand their minds. Falconry allows us to

observe a bird closely and learn to understand it, to share the bird's natural behaviour and eventually join it in the hunt. My introduction to falconry was an essential step towards understanding birds sufficiently to paint them. In the intimacy of a hunting partnership one becomes really familiar with the falcon, its instinctive behaviour and how it thinks. To search for a lost bird is to understand bird behaviour, and the nature of shelter, at a whole new level.

David Reid-Henry held a second great attraction of course: he belonged to the British Falconry Club and had a number of birds of prey. The best known of these was Tiara, an African Crowned Hawk-eagle (*Stephanoaetus coronatus*), a monstrosity of a bird weighing about six kilos and designed to kill monkeys in forest canopies. She had been taken as an eyass (nestling) in Rhodesia and retained a kind of fierce aloofness. Normally, the intention of falconry is to pursue game, but I doubt that Tiara was ever flown free. In fact, I suspect that David was slightly frightened of her. David was wont to claim that she had once killed an Alsatian dog in Rhodesia. In Rhodesia, I was informed drily that the dog had been killed in London!

David's tuition in England had been hugely beneficial, but eventually he travelled to Africa, leaving Tiara at Sladmore Farm. The hawk-eagle was consigned to a large aviary, which is unusual, and mostly inadvisable, for birds of prey can fly into the wire and damage their feathers and their faces. Tiara was indolent enough to suffer no disfigurement.

Interestingly, as Tiara was placed in the cage, a male Silver Pheasant (*Lophura nycthemera*) began a courtship display. It seems that the stimuli for fear and for sexual expression are closely allied, a theory espoused by some of the youth of Rhodesia when they took their girlfriends for a

drive on the winding Mazoe Road, rendering that route intensely dangerous.

When David returned from Africa, Tiara had not been handled for several months. A few of us watched as he entered the cage and walked up to her, inviting her to step onto his gloved fist, which she willingly did. After smoothing the feathers of her breast for a short while, David returned her to the block of wood on which she'd been perching, and turned towards the door. Immediately, Tiara took off and flew after him. 'Look out!' yelled Harry, and David ducked as Tiara's huge talons shot out to snatch at his shoulder. Nearing maturity, she was now defending her territory. It was a timely warning not to handle eagles unless I knew who would come into contact with them later. I have seen other animals and birds whose fear of humans has been allayed as they were tamed and who have become dangerous when they reached sexual maturity and began to defend territory.

In David's absence, Tiara's jesses had perished and needed replacement. This was a hazardous exercise, as her massive feet could inflict terrible

ABOVE Pencil sketches of a Cape Starling (*Lamprotornis nitens*) BELOW Pencil sketches of Gemsbok (*Oryx gazella*) from a Namibian sketchbook OPPOSITE ABOVE Pencil sketches from one of my African sketchbooks of a Secretary Bird (*Sagittarius serpentarius*) OPPOSITE BELOW *One Challenge Too Many*, watercolour, 21 × 30 cm A sketch from memory of an aggressive incident in Chobe National Park in Botswana; such events may erupt spontaneously and can be dangerous

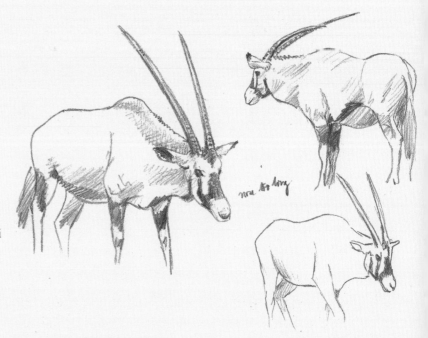

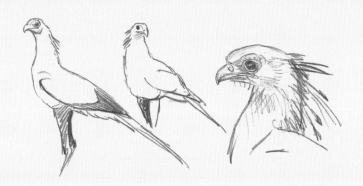

injury with one clutch. She was to be hooded, held on her back and given a cushion to squeeze; the angrier she got, the harder she would squeeze. Unfortunately, the plan was flawed. David undid the old jesses but Tiara lashed out with those rapier claws, closing on David's arm. Immediately, she drove one powerful hind claw between the radius and ulna right through and out the other side. David went white with shock. There was absolutely no chance of loosening the iron grip of an eagle; his only hope was that she would snatch again at the cushion. Eventually she did, leaving a gaping hole and blue bruise on David's arm. We bundled him into a car and dashed down to High Wycombe Hospital. His wound was serious; the bacteria from rotting flesh on the claws can cause dangerous infection, particularly in an anaerobic puncture wound. David hated hospitals, so to ensure he didn't discharge himself, we removed his trousers and took them with us. Fortunately, he made a swift and complete recovery.

BORROWED FROM THE WILD

Falcons are very intelligent, and can be tamed, but are never pets. Like cats, they tolerate human beings, but regard them as no more than a flightless equal. Training falcons is not difficult, but self-discipline, honesty, patience and tolerance are necessary if the bird is to learn to trust its trainer absolutely. The falcon is constantly aware of, and reactive to, the mood and character of its trainer. Ideally, a falcon is borrowed from the wild, hunted for a period and then 'lost' when it wishes to return to the wild.

I was able to fly falcons with other, experienced falconers, apart from David Reid-Henry and John Condy. I also kept, but did not hunt, other birds of prey, to sketch and study them, including an African Cuckoo Hawk (*Aviceda cuculoides*), a close relative of the Australian Pacific Baza (*Aviceda subcristata*) and perhaps the least likely falconry bird on Earth.

When first I returned to Australia, wildlife laws were tightening as conservation became increasingly important politically. Falcon numbers had plunged in settled areas due to DDT poisoning; chlorinated hydrocarbons were thinning the birds' eggshells and threatening their reproduction and survival as a species. Fortunately, so much of Australia is wild or rangeland that there are plenty of areas where birds were less exposed to pesticides, but that is no reason to be irresponsible in their long-term conservation.

Back then, nobody in authority considered falconry, although the occasional falconer had practised the ancient art. I enquired about a permit to fly falcons and other raptors, and after many discussions, I was awarded a permit to trap, keep and hunt birds of prey. Interestingly, discussions with the then Director of the Department of Fisheries and Wildlife ultimately paved the way for the Bird of Prey Flight Display at Healesville Sanctuary, initially with a Rhodesian falconer in charge.

My first Australian falcon was a young Brown Falcon, still with some down from its youth. I named him Shinshu, a Japanese word associated with kamikaze pilots, which seemed appropriate, considering the flight skills of a young Brown Falcon.

One of the most difficult aspects of training Brown Falcons is their propensity to become 'screamers', birds that constantly beg food with an extraordinarily irritating screech. Shinshu was of course such a bird and it was not until I trained my third Brown Falcon that I became sufficiently adept to avoid producing a screamer.

Brown Falcons are normally indolent. My self-esteem as a falconer was dented early on when my father asked if he could watch Shinshu train one afternoon. Shinshu was learning to come, over

a limited distance, to a lure. Placing him on the station trough below the horse yards, I turned and walked away about fifty metres, then swung the lure to attract his attention, expecting Shinshu to fly directly to me and snatch the lure, for which he would earn a small reward.

Instead, he leant forward, gave a few begging screams, then dropped lightly to the ground before scampering across to me and begging for the lure. A most unsatisfactory demonstration!

It is easy to assume that all birds are similar, but not so: each bird is an individual. Often they are sufficiently unique to be distinguished by sight from others of their species. Shinshu was a very likeable bird; his three greatest characteristics were loyalty, a sense of humour (he would deliberately play tricks on me) and a quite remarkable level of coordination – he had 'an eye like Bradman'.

At the time I was learning with Shinshu, I also had a young female Brown Falcon called Shimbu. She was a different character entirely: stolid, lazy and infinitely less appealing. They got on very well together, but all that changed in a moment on a road north of Loxton in South Australia. Huddled on the side of the road was a Brown Falcon, clearly dazed from a collision with a car, but apparently not greatly injured. I stopped, picked him up and put him in the back of my car, with little hope that he would survive, although his best chance of doing so was to be cared for in a warm, secure environment.

Immediately, Shinshu attacked Shimbu in a display of lethal aggression. I managed to separate them, only to see warfare break out again. I hooded both birds, so that they could not see each other, and things settled into an uneasy truce. It was not difficult, therefore, to find a name for the new bird: 'Hypotenuse', the third side of the eternal triangle. However, why a male would attack a female in the presence of another male is baffling.

OPPOSITE *Shinshu*, gouache, 21 × 30 cm My first Brown Falcon, coming to the lure in a pathetic demonstration of falconry for my father

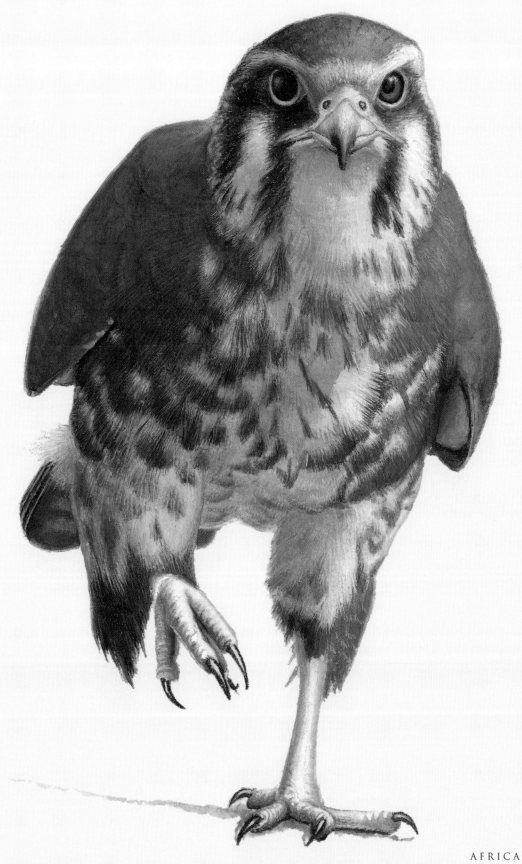

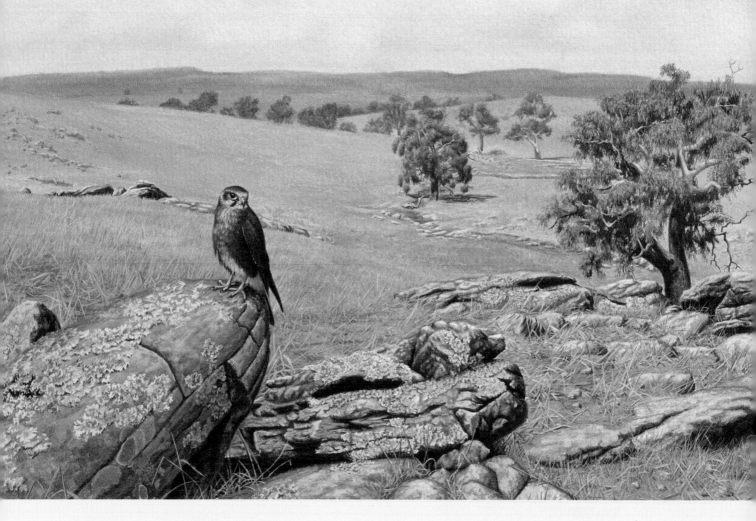

These were the early years of my falconry. I caught my first Peregrine in the wild as a mature bird. I had seen her hunting duck on a local wetland where I grew up, so I set a trap like the one John Condy had used in Rhodesia. It worked immediately, and I suddenly had a Peregrine to train.

There she lay, on her back, screaming her anger in a series of short yelps, hissing through her open bill and snatching at me with her needle-sharp talons. She was immensely beautiful, with her startling yellow cere, orbit and feet and the finely barred soft apricot of her belly below a snow white chest. The markings on her slate-blue back were similar to those I had known on Awala, my Lanner Falcon.

Quietly extricating her from the net in which she was entangled, I slipped her into a tubular section of a stocking, cut for the purpose, where she lay glowering at me. There were blood stains on her plumage, none of it her own, and my hands were stinging from the puncture marks she had inflicted. How could this fierce, wild spirit ever be persuaded to placidly accept my presence?

Over the next few days I followed the steps that I had learnt with Awala and my new bird steadied, learnt to accept my company and to recognise the lure as a symbol of food. She learnt

ABOVE *Hypotenuse at Tungkillo*, gouache The Brown Falcon I rescued from the roadside near Loxton, depicted in a landscape near Tungkillo, South Australia

to fly to me over a short distance and to step from the lure she had seized back onto my fist for her feed. She was becoming placid about more and more distractions – horses, dogs, tractors, cars, strangers. It was time for her to fly free.

The first free flight of a falcon is nerve-racking. There she sits, leaning forward eagerly, eyes surveying her surroundings, impatient to go. Will she be distracted by that parrot flying past and chase it? Will a car appear and terrify her? Will she see this human calling her as a danger once more, as she did so short a time ago? But no, here she comes, straight as an arrow, grasps the lure in the air, tumbles with it to the ground and looks up to your fist, before quietly stepping onto it and beginning her meal.

This, of course, is an intermediate step, a means to an end. Soon, calling her to the lure becomes a game, a means to build her fitness: just as she reaches to snatch the lure, I pluck it away and she misses. Glancing over her shoulder, she uses her speed to rocket skywards, gaining height to lend momentum to her next stoop. Gradually, the length of this game can be extended until she is fit enough to resume hunting. Normally, I would have in mind a set number of 'stoops' needed to maintain the bird's hunting fitness. For a Peregrine Falcon this would be about fifty really hard, vertical stoops each day.

Flying a falcon to the lure is also a game that cements the close hunting relationship between bird and human. A falcon is used to smiting its prey with a foot as it shoots past, hoping to injure the quarry sufficiently to incapacitate it so it can be captured. She will be endeavouring to strike the lure in the same way. Sometimes she will grasp it, falling with it to the ground; sometimes she will grab it, only to have it wrenched from her grasp by the speed at which she is travelling; and sometimes she will only clip it. If this happens

early in a session, it might be tempting to ignore it and continue to exercise her. However, the trust required to build a working partnership relies on total honesty. If the bird touches the lure, she expects to receive a reward – at least a morsel of food. The falconer must never pretend that she missed it, but must immediately allow her to capture the lure on the next stoop. There is no umpire, only the matter of fairness upon which the falcon's trust depends. To pretend she missed will break her trust and cause difficulties in your future relationship.

The falconer will induce a number of stoops before deciding that the bird has had enough and deserves its reward. Of course, the bird can make the same decision and try that little bit harder to beat the falconer and grab the lure. Mostly, it is possible to detect the subtle signs that the bird has decided it's time. With a little more care it is possible to keep the lure away from a Peregrine, but I've never managed it with a Black Falcon (*Falco subniger*): the bird has always won.

I trained a male Black Falcon and flew him for about two years. He had been brought to me injured, to nurture back to full health for release to the wild. A minor injury in his right wing caused a slight 'limp' in his flight, but he seemed able to perform effectively.

Once, he wrenched the lure from my grasp and flew up into a tall tree. Looking down he seemed to ask, 'Now what are you going to do, eh?' I quickly fashioned another lure, and he came back down, leaving my good lure carefully balanced about thirty metres up the tree.

Three weeks after my Peregrine lay hissing and struggling in the net, my friend Dr David Hollands came to stay with me. David was writing *Eagles Hawks and Falcons of Australia* and was keen to photograph my Peregrine, M'sasa, preferably in action. We travelled back

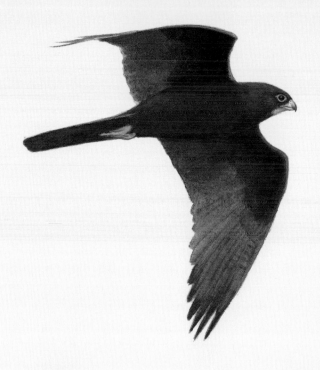

to the swamp where she had been captured and, removing all jesses and other accoutrements, I launched her into the territory she knew so well. Immediately her wild mate was flying beside her. There were many duck, mostly Grey Teal (*Anas gibberifrons*), in the air with them, and so the hunt began. Prudence dictated that I call M'sasa back, and at first I thought she would ignore me, but to my immense relief she turned, came like a bullet and took the lure, while I refitted her jesses and her mate flew overhead. With so little training to build the bond between us, this was a flight filled with trepidation, but it was unspectacular compared to what can happen.

Perhaps the most magnificent demonstration of flight that I witnessed from any of the birds I've trained was from a Peregrine tiercel called Tambuti. On one of those golden sunny days without a breath of wind, when the blue dome of the sky is immense, I cast Tambuti off, and immediately he started to circle to gain height. He must have found an excellent thermal, for he continued to ascend, becoming smaller and smaller. Eventually, he disappeared from sight, so pulling out my Leitz 10×40 binoculars, I continued to track him, until he was out of sight again.

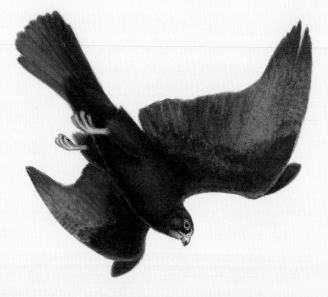

I was unsure what to do next. Then I heard the 'whoosh' of his freefall. His wings were tightly closed, and he was falling like a brick. Just as a downhill skier may descend on the fall line but occasionally turn slightly to break his speed, Tambuti came down in three glorious stoops with just two checks, when he hesitated to correct his direction. No wonder this is the fastest bird that flies!

About forty metres away flew a lone Galah (*Eolophus roseicapilla*). Tambuti hit him on the back as he went past like a steam train, but Galahs are very tough, and their back is well protected by a rigid, bony structure. There was a cloud of feathers

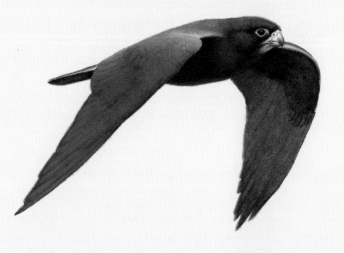

as Tambuti turned like
a jet fighter, wings
vertical, and swept
back towards the limb of
an old, dead red gum. The
Galah lumbered on into the
distance, alive, but probably
bruised and shocked; his worst
injury was to his pride.

As Tambuti's feet reached out to grasp the
branch, a tiny bat dropped from a crack and fled,
wings fluttering, swift as a swallow. Tambuti
gripped the branch with his powerful legs, flung
himself forward and onto the trail of the bat,
which he wrenched from the air with his left
foot before sweeping back to the branch to feed,
a glorious, virtuoso performance of speed and
power in flight.

We believe the Peregrine to be the fastest
bird that flies, and Tambuti's antics support this
belief, but I have seen a young duck, scarcely
old enough to remain airborne, fly away from a
Peregrine on the flat when the falcon lacked the
advantage of height to build speed. Equally, I have
watched a tiercel hunting Grey Teal fly in amongst
the ducks before switching on some kind of
supercharger to accelerate through the flock and
grab his prey by the base of each wing, riding on
its back and guiding it to the shoreline, where he
forced it to the ground.

I believe that the Black Falcon may be even
faster than a Peregrine. They are rapacious, often
robbing other raptors of their kills. Peregrine
tiercels fear them and will hide when a Black
Falcon is in the air nearby.

The capacity of a Black Falcon to outfly a
Peregrine was demonstrated to me on one occasion
when I was flying Tambuti of an evening. It
had been a busy day, so I had had no time to go
hunting with him, but I made the lazy mistake of

leaving his Aylmeri
jesses on while I
exercised him to
the lure, which is
bad falconry practice,
lest they catch on a branch,
leaving him hanging upside down when
he tries to take off.

Almost immediately, a female Black Falcon
saw him and assumed that he was carrying prey.
Straight as a die she stooped at him, but as she
struck, Tambuti rolled onto his back and grasped
her talons in his, pulling her in a great fluttering
ball to the ground below, where I rushed to
separate them. Carefully, I loosened Tambuti's
grip, securing the Black Falcon's feet as I did
so, until the birds were separated completely.
Assuming Tambuti would have been shocked by
the attack, I left him on the ground, stood up and
held the Black Falcon over my head, way out of
his reach, about two and a half metres above him.
With one giant leap he was suddenly reattached
and ready to fight back. Not for him to back down
under attack!

Tambuti loathed Magpies. When he was
still a young bird he received a salutary lesson.
He managed to catch one of a group of Magpies
feeding in the paddock, but being intensely social
birds, the remaining Magpies set upon him to try
to free their sibling. Tambuti very nearly lost an
eye in the exchange; his lower eyelid bore a scar
ever after, and from then on he treated Magpies
with respect. One evening, though, he found
one that was relatively isolated. He seized his
opportunity and struck. I moved in to separate him
from his prey and pick him up onto my fist to feed
him. Just then, a young Australian Hobby (*Falco
longipennis*) landed alongside me and, turning to
the Peregrine, began to beg food. I'd love to know
whether that Hobby survived into adulthood!

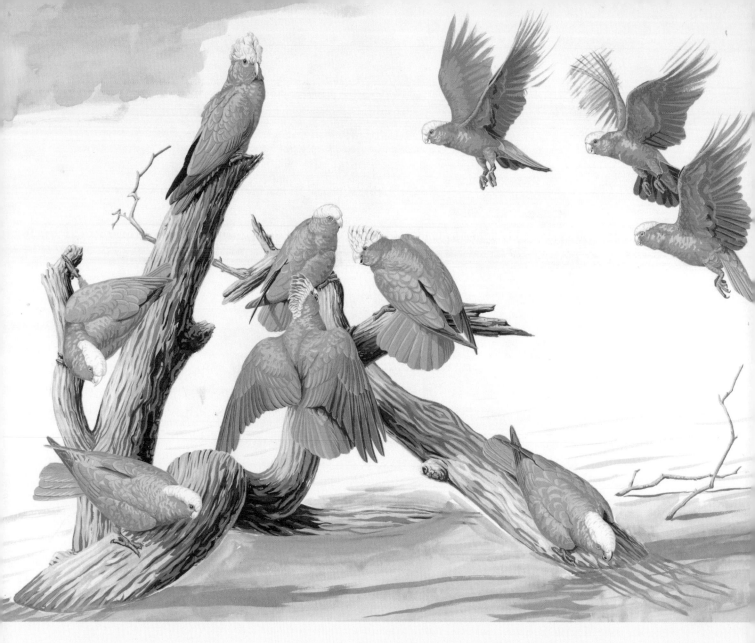

RELEASING FALCONS

Tambuti was raised in a cage, having been hatched in a brood of three bred from a captive pair at Melbourne Zoo. The Australian government had previously given the progeny of these successful Peregrine Falcons as political gifts to Arab sheiks, but this time it was deemed more sensible to release them into the wild population.

The three siblings were as different as they could possibly have been. Named for three species of African trees – M'susu, Mopane and Tambuti – they were different in structure and behaviour. M'susu was robust, a standard Australian Peregrine Falcon that could have stepped from the pages of a field guide. Mopane

was slender and paler, reminiscent of the desert-loving Barbary Falcon (*Falco pelegrinoides*) of northern Africa. Tambuti, named after the dark, iron-like hardwood of the Rhodesian lowveld, was built like a wrestler, compact, broad and strong, with very dark plumage. He was closer to the description by the taxonomically inventive G. M. Matthews of a south-western Australian variant of the Australian Peregrine, which he named *Falco submelagonys*. Such individuals can occur anywhere in Australia, but in museum collections, they more frequently occur around Cobar in New South Wales. It was interesting to see this genetic variation occur randomly in captivity.

With three peregrines to train simultaneously, I sought help from a young English friend. His

ABOVE Loose layout sketch in gouache for a screen print entitled *Narcissus*, depicting Galahs coming in to drink at a stock dam in South Australia
OPPOSITE Gouache sketch of the Peregrine, Pedro

father, who had served with the SAS in the British
Army, had sent him to Australia to toughen him
up and stiffen his upper lip before he went into
the army, also destined for the SAS. Fergus,
however, was a sensitive youth, not really suited
to slaughtering enemy soldiers, and had returned
to England to read anthropology at Durham
University. He had worked with Philip Glazier, a
professional English falconer, and he harboured a
secret desire to train a Peregrine Falcon. A short
message to Fergus brought him to our doorstep
with extraordinary alacrity, and so began a
wonderful summer.

At the time, I was fully engaged in painting
and drawing the illustrations for *The Fairy-
Wrens – a Monograph of the Maluridae*, so we
reached a simple arrangement. Fergus would
work each morning with the sheep and cattle
on our property, Connewarran, and be free each
afternoon to train M'susu, who became 'his' bird.

It was a great joy to see the three falcons
developing their skills. They were joined by a
fourth, M'futi, a Peregrine tiercel, and all four
had to be flown each night. At the same time I
was breaking-in a little thoroughbred chestnut
gelding, and given the history of falconry on
horseback, it seemed appropriate to expose
the falcons and the horse to each other. The
Peregrines would willingly stoop under the horse's
belly while being exercised to the lure, and the
horse was unconcerned if a falcon leapt from the
ground to the fist, carrying the lure.

In 1977, a young American ornithologist
named Steve Sherrod had executed a thorough
and fascinating study of the behaviour of fledgling
Peregrines. Camped with his wife, Linda, in
conditions of exquisite discomfort on the shores
of Lake Purrumbete, he watched young Peregrines
as they underwent their early education in flying
and hunting. He recorded their development,

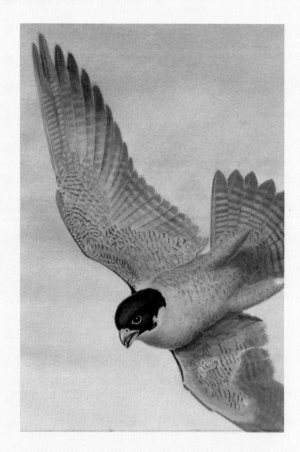

their growing success and aerial ability in a
volume entitled *Behaviour of Fledging Peregrines*,
published by the Peregrine Fund. In some ways,
Fergus and I were in the privileged position of
sharing this developmental period with the falcons
we were training.

All four eyasses hunted in a similar manner
when they began, but differences in temperament
and skills emerged early. At first they would use
any advantage that they had in height to gain
speed, and to strike their prey from above. We
observed that tiercels seldom move past this
technique, merely becoming more adept at
gaining and utilising height. The female falcon,
however, developed a most effective variation.
She learnt to dive below larger quarry and, using
the speed from her dive, to sweep back up from

underneath, where she was less easy to see, and, rolling over on her back, grasp the prey from beneath. This was particularly useful for larger prey, to the size of an ibis.

Often, I have hunted with birds for two or more years and then gently returned them to the wild, with assisted feeding until they have proven that they are totally independent. One Peregrine returned to my garden for a free feed exactly one year to the day after I returned her to the wild. A Black Falcon paired with a wild mate three days after release and was seen copulating on a nest soon after. These days, birds can be fitted with radio tracking devices which enable them to be traced and recovered if they go missing, but I have never used one, as I prefer to watch their pure skills, unencumbered by non-essential accoutrements.

Over many years, I trained many birds, often ones that had been injured and needed to be

treated and prepared for release. Elsewhere, there have been many injured birds that have been rescued in similar circumstances by other carers, but kept in cages until they were considered fit for return to the wild. Banding studies show that very few of these have survived, but that birds trained and flown by experienced falconers before release usually do survive and eventually thrive.

Birds of prey become morose, inactive, and very unfit in cages. To survive in the competitive environment that is 'the wild' a bird needs to be very fit indeed, and, if released in poor condition, or out of practice in hunting skills, will be chased from territory to territory by opponents of greater strength until

ABOVE *The Malevolent Magpie*, gouache study, 21 × 39 cm A familiar sight in the spring breeding season; Magpies were wont to gang up and attack a Peregrine such as Tambuti if he attempted to secure one of their social group

LEFT Pencil sketch of M'susu, a female Peregrine eyass

ABOVE An early attempt in gouache to capture the speed, power and concentration of a Peregrine Falcon in attack; I saw this pursuit of a Banded Lapwing (*Vanellus tricolor*) at Connewarran, just after Jenny and I moved there to live

starvation ensues, the bird succumbs to exhaustion or is killed in a fight.

AS MY TIME in Rhodesia drew to a close, I faced the necessity of returning to London to prepare more works for my exhibition. I had done twenty-three paintings in Africa, so needed some variety to complete a collection. Before I left, I was asked to meet a lawyer in his office in Salisbury and to take my paintings with me. As we sat talking, he shuffled through my paintings, loosely arranging them into two piles. Eventually, he pointed to one pile and said, 'I'd like to buy those ones, please.' I explained their

critical necessity in London and he asked that his purchases be recorded with the gallery and the paintings returned to Salisbury post-exhibition. This was an enormous boost to my confidence, and confidence is an essential commodity for an artist.

My exhibition at the Sladmore Gallery opened on 24 November 1971 (I had framed the final painting at 1.30 that morning!) and ran until Christmas Eve. As the exhibition catalogue says, I was the youngest artist to have had a solo exhibition at Sladmore Gallery. At the end of the first week, the gallery placed an advertisement in the newspaper to announce that the exhibition would run until Christmas Eve, despite the fact that all sixty-one paintings were sold.

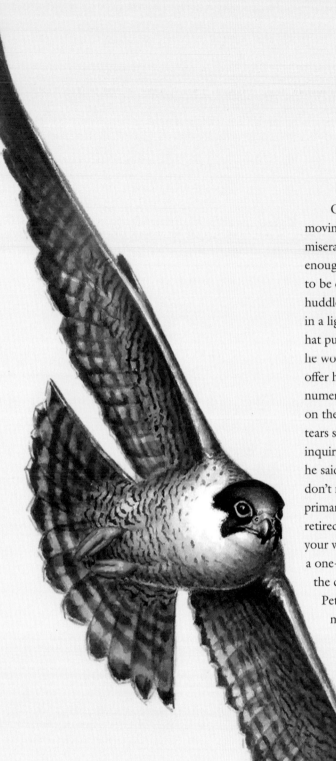

On the morning of the opening I had a most moving experience. I arrived at the gallery on a miserable, cold London day, with mist not heavy enough to be called rain, or rain not light enough to be called mist. Outside the gallery, standing huddled against the cold, was a gentleman dressed in a light, grey plastic raincoat with a plastic rain-hat pulled down over his ears. I asked him whether he would like to come inside to keep warm, an offer he readily accepted. Inside, I set about my numerous tasks while he perused the paintings on the wall. Soon I noticed that he was weeping, tears streaming down his cheeks. Taken aback, I inquired whether he was all right. Turning to me he said, 'Oh yes, absolutely!' Then he added, 'You don't recognise me, but I was your art teacher in primary school. I've lived in Edinburgh since I retired and I've been on the train all night to see your work. You are the first of my students to have a one-man exhibition in London.' I remembered the careful encouragement and guidance that Peter Edwards had given me at the outset of my education, and realised how important he had been.

I returned to Australia shortly after Christmas in 1971, having committed to another one-man exhibition in a year's time. I soon realised that, with greater experience, my paintings were becoming more complex and were taking longer to finish. I painted familiar Australian birds supplemented by European birds, but by November 1972 I had only completed eighteen paintings, a third of the number I'd exhibited in the first show. To better fill the

LEFT Gouache drawing of a Peregrine Falcon, first sketched in Wales, but later used as a painting of an Australian Peregrine; they have different proportions, which I had to adjust
OPPOSITE Quick pencil sketches of White-faced Whistling Ducks, endeavouring to catch character and movement

gallery space it was sensible to share with another artist of similar interests, Bryan Reed.

Before that, I exhibited my new paintings at my sister's house in South Melbourne, where some of the people who came to see them became lifelong friends, including the renowned naturalist Graham Pizzey and his family, and the grandson of Heidelberg School artist Fred McCubbin, the naturalist and artist Charles McCubbin.

Charles had recently published *Australian Butterflies*, beautifully illustrated with his own brilliant watercolours. We became firm friends and spent much time together painting. He had studied oil painting with Murray Griffin, and taught me many things.

My second exhibition at Sladmore Gallery ran from 17 November to 9 December 1972, and again, my paintings sold; at the end of the exhibition, only one painting remained unsold, of English Lapwings flying over a ploughed field in a storm. I used to assume that the comment, 'has always remained in the artist's collection', meant the artist was so pleased with a work he or she refused to part with it. Now I had a different interpretation!

It was time for me to return to my home in Australia to live and paint the fauna with which I was familiar from the farm where I had spent my childhood.

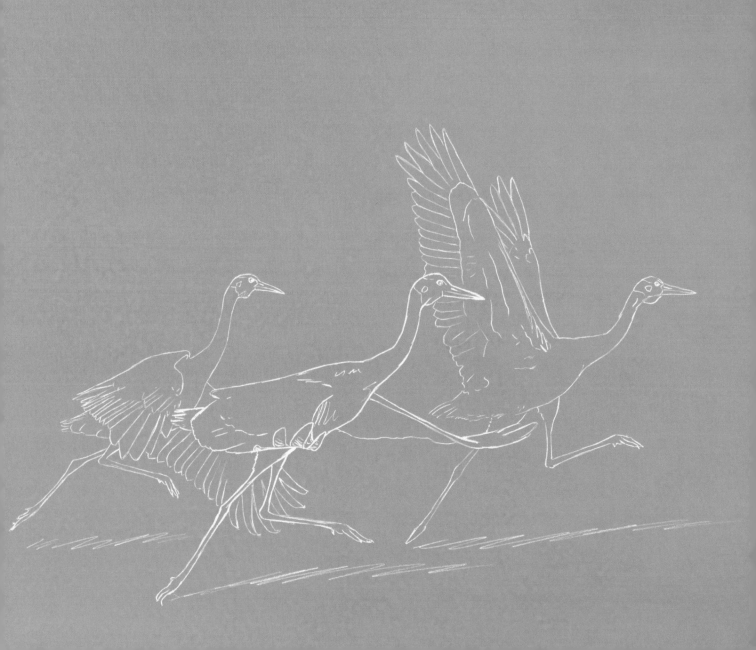

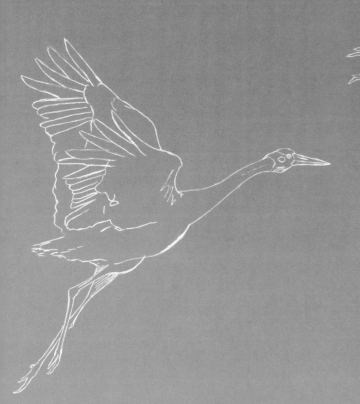

AUSTRALIA

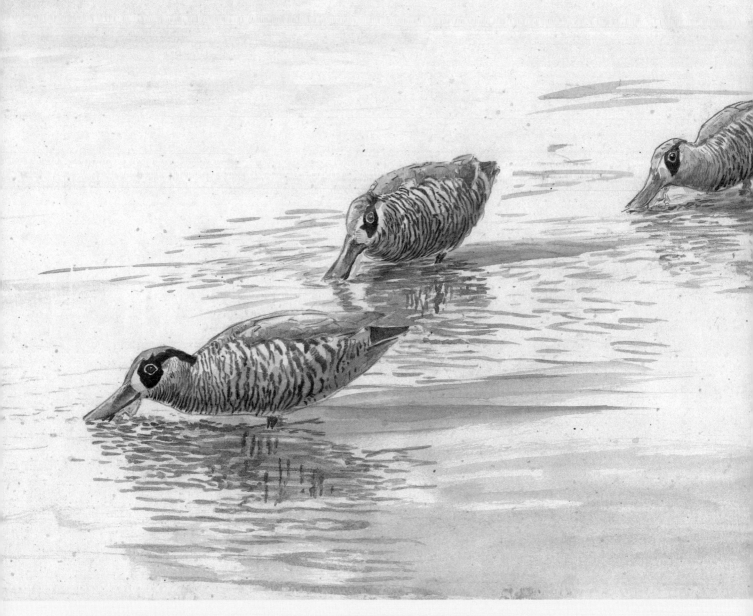

WHEN FIRST I returned to Australia, it was unusual for artists to exhibit wildlife art in galleries. A small number of artists were painting wildlife, sometimes published in massive tomes, lavishly bound and issued in limited editions, and while the paintings might be exhibited in galleries, their primary purpose was illustrative. There was little sign of the creative paintings in Europe or America by such celebrated artists as Sweden's Bruno Liljefors, the German Wilhelm Kuhnert or Switzerland's Léo-Paul Robert.

Liljefors was a naturalist and woodsman whose monumental works featuring wildlife were created from an intimate, almost intuitive familiarity with light, movement and the structure and behaviour of his subjects. He was arguably the greatest wildlife artist of all time and painted epic exhibition art, not illustrations.

Kuhnert's sometimes melodramatic work was influenced by big-game hunting in Africa, and foreshadowed the legacy of hunting in much of the wildlife art emanating from the northern hemisphere.

I had been exposed to the influence of hunting through London galleries, where works by Lodge and Thorburn – exhibiting members of the Royal Academy – and Landseer were still a benchmark of British wildlife art. Yet their

PREVIOUS Pencil sketch of Brolgas taking flight
ABOVE Loose layout sketch in watercolour for a possible oil painting of Pink-eared Ducks (*Malacorhynchus membranaceus*) feeding on the dam at Connewarran
OPPOSITE Watercolour study, 16 × 23 cm, of Pink-eared Ducks at Connewarran, recording colour and plumage

most sought-after works derived from shooting: pheasants, grouse, partridge and other game birds in Thorburn's case, and in George Lodge's, falconry, waterfowl and highland game species such as ptarmigan and grouse.

In America, most traditional wildlife paintings involved hunting: Moose (*Alces alces*), Grizzly Bears (*Ursus arctos horribilis*), buffalo and deer. But Robert Bateman's new work foreshadowed change when it was shown at the group exhibition *Bird Artists of the World* at the Tryon Gallery in London in 1972. Instead of portraying human dominance of nature it showed that we were beginning to recognise our place in the natural world.

In 1975, the Royal Ontario Museum held an exhibition in Toronto entitled *Animals in Art – an International Exhibition of Wildlife Art*. David Lank's catalogue essay stated that the exhibition was designed to give wildlife art credibility as an established genre.

In Australia, the appetite for paintings of hunting and shooting was extremely limited. We had noted artists painting wildlife: names such as Sidney Long, Arthur Boyd, Russell Drysdale, John Olsen, Albert Tucker, Clifton Pugh and others. However, to quote the Melbourne-based artist Peter Trusler, 'The paradigms for the production and appreciation of mainstream art of the day and that of scientific art were not the same.' Our wildlife interests stemmed more from a pioneer involvement with the land, a recognition of the extraordinary creatures with which we shared it; a dawning awareness of the need for conservation was perhaps the stimulus for a burgeoning interest in wildlife art.

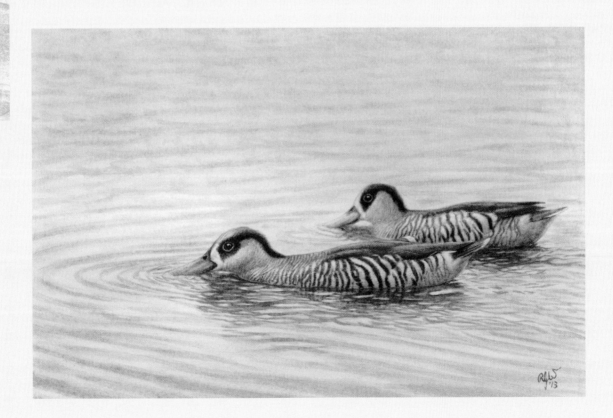

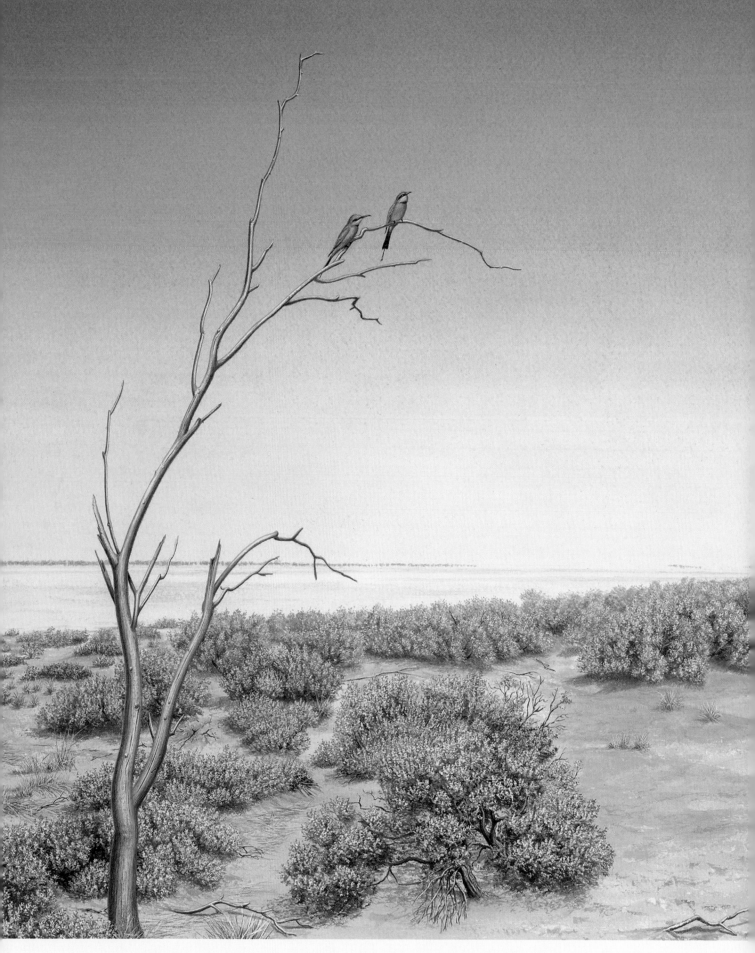

ABOVE *Lake Way* – Rainbow Bee-eaters (*Merops ornatus*) at Lake Way, near Wiluna in Western Australia, gouache, 38 × 52 cm

Simpson Desert

IN 1973 CHARLES MCCUBBIN, with Warren
Bonython, had walked across the Simpson
Desert and been fascinated by the wildlife he
had seen. Charlie was an excellent entomologist,
amongst his many talents, and had received a
Whitley Award for outstanding publications that
contain new information about the fauna of the
Australasian region for his learned scientific book,
Australian Butterflies. He resolved to return to
the Simpson Desert to study the intricacies of the
ecosystem in greater detail and in a more leisurely
fashion. He asked me if I would accompany him. I
showed no hesitation.

 We intended to be there in the cool months
of winter, setting off in May. John Blyth, head of
the Museum of Victoria's Survey Department, was
accompanying us, for we were to be collecting
material for the museum. Various other people
were to join us during our expedition.

 Preparation for the journey included
making two carts in which we would haul our
food and water into the desert; assembling an
extensive collection of appropriate maps (the
Australia 1:250,000 series); and measuring and
packing our rations for the duration of our stay
(the Melbourne Walking Club considered 180
grams per day sufficient for a sustainable diet
in similar conditions, but we would take only
130 grams, intending to procure the shortfall
from the land around us). Each meal for three
months was carefully weighed, packaged and
then grouped with two others (a day's rations);
these were grouped in bags of seven (a week),
which were agglomerated in packages of four
(a month). We allowed only three litres of
water per day, which proved to be grossly

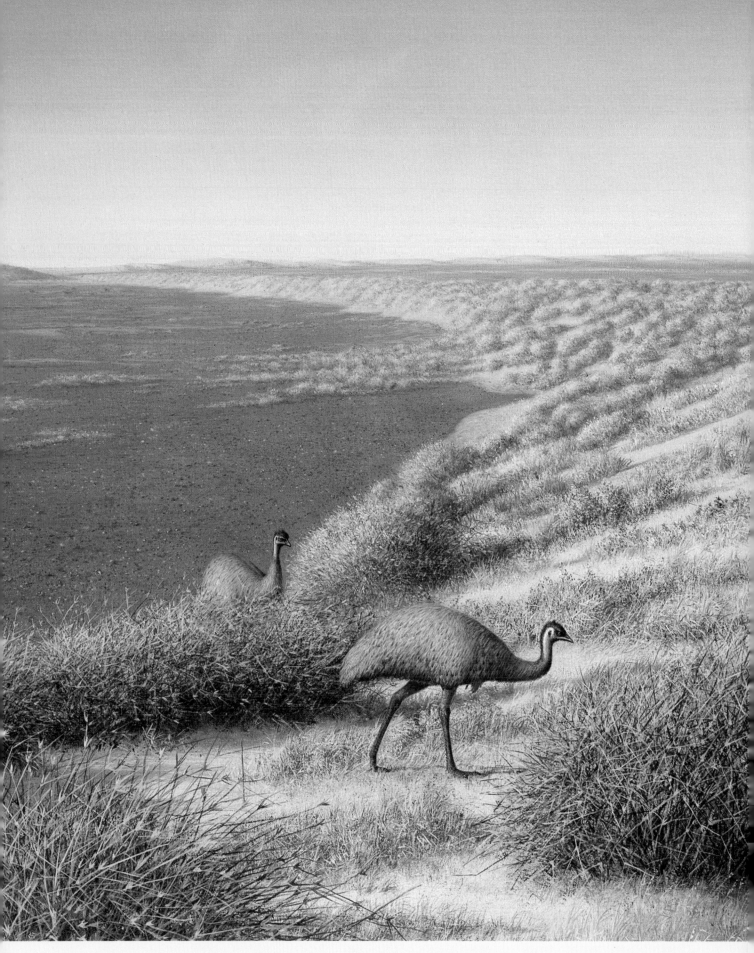

ABOVE *North of Birdsville*, oil on linen, 66 × 92 cm Emus (*Dromaius novaehollandiae*) on a Simpson Desert sandhill north of the Birdsville airstrip; the gibber plains change from a deep mauve to bright rusty red viewed at different angles to the sun

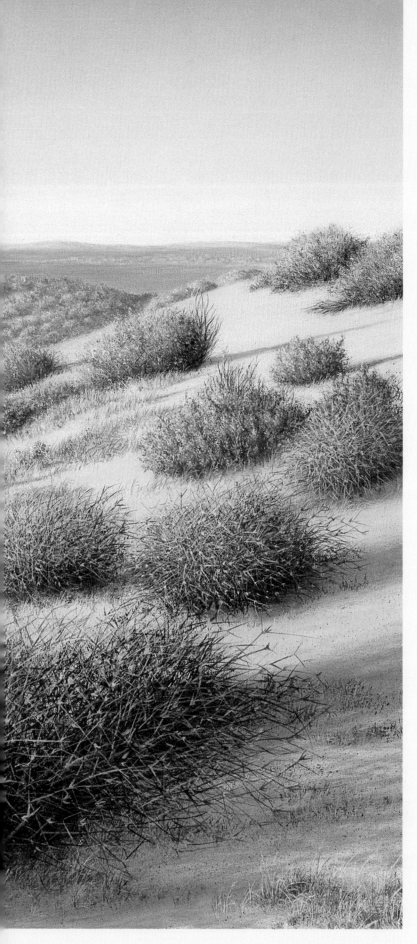

inadequate in the desiccating conditions of the Simpson Desert.

Eventually we departed in a 1958 Holden sedan, which Charlie had seconded from his mother-in-law, a Mini Moke, bought for the trip, and photographer John Brownlie's Volkswagen Campervan. Long before we had reached our goal, we were forced to make running repairs on the Moke. First, John Blyth took a deep water-crossing on the Birdsville Track too fast and came to a sudden halt midstream. He then removed the distributor cap, dropped the carbon brush into several feet of muddy water and lost it. We fashioned a replacement from the carbon core of a 'D' sized torch battery and the Moke ran smoothly until our return to Melbourne.

We pushed on towards Birdsville as fast as we could. The abundant season following the huge rainfall of 1973 was still obvious and was having interesting effects on the fauna. Birds that would be common at my back door in Victoria had penetrated this expanded habitat with ease, apparently at the expense of specialist arid-country avifauna.

RIGHT Pencil sketch of an Emu

THE RAT PLAGUE

The heavy growth of *Psoralea* had formed dense cover and an abundant food source for the Long-haired Rat (*Rattus villosissimus*), which was demonstrating one of its periodic 'irruptions' throughout the Diamantina River basin. They were everywhere. First night in any camp could be tolerable, but by the second or third night, their boldness would become unbearable. They would eat whatever was left available to them, including windscreen wipers, the straps on rucksacks – anything – quite apart from any food left out.

One evening, in place of television for entertainment, we set up a stubbie on a stick, poked into the Diamantina riverbank and leaning out over the water. Inside the bottle we placed some cheese. A line of rats formed, climbed the stick to reach the bottle, slipped on the glass surface, fell into the water, swam ashore, and joined the line of rats climbing the stick once more: this was cynical and mean of us, but was perpetual motion.

Not surprisingly, the numerous rats were a potent food resource for a variety of both diurnal and nocturnal birds of prey. By far the most numerous of these were the Black Kites (*Milvus migrans*), constantly circling in scarcely believable numbers, from close above us to barely visible through powerful binoculars, and possibly higher. However, in their midst flew other species, Whistling Kites (*Haliaster sphenurus*), Brown Falcons, and sometimes, even in the daytime, nocturnal birds such as Letter-winged Kites (*Elanus scriptus*) and Barn Owls (*Tyto alba*). One afternoon, Charlie McCubbin lay on his back with his camera and took a panoramic view of the sky on high

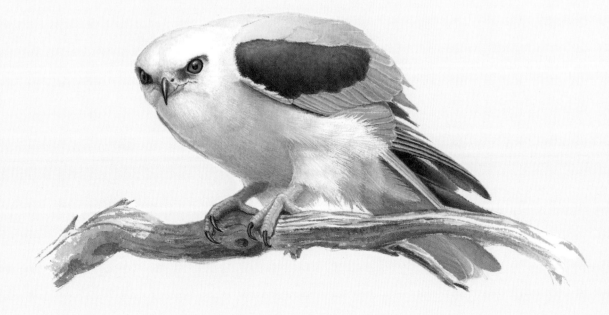

resolution colour slide film, to be projected, analysed and counted in the Museum of Victoria at a later time. The numbers were astonishing; Charlie estimated, from his photographs, that there could have been as many as three thousand Black Kites above him; also, thirty Whistling Kites, six Brown Falcons, a Black Falcon, and some Letter-winged Kites. Each of these birds, together with more Letter-winged Kites and Barn Owls at night, must have been predating on Long-haired Rats, themselves a nocturnal species. Despite their nocturnal habits, there were always rats about in daylight, and they were also feeding a burgeoning population of feral cats. The depredation on their numbers must have been enormous.

The feral cats were impressively different from Auntie Maud's pet tabby, warming itself at the fireside. They were very big, mostly longer-legged than their domestic counterparts and very effective hunters. As part of our museum survey work, we were endeavouring to trap the small animals of the desert, with little success. The Long-haired Rats were reaching our traps before any other fauna could get there.

Eventually, in desperation, we started collecting feral cats, killing them, cutting them open and examining their stomach contents. It was then we understood what devastating predators they are upon our native fauna. Less than fifty per cent of their consumption was the ubiquitous rats. Species such as the Fat-tailed Dunnart (*Sminthopsis crassicaudata*), Mitchell's Hopping Mouse (*Notomys mitchelli*), and many others were regularly represented in the cats' well-fed bellies. Also present were large quantities of endoparasites, intestinal worms that in more settled agricultural areas could pose a health

OPPOSITE Pen and ink sketch of the lagoon at Birdsville
ABOVE Pencil sketches from David Holland's hide at the Letter-winged Kite nest; the lower bird is showing the wing–tail stretch beloved of all birds, from the tiny hummingbird to the Ostrich
RIGHT Gouache study, 21 × 30 cm, of a Black-shouldered Kite (*Elanus axillaris*) showing differences between it and the Letter-winged Kite (above and overleaf)

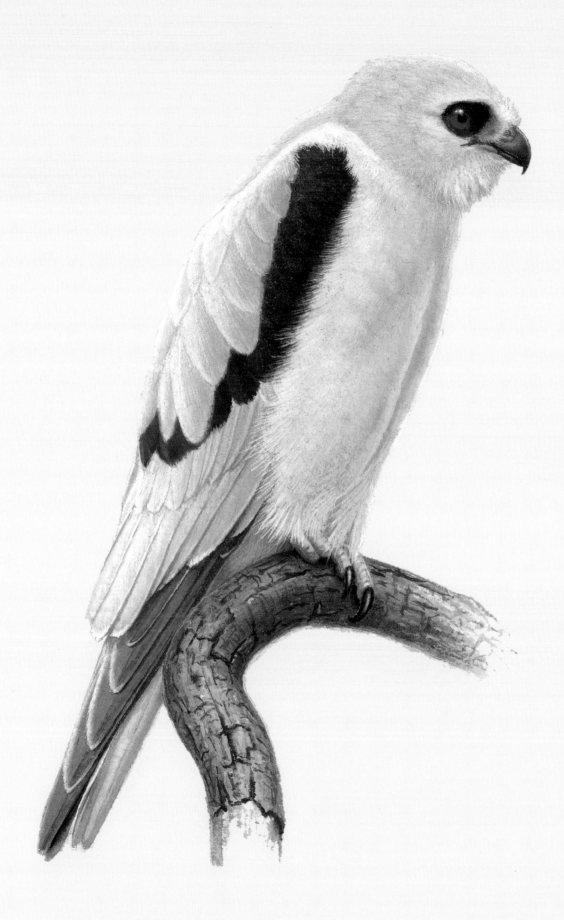

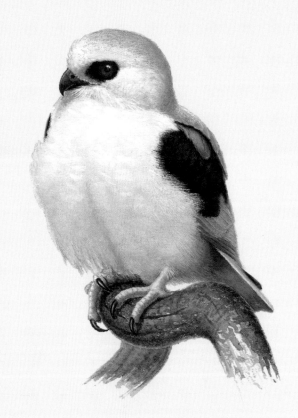

risk to both livestock and humans through sarcocystosis, a disease transmittable by cats and dogs that live in proximity to herbivores.

The plague rats induced enormously successful breeding amongst the birds of prey. One of our camps was at Bluebush Tank, near Ten Mile Waterhole to the west of Birdsville, nestled at the end of a red sandhill that projected onto the gibber plain. Near the tip of the sandhill was a loose group of stunted and ailing Coolibah trees (*Eucalyptus microtheca*), gathered round where, in wetter times, a waterhole might have been. Because of the rats, there were always Black Kites circling above us, though fewer in the centre of the Simpson Desert. As we approached Ten Mile Waterhole, there seemed to be more than usual, circling, dipping and turning all round us, from several hundred metres above to almost at eye level. Also present were Whistling Kites, similar, but more stolid in their flight. Their pale, wedge-shaped tails do not fan and twist constantly like a Black Kite's and they seldom turn for a second inspection, while Black Kites readily circle close above, time and time again.

Suddenly, there was a new presence amongst them, a ghostly bird dressed in bridal white, almost glowing against the deep blue of the sky; it had a narrow black streak on the under-surface of each wing, starting from the centre of the axillaries and leading to the carpal joint in an angled line, which gave the impression of a shallow 'M' or 'W' from beneath. Soon, a second Letter-winged Kite joined the first, with deep, loose wing-beats reminiscent of the 'rowing' action of a tern. Then there were three. We watched as they imperceptibly grew smaller and higher, until they were impossible to discern against the deep blue dome of the sky.

The Coolibah trees clustered on the banks of the dry waterhole were about twenty metres high, supporting some bulky stick nests of Black Kites,

and the nest of a Whistling Kite, with a single, rather depressed-looking youngster still in the nest. Further back from the waterhole were some smaller, sparser and more straggling trees. Here we found the nests of Letter-winged Kites. It was a rare opportunity to camp close to a colony of breeding Letter-wings and to learn something of their mysterious behaviour. They were, at that time, one of the least studied birds of prey in Australia and the subject of considerable speculation.

One of the first observations was the enormous capacity of Letter-winged Kites to irrupt when conditions suit them. There was a sense of frenzied reproduction in the colony, with newly laid eggs, chicks and young kites nearly ready to fledge in the seven nests; some individual nests showed the same developmental range. Egg-laying appeared to be continuous. One nest, which contained four eggs, four days later contained three chicks and two eggs. Another nest with a small chick and three eggs later contained two newly hatched chicks and a further three eggs to replace the first chick. Of course, we were unable to determine whether the eggs in each nest were being laid by more than one bird, but there was no denying the urgency of the birds to multiply while the season favoured them.

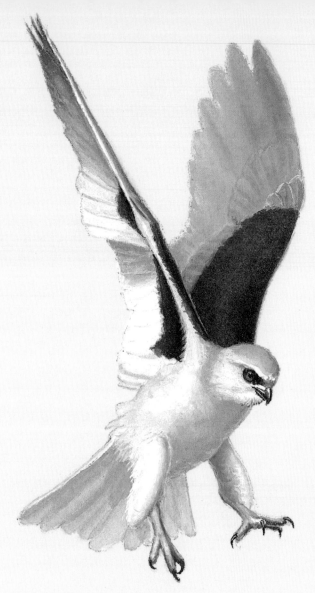

Letter-winged and Black-shouldered Kites

David soon had a hide near one of the nests, which he generously shared. Thus we were privileged to have close views of this normally shy creature without disturbing the colony.

Superficially, Letter-winged Kites are similar to their close relation, the Black-shouldered Kite. However, at close quarters, their head appears larger and rounder in relation to their surprisingly slender, light body, with a greyer crown, contrary to what some observers have noted. The head of the Black-shouldered Kite appears pale, narrow and almost serpentine, with eyes the colour of a good pinot noir, whereas the Letter-winged seems more owl-like, with noticeably larger eyes, coloured the deep red, rusted iron of the gibber plains in sunlight. The Letter-winged has a small patch of black in front of the eye whereas on the Black-shouldered it extends in an eyebrow to behind the eye, lending a rather cross, severe expression to the bird.

Another major difference was in behaviour. Black-shouldered Kites are commonly observed sitting on obvious perches at the top of small trees, glowing white in the sunlight, or hovering with head down as they hunt, predominantly for mice, in open country, white tail spread and wing-beats fast, shallow and fluttering. When they spot prey, they usually thrust their head forward in earnest interest and, as though this has unbalanced them, roll into a dive, head down and wings cocked backwards, extending their feet at the very last moment to snatch their prey. Sometimes they will raise their wings above their backs, straight and almost touching, and drop like a stone with their feet outstretched. I have watched individual birds use both methods only a few minutes apart. Letter-winged Kites frequently

Significantly, one of the nests contained a feral cat, a large, rangy tabby, snugly curled up in comfort. Clearly there were forces at work reducing the breeding irruption of the kites.

For a short period in our journey we had been joined by Charlie's brother John, a magnificently eccentric GP from Melbourne, and the experienced ornithologist David Hollands, also a GP, from Orbost. David was born in England, but arrived in Australia in 1961, where he was delighted to find that many of the birds of prey, a group that had fascinated him all his life, had rarely, if ever, been photographed. He had taken on this challenge and was in the process of preparing his book – *Eagles Hawks and Falcons of Australia* – the first of many excellent publications on specialised groups of Australian birds that he has published since.

LEFT Gouache sketch, 21 × 30 cm, of a Letter-winged Kite descending, with wings held high to 'spill' air
OPPOSITE Gouache sketches of a Black-shouldered Kite moving from hovering in search of prey to diving to grasp it, only extending its feet at the very last moment

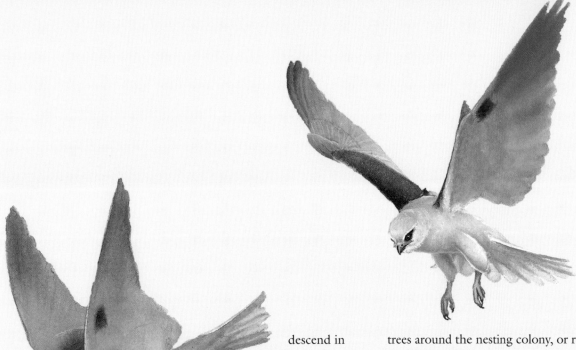

descend in this manner, wings straight and erect, even when coming to perch on a dead branch.

Black-shouldered Kites are typically diurnal hunters, frequently glancing over their shoulders to avoid other birds of prey, particularly Black Falcons, for whom they are often a target. I have seen a Black-shouldered Kite settle on a fence-post to begin to feed on a mouse. From almost a kilometre away a Black Falcon went into a shallow dive and, arriving at great speed, clipped the Black-shouldered Kite, which was already abandoning its kill and seeking safety. Black Falcons do kill and eat Black-shouldered Kites, so better to release the kill and survive. Perhaps this is why Black-shouldered Kites sometimes hunt in the half-light of evening, when falcons may be less active, although the Australian Hobby certainly hunts long into the twilight, hawking insects. Once, lit by my headlights, a Black-shouldered Kite was hunting in full darkness, hovering over the Hopkins River flats near my home in Victoria.

During the day the Letter-wings perched on high, dead branches in the small trees around the nesting colony, or remained on the nest tending their eggs or young. As the sun set, ringing up that attractive mauve shadow on the eastern horizon, little changed. It was not until about an hour after full darkness that the colony would stir. Unfortunately, visibility was much hampered by the lack of bright moonlight.

We had expected Letter-winged Kites to be crepuscular, but that was not so. From the hide, we could monitor activity at night in one nest, which appeared to reflect what was happening elsewhere in the colony. An hour after sunset, when it was totally dark, the male bird left his observation perch, returning with food for the female and chicks after about half an hour. He returned a second time in about another half-hour, and then resumed his vigil on a high branch, the appetites of both the female and chicks possibly satiated.

Elsewhere in the colony there were still sounds of activity, but about midnight all was quiet and remained so for several hours. We were weary enough from our travels to sleep, so were unaware of when the birds resumed hunting, but were dimly conscious of activity for a couple of hours before dawn.

I returned to the colony a year later, in 1976, but by then the frantic activity was all over, the rats scarce and the kites already dispersing in groups of up to twenty birds.

Sadly, our little expedition had to do the same, and we turned our steps to the south and east after three and a half months of outback travel.

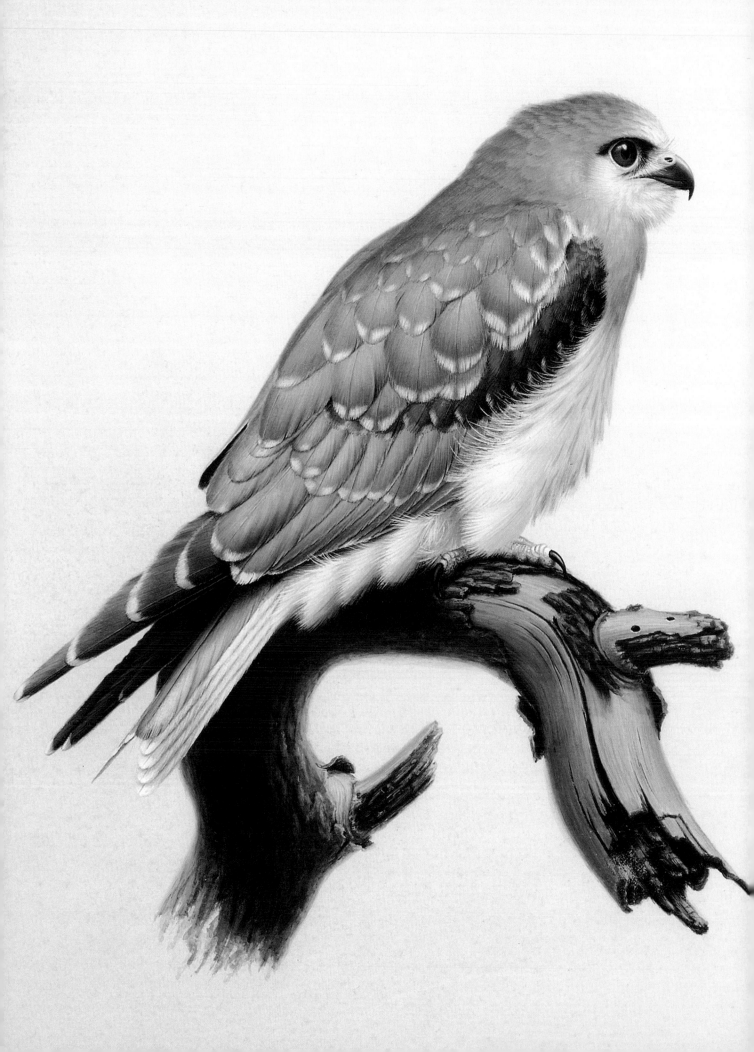

The 1958 Holden sedan Charlie borrowed from his mother-in-law was starting to show signs of wear and tear, and while we were negotiating a roughish section of track one day, the engine leapt off its blocks and landed on the ground. We jacked it back onto its blocks and, using knots that would have had a scoutmaster beaming with pride, tied it into position with a washing line. Thereafter, whenever the driver braked, the engine would slide forward and extend the accelerator cable. The consequent acceleration would be followed by a sinking feeling as the motor relaxed backwards, releasing the accelerator cable, so that the engine died, giving us the abdominal sensation of a high-speed lift heading for the ground floor.

John Brownlie's Kombi skidded off a flooded section of the Birdsville Track and died, apparently having disabled its petrol pump. The floodwaters were up to the floorboards, and the petrol pump was under the floor, but eventually we managed to drag it to higher ground and set about creating an alternative petrol pump. We glued two syringes to the bottom of a plastic orange-juice container and ran neoprene tubes as fuel leads. A resolute non-smoker then sat in the back, filling this device regularly with a jug of petrol. At Marree, we loaded our vehicles and ourselves on a train to Port Augusta for repairs before the drive back to Melbourne.

I THINK HE'S MARRIED

Mike Vance, a producer from the ABC Wildlife Unit, had asked Charles McCubbin to be a location scout for a film to be made in the red centre. Not long after we returned, we were invited to dinner to discuss our experiences.

Mike had a delightful assistant, Jenny Hobson, who had recently been dispatched to survey the Coorong for a proposed film. To balance numbers, she was also asked to dinner. Then she wasn't. 'I think he's married. You'd better stay away,' Mike said. (In London I had been briefly married to an English girl, which had not been a great success; we divorced after five years, so I had been single for some time by this stage.) Then, 'I think he may be separated. You'd better come!'

By such narrow margins are acquaintances made! The very attractive young woman sat next to me at dinner and we chatted cheerfully. Then Mike asked Charlie if he'd taken any photographs of the country. With a chirp of enthusiasm, Charlie fetched a projector and a shoebox full of two and a half thousand colour transparencies.

Eventually, at about 4.30 am, we managed to drag Charlie away, enthusiastic as ever. Jenny and I arranged to meet up again, sometime, somewhere.

We had dinner together a few weeks later, and she seemed unperturbed by several birds of prey in the car. There was a Whistling Kite, a weak juvenile left in a nest when its siblings fledged near Birdsville; a Black-shouldered Kite, rescued under similar circumstances near Lara; and the Brown Falcon that had been hit by a car in South Australia and which I had nurtured back to full health for eventual release into the wild. These birds were all well used to travelling by car, and balanced on a screen perch fitted across the back seat. Jenny was keen to film close-up sequences of portraits, eyes and feet as fill-in shots for the programs she was involved in making, so we arranged that I might travel to the Coorong with them to help on the film.

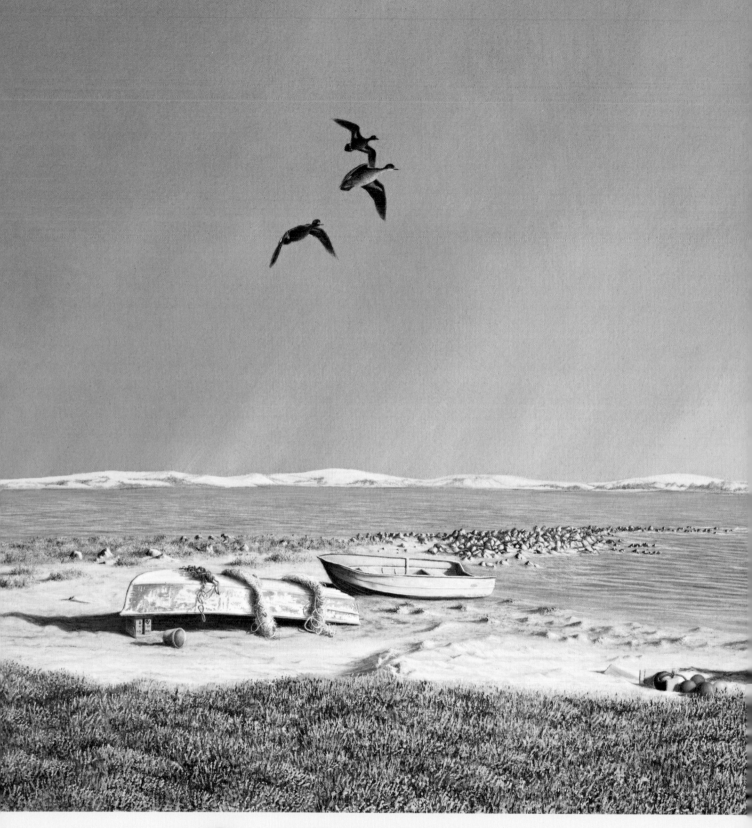

ABOVE *Fisherman's Camp*, gouache, 38 × 56 cm
Painted at Policeman's Point in the Coorong as a comment on developing environmental problems. Reduced flows in the lower Murray River fail to clear the river mouth and the Coorong water becomes increasingly saline, jeopardising aquatic wildlife. Three Chestnut Teal (*Anas castanea*), a species that manage brackish water better than most ducks and prefer saltwater estuaries and lagoons, are backed by threatening storm clouds as they fly over discoloured saline water, salt-tolerant samphire, coastal erosion and abandoned fishing detritus.
LEFT Watercolour study, 21 × 30 cm, of a Hooded Plover (*Thinornis cucullatus*), itself a vulnerable coastal species that suffers much from human disturbance

ABOVE RIGHT Linear pencil sketch of a Red-kneed Dotterel (*Erythrogonys cinctus*), drawn from a pair that were fighting on a swamp at Connewarran
RIGHT Pencil sketch, 21 × 30 cm, of Emu tracks on a Younghusband Peninsula sandhill

THE COORONG

I ADMIT THAT Jenny was the major attraction for a trip to the Coorong, about which I knew very little, so it was also a great opportunity to learn. There were a couple of old three-wheel motorbikes for survey forays to other sites, and occasionally we would borrow these to visit parts of the Younghusband Peninsula, the narrow band of sandhills and vegetation that separates the Coorong from the Southern Ocean.

Jenny had done her survey well and was adept at guiding us to interesting places, such as one of the old Indigenous middens in a large deflation area behind a sand dune, where two ancient bodies had been uncovered by erosion. Another burial site showed two skeletons, surrounded by eight others in a loose oval formation. The site had such mystique that we left quietly in a reverential mood. Sadly, when we visited a few years later, it had been desecrated by intruders, an appalling reflection of the attitude of some of those who seek leisure-time access to our national parks.

All over the dunes were clues to the activities of animals and birds. Emus left long ribbons of tracks sloping diagonally across the dunes, the dragging middle toe creating an elongated mark with each step. Fox tracks were common and showed a pattern of movement that helped us understand the ecology of that environment.

Along the ocean beach on the southern fringes of the Coorong, Jenny showed me the spectacle of over

twenty Whistling Kites playing with *Posidonia* balls, created when waves roll seagrass around to form tough, spherical, fibrous balls that wash up on the tides.

Do animals play? The kites were swooping down to grasp the balls in their talons, lifting them high before dropping them again, competing to catch them before they touched the ground and then starting anew the race to be first to catch or pick up the treasure before it was snatched by another kite. These birds were probably supported by a plentiful supply of rabbits, for they clearly had energy to burn, but they were a spectacular sight as they wheeled in the ocean breeze, their patterned wings flashing in the sunlight.

Pelicans

The bird of the Coorong is the Pelican (*Pelecanus conspicillatus*), popularised by Colin Thiele's book *Storm Boy*. If the environment and the supply of fish are right, they breed there, and the breeding colony at Jack Point was the largest then known in Australia. It is wonderful that such a ridiculous-looking bird can fly or swim with such majesty. Columns of Pelicans may soar in a thermal to gain height with minimal effort, before gliding out to feeding grounds. For a bird that seems to derive from the earlier branches of the phylogenetic tree, the Pelican and its relatives, the albatrosses and petrels, seem to have mastered the art of flight very early on.

OPPOSITE Pen and ink with wash sketches, 21 × 30 cm, of Australian Pelicans loafing on the edge of the Coorong
BELOW Gouache study, 21 × 30 cm, of an Australian Pelican 'compression gliding'

It has always fascinated me how they can glide over great distances just above the water, apparently by a simple matter of altering the 'angle of attack' of their wings. This is a phenomenon known as 'compression gliding'. Not all birds can do it, as it depends on long, narrow wings and sufficient body weight to maintain momentum. When the bird is within much less than its wingspan of the water's surface, a cushion of air passes between its wings and the water and is compressed, supporting the bird and allowing it to remain airborne even when its speed reduces and it should, theoretically, stall. Occasionally they lift and flap their wings to regain airspeed so that they can continue compression gliding. 'Ground effect' as it is also known, saves energy, just as a plover stands on one leg to keep the other leg

from losing heat, or energy. When a bird buries its bill under its mantle feathers, 'putting its head under its wing', it is to prevent heat or energy loss. Birds also rest in sheltered places, again, to save energy. A whole group of birds that regularly fly over water have evolved long, narrow wings to enable efficient compression gliding in order to save energy.

Of course, the same effect will work over land, and mudflats or sand are perfect for a Pelican gliding, but elsewhere bushes, tussocks or other obstructions pose threats.

I enjoy watching bands of Pelicans fishing in stately formation quietly herding together shoals of fish in shallower water before plunging their huge bills under the surface in unison, then tilting their heads back to swallow their catch.

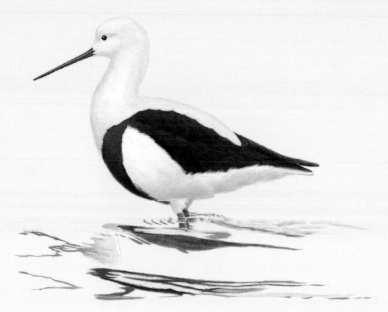

WADERS

The Coorong supports many non-migratory species. The saline conditions are excellent for breeding brine shrimps and other salt-loving invertebrates, providing perfect conditions for Red-necked Avocets (*Recurvirostra novaehollandiae*) and Banded Stilts (*Cladorhynchus leucocephalus*), both gregarious species that often flock together, as both feed in similar brackish conditions.

Large flocks of avocets are always attractive, especially when lit by bright sunlight shining against a leaden sky. With their dapper white bodies marked by a strip of black and their chocolate-coloured heads, they are perhaps the most attractive species of avocet anywhere in the world, their white plumage as brilliant as that of the Banded Stilts. When brightly lit, these flocks can be extraordinarily attractive, and large, extensive flocks roosting close together are particularly impressive.

The shallow waters of the Coorong are also an important feeding resource for migratory waders on the East Asian – Australasian Flyway. It is recognised as a wetland of international importance under the Ramsar Convention, an international treaty signed at Ramsar in Iran in February 1971, and commonly referred to as the Convention on Wetlands. The agreement draws together international representatives every three years to formulate policy and make

ABOVE LEFT Gouache study, 21 × 30 cm, of a Banded Stilt; they will wade deep and even swim, plunging their heads beneath the water in search of aquatic invertebrates on which to feed
LEFT Pencil sketch of a Red-necked Avocet in flight at the Metropolitan Treatment Works, Werribee

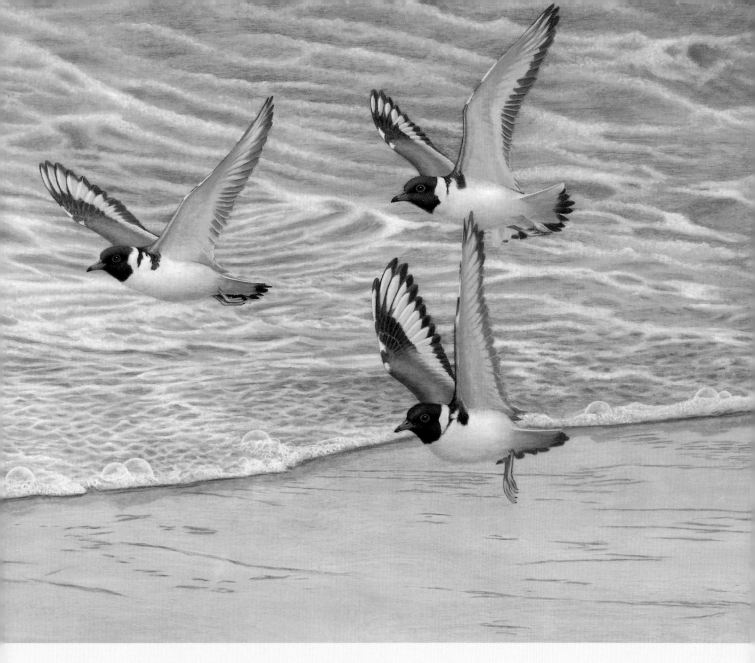

decisions on the conservation and sustainable use of wetlands. An important factor common to our wetlands, shorelines and tidal flats across southern Australia, is that they represent vital feeding refuges at the southern end of one of the great avian migration routes on Earth, the East Asian – Australasian Flyway for migratory waders.

The shallow waters of the Coorong provide a rich feeding ground. After their massive journeys from Alaska or Siberia, the birds are vitally depleted and must feed intensively to replenish the condition they have lost. The importance of the Coorong as a refuge can hardly be overstated.

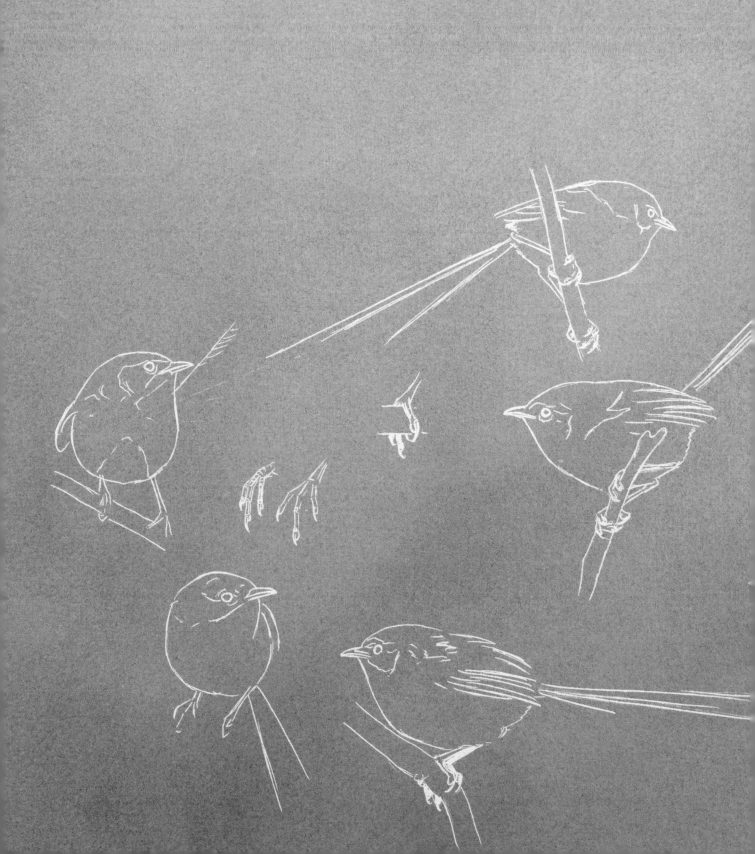

LEARNING ON THE LAND

CONNEWARRAN, IN THE
Western District of Victoria,
had been in my family for four
generations, bought by my great-grandfather
William Weatherly, who was born in Scotland in
1839. William arrived in Melbourne in August
1860, and after working on properties in Victoria
and western New South Wales, in 1895 he
bought two adjoining properties watered by
the Hopkins River and the Blind Creek called
Connewarran and Woolongoon, where
I grew up.

Parts of Connewarran were covered
in dense scrub: a horse might push
through, but it was impossible to drive a buggy.
In one paddock, named the Gum Scrub, a
girl from Melbourne, who was staying with
William's daughter (my great-aunt), became lost
for twelve hours before she was rescued. My
predecessors recognised such a valuable resource
– uncharacteristic of the times – and there were
bush areas enclosed and protected, sometimes
to conserve stands of red gums, or preserve
untouched areas for posterity. One protected
block of scrub on Connewarran was unfortunately
burnt in 1920. Sadly, it was thought that it would
never recover after that fire and was not re-fenced.
I find it frustrating that there is nowhere, nowhere
on Earth, that I can visit to see an example of the
original landscape and vegetation on Connewarran
prior to white settlement.

My grandfather, Lionel Weatherly, took over
Connewarran and Woolongoon in 1909. At that
time, there was a big, shallow dam on the Blind
Creek, below the house, but this was drained when
my grandmother fell ill with tuberculosis in the
early 1900s. It remained dry until 1937, and when
it refilled, the newly flooded pasture provided a
rich food resource for waterfowl. Ducks of many
species were crowded wingtip to wingtip around its

shoreline and covered much of
the water.

I remember my
grandfather as a stern but
gentle man, very fond of, and
interested in, animals and birds.
He worked hard, but I recall a
story of him spending hours on
his hands and knees attempting
to gain the trust of a baby Masked
Lapwing (*Vanellus miles*). The family had
a pet Kookaburra (*Dacelo novaeguineae*) and
a dozen pet Black Duck, one of which added a
wild mate to the group. She stayed for a couple
of years, until she was taken by a Peregrine Falcon
as she left her nest in a hollow red gum near
the house.

Lionel's period of administration covered
a world war, the allocation of more than half
his land to Soldier Settlement, and the Great
Depression. He generously donated 880 acres
(355 hectares) of some of his better country to
assist returned soldiers. Despite his numerous
responsibilities, his interest led him to keep a
list of the 114
species of birds
he'd seen on the
property, which I still
have. The landscape must
have changed enormously, with
the loss of understorey shrubs like
banksia and ti-tree, and dieback occurring
in the older trees. In addition, many of the
ephemeral swamps had been drained to prevent
liver fluke.

Management of Connewarran and
Woolongoon was handed to my father from
the end of the Second World War, and my early
memories, at the beginning of the 1950s, are of
open, cleared country with areas of magnificent

PREVIOUS Pencil
sketches of Southern
Emu-wrens
LEFT, BELOW Gouache
studies of the
Australian Hobby
flying figures of eight
in the updraft on the
banks of the Hopkins
River

old red gums in some parts, particularly on the river flats. There were many skeletons of old trees killed by ringbarking or dieback. My father kept lists of bird species as his father had done before him, and recorded 141 species, thirty-seven more than his father. Of those species, perhaps half would have been associated with the dam on Blind Creek that had been re-flooded in 1937. He was very aware of what was happening on and around that dam and loved to spend time observing the bird activity there, as did I.

In the mid-1960s, my father increasingly shifted responsibility for the day-to-day management to my older brother. In 1966 he began to transfer land to me, and James and I formed a partnership, with him as managing partner. This arrangement persisted until 1975, when I sold my livestock and leased the land.

In August 1976, a year after we met, Jenny and I married, with Charles McCubbin supporting us as best man. On marrying, Jenny moved to rural Victoria with me, and left the job she loved, making natural-history programs with the Wildlife Unit for the ABC. I was in the midst of fieldwork and painting for the 'wren book', which was to dominate our lives for eight years.

Jenny and I decided to live on our farm but to continue to lease it instead of farming it ourselves. That way we would have access to the wildlife and freedom of a farm, without the burden of day-to-day management.

ABOVE Study in pencil with colour wash of an Australian Hobby taking a male Red-rumped Parrot (*Psephotus haematonotus*) in the paddock just beyond my garden; the Hobby came in low and fast, using me as cover, then, lifting over my shoulder, it snatched the parrot as it left the ground

In August 1976, Jenny and I moved a weatherboard cottage to Connewarran, next to the site of the original cattle yards of the 1840s on a bend of the Hopkins River. Our new home was only four hundred metres from the old Connewarran homestead, by then a ruin, perched at the top of a steep bank overlooking the river. This was the site to which I used to ride during my childhood. The steepness of the bank frequently produced a strong updraught in a westerly wind, and this would sometimes attract falcons to play.

One afternoon, I sat on a patient brown mare for over an hour near this steep bank of the Hopkins River that created powerful updraughts, as an Australian Hobby flew figures of eight above my head. A shallow dive into the wind would be followed by a steep climb using the speed from the dive. As that speed diminished, the falcon would roll over into another shallow dive, before rising and diving back on its original course. This was perpetual motion without input from a single wing-beat, up and back in endless play.

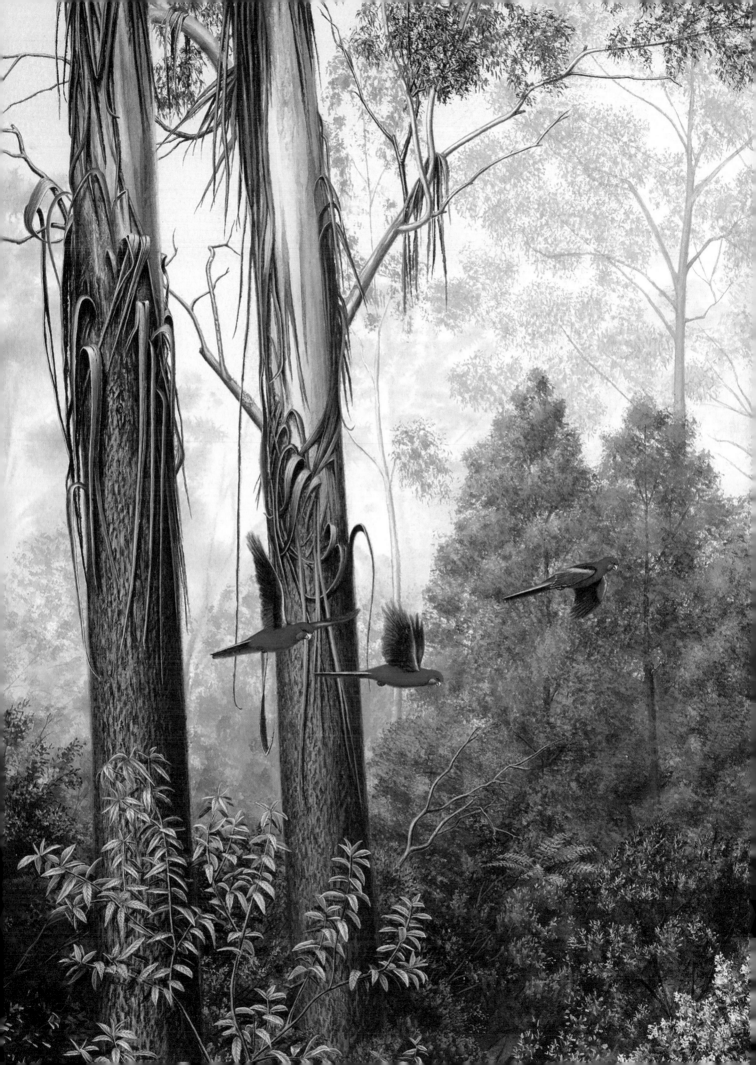

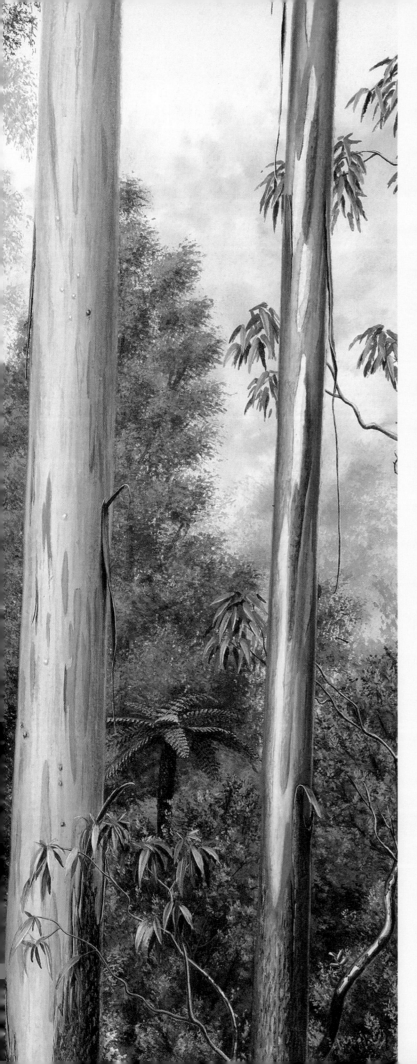

In the river below, Platypus (*Ornithorhynchus anatinus*) would emerge to feed, often on a still sunny day and at mid-afternoon. They would ignore a stationary spectator and would occasionally paddle up to within a metre or less, or clamber out onto a stump to scratch or rest, or shake the water from their fur. Their dives normally lasted for about seventy seconds, and by moving quietly to the place where I anticipated they would surface, I could frequently see them from very close. Any noise or movement would immediately trigger a crash-dive, ending the observation for that day.

By late February of the crushing drought of 1982–83, it was evident that Connewarran was overgrazed and overstocked. High in the sky soared two Wedge-tailed Eagles, surveying the parched land beneath. To the west a Little Raven (*Corvus mellori*) gave its funereal, croaking call from the top of a dead red gum, drawing attention to the silence. The land felt soulless and deserted, there was bare earth and drifting dust as far as the eye could see, and we waited helplessly for the next ghastly phase of this inevitable process, the loss of our topsoil.

Few who saw it will forget the wall of dust and soil hanging like thick smoke in the air to Melbourne's west, before it descended on the city, blanketing everything with the nation's precious topsoil and reducing the land's fertility for years to come.

We decided that it was time for us to manage the property ourselves.

LEFT *Mountain Ash and Crimson Rosellas*, gouache, 36 × 48 cm
Painting originally commissioned by *The Age* newspaper for a series of six paintings of trees; sadly the 'mist' is smoke from the 1983 bushfires at Acheron, Victoria

BIRDS, PLANTS AND INSECTS

WHEN JENNY AND I first moved to Connewarran, the land was bleak and flat, with poor pasture and low productivity. There were no sheds, the remote yards needed repair, or replacement, and there was very little shelter, particularly for new-born lambs in the bleak winds of the 'pleurisy plains', as the Western District is sometimes called. For water, we had five small stock dams. The Hopkins River flowing around two sides of our farm was periodically too saline for watering livestock or a hazard for young sheep, which frequently became bogged.

We began by creating wetlands and planting trees to provide shelter for stock and protect the soil. Our planting was for environmental purposes, and for shade and shelter for livestock. Any returns were to come from increases in farm productivity and ecosystem services, not from forestry. Initially we planted seedlings, a slow, back-breaking process, resulting in too many apparently healthy trees suddenly deciding that life was not for them, and dying. The gnarled old red gums looked sick and needed either to be replaced or to have the support of an understorey to provide insects and birds that could help protect them from damaging leaf-eating pests.

We decided to attempt direct-seeding our new trees, a traditional but now discarded means of revegetation, ploughing the ground with a mouldboard plough to invert the topsoil and bury the weeds, and then hand-scattering seeds on the bare surface.

This had been successful until the early 1950s, when agriculture departments promoted the use of superphosphate and subterranean

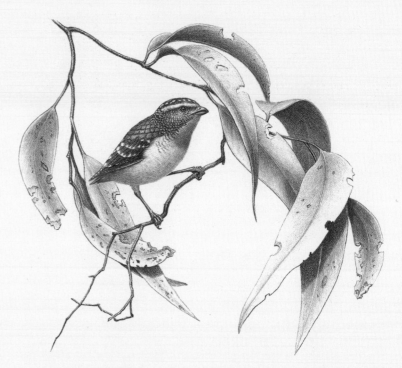

clover to improve pasture productivity. After the first application of the fertiliser, the effectiveness of direct-seeding was halved; after a second application, it was a failure. Fertiliser fed the weeds that germinated, allowing them to outcompete the native tree seeds, which mostly prefer soils with lower phosphorus content. It was the release of a range of herbicides to control competitive weeds that allowed us to return to direct-seeding.

To replace hand sowing, we needed a reliable mechanical process, so with great help from a consultant, David Debenham, capital from eight interested farmers, and Lou Canoby, a creative and helpful engineer in Leongatha, Gippsland, a machine was built.

The tree-seeder had a ripping tine in front, followed by three discs for seed-bed preparation. A geared seed box deposited measured quantities of seed onto the seed bed, where it was buried by a compression roller. The ripper was soon replaced by a scalping mouldboard.

Within eighteen months there was shelter developing for lambs and calves, and animals and

ABOVE Spotted Pardalote (*Pardalotus punctatus*), an image in pencil, 19 × 19 cm, originally drawn for the CSIRO publication *Wild Places of Greater Melbourne*, by Robin Taylor
OPPOSITE Superb Fairy-wren (*Malurus cyaneus*), a small gouache study, 20 × 16 cm, painted for a Christmas card

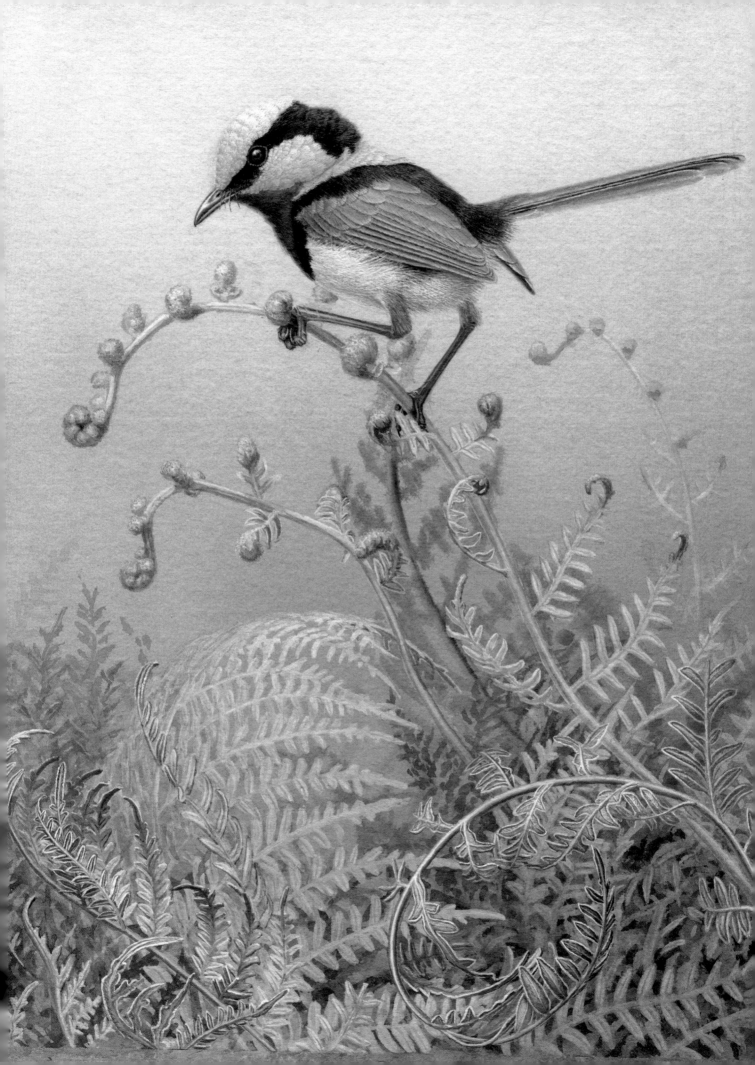

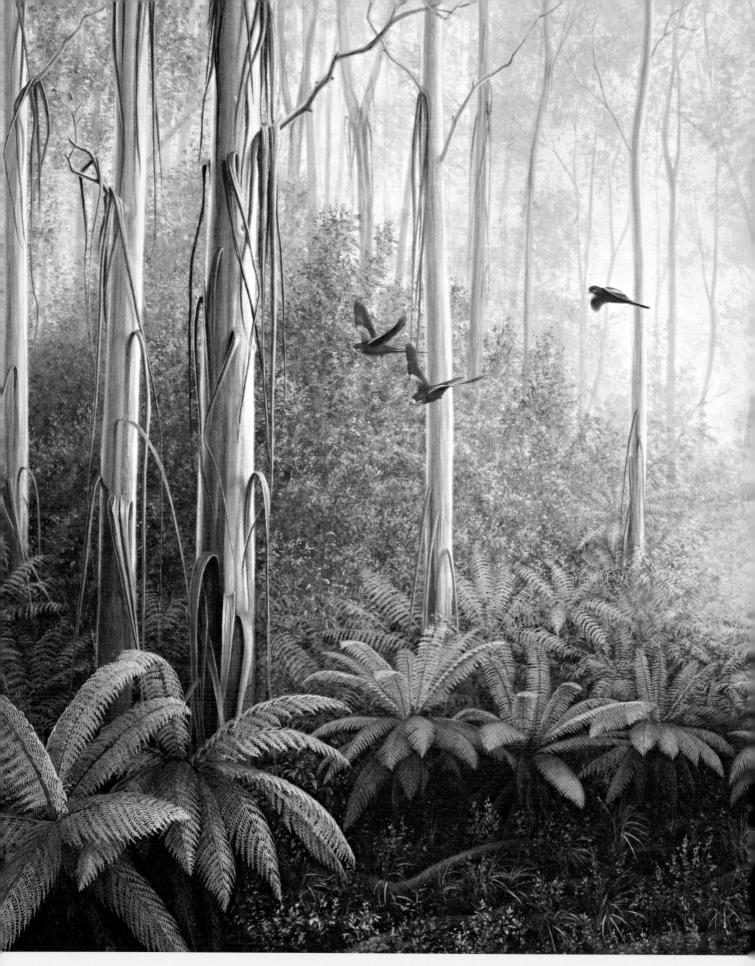

ABOVE *Forest Flight*, gouache, 38 × 56 cm Trying to capture light through mist and the lilting flight of Crimson Rosellas down a gully in the Otway Ranges

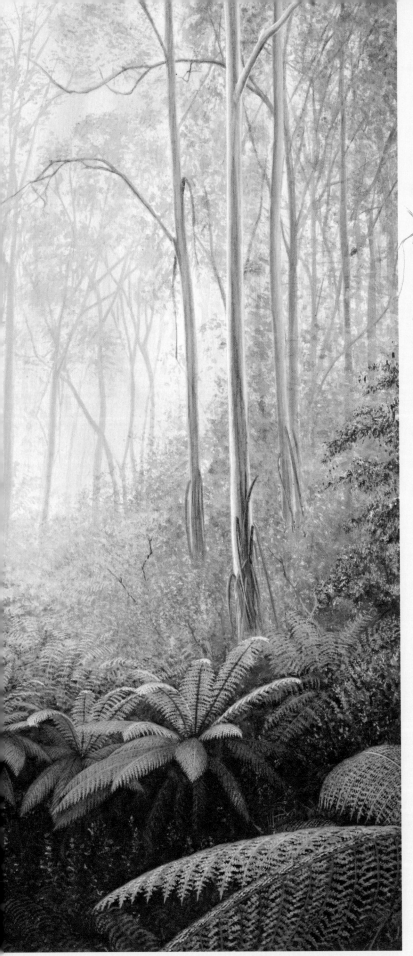

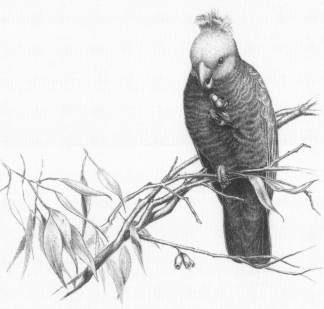

birds never previously seen on the property began to arrive, sometimes as vagrants, some to take up residence and breed. The balance of insects changed perceptibly; ant species not previously recorded began to spread. They were followed by echidnas, an animal never seen on Connewarran during the seventy years of my father's time, and it was particularly exciting the first time we found an 'echidna train', a line of echidnas all following a female, nose to tail, during courtship.

Our new young trees attracted pest insects, which we had hoped, and been advised, would be controlled by attracting birds: Magpies, Straw-necked Ibis (*Threskiornis spinicollis*) and Australian White Ibis (*T. molucca*). But the numbers of nuisance insects taken by birds appeared trivial in comparison to the numbers destroyed by predatory insects. It soon became apparent that, of the species of birds that could assist in controlling pest insects, nearly all favoured a dense understorey as habitat. At the time, entomology was a closed book to me, but by observation and patience, we began to get a feel for some of the ecosystem services that helpful insects can provide given the right resources of secure cover and continuous nectar flow. By changing the conditions, we were constantly finding new,

ABOVE Pencil study of a Gang-gang (*Callocephalon fimbriatum*), drawn originally as a chapter heading for Graham Pizzey's book *A Garden of Birds*; most Gang-gangs are 'left-handed'

mostly predatory, insects, and I soon realised that getting the insect balance right might be more important than attracting more birds.

Of the birds, we knew that Crimson Rosellas (*Platycercus elegans*) and Gang-gangs will eat sawfly larvae (*Perga* spp.), but both species prefer denser woodland or forest. Magpies, currawongs, ravens, starlings and ibis feed on various caterpillars, and Southern Boobook Owls feed on Christmas beetles, but owls prefer dense acacia scrub in which to hide during the day.

Birds such as currawongs and Silvereyes (*Zosterops lateralis*) help reduce leaf beetles, which can defoliate a tree. Birds are also one of the natural enemies of psyllids, tiny sap-sucking insects that, in adulthood, resemble miniature cicadas. Psyllids construct distinctively shaped lerps, sweet, waxy hummocks under which the nymph shelters; some form long, waxy filaments, some are irregular scales and some even resemble tiny Shell petrol signs.

Indigenous people would harvest lerps for their sugary energy, as will some wasp species, honeyeaters and pardalotes. However, pardalotes also require adequate cover to hide from enemies such as hawks and attacking species of honeyeater, which can be intensely aggressive.

We came to understand the importance of insects in building the health of ecosystems, and hence the desirability of smaller trees, shrubs and even ground-level vegetation to attract those insects, together with small birds. The key appeared to be a continuous energy resource through an uninterrupted and easily accessible nectar supply and good, dense protective cover at shrub level.

As the trees and understorey developed into denser cover with

greater diversity, more and more bird species arrived, and the health of the ecosystem improved. It became abundantly clear that the beneficial effects were extending well beyond our plantations and far out into the pasture, where insect damage was greatly diminished.

While we delighted in an increasing diversity of bird species, some species indicated health, while others presaged trouble. As the lower levels of scrub developed under our trees, we saw more of the small birds that had been missing in our open habitat. We frequently heard that most vocal of tiny birds, the Brown Thornbill (*Acanthiza pusilla*), as it foraged for morsels in the foliage, and it was often joined by its relatives the Striated Thornbill (*A. lineata*) and the Yellow Thornbill (*A. nana*).

We were assisted by the 'edge effect', the common boundary of two differing habitats. This may be the meeting of plantations with pasture, or wetland with native grassland, or any juxtaposition of two habitats. The Hopkins River was particularly helpful. It follows a geological fault line between two differing soil types, the old Tertiary sediments and the more recent basalt soils that were the legacy of volcanic activity possibly more than thirty-five thousand years ago. This fault line marks a junction between habitat types: the red-gum woodland of the Tertiary soils to the east, and the grassland plains of the basalt soils to our west. We were fortunate to live in an area of natural diversity.

We understood that isolated blocks of habitat would be too small to provide much benefit, so we developed 'habitat nodes', larger areas that were interconnected by shelterbelts between twenty and one hundred metres wide of multiple species along the boundaries

of each paddock. Wildlife could move freely between the nodes. Without being aware, we were moving into the field of regenerative farming, mostly because we wished to harvest the production of a farm ecosystem, rather than to mine the farm. However, we became increasingly aware of a difficulty. Through friendship with some extraordinary naturalists – particularly Graham Pizzey, whose information and ideas often seemed fifty years ahead of their time – we began to understand how much size matters. The study of minimal sustainable areas and the effect of isolated habitats on species diversity was very much a contemporary science at the time, and our 'nodes' and corridors of habitat, while infinitely better than nothing, were likely to be too small to be sustainable; Connewarran, even with the concept of its 'open-plan ecosystem' of interconnected habitat nodes, was unlikely to ever have enough habitat to stand alone. It needed to connect with other, broader areas.

Fortunately, there was a property some twenty kilometres upstream on the Hopkins River with an excellent conservation history over three generations and a series of exemplary wetlands, surrounded and connected by vegetation. We decided to attempt

to connect the two properties by working with neighbouring landowners along the river between us to conserve the stream frontage and use it as a corridor.

We were the beneficiaries of a developing understanding of what constitutes an ecosystem and of the minimum size for one to be sustainable. The early settlers had laboured with axes and saws, until the forests and bushland of Australia shrank, receded and were divided into isolated areas. In 1956, John T. Curtis published a paper showing how swiftly, insidiously and completely habitat could be fragmented and diminished by human interference, breaking into isolated 'islands' of retained vegetation, essentially the effect we were attempting to redress on Connewarran.

These islands of habitat contained some of the species of the original bush entrapped within their boundaries, but such fragmented relics of former ecosystems are subject to a force for which the scientist Tom Lovejoy coined the persuasive term 'ecosystem decay' after his experiment on the long-term effects of ecosystem fragmentation in the Brazilian Amazon. Species are gradually destroyed due to pressure from without – weeds, drying winds, heat, pest species, competition – and insufficient resources within.

Over the years our original vegetation had been fragmented by agricultural development, roads, forestry and all kinds of human activity, leaving limited islands of habitat in place. By tree-planting and interlinking these isolated islands of vegetation, we hoped to better connect the remnants. The original forest areas were long gone, but there were valuable isolated blocks of sufficient size to be included and interconnected. However, the only obvious major

remaining areas were the Grampians National Park, way to our north-west, and the forests of the Otway Ranges, well to the south and established as the Great Otway National Park in 2005.

The germ of an idea began to grow. By protecting or rehabilitating riparian areas along the rivers running across the region, it could be possible to connect the Otways and the Grampians with a network of vegetation, possibly contributing to the long-term sustainability of both parks. The 'skeleton' provided by the rivers and creeks could be fleshed out with additional planting to provide shade, shelter and ecosystem services on the adjacent farmland.

Such connection could be made more robust by widening its scope and establishing linkages from ridgetop to river-front throughout the catchment; it would be largely a matter of planning. Scientific research indicated that we could anticipate results on most properties similar

ABOVE A White-faced Heron (*Egretta novaehollandiae*), from a series of pencil sketches, including the one used for the heron in the painting opposite
RIGHT *The Watering Place*, oil on linen, 51 × 67 cm
This commissioned painting was an interesting challenge: muddy water under a clean blue sky, and rams that I had bred, now living on another property!

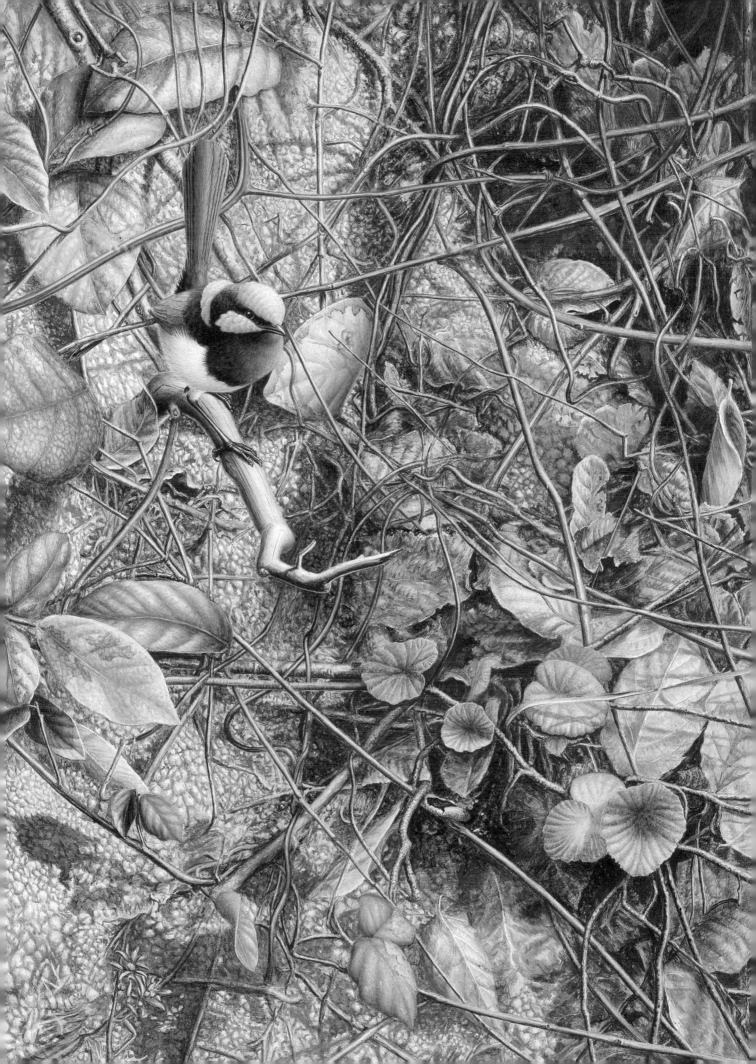

OPPOSITE *Primary Colours*, oil on panel, 41 × 31 cm
The juxtaposition of red, yellow and blue interested me most at first, but the work developed into a technical design exercise, using the Renaissance quadrant: the painting is broken into four quadrants, two vacant and two full, which balance each other, while a circular format leads the eye rhythmically around the picture before leaving it at rest in the centre; exhibited at the Leigh Yawkey Woodson Art Museum's *Birds in Art* exhibition in 1989
BELOW RIGHT Gouache study of a Superb Fairy-wren

to the improvements in productivity and financial viability we had seen on our own. The plan, as it grew, would include an area of about 800,000 hectares, stretching over about two hundred kilometres of corridor. It would create a kind of open-plan ecosystem with vegetation surrounding each paddock to provide shade and shelter to benefit both the farms and the habitat, as well as ecosystem services to farmers. It would take planning and enthusiasm, but it should benefit the communities involved, bringing them together in a spirit of co-operation.

Similar innovation can be achieved in urban design; parks and gardens scattered throughout our towns and cities can be interconnected by corridors to the benefit of all. Even cities can incorporate the concept of habitat interconnection. In Britain, the Blue Campaign was to reverse the decline in natural ecosystems by encouraging each household to keep a portion of their garden wild, establishing corridors through urban areas and connecting them back to the country. Designing the general landscape as an entity, not merely as a series of individual holdings, could encourage revegetation of denuded sections. Habitat nodes interconnected by corridors of sufficient scale might return the environment to some form of viability.

ISLAND ECOSYSTEMS

CHARLES DARWIN, IN writing of his journey to the Galapagos Islands, noted, 'The species of all kinds which inhabit oceanic islands are few in number compared with those on equal continental areas.' The smaller an isolated area, the fewer species are likely to be able to persist, both numerically and in diversity, and this includes habitats isolated by clearing.

In 1984 Jared Diamond showed that 171 species and subspecies of birds had become extinct since 1600, of which ninety per cent were from islands. Australia's Lord Howe Island had lost more bird species than Africa, Asia and Europe combined. Since only twenty per cent of the world's bird species are confined to islands, why do they face fifty times the normal threat of extinction?

In an experiment called Minimal Critical Size of Ecosystems Project, the enlightened scientist Tom Lovejoy compared the effects of isolation on plots of various sizes saved from clearing in the Brazilian Amazon. He demonstrated how important size was for sustainability. First to disappear, particularly in the smaller plots, were the large predators. They were followed by the larger prey species.

Initially birds seemed the sole source of optimism in Lovejoy's experiment, as they seemed to increase in number. Highly mobile, they were able to evade the mechanical clearing of the surrounding forest by escaping into the retained refuges (known as the 'lifeboat effect'), but soon competition and limited resources depressed their numbers in balance with the niches available and they 'relaxed to equilibrium' as the reality of overpopulation forced their decline.

Significantly, birds continued to decline further. Some species proved less vulnerable than others, notably those that had closer relationships with other species to help procure their food resources. Species that were 'specialists' proved more vulnerable than those that were 'generalists' and were more flexible in their behaviour and methods of feeding. With the increased exposure of the forest to light and climate, the secretive bird species of the dark forest and the large, bright butterflies of the original rainforest became rare. However, their light-loving counterparts from the forest edges began to intrude in competition.

Along the fringes, rainforest trees became desiccated and died, dragging down others as they fell. Exotic weeds invaded, and many species of birds disappeared. With no predators to control them, smaller predators replaced larger ones, and became more prevalent; opossums and armadillos more than doubled in number, and peccaries and monkeys also increased, probably causing the extermination of many birds, particularly ground-nesting species.

Tom Lovejoy's long-term study demonstrated the gradual decay of the interrelationships between species and the impoverishment of the environment. He described sequences of trophic cascade – when the loss of one element of an ecosystem triggers a series of often damaging changes.

Christmas Island

In an enclosed environment, the introduction of a single species may have cascading consequences. In October 1958, when Australia acquired Christmas Island, its unspoilt rainforest contained exceptional flora and fauna, including some unique bird species and many species of crab, particularly the brilliantly coloured Christmas Island Red Crab (*Gecarcoidea natalis*), which covers the island in millions, tilling and aerating the soil, chewing through tons of leaf litter, returning nutrients to the land and clearing the rainforest understorey.

At some time prior to the 1930s, a seemingly unimportant immigrant, the Yellow Crazy Ant (*Anoplolepis gracilipes*), appeared on Christmas Island, probably carried in cargo from West Africa. Yellow Crazy Ants are 'unicolonial' and can coexist peacefully in multi-queened nests termed 'super-colonies'. In the late 1990s, the ants' behaviour changed abruptly. Something triggered the formation of enormous super-colonies, some covering many hundreds of hectares. So, what had changed?

Crazy ants farm sap-sucking psyllid insects, protecting them from predators in return for their 'honeydew'. Psyllids were rare on Christmas Island, but in 1996–97, drought-stressed trees began to produce more concentrated, nitrogen-rich sap congenial to the psyllids and, by extension, to the ants. Trees weakened by the increasing psyllids and the moulds and fungi growing on excess honeydew often died, opening the forest to light, desiccation and weeds. Ant populations soared.

Crazy ants are voracious predators, squirting acid from nozzles in their abdomen. Small animals, reptiles, ground-dwelling insects and the ubiquitous crabs were severely impacted, sometimes to the point of extinction. Blinded with acid and unable to feed, red crabs provided more

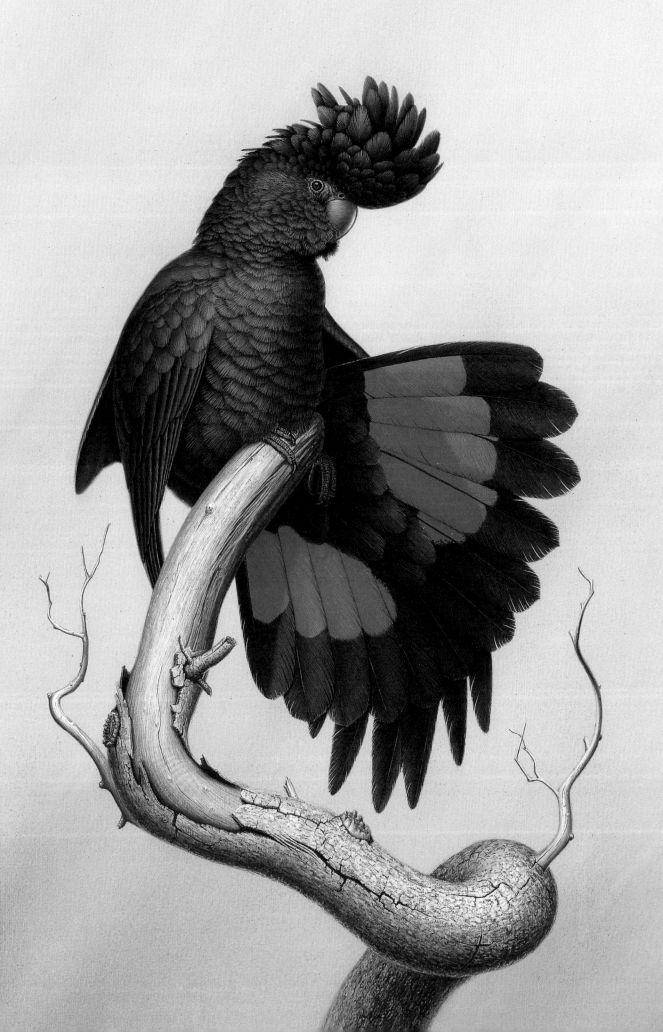

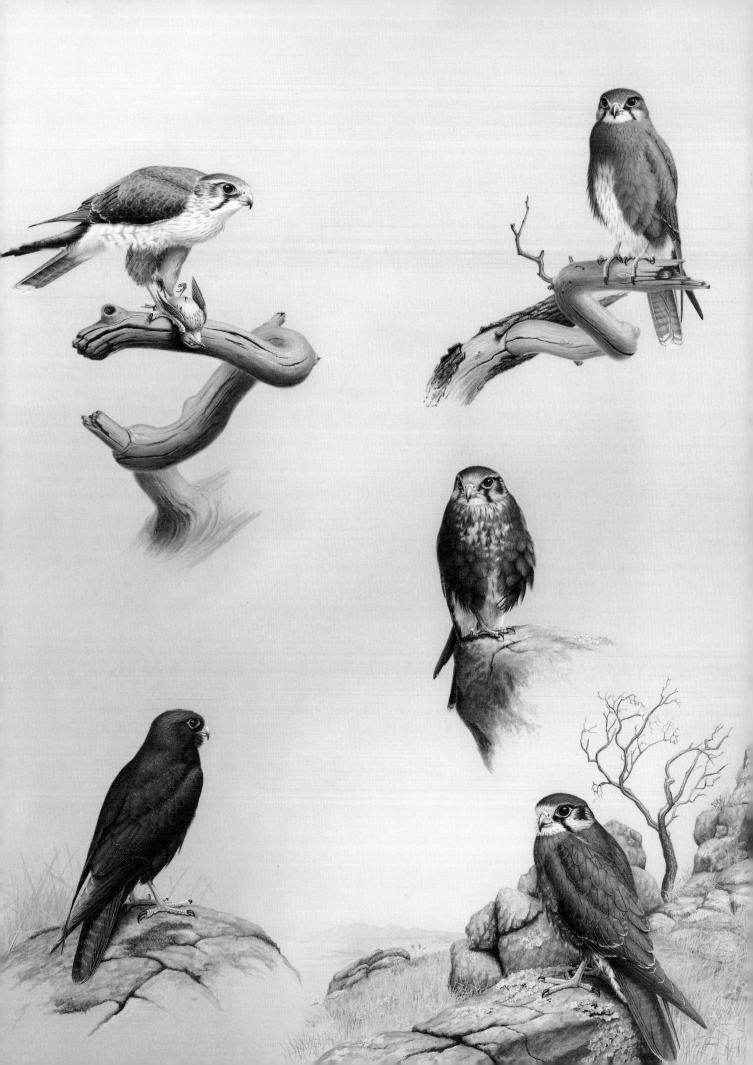

food for the ants, and where the ants were well established, red crabs were eliminated. This altered the forest: without the crabs, a dense understorey developed, choking the rainforest, altering the habitat and forcing out species such as the Christmas Island Boobook (*Ninox natalis*). Secondary invaders became established, such as the Giant African Land Snail (*Achatina fulica*), previously controlled by the red crabs. All of this from the introduction of an ant.

It's unclear whether the ants are predating birds, nests and arboreal animals and insects, but clearing and mining have fragmented the rainforest, exacerbating environmental damage and leaving isolated blocks more vulnerable.

Hawaii

In Hawaii, another seemingly innocuous introduction to a closed island ecosystem did irreparable damage. In the early 1800s, a British ship visited to replenish its water supply, emptying the stagnant residue before refilling the barrels with clean fresh water.

The discarded water contained the wriggling larvae of a species of mosquito from Mexico, which hatched and flourished. Soon they swarmed throughout the islands, and birdsong was gradually replaced by the buzz of mosquitoes as the number of avian extinctions swelled. The missionaries' poultry had carried a potent bird-pox virus that was now spread by mosquitoes, along with a parasite that caused avian malaria. All avifauna in the lowlands up to about six hundred metres gradually disappeared.

Indigenous nectar-bearing plants lost their pollinators, whose long, curved bills had evolved to match their curved, tubular flowers, and, lacking the partnership of the birds that had coevolved to pollinate their flowers, some species of native plants began to disappear.

POLLINATION

IN THE CRETACEOUS period, plants with flowers containing male and female reproductive features began to emerge. At the same time, the earliest of the modern groups of insects, including those that became pollinating insects, appeared. To attract and reward these insects, plants evolved sugar-rich nectar and pollen rich in proteins and nitrogen; plants and pollinators began to coevolve, leading to structural modifications in each to improve their co-operation.

Many Australian plants provide extravagant quantities of nectar to reward pollinators, and are heavily reliant on birds, particularly honeyeaters, lorikeets, and also the Swift Parrot (*Lathamus discolor*), not itself a lorikeet, being more closely related to the rosellas, but an example of convergent evolution. For twenty million years, plants and birds have coevolved so that the structure of flowers and the bill shapes and tongue structures of birds match, enabling birds to transport pollen as they access nectar. Many trees have evolved orange or red flowers, colours particularly attractive to birds, whereas insects tend to favour the cooler colours of the ultra-violet spectrum. Each Australian plant has evolved its own collaboration with a pollinating vector.

Because avian eyesight is so sharp, eucalyptus blossoms attract attention with their brightly coloured stamens surrounding a sturdy, wooden cup brimming with nectar. Petals have been modified into a protective

cap that is discarded when the flower is ready for pollination.

Small mammals and many insects are also attracted to these flowers, but to stand beneath a eucalypt in full flower is to understand the importance of birds. The shrieks and whistles of lorikeets are swelled by the harsh challenges of honeyeaters as they vie for territorial control of the blossoms. Smaller honeyeaters dart to and fro, seizing every opportunity before they are chased by the larger birds. The smell of nectar hangs heavy in the air, confirming the partnership between bird and tree.

Callistemons and melaleucas have a similar flower structure to the eucalypts, but tend to pack their flowers into dense, showy bottlebrushes near the ends of branches. These can ooze nectar which may attract all kinds of pollinators: flies, wasps, beetles, butterflies, moths, animals and birds.

One family of Australian plants has shown an enormous degree of innovative design, like their shape-shifting ancient Greek namesake Proteus; the Proteaceae includes the genera *Grevillea*, *Banksia*, *Hakea*, and others.

The style of Proteaceae blossoms has evolved in an astonishing way to become first a distributor of pollen, then a receiver. The flower is structured so that any bird attempting to reach the nectar can scarcely evade the style, which dabs pollen on the bird's head with a gentle pat. Adapted to adhere to the webbing of feathers, pollen can then be carried to another tree at a different stage of development.

After several days or more, the style, having fulfilled a male role, will revert to a female form and develop a sticky adhesive tip to receive pollen from the head of another bird, probably from another plant, ensuring cross-pollination and greater genetic diversity.

All over Australia, there are examples of flowers that have evolved to fulfil their partnership with birds – tubular flowers that match the long, curved bills of honeyeaters, dabbing their foreheads with pollen as they plunge their bill deeply in search of nectar; shorter blossoms for shorter-billed birds – but everywhere there are examples of mutual benefit to birds and flowers through long coevolution. There are also thieves, who seek a reward without repayment. Some birds, like Silvereyes, have learnt to cunningly chip through the base of tubular flowers to steal the nectar by an illicit route, bypassing the pollination mechanisms of the plant.

CANARIES IN THE COAL MINE

Australia has a grim history of extinctions, worse than many other countries and achieved in a remarkably short time. The first European settlers arrived at a time well before Darwin published his groundbreaking book *On the Origin of Species* in November 1859, delayed in part because, through his strongly Christian wife, Darwin was acutely aware of the antipathy it would produce amongst Christian believers. If people thought that all life was created by God, how could they envisage the concept of extinction? Surely man's effect on the land would be governed by the creativity of God, essentially be seen as God's will? If the natural world was created and controlled by God, it was surely eternally renewable?

The decline of the Dodo (*Raphus cucullatus*) into total extinction around the year 1662 occurred only about a hundred years after its discovery. Initially its demise passed almost unnoticed. But its weird shape, its flightlessness and its confiding habits had given it a degree of notoriety alongside

ABOVE Pencil drawing of the Gumtree Hopper (*Eurymeloides pulchra*), a chapter heading for Graham Pizzey's *A Garden of Birds*
OPPOSITE ABOVE Pencil drawings of a Crested Bellbird (*Oreoica gutturalis*); this is the bird that makes the rhythmic, clear musical sound of the arid country
OPPOSITE BELOW *Desert Dingoes*, oil on linen
A painting done on Mt Keith Station in Western Australia, showing overgrazing on fragile soil and serious land degradation around a water resource; in the foreground is an annual saltbush, in the background, mulga scrub; the symbolism of the dingoes and the sheep skull adds to the gravity of the message

Australia for attempting to gain a foothold in a strange environment. They were still developing an understanding of the concepts of extinction and sustainability and it was to be another century before these were accepted.

Now we know that the expansion of our settlements fragments habitat, that these islands of vegetation will lose diversity and their ecosystems will decay. We also understand the complicated and imponderable degree of interdependence of species within an ecosystem and the cascading effects on other species resulting from the loss of one or the introduction of another.

At times of the year, when flowering is at its peak in some species of tree or another, and the buzz of insects provides a low hum behind the shrieking and screeching of birds in the foliage as they gather nectar or pollen, it is easy to believe that these systems will never cease.

However, for years we have been aware of a decline in woodland birds, particularly in western New South Wales. There is worldwide concern at the decline of insects. What if they continue to decline? The trees and other vegetation will lose their services as vectors of pollen and a vital link in their reproductive system will be lost. Gradually, we could be left with stands of sterile, old plants becoming older and sparser as they succumb to disease and senility. Without the means to pollinate, our arable crops would die out and we would face major food shortages. Perhaps the quietening of our woodland birds is an early reminder of the silence of the canary in the coal mine.

Australia's expansion into new developments is piecemeal and reactive. We may need to become more proactive in planning developments that recognise landscape and ecosystem values and maintains nodes of habitat sufficiently interlinked for sustainability in both urban and rural areas. The Chinese have begun to limit

its vulnerability. The eventual realisation of its total loss was a collective shock to human awareness, this being the first time that the blame for the disappearance of a species could so clearly be attributed to human activity: the constant predation by sailors in search of fresh food supplies for their voyages, together with the depredation resulting from the introduction of feral pests that those same sailors brought to shore via their ships.

Another species, the Great Auk (*Pinguinus impennis*), a flightless seabird, was once common on rocky coastal islands to the south-east of Newfoundland, but by the 1830s they had become perilously rare. Fishermen were inclined to collect young auks for bait, and the very last of the species in North America were taken from Funk Island some time around 1841. They became globally extinct only a few years later, when the last known surviving pair was killed on Eldey Island, a high, sheer, rocky outcrop south-west of Iceland, in June 1844.

The conflict between science and religion that Darwin had feared was to increase. It is unfair to blame the early European settlers in

their industrial development by moving towards 'ecological civilisation'.

On 1 March 2019, the General Assembly of the United Nations declared 2021–30 the 'Decade of Ecosystem Restoration'. There is much planning to do before this can becomes a reality. Much of the habitat we retain is too small to be sustainable. Even national parks exhibit signs of ecosystem decay, possibly exacerbated by hazard-reduction burns. Connecting the remaining areas with corridors allows greater freedom for organisms to transfer between sites and creates more resilient ecosystems.

Humans are intelligent and should be able to foresee the hazards of our behaviour: consuming more than we need, throwing away what is broken or out of date, choking our oceans with plastic, overusing our resources, poisoning our environment and potentially destroying our chances of survival. We seem unconcerned about our species' future, let alone the future of our planet and all the species that live on it. Technology continues to improve, and we still believe that it can compensate for the damage we do to the environment, but as Aldo Leopold pointed out in 1938, we have yet to learn the simplest of lessons: how to occupy an area of land without spoiling it. Our western economic system, demanding constant growth, is close to a blueprint for disaster.

Dr Hopkirk, whose name seemed to intimate the voluntary nature of attending the Mortlake Presbyterian Church, would sometimes offer up a prayer that began, 'Oh Lord, we are so much more clever than we are wise.' What a perceptive phrase!

Rehabilitating Wetlands

It was the rehabilitation of the wetlands on Connewarran that made some of the greatest differences to the environment. To my father's horror, or at least concern, we began reinstating many former wetlands that had been assiduously drained by my forefathers. One, the largest, we specifically created on a river flat by erecting an earth wall four hundred metres long by three metres high to retain floodwater. It floods about twenty-six hectares to a depth of a metre and a half and is semi-ephemeral, lasting about eighteen months without top-up rainfall or additional flooding.

When this wetland first filled it was spectacular. The stored food supply on what had previously been pasture was enormous. Immediately, about five thousand ducks of various species arrived, joining about two hundred swans and numerous wading birds. Before it flooded, I had towed a number of 'loafing logs' out onto the flats: old, fallen red gums which I pegged down to prevent them floating away before they became waterlogged. To these logs I attached various nesting hollows and nest boxes to encourage waterfowl to breed. I also placed a couple of large, old, round hay bales where they would be flooded to provide nesting substitutes for birds such as Brolgas and Black Swans (*Cygnus atratus*). Until the wetland had time to develop sufficient aquatic vegetation, I reasoned there would be insufficient nesting material for such birds. Certainly, both

Brolga and Black Swans bred in that first year, using the hay rolls.

With the creation of our wetlands, both the number and variety of frogs increased, which, of course, allowed a build-up of snakes, and Tiger Snakes particularly used the corridors as habitat. With increasing diversity of habitats, the list of bird species on Connewarran grew to 207 species, almost a quarter of all Australian birds, and up from the 114 species of my grandfather, and the 148 species my father recorded.

Brolgas

Since so many swamps have been drained for agriculture, Brolgas are being forced to become adaptable. Normally they prefer discreet locations with good visibility of their surroundings, but in some instances they seem to have had to compromise, particularly in their search for breeding refuges. There have been records of Brolgas nesting in the most unlikely situations: once, in a town drain in the streets of Heywood, a small rural town in western Victoria. Another nested on the edge of a tiny stock-watering dam on the inside of a bend in a highway, only a few metres from the traffic roaring past. This would appear to be the result of intense competition for good breeding swamps. In the early 1980s there was an incident over a swamp on our next-door neighbour's property, just over our boundary. Four Brolgas could be seen in conflict over this swamp and the battle ended with the death of one of the birds. A similar conflict was seen and photographed by Dr David Hollands, an excellent ornithologist and photographer, at the Melbourne Metropolitan Board of Works farm near Werribee in Victoria. His images show a Brolga virtually riding another Brolga as it descends rapidly towards the ground, and presumably using that formidable dagger that is its bill to stab at its rival.

In 2001, an apparently young pair of Brolgas built a nest on a small swamp in a paddock at Connewarran that was optimistically named Gum Scrub. When we started farming Connewarran, there was only one live tree remaining in the Gum Scrub (the paddock in which a girl had become lost in the dense vegetation about seventy-five years previously) and round it we erected a fence, enclosing a little more than two hectares in an attempt to induce the original vegetation to regenerate. There was a small swamp alongside, and into it we drained the surrounding area to turn it into an attractive little ephemeral water meadow. It was here a pair of Brolgas chose to nest.

The swamp was a shallow saucer of about two hectares, fenced with a suspension fence, inside which were young trees direct-sown to protect the water from evaporation as the hot winds

of summer began to blow. Beyond were crops: wheat, barley and canola. The entire swamp was full, to a depth of about a third of a metre, but the water was nearly invisible because of the tall aquatic grasses covering the entire area.

Towards the north-eastern edge was a circle of open water surrounding a hump of vegetation. This was the Brolgas' nest, the cleared area being where they had dragged vegetation on to the nest pile to build against higher waters.

At the time, my friend David was compiling his book *Cranes, Herons & Storks of Australia*. I knew he needed to photograph a Brolga nest, so I told him of these birds. He arrived during October and we erected his hide amongst the trees surrounding the swamp and about fifty metres from the nest. He carefully covered it in camouflage netting, for these wary birds are easily disturbed.

The hide was erected cautiously and quietly, and neither of the Brolgas departed from the swamp while we were there. Indeed, as we left, one bird stepped purposefully back towards the nest and, carefully re-arranging the eggs with its bill as it lowered itself, resumed its incubation.

The following day, David spent most of the afternoon in the hide, photographing and observing the Brolgas. They appeared relaxed and undisturbed by the presence of the hide. (It is always important to 'see a person in' to the hide and to 'see them out' at the finish of the session. The shock of a single person arriving, or leaving the hide, can make birds eschew the structure completely. They clearly discern the difference between one person and more than one but, having been disturbed by people arriving at the hide, they accept the departure of a single person as an indication that no one is remaining.) When I arrived to relieve David from the hide, he told me that he once erected a hide to photograph Whistling Kites, creeping in under cover of darkness long before dawn. The kites were relaxed throughout a full photographic

session, but when he emerged unannounced at the conclusion, the birds were disturbed and never again came down near the hide. They remembered its association with a human presence and avoided it accordingly.

David was confident that he was going to have a long and valuable association with this particular pair of Brolgas. However, sadly, this was not so. The following morning, as we approached the swamp, but were still hidden from it by trees, we were surprised to hear the loud clarion calls of Brolgas. Normally, Brolgas remain relatively mute in proximity to their nest. As we peered round the end of the trees we could see a Brolga standing on the nest with another beside and two more not far beyond. As we watched, the pair at the nest appeared to lunge at the other two, but, seeing us, they all took to the air and flew off.

Unsure what to make of this spectacle, we walked to the hide, from where we could see that the eggs were no longer in the nest, but had been cast into the water. Each had a ragged puncture mark of a size and shape that would suggest a blow from a Brolga's bill. We were both most

disturbed by what we had seen (David particularly, as he had promised Jenny not to disturb our Brolgas – on pain of being banned from Connewarran!) and we were at a loss to explain the incident. More in hope than in certainty, David stayed in the hide to attempt to witness any further developments.

When I left, it took less than a minute for a pair of Brolgas to return. David described them as being 'in a frenzy to get back'. They rushed towards the nest, the female stepping onto it and immediately gathering weed to repair the platform. Next, the male joined her on the platform, where they faced each other, stretched their bills skywards and bugled in duet. With this bonding ceremony completed, they paraded the area of the breeding swamp, inspecting every corner, occasionally breaking off to repeat their bugling ceremony, or for the female to rush back to the nest platform, perhaps hoping to find her eggs still there. Intermittently, the male would leap high into the air with wings spread in the classic 'dance' for which cranes are renowned.

Eventually, they both turned to face into the wind, leant their heads forward and, after a short run, soared effortlessly into the air and left. They did not return.

David and I were left to discuss the meaning of what had taken place. It seemed inescapable that we had witnessed an attack of one pair of Brolgas on another pair's nest. But why would this happen? It seems the scarcity of nesting sites creates strong competition for those that remain. It also emerged that the nearest nesting pair on Mustons Creek, only a short flight away, had lost their nest and eggs to rising floodwaters at just that time. However, it seems to be extraordinary that this should trigger such a determined attack on another pair of the same species.

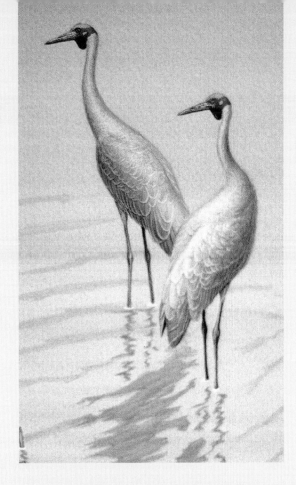

Breeding season

The breeding activity in the first season our big wetland filled was extraordinary. The flooded pasture and its accumulated nutrients were a boon to all manner of life. A number of species of dragonfly bred in the first spring, and the mud eyes that were their larvae were a valuable food resource for many other species. Whiskered Terns (*Chlydonias hybrida*) nested, their eggs balanced delicately on dips in the surface of the red-gum 'loafing logs' that I had provided and feeding their young predominantly on the dragonfly larvae. All manner of waterfowl – swamphens, waders, ducks – built nests and hatched young. Unfortunately, such a concentration of exposed young birds caught the attention of a number of raptors. The wetland was situated in something of a hollow, so that the high-speed approach of a bird of prey could be concealed from the birds at water level until the last moment. Swamp Harriers (*Circus approximans*) and Australian Hobbies particularly,

ABOVE Small gouache painting of Brolgas designed for an exhibition of images for bookplates and aiming for simplicity, peacefulness and elegance

would come flashing over the crown of the bank at top speed in the hope that a panicked bird could be snatched as it took off.

Of the larger birds, Black Swans and Brolgas nested immediately, along with many species of shorebirds. In fact I witnessed the comical sight of a pair of White-headed Stilts (*Himantopus leucocephalus*) driving a feeding Brolga away from their nest, repeatedly dive-bombing the Brolga, which showed considerable discomfort and took high-stepping evasive action.

Surprisingly quickly, as a result of the frequent attacks by birds of prey, the waterbirds responded by changing their nesting behaviour. I had moved a children's cubbyhouse to the wetland to act as a bird hide, and from this I saw birds that would normally nest in the open respond by moving their nests into nest boxes. Two species that did this, to my great surprise, were Purple Swamphens (*Porphyrio melanotus*) and Blue-billed Ducks (*Oxyura australis*), a species that had not previously been recorded nesting on Connewarran. One peaceful evening, I watched as the female Blue-billed Duck led her freshly hatched ducklings out of a nest box and onto the water, from whence she shepherded them across to a position just in front of the window of the hide, only a few feet from where I was sitting. It was a wonderful observation to be looking down on them from so close. Seen from above, the mother duck appeared surprisingly circular, hemmed in by a fringe of tiny fluff-balls, her ducklings.

Ducklings at this age are vulnerable, and are a huge responsibility for the mother to protect. In more populous regions such as urban wetlands, it becomes evident that the tamer and more trusting the mother becomes, the less successful she is at raising her full brood without loss.

Years ago, I was told by an elderly station-hand who worked for my father of an incident

ABOVE *Black Swans at Dusk*, oil on linen, 30 × 40 cm A small painting about late-evening light and the elegance of swans, which are simplified by being in silhouette

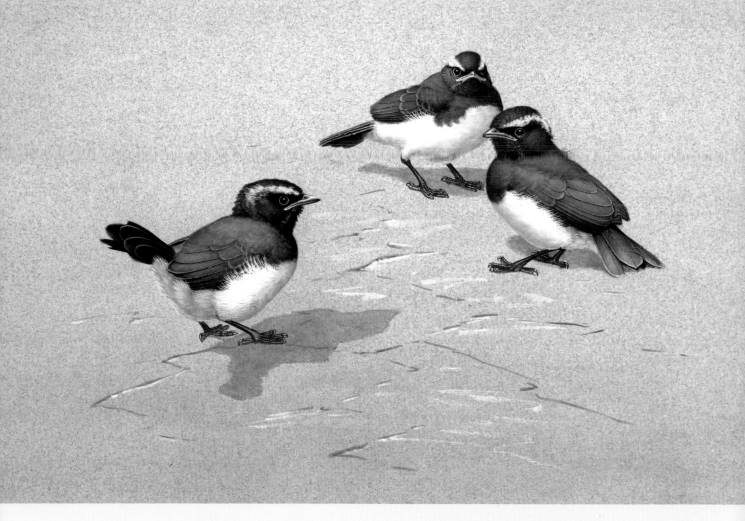

concerning a hardened and fully wild Black Duck protecting her young from a marauding Swamp Harrier. One day, he told me, he was riding the paddocks to check on livestock when he rode up onto the bank of a big stock-watering dam. Caught out in the centre of the dam was a mother Black Duck with a large group of ducklings, maybe ten or a dozen. These were under attack from a Swamp Harrier and she had them clustered tightly round her. Each time the harrier plunged down to seize a duckling, the mother duck would sit back on her tail and use her wings to splash water up at him. Between each attack, she was gently shepherding her babies towards a dense clump of reeds closer to the dam bank. Time after time the harrier attacked and each time the mother duck managed to repulse him. Clearly she was becoming weakened by the effort, but

ABOVE Gouache character study of baby Willie Wagtails (*Rhipidura leucophrys*), just after they have left the nest LEFT Pencil sketch for the study above OPPOSITE Sepia pencil with wash study of Australian Shelducklings (*Tadorna tadornoides*) only a day or two old; baby birds often show enormous character and time spent sketching them is seldom wasted

eventually she managed to guide her ducklings to the safety of the reeds and they quickly scuttered out of sight. By this time, the harrier, though tiring also, realised the weakening condition of the duck and turned his attack upon her. Many times she managed to repulse him, but eventually she became so tired that the end of the battle was obviously nearing. Once more the harrier dipped down towards her, talons extended to grasp her, but this time she changed her tactics. Snatching one of the harrier's long primary feathers in her bill, she dived, dragging him into the water, where she managed to hold him under for long enough to drown him.

Perhaps this was a 'cruel' death, but I am not so sure. We tend to embellish such events with traits such as fear or pain or sorrow. Perhaps they are more benign than we think. Drowning is reputed to be a better way to die than some other causes of death, and I recall that, when I very

nearly drowned in Fiji many years ago, I felt no fear, but only a sense of enormous peace.

It is tempting to see the duck's actions as bravery, but such human emotions are inappropriate. The Black Duck had fulfilled her strong maternal instincts and repulsed a dangerous attack from a predator.

I did witness one event which I found difficult not to view in terms of human emotions. I had found the nest of a Masked Lapwing: four olive-green eggs with dark blotches and streaks, each coming to a clear point and lying, points innermost, in a shallow hollow on the ground. They were beautifully camouflaged, and it occurred to me that, if they were hard for me or a predator to see, how did the lapwing find them herself? So, flushing her from her nest I backed off some distance to observe.

I did this several times over a number of days and found that she only ever returned to

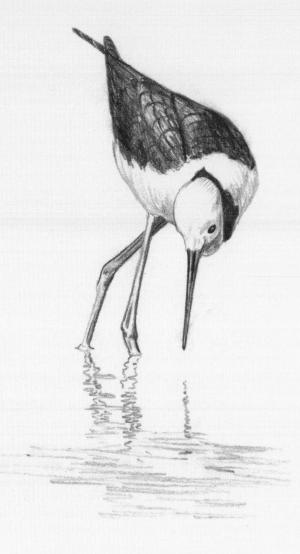

the nest by the same route. It involved going to the remnants of a decayed stump, from there to a rounded lump of basalt and from there to a broad, flattened rock, nearly flush with the ground. From there she headed due north to the nest.

My observation point was at the end of a little plantation with low trees in it on the shoreline of a swamp. While I was watching, my attention was taken by the arrival on the ground close by of a Yellow-rumped Thornbill. These birds frequently feed on the ground alongside plantations, but, it being spring, this one was collecting nesting materials, or, more specifically, feathers to line a nest. What she had come down for was a swan's breast feather.

Feathers come in all shapes and sizes, depending on the purpose for which they are adapted. The body feathers of waterfowl are mostly tightly decurved to improve their ability to exclude water from the down beneath. This one

was curved in just such a manner as to perfectly fit the inside of a thornbill's nest.

It was difficult not to interpret an expression of joy on the thornbill's face. Picking up the feather, which was nearly as big as the bird, she launched herself into the air to carry it back to the nest. However, this was no ordinary feather; it came with aerodynamic qualities all of its own. The moment the thornbill reached flying speed, the curvature of the feather threw her over on her back and she crashed. She regarded the feather suspiciously for a moment before picking it up again and attempting to fly. Again she did an involuntary half pike with twist (degree of difficulty 3.8) and landed in an undignified heap. This time she regarded the feather for longer, but the attraction was so great that she made a third attempt, unfortunately with similar results. Giving the feather a contemptuous look, she abandoned her efforts to gather it and flew off back into the plantation.

The whole event was so ridiculous that it was impossible not to feel empathy for the bird and difficult not to ascribe human emotions to her behaviour.

Birds of prey

To some, it may seem unpalatable that birds of prey were able to take so many young birds on the new wetland. To my mind, this is not so. The multiple opportunities presented to them were only due to the extraordinarily rich breeding event that was occurring, and raptors have evolved to feed on prey. They are, in fact, a driving force of evolution, in that they remove the less adapted individuals from the system.

One evening I was at the wetland when a Peregrine tiercel came across the hillside at high speed. There was a mob of Grey Teal in the air at the time, circling over the water as ducks will.

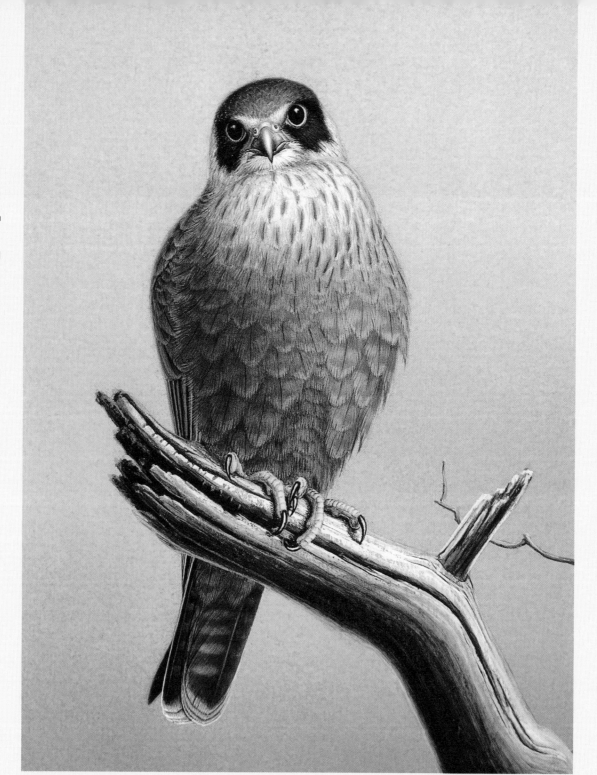

OPPOSITE Field sketch in pencil of a White-headed Stilt feeding; they are elegance and energy in action
RIGHT Gouache study, 25 × 20 cm, of an Australian Hobby in adult plumage

Quite deliberately, the Peregrine flew into the back of the mob and flew with the ducks for some time. I imagine that he was appraising the individuals for an easy target. When he had selected one, he switched into overdrive and sped through the mob until he had grabbed his chosen duck from behind, grasping the bases of its wings where they emerged from the body. With a firm grip on his prey, he sat on its back, steering it out of the mob and away from the water. When they were over dry land, he forced the teal down and, after catching his breath, started plucking it. When he had settled, I tried to stalk closer, but overplayed my hand and frightened him. Taking off, he released his grip on the teal, which to my astonishment fled across the water to join its flock. Landing, it ruffled its feathers, settled them, and immediately started preening in the most relaxed manner imaginable. I wonder how

terrifying or painful the experience had been. It certainly wasn't obvious. Probably the preening was a displacement activity.

Under normal circumstances this should not have happened, and I wonder whether my presence hadn't altered the falcon's routine. When a falcon kills a bird, there is a rigid and established pattern which it nearly always follows. Just behind the point of its upper mandible are two small, sharp teeth, the tomial notch, one on either side. With these, the falcon feels for the vertebrae at the base of the skull of its prey and bites through the spinal cord to disable the prey. It then seizes the humerus bone on each wing, near the shoulder, and with a sharp, upward jerk, it breaks the bone. This is repeated on the other side. By this stage, the bird should be dead, or at least paralysed, and unable to fly, but to be certain, the falcon then seizes each leg above the tarsus and breaks it, to ensure that, should its prey escape, it cannot run away. It is extraordinary to consider how this instinctive behaviour has evolved, but hunting is never certain, so a capture made and lost could be a threat to the survival of the hunter.

As a child, I read much about attitudes to birds of prey, and can remember the number of times that the raptors themselves became prey species at the hand of man. Farmers, particularly, have been inclined to persecute birds of prey. However, their removal does not strengthen an ecosystem. Rather, it weakens it, and the escape of the Grey Teal was not a triumph. Was it sufficiently uninjured to survive? I have no idea, but its escape ensured that some other bird must die to feed the Peregrine, which surely would have started hunting again immediately.

In Australia there have been the sad images of rows of Wedge-tailed Eagles hanging along fence-lines after they have been shot. Farmers were convinced they kill lambs. My understanding

has always been that most animals are inherently conservative in their use of energy and will take the easiest course to procure food. Thus, if an eagle eats a lamb, it will normally be a dead lamb that is taken, or at least a sick or dying lamb. The easiest course is to take the smallest or weakest, and the farmer's task is to select for the biggest and strongest, so in a paradoxical way, they work to the same ends and the eagle is assisting the farmer.

There are, of course, contrary incidents. One day, I arrived back on Connewarran after a trip into our local town. Beside me in the vehicle was my daughter, Skye. As we turned through the cattle grid into our front paddock, there was a large, dark old eagle, the female from the pair that nested next to the Hopkins River on our country. With her she had a young female eyass, not long fledged, and she was teaching her how to kill a lamb. The one that she selected was not a particularly weak individual, nor was it outstandingly strong. It was a typical, average three and a half month old merino lamb which she had grasped over the loins in the kidney region and was crushing with her massive talons.

So, eagles may kill lambs, but I know that the last five food items delivered to that particular nest that year by the parent birds were a Straw-necked Ibis, two European Brown Hares (*Lepus europaeus*) and two Long-billed Corellas (*Cacatua tenuirostris*). Whether any or all of these were killed or were found as road kill I have no means of knowing, but the indication was that these eagles did not habitually kill lambs as a major portion of their diet.

Experiments by ranchers in the US to prove the culpability of Golden Eagles by tying out a lamb in the open had a positive result, but a tethered lamb would be obviously stressed and would likely be selected as prey by any passing eagle.

ABOVE *Grey Falcon (Falco hypoleucos) with Crested Pigeon (Ocyphaps lophotes)*, gouache, 36 × 43 cm Painted after watching Grey Falcons at their nest and hunting on Merty Merty Station on the Strzelecki floodplain

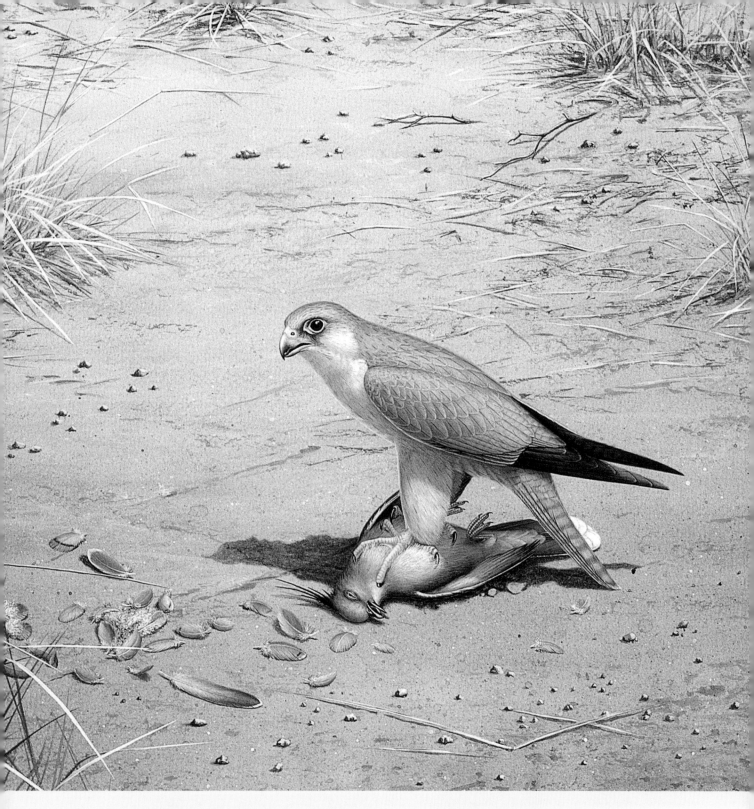

In later years, Connewarran has had a gas-fired power station built next to it, with a chimney that exhales vapour at 800 degrees Celsius, providing a ready and reliable thermal for soaring eagles, which frequently can be seen above our lambing paddocks. So far we have not noticed any increase in the depredation of lambs, but we take great pleasure from the presence of the eagles.

Wedge-tailed Eagles have nested at Connewarran for as long as I can remember. The homestead paddock had a pair nesting quite close to where we built our house when we moved there, but they are sensitive to disturbance and built a new nest in a delightfully pretty little bend of the Hopkins River and have nested there or nearby ever since. Their new nest was in the fork

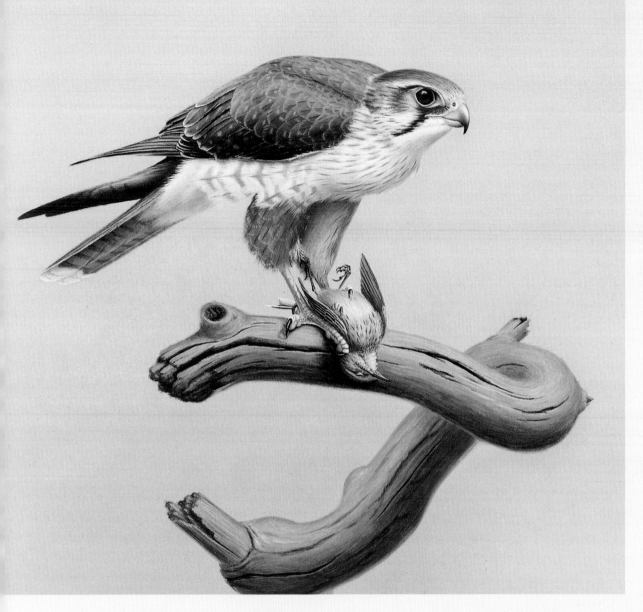

LEFT This adult male Brown Falcon from King George Sound in Western Australia is a detail from my gouache plumage studies on page 90
OPPOSITE Pencil drawing of Hypotenuse, the Brown Falcon I picked up injured on the roadside near Loxton in South Australia

of a grand old red gum about ten to fifteen metres above the ground and grew into an enormous structure over the years.

On a golden, still evening as the day's heat was fading and there was hardly a breath of breeze, I rode a horse down along the river flats, and as I approached the eagles' nest I saw that the female was present, incubating her eggs. My approach was framed by two large trees, forming an arch through which I could see the nest. As I got closer, the eagle stood up and walked to the side of the nest closest to me, dropping casually off the edge to gain the flight speed she needed before levelling off roughly three metres from the ground, about eye level for me on a horse. With her eyes fixed on mine, she flapped those giant wings, flying directly towards me. The hair on the back of my neck stood rigidly to attention. As far as I am aware there has not been a record of a Wedge-tailed Eagle deliberately attacking a person, although they will certainly make physical contact with hang-gliders and ultralight aircraft that fly into their territory, but I became consumed by doubts as she covered the ground between us. When she was about ten metres away from me and aimed directly at my face, she swept up and over my head to land on a red-gum branch directly above me, where she sat, peering down at me in defiance. I can't pretend that the incident did not leave an indelible impression upon me, but it was a wonderful experience.

ONE DAY I drove into one of our paddocks and immediately noticed a Brown Falcon on the ground some distance away. I nearly always carry a good pair of binoculars with me, so I paused to observe its behaviour.

It had found a tiger snake; indeed, it had surprised it in the open. I had previously recovered snake carcases from Brown Falcons' nests and I was interested to watch their method of capture. The snake was acutely aware of the danger it was in, and had assumed an aggressive posture, flattening its front portion, and trying to face the falcon. The falcon, on the other hand, sought to be behind the snake, a dangerous decision, as a

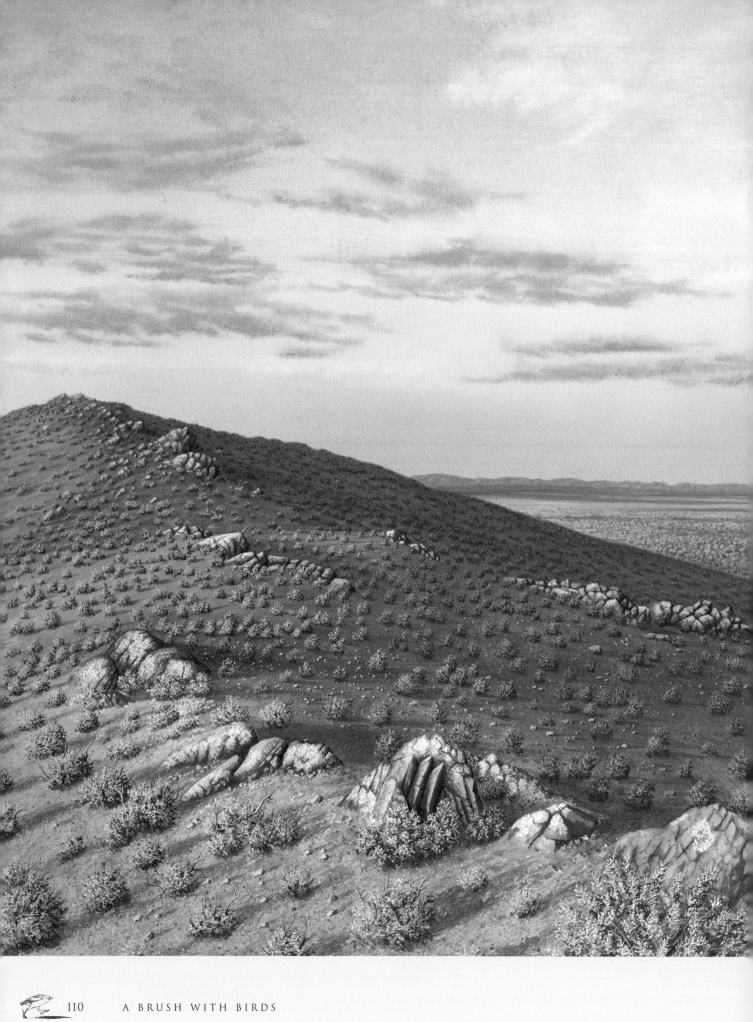

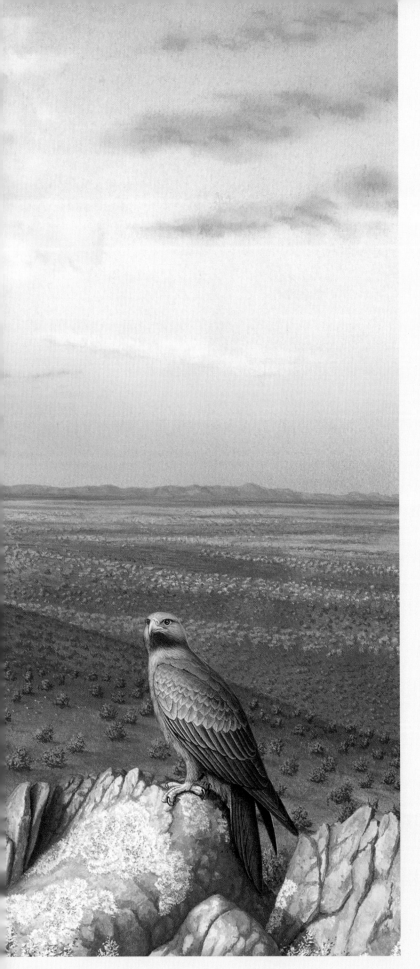

snake can strike much further at a target behind it than in front. The falcon would amble in and step on the snake, squeezing with its feet, and the snake would attempt to escape before striking at the falcon, which by that time would have moved out of range. This odd game of apparent ineptitude continued for nearly twenty minutes, with the snake clearly tiring and becoming increasingly inaccurate in the timing of its strikes, before the falcon managed to grasp it close to its head and subdue it by biting behind its neck. The long, scaled tarsi of the bird, and its 'baggy trousers', such an innocuous target for the snake's attacks, made much more sense in the light of that observation.

LEFT *Desert Sunset*, gouache, 35 × 44 cm
Painted on Glenora Station north of Burra in South Australia after seven years of severe drought, the painting is all about light; the young Wedge-tailed Eagle leads the viewer's eye back to pale cloud in the sky. I portrayed the sparse bushes in a style as close to naive painting as I have ever ventured.
ABOVE Loose pencil study of the head of a young Wedge-tailed Eagle, useful to have in my files for such paintings as *Desert Sunset*

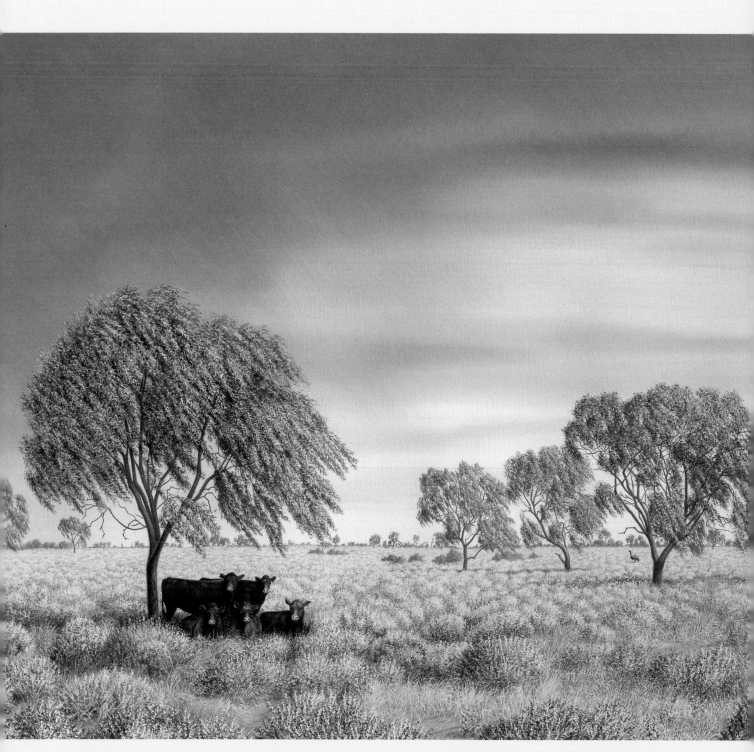

ABOVE *Weeping Myall*, gouache, 47 × 63 cm One of three paintings I did of Buttabone Stud Park, originally sketched on a still sunny day under a blue sky; I added wind to give movement and clouds to reflect the colours of the landscape and vegetation
OPPOSITE A Striated Grasswren (*Amytornis striatus*) sketched in pencil at Hattah Lakes in September 1974, at the very beginning of my work on malurid wrens

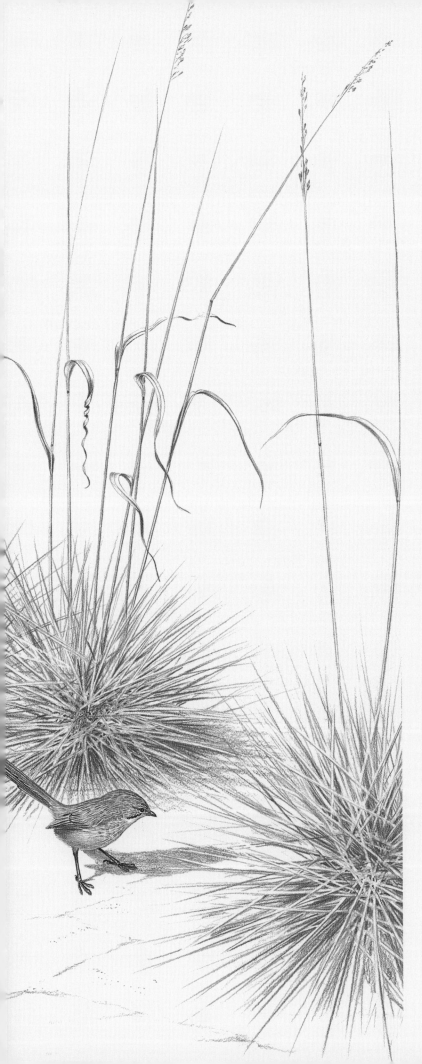

FAIRY-WRENS

AFTER MY SIX-YEAR absence in Europe and
Africa, I had re-established contact with Allan
McEvey, who became an increasingly close friend
and adviser. Allan was keen to build a Society of
Wildlife Artists for Australia, like the one in Great
Britain, and requested my help. Using Allan's
name and status as the Curator of Ornithology at
the Museum of Victoria, we sent various letters
to artists, sometimes eliciting strange replies. Our
plan was to hold an exhibition of wildlife painting
to coincide with the Sixteenth International
Ornithological Conference, to be held in Canberra
in late 1974.

At the society's inaugural meeting, Charles
McCubbin was elected Honorary Secretary and
I was elected President. Charles was excellent
company during the frenetic activity leading up to
the inaugural exhibition of the renamed Wildlife
Art Society. That exhibition changed my plans for
the future.

Early on, an attractive young woman bought
my painting of an Azure Kingfisher (*Ceyx azureus*).
She was the secretary for Dr Richard Schodde, a
senior research ornithologist in the Division of
Wildlife Research at the Commonwealth Scientific
and Industrial Research Organisation (CSIRO).
She told Dr Schodde that if he was seeking an
artist to illustrate a book he was intending to write
on wrens, he should attend the exhibition.

Before I left Canberra, Dick Schodde and I
met to discuss the possibility of collaborating on
a book. Both of us liked the idea and after much
deliberation we loosely agreed that a monograph
on the fairy-wrens (malurids), a family of small
but beautiful birds restricted to the Australasian
region, would be an attractive proposition.

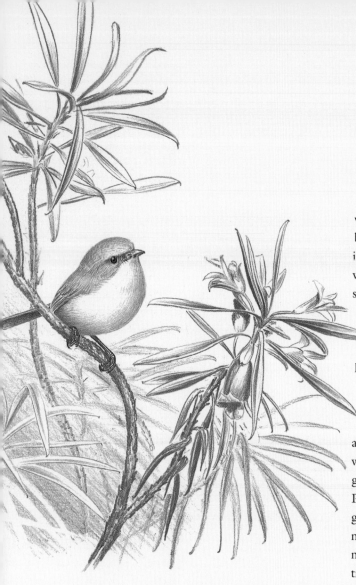

How arrogant of me. How naive! Very few birdwatchers have seen all of the fairy-wrens, and I doubt that I had ever seen a grasswren in my entire life, yet now I was heading out of Canberra into the field intending to see and draw them all.

I was bound for Paratoo in South Australia; Dick had given me a tip about Hattah National Park. On the road into the park there was a botanical walk of a few hundred metres looping back to the road. Where the path bent to return, there would be Striated Grasswrens.

And there they were! I was astonished (and grateful) that they were so territorial. I was particularly lucky that these birds were less shy than most of their species. I managed to see slightly more than a blurred form vanishing into cover and was actually able to observe them briefly.

My first impression was of enormous electric energy. When disturbed, they ran for cover

with extraordinary speed, scuttling like startled, bouncing mice. But when feeding they were inclined to hop more sedately. Their colouration was cryptic, paler below than on the dorsal surface and with white streaks bordered by darker markings to help camouflage their grey-brown, dirt-coloured plumage. Nearly all I saw on this first sighting were small, bouncy little balls dashing for cover or bouncing about with their tails held erect above them – brief observations, but a beginning.

A few days afterwards I was sketching at Paratoo, near Yunta in South Australia, and was surprised to encounter another species of grasswren. I was in an area known as the Cattle Paddock, in a drainage line vegetated with strong growth of saltbush. As I sat in my car, resting my sketchbook on the steering wheel, a sudden movement caught my eye. On the edge of the track only a few yards in front of me, a dusty-coloured, rotund little bird had emerged, similar to the grasswren I had seen at Hattah, but clearly of a different species. It was apparently unaware of my presence and ignored the vehicle I was in. I stayed very still and watched.

This was the Thick-billed Grasswren, but the eastern variant, then known as *Amytornis textilis modestus*, but now separated, with modern genetic analysis, as a different species, *A. modestus*. It was well to the southern limits of its usual range. Renowned for being shy and elusive, it provided a remarkable opportunity to observe it apparently undisturbed. It was not long after that I became aware of a second bird, about fifteen metres further along the track, a female, with a clear chestnut spot at the front of her flanks, but otherwise similar, with the same thickset, slightly hunched posture. She soon dashed up to the male, and they foraged towards me with zig-zagging, scrambling runs between bushes, pausing to

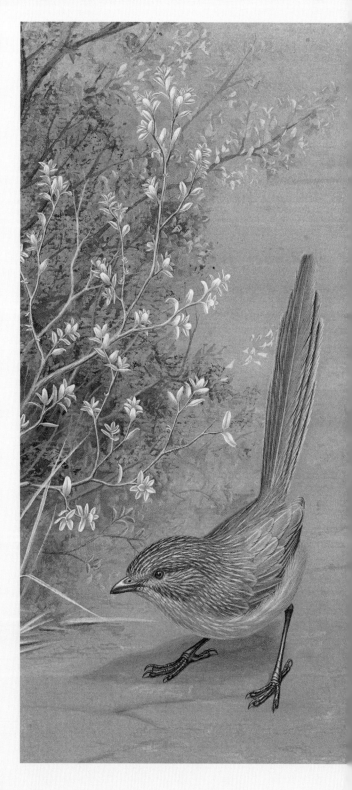

pick around the base of the saltbush while they were under cover. Periodically they would freeze at some perceived danger or sound and then magically disappear into a dense saltbush, sometimes working their way up into its centre, before returning to the ground to feed again. Their capacity to disappear completely if alarmed was astonishing; it was not by fleeing, but by hiding, remaining motionless and peering unobtrusively from their concealing cover.

In comparison to the Striated Grasswrens I had encountered a few days before, these birds seemed more compact, more spherical: fluffy balls of more uniform colour and with few distinctive markings on their face. Whereas the Striated Grasswrens had seemed lean and leggy, with larger heads, these looked rounder and squatter, with smaller, more arrow-shaped heads. It was only much later, after years watching wrens with Dick and listening to his taxonomic theories of their origin, that I began to understand why.

The Superb Fairy-wren and the White-winged Fairy-wren (*Malurus leucopterus*) were easily found in south-eastern Australia, as was the Variegated Fairy-wren (*M. lamberti*), which I eventually painted from sketches I'd made in Surrey Hills during a visit to our intended publisher. In the Simpson Desert, I had seen Rufous-crowned Emu-wrens (*Stipiturus ruficeps*), but at that time the Eyrean Grasswren (*Amytornis goyderi*) was considered to be extinct, so that work for the plate portraying it was still incomplete a year later. And there were other species that were rare, shy or difficult to see; it was to be many years' work to observe them all. Thus, in 1976 I arranged to travel to Borroloola in the Northern Territory to join Dick and to begin more serious research on a number of unfamiliar species of wren.

OPPOSITE Pencil sketch of a hen-plumaged White-winged Fairy-wren investigating the source of a disturbance at Yudnamutana in the Flinders Ranges, South Australia
ABOVE Pencil study of a Thick-billed Grasswren at Myrtle Springs Station, Lyndhurst, South Australia
RIGHT Gouache study of an adult male Western Grasswren from the Murchison District in Western Australia

Red-backed Fairy-wrens

The grasslands were well stocked with that remarkable jewel, the Red-backed Fairy-wren (*Malurus melanocephalus*), tiniest of the Australian fairy-wrens. Northern members of this species are smaller and more richly coloured than those along the east coast, bright scarlet on their backs, as opposed to the fiery orange of the birds to the east. For such a bright bird, the males can be oddly difficult to study closely. In the early morning they may find a comfortable, sunny, exposed spot from where they can view their surroundings and preen their plumage to its full glory, before the sun warms the insects on which they feed, making them more active.

When approached, the particularly drab females and uncoloured males pop up out of the grass to gain a vantage point from which they can inspect the intruder. But the coloured male behaves with greater circumspection, skulking in thicker cover further away. The birds' spritely attitudes can be enchanting, and I tried to capture their curiosity in my drawings, and in the painting I did for the book, which I still consider to be amongst the better plates.

Purple-crowned Fairy-wrens

Dick guided me to a very different fairy-wren on a melaleuca vegetated scarp in the Buckalara Range on the McArthur River near Borroloola. One of the least encountered, but the most robust of the Australian fairy-wrens, the Purple-crowned Fairy-wren (*Malurus coronatus*) is one of the few birds to sport the colour purple in its plumage. In clumps of *Melastoma malabathricum,* we found a small group of these elusive and striking birds, moving quickly through low bushes in a loose party, or hopping lightly to forage in the dry litter below. Their movement is electric, as

they flutter from one feeding point to another, constantly poking into piles of debris or leaf litter, or scrambling into the spiral security of the screw-palm's foliage to probe and fossick. At times they ceased their activity and huddled on a secluded twig, fluffing their feathers and mutually preening as they jostled for position within the group.

They are attractive little sprites, the females with strikingly marked facial plumage, a bluish-grey crown separated from rich chestnut ear patches by a white eyebrow that encompasses the lores and encircles her eyes before fading on the plumage of the neck.

The males have a broad black band running from their bills through their ear coverts and encircling the crown at the back of the neck. This is topped by a delicate but glistening mauve cap, in the centre of which is an irregular, elongated, black spot.

Both sexes have soft, pale-brown bodies and pale, near-white underparts tinged with buff towards the flanks. Their tails, which they mostly carry cocked, are an attractive bright greenish-blue, with the outer tail feathers subtly tipped with white. They exhibit a frenetic energy as they feed in the early morning and late in the day, but they rest quietly during the middle of the day.

The melastoma shrubs were in bloom, the attractive violet flower similar to the colour of the male wren's crown, but less vibrant. Within the foliage I found a nest of a species of paper wasp (*Polistes* sp.), like a field mushroom hanging by a delicate stem, with a complex of small cells like honeycomb. I located this nest, not by amazing visual acuity, but from the sudden agonising pain on the back of my knee as the wasps swarmed forth to

LEFT Gouache study of a male Red-backed Fairy-wren from near Borroloola in the Northern Territory
BELOW Gouache study of the rare Purple-crowned Fairy-wren, one of the few birds to include the colour purple in its plumage
OPPOSITE *Red-backed Fairy-wren*, gouache, 33 × 24 cm
The plate for *The Fairy-Wrens*

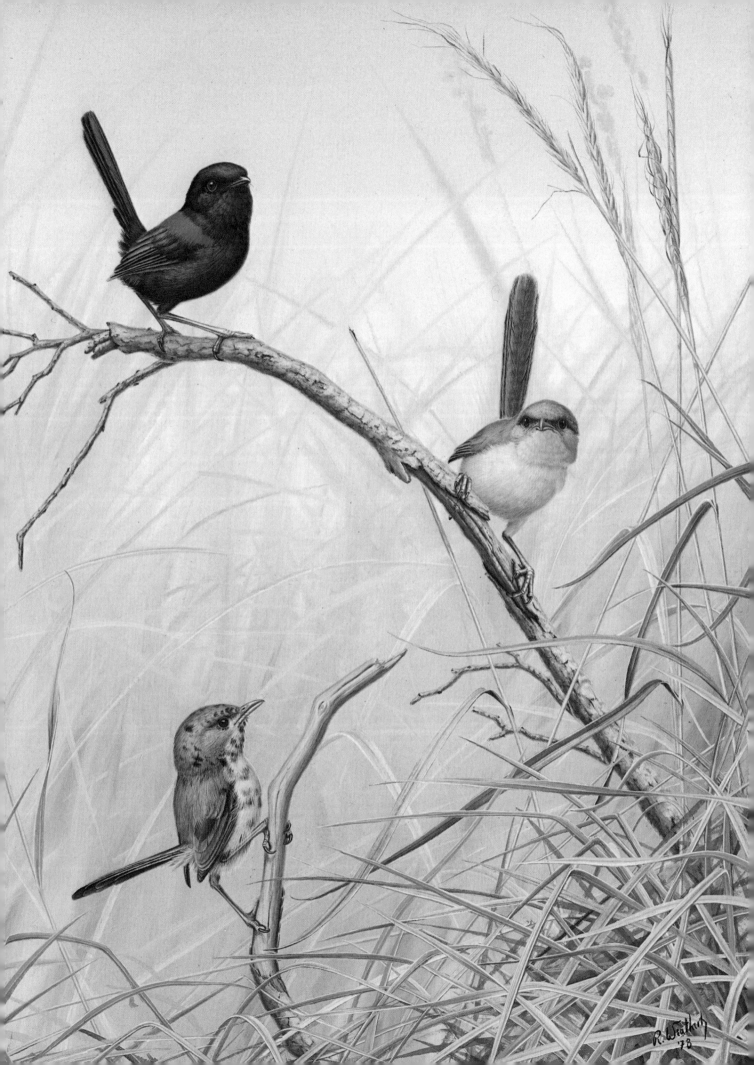

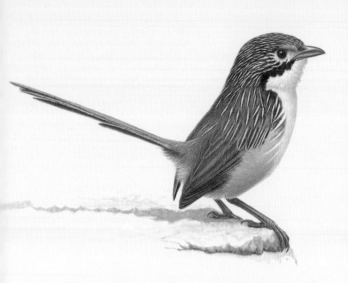

drive away the intruder. The occasion and the pain were sharply imprinted on my mind, and I took my revenge by portraying one of the birds carrying a *Polistes* wasp.

Carpentarian Grasswrens

Close by, in the Buckalara Ranges, were Carpentarian Grasswrens (*Amytornis dorotheae*), mid-sized but striking grasswrens that exhibit the explosive energy and elusive shyness of all their relatives, but with a couple of individual characteristics. Even for a grasswren they are difficult to find, but sometimes reveal themselves when they are flushed and fly short distances before dropping into cover. Their capacity to then vanish is renowned, as they peer out from the crevices of their rocky habitat, or from behind some scrap of vegetation. Alternatively, they may dart out and scamper with extraordinary alacrity up the rugged rocky slopes or through the long, unburnt clumps of spinifex that they favour.

They are a startlingly attractive grasswren with bright russet colouration, a fresh white bib on their throat, clear white striations on their heads and a dark moustachial stripe beneath their ear coverts; the flanks of the female are dark chestnut and those of the male sandy coloured. They frequently carry their tail cocked, giving the perky, energetic appearance of Striated Grasswrens.

They have a distinctive and endearing habit of concealing themselves behind a rock or clump of vegetation and examining an intruder by peering back over their shoulder. They are, by some margin, the most difficult grasswren to observe and sketch.

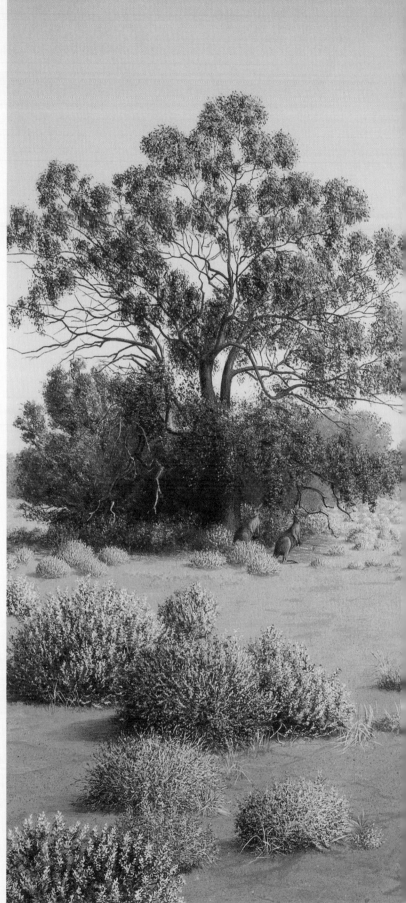

ABOVE LEFT Gouache study of a Carpentarian Grasswren, the most difficult grasswren of all to observe

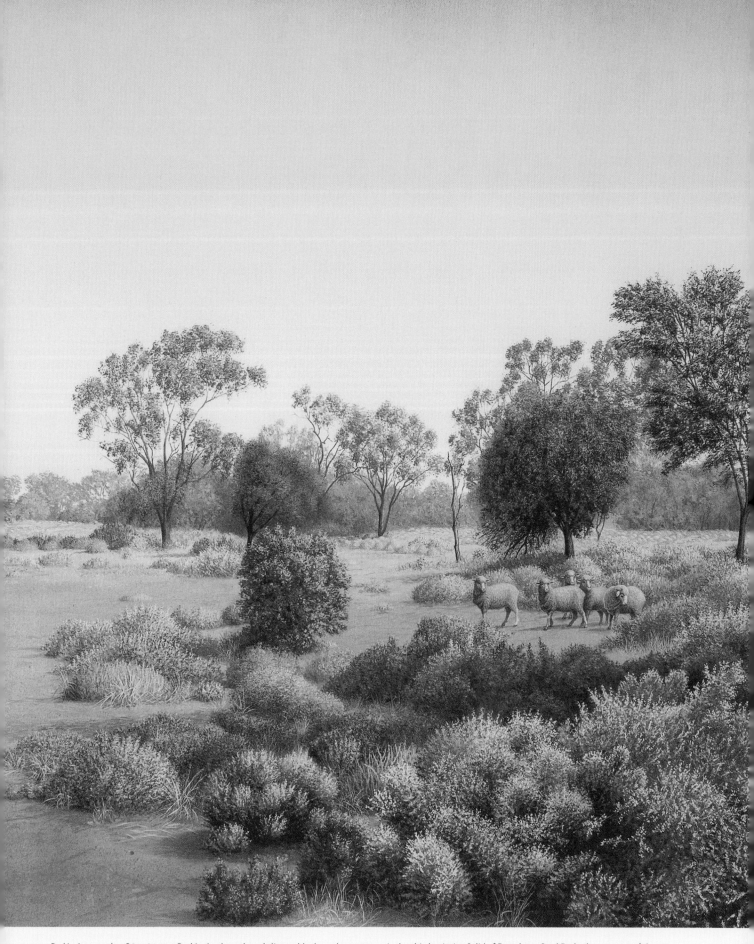

Button quail

One afternoon in early June we were driving through recently burnt open grassland. In stark contrast, there was a small area, possibly three or four hectares, that remained unburnt. Here was a classic demonstration of the 'lifeboat effect', where species normally distributed over a wider area are forced to flee their damaged habitat to congregate in a preserved vestige. This small patch was alive with several species of button quail, normally very difficult to observe and mostly seen only when they are flushed from close underfoot to whirr away before pitching back into dense grass cover.

Here was an opportunity, with stealth and patience, to observe the birds on the ground. The area was alive with secretive, scuttling forms, which would freeze – using their cryptic plumage for camouflage – before exploding into the air with a buzz of energetic wing-beats. Button quail are superficially similar to true quail, but this is one of evolution's many convergent adaptations. Their DNA tells us they are really more closely related to shorebirds. The females have brighter plumage and are slightly larger than the males and, in common with stone curlews and many plovers, they have no hind toe.

Tiny Red-backed Button Quail (*Turnix maculosus*) had distinctive bright yellow, relatively fine bills and yellow legs. Their wing coverts were a sandy colour with obvious black spots; these melded well with the sandy yellow sides of their breast and flanks, which were clearly marked with black crescents formed by the dark centres of the feathers within broad, pale margins. These were the most secretive of all, hiding in the grass stems until they were nearly underfoot. When they flew, the pale wing coverts were in clear contrast to the darker flight feathers of the remainder of the wing, making them immediately distinctive.

Their companions in this dense, cosmopolitan covey were a similar species, the Red-chested Button Quail (*Turnix pyrrhothorax*). They were larger, more brightly rufous below, with a heavier, grey bill and darker backs. The males had less obvious black scalloping on the sides of their breast than their Red-backed relatives, and in flight they were clearly russet on their flanks and under-tail coverts. There was a third species, the Little Button Quail (*Turnix velox*), and these were generally cinnamon coloured with a heavy, leaden bill. It was most unusual to witness all three species together, and I value the drawings I have from that 'lifeboat' greatly.

I sometimes wondered what happened to all those birds; clearly, they could not persist at such density in so small an area. Most would have had to disperse, but such behaviour is normal for these small button quail. At least some of their number are thought to be sedentary, but they are generally dispersive and may turn up anywhere within their normal distribution without notice. Surprisingly, I saw Red-chested Button Quail and Little Button Quail on Connewarran, when showing Dr Norman Wettenhall around later the following year. These were most unusual records, repeated only rarely in the three generations of observations on the property.

Dusky Grasswrens

From Borroloola, we drove across the Barkly Tableland to Tennant Creek and on to Alice Springs. On that first night, I was up until 2.30 am drawing a Spotted Nightjar (*Eurostopodus argus*), a species which, although widespread in distribution, I was keen to draw. We intended to find and study the delightful Dusky Grasswren (*Amytornis purnelli*), possibly the most confiding of all grasswrens and a common resident in the spinifex-covered rocky slopes of the MacDonnell Ranges, where, especially near tourist destinations, they can become quite tame.

Years prior to my visit, I had heard from Mr Sandford Beggs – the farmer and naturalist who had helped me identify the Striated Fieldwren – that he had visited the area to search for Dusky Grasswrens. He invited his wife to join him in

scrambling over the rocky slopes and scree to search for wrens. 'No thank you, Sandy,' she had replied sagely, 'I think I'll stay in the car park and read my book.' Hours later, pink in the face and wet with perspiration, Mr Beggs had re-emerged from the hills, with scratched and bleeding legs from scrambling through spinifex and dead acacia.

'Did you find them, darling?' she asked.

'Never saw a bloody thing,' was the gruff reply.

'Oh, I'm so sorry. By the way, what are those delightful little fluffy brown birds with the tail that sticks up in the air? They kept hopping around me in the car park.'

His answer, I believe, was quite terse.

However, we had to find and study wild birds behaving normally in their home territories. Climbing the hills in some spectacular scenery, we set about searching, and soon happened on pairs

and parties of grasswrens. Although shy, they were relatively common amongst the rocks and spinifex. If I remained immobile, I found that their natural curiosity would frequently bring them out into the open to come and scrutinise me from relatively close range.

Dusky Grasswrens are a thickset, russet-brown version of the Thick-billed Grasswren. They hop and run powerfully and energetically amongst the boulders and rocks of the slopes that they favour, often spending time amongst the collapsed branches of dead acacias, presumably rewarded by seeds and ground insects. They are generally plumper in appearance than their relatives, with slender bills. In the chill mornings of winter in Central Australia, they seemed slow to become active, and in the heat of midday they would seek the shadow of crevices in the large boulders: they were most observable in the mid to late morning or later afternoon. It may be the coolness of the mornings that causes them to fluff their feathers for warmth and leaves me with the impression that they are spherical fluff-balls of electric energy. They remain one of my more favoured birds.

We were sometimes surprised by Wedge-tailed Eagles that would suddenly appear alongside us, gliding up silently from behind to ridge-soar as they watched for prey. Often they would be at eye level or below – an inspiring angle from which to observe an eagle – allowing us an excellent view of the tiny ways in which they can move their flight feathers to manipulate the air currents on which they ride.

Rufous-crowned Emu-wrens

We descended to the flat country of spinifex and acacia to search for the Rufous-crowned Emu-wren. Lawson Whitlock had found them at Hermannsburg in 1924, but it was not until the 1970s that their presence was reported in the Simpson Desert, where I first sketched them in 1975.

These attractive, tiny birds weigh less than half the weight of a box of matches, so can shimmy up the delicate grass stems of flowering spinifex with ease, from where they spy shyly on their observers. The males are strikingly beautiful, with a bright chestnut crown and nape and a bright pale-blue face and gorget, delicately set off with russet-buff underparts. Their tail is shorter and less flimsy than the tail of a Southern Emu-wren and being less filamentous appears to be bronzed. The females lack the blue face and upper breast, but are still delightful-looking birds.

Except when curiosity coaxes these wrens out to examine their surroundings, they can be frustratingly difficult to observe. Their normal feeding behaviour could best be described as skulking, for they seldom leave the cover of the

ABOVE LEFT Pencil sketch of a young Wedge-tailed Eagle, not long fledged, that flew past us in the MacDonnell Ranges while we searched for Dusky Grasswrens
OPPOSITE Pencil drawing of a Rufous-crowned Emu-wren at Hermannsburg, Alice Springs

spinifex, sneaking
swiftly through the
intimidating spines or in the
low cover of overhanging shrubs. If
alarmed, they dive deep into the interior
of the spinifex clumps, waiting quietly until
they are confident that danger has passed.

This field trip was excellent experience, giving
me access to some astonishing expertise within the
CSIRO team, but also a wide range of sketches,
drawings and ideas for subsequent paintings, as
well as the beginnings of the artwork for our book
on fairy-wrens.

From Alice Springs, I travelled via Birdsville
to check on the nesting Letter-winged Kites
that we had visited at Ten Mile Waterhole the
year before. Mike Vance, the producer from the
ABC Wildlife Unit, hoped they could be filmed,
but when I arrived at the nesting colony, all the
excitement and energy of the breeding irruption
was gone. The nests were deserted and lifeless;
even the rats were absent, and that, of course,
was the reason: the kites' rodent smorgasbord
had vanished.

About twelve kilometres north of Birdsville
there is a grove of Waddi trees (*Acacia peuce*).
These extraordinary wattles are found in only
three locations in Australia and are favoured
by Letter-winged Kites, much as they seem to
prefer to nest in Beefwood (*Grevillea striata*)
over Coolibahs. However, the kites had indeed
dispersed, and I had a long walk back to Birdsville
due to mechanical problems with the Land Rover.

Eyrean Grasswrens
I was left with a short-wheelbase Land Rover,
leased from Taffy Nicholls at the Birdsville Pub, and
a week to wait for the next flight out of Birdsville.
It seemed, therefore, to be an opportune time to
search for the Eyrean Grasswren, a species not seen

OPPOSITE *Eyrean Grasswren*, gouache, 33 × 24 cm
Male and female birds in the southern Simpson Desert west of Birdsville; the plate for *The Fairy-Wrens*
BELOW Male Flock Bronzewing, west of Birdsville, a loose colour study in gouache to record posture and plumage patterns

for nearly a hundred years. They live in the dunes of the Simpson and Strzelecki deserts, but little was known then of their distribution. There were rumours that a survey party had seen grasswrens – thought to be Eyrean – in the southern Simpson Desert, but their identity had not been confirmed, and there was always the possibility that the occasional sight records were of the similar Thick-billed Grasswren, or even, in some locations, the Striated Grasswren. It was not until August 1976 that Ian May returned to Poeppel Corner and confirmed beyond doubt that the birds he had reported there four years previously were indeed Eyrean Grasswrens.

The dirt track that leads from Birdsville to the breeding colony of Letter-winged Kites at Ten Mile Waterhole meanders on westward to the Adria Downs Number Two Bore and then to the ephemeral dish of Lake Nappanerica on the fringes of the Simpson Desert sandhills. This was an easy and safe route to take into the southern Simpson. There was no need to rush: I had a week before my flight out, so I could move slowly and watch birds as I went.

Flock Bronzewings

At one point there was a little pond of fresh water in the desert to which mobs of Flock Bronzewings (*Phaps histrionica*) were flying to drink. Parking

the vehicle out of sight, I pulled a couple of old sacks from the tray and walked out to the pond. At one end was a shallow gully in which I settled down, pulling the sacks over me. Without daring to move, I lay there, hearing the wing-beats passing over me, now close, now far away. Eventually there was the whirr of wings as a pair landed and walked shyly in to drink. Soon, others began to join them, becoming increasingly confident in their approach. I peered furtively out from beneath the sacks.

Like all bronzewing pigeons, they are striking birds; less attenuated than other bronzewings, their upper parts are soft cinnamon-chestnut and their underparts are a soft bluish grey. While they lack the glistening bronze wing coverts of their relatives, they have strong facial markings. The male birds have a black head, on which a white face and forehead extends to the front of the eye, where it ends sharply. A C-shaped white mark outlines the ear coverts, and a white bib separates the black throat from the upper breast. The females have no black on the head and are generally paler, but are nevertheless striking.

Brown Falcon

Returning to the Land Rover, I followed the track around one of the first sandhills. There were some skeletal trees nearby, the top of one of which was the favoured perch of a Brown Falcon. She showed many of the classic signs of adulthood. The ochre toning of her breast and belly was now white and the colour of her flank feathers and trousers, which would have been sepia in her youth, had now become a pinkish chestnut; the flank feathers were marked by bold white dots either side of the central shaft, giving the effect of chestnut cross-bars on a white background. Her back was rufous brown, and as she lifted

effortlessly into the westerly breeze, her under-wings were white, only sparsely decorated with chestnut marks and bars. She must have been an old bird, possibly seven or eight years or more. The fact that she was there, even though the rats had gone, and looked healthy and well groomed, if slightly lacking in energy – a characteristic of most of her species – indicated that she was excellently adapted to glean a good living from her desert environment.

Recently, Peter Slater suggested to me that the wide variation in Brown Falcon plumages could be the result of subspeciation (he had been referring to a short note I published, with Nick Mooney and David Baker-Gabb, in 1985 in *The Emu*, the journal of the Royal Australasian Ornithologists Union). His is an interesting thought, given the regional nature with which some variants seem to occur more commonly. However, tagging studies examining the dispersal of Brown Falcons would be required to make such a determination.

Australian Owlet-nightjar

Only about eighty metres further on, a hollow branch in another tree was a perfect haven for an Australian Owlet-nightjar (*Aegotheles cristatus*). Stopping the vehicle, I reached up and gently tapped the branch with a stick, and was rewarded by the appearance of a wide-eyed elfin face peering back at me, with large, brown eyes surrounded by broad pale areas. A dark line over the crown divided the eyes and enhanced the bird's owlish and binocular appearance, almost reminiscent of the bushbabies in Africa, or even a Sugar Glider (*Petaurus breviceps*). For a moment the Owlet-nightjar paused, gazing at me in apparent astonishment, before flying swiftly around the end of the dune and disappearing.

Hoping to avoid disturbing it a second time, I followed the flank of the dune a further few hundred metres before stopping and climbing towards the crown. This was the southern Simpson Desert, where the sandhills are twice as high as in the north, and a muted orange-yellow instead of deep, bright red. Along the flanks grew vegetation, acacia and cassia shrubs near the bottom, merging into Cane Grass (*Zygochloa paradoxa*) near the top, before it petered out into bare sand at the crown.

After months in the Simpson Desert with Charlie McCubbin, I was hard-wired to scrutinise the multitude of tiny tracks that crisscrossed the sandy slopes. Here were the signs of a beetle labouring across the slope; a scorpion, leading to its diagnostically shaped hole; or the tracks of a lizard, crossing between clumps of vegetation. As I walked along the dune, occasionally a shadow would break away from mine as a Black Kite, coming low to inspect what I was doing in the hope of some reward, grew tired of waiting and eventually left.

Gradually, I was appreciating the diversity of life that inhabited the dune. I was puzzled

LEFT An old female Brown Falcon seen on the fringes of the Simpson Desert west of Birdsville; gouache
OPPOSITE ABOVE Pencil sketches of dogs, as models for *Abandoned*
OPPOSITE BELOW *Abandoned*, gouache, 27 × 40 cm
Exploring the loneliness of some Indigenous children once traditional structures are disrupted, the painting is full of little symbols – the storm clouds brewing, the spilt tea signifying the withdrawal of British influence, the tracks leading nowhere, the close relationship with animals, the rubbish of our capitalist throw-away lifestyle

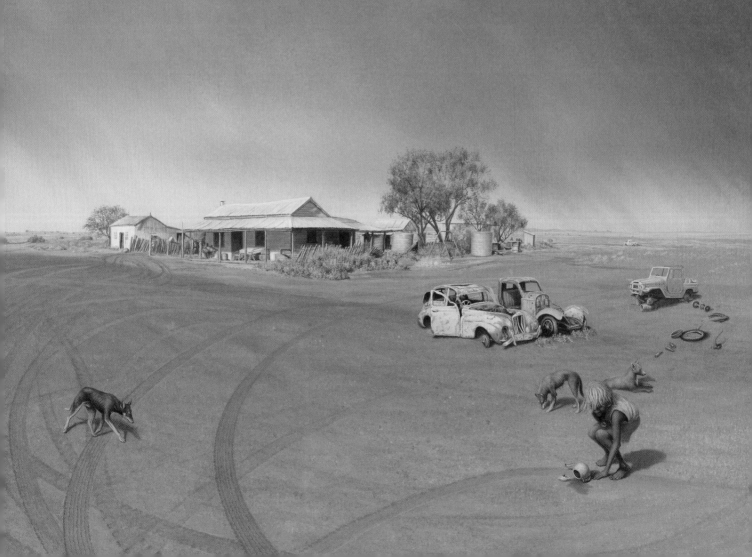

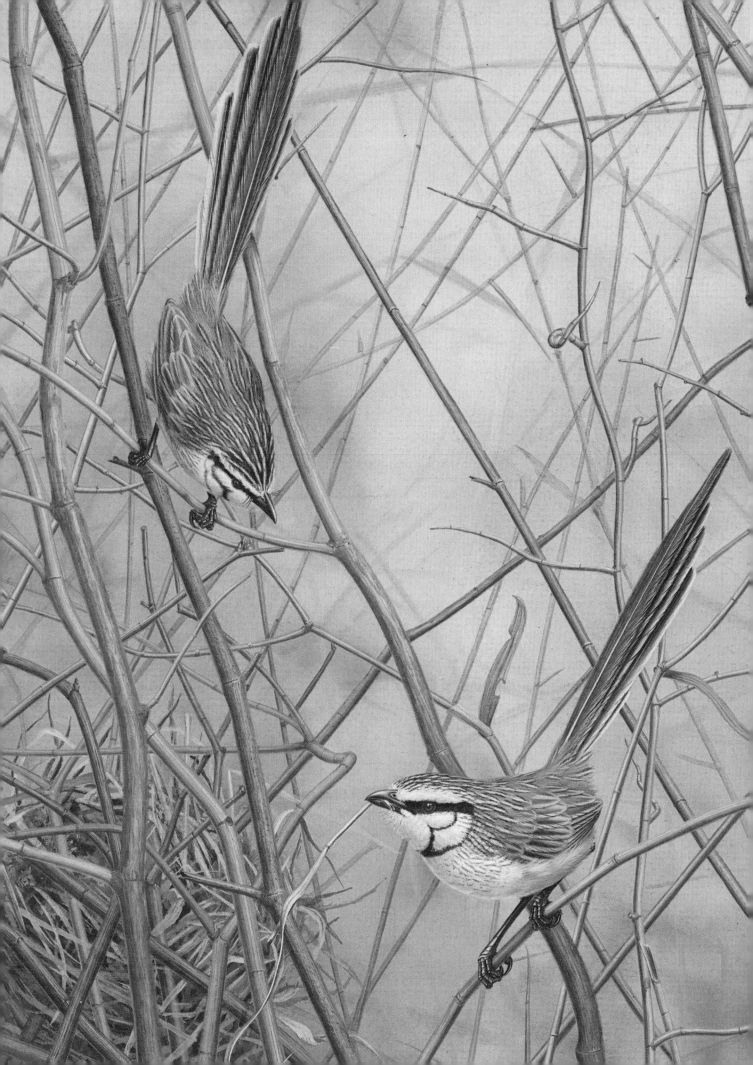

by one series of tracks that were quite common, interlacing all the other tracks. Typically, they led from one clump of Cane Grass to another close by. Mostly they were direct, but sometimes showed abrupt changes of direction. They were the marks of a small bird, which mostly hopped, left foot slightly advanced, sometimes breaking into a scrambling run. Increasingly, I became confident that these were the tracks of Eyrean Grasswrens.

Had I been a more experienced ornithologist, a better bushman, with better hearing, or luckier, I surely would have seen them, but I could only let Dick Schodde know what I had found, or what I thought I had found.

When we returned in November, it was in my Hilux utility with an enchanting passenger. Jenny and I had been married in August, and essentially this was our honeymoon, a camping trip of infinite discomfort in the company of two CSIRO ornithologists. Poor, tolerant Jenny! We returned to the Bluebush Camp at Ten Mile Waterhole to meet Dick Schodde and John McKean, the latter of whom was very intent on seeing an Eyrean Grasswren. He had little regard for two non-professional birdwatchers, particularly Jenny. Without asking her about her experience, he challenged her to point out how many birds she'd seen from Peter Slater's recently published *A Field Guide to Australian Birds*. When she was halfway through the fifth page of seabirds, John blurted, 'OK, that's enough!' Jenny had visited Macquarie Island in the sub-Antarctic aboard the much-loved *Nella Dan* on an Australian National Antarctic Research Expedition, making wildlife films for the ABC, and was knowledgeable about birds John hadn't yet seen.

For three days we walked the dunes, failing to find grasswrens. It was only just after John McKean had left that we had an unexpectedly close encounter with our first Eyrean Grasswren, and it was another two years before I had sufficient drawings to paint them. I felt I had captured something of their nervous energy and a sense of the cane-grass habitat that they frequent on the sandhills of the desert.

Grey Grasswrens

Returning from the Simpson Desert, we headed to the impressive Koonchera Sandhill, about one hundred kilometres south of Birdsville, which runs roughly north-westwards for twenty-one kilometres, from just beside the Birdsville Track until it projects into Goyder Lagoon at Koonchera Waterhole. A track along its western side runs through the eastern overflow of the Diamantina River, the heavy soil covered with large clumps of Lignum (*Muehlenbeckia florulenta*). This typically Central Australian floodplain habitat is the preferred home of the Grey Grasswren, a bird seen first by Europeans in 1942, when the Victorian naturalist Norman Favaloro and his companion A. Storer flushed a single bird from a Lignum clump on the floodplains of the Bulloo River, about five hundred kilometres to the east.

On 7 July 1967, Favaloro returned and collected the first specimens of the Grey Grasswren. He was swiftly in contact with Allan McEvey at the Museum of Victoria, with whom he described this, the first Australian bird unknown to science in almost half a century. This was just at the time that I first visited the museum and met Allan, and I remember his bubbling enthusiasm as he told me of the discovery of this new bird. I also recall my disbelief that it could have taken twenty-five years for Norman Favaloro to return to what he was confident was an unnamed species.

Koonchera,
22ⁿᵈ November 1976

Thus, the Grey Grasswren has always held a special interest for me.

I had visited Koonchera in May 1975 with Charles McCubbin on his Simpson Desert expedition. On that occasion, we camped well up on Koonchera Sandhill and, unusually, pitched a tent, as we normally slept under the stars. It was evident during the evening that clouds were building and we did well to heed their warning. That night it rained – one hundred millimetres – and we remained huddled in our tiny tent, accompanied only by a flagon of port and Charlie's unending supply of stories. In the morning, the flats were inundated and we were less concerned with ornithology than finding a safe route back to the Birdsville Track, but it was only three months later that the ornithologist John B. Cox was to lead an expedition of the Nature Conservation Society of South Australia that found Grey Grasswrens at Goyder Lagoon.

For my visit with Dick and Jenny in late 1976, the weather was vastly different. We laboured under a scorching November sun, but had little trouble finding and observing Grey Grasswrens along the Lignum-filled channels on the edge of Goyder Lagoon just alongside where we had camped a year before. The birds' habit of perching on top of high Lignum bushes, either to preen, sing or scan for intruders, before diving into the dense interior of the Lignum, made them one of the easier grasswrens to find. If left to relax, they would come out into the open to

forage on the ground, where they moved with erratic energy, their tails held high, but they preferred to spend their time in denser thickets, foraging carefully and deliberately through the vegetation.

When I had been at Koonchera first, there had been a day of very strong wind from the south-east. Thousands of ducks crowded into the waters of Goyder Lagoon, seeking shelter, and waterfowl were creeping in greater and greater numbers out onto the sheltered bank in the lee of the dune. I stalked the roosting waterfowl until I was about ten metres away from the closest and then, finding a bit of a gully, crawled in and lay very still, watching. More and more birds were swimming in to rest, pushing the early arrivals further and further up the bank. Eventually, I found myself almost as one with the flock, as birds were pushed in all round me: Pink-eared Duck, Grey Teal, Pacific Black Duck, Hardhead (*Aythya australis*) and Freckled Duck (*Stictonetta naevosa*) were all clustered within an arm's length, so long as I remained motionless and unseen. It seemed to me that the entire Australian population of Freckled Duck were gathered there that day, and I revelled in the opportunity to observe them.

My next trip came in the spring of 1977, when I met Dick in Perth to travel to Wiluna and a camp on Milbillillie Station, a sheep property about one thousand kilometres to the north-east and almost in the geometric centre of Western Australia. But first we visited the Dryandra State Forest about twenty-two kilometres north-west of the town of Narrogin, on the western edge of Western Australia's wheat-belt region and at the

transition between the moister forests of Jarrah (*Eucalyptus marginata*), Karri (*E. diversicolor*) and Marri (*Corymbia calophylla*) further to the south and the semi-arid wheat belt to the south-west. We were hoping to find two species of fairy-wren in very attractive landscape, with red earth, white-barked eucalypts, Salmon Gum (*Eucalyptus salmonophloia*) and Wandoo (*E. wandoo*), amongst a distinctive species-rich heath, set in country surrounded by the serious salinity problems of Western Australia's wheat belt.

Splendid Fairy-wrens

The Splendid Fairy-wren, as its name suggests, is a striking bird. In the shrub layer of the Dryandra State Forest, against red earth and amongst the dry-looking dryandra (now reclassified as banksia) and calothamnus, the vivid blue of the male bird, a deep, violet-tinted cobalt, seemed to gleam, almost with an inner glow. Early Australian ornithologists were uncertain for many years as to whether this group of brilliantly coloured fairy-wrens – the Splendid, the Turquoise and the Black-backed – were separate species or races of the same bird. Now it is understood that there is genetic exchange between races where they meet and that they are colour forms of the same species. There has even been one additional race added to the group at its most north-eastern extremes of distribution: *Malurus splendens emmottorum,* with the palest coloured males of all. At the opposite end of the range, where we were watching the wrens at Dryandra, the male birds are the darkest, a deep, royal tone, but it is in Central Australia that their relatives are most spectacular.

Turquoise Fairy-wrens

Dick and I had worked with the central subspecies, the Turquoise Fairy-wren, while we were in Alice Springs the year before, when we were watching

the Dusky Grasswrens. We found the Turquoise in the arid, rocky country not far south of the town. If all the variants of the Splendid Fairy-wren are brilliantly coloured, perhaps the Turquoise is the most striking of all. It is a startling cerulean blue over all its body, except for a darker, violet-blue gorget and a black band across its chest and its lower back. A black band runs through its eye, from bill to nape, which is also black. At one point, when the relationships within the Splendid Wren group were less well understood, the Turquoise was considered a full species, *Malurus callainus*.

The Splendid Wren in all its forms has much in common with the familiar Superb Fairy-wren of eastern Australia. Dick, in his text for our book on fairy-wrens, discussed how they may have evolved from a common ancestral stock of 'blue wrens' once widespread across the south of the continent. Separated by climatic conditions over the last several million years, they diverged into the Superb Fairy-wren in south-eastern Australia and the Splendid in the south-west. The Splendid, he suggested, adapted to aridity better and expanded round the Nullarbor Plain into the centre of the continent, sporadically permeating the Murray mallee, with climatic changes shaping their current patchy distribution in the east of their range.

ABOVE Pencil drawing of a banksia from the Dryandra State Forest near Narrogin, Western Australia, as possible background material for a painting of fairy-wrens
LEFT Pencil sketches of Blue-breasted Fairy-wrens (*Malurus pulcherrimus*) in Dryandra State Forest
OPPOSITE Pencil drawings of the reclusive Red-winged Fairy-wren (*Malurus elegans*)

Unlike many of the grasswrens, which are late risers, the Splendid Fairy-wren rises before dawn and is already searching for food by the time the sun appears. The birds continue to work through their territory as the day warms, mostly foraging at ground level, but occasionally moving higher into the foliage of bushes and trees. Their movements are sporadic; a dashing run may be followed abruptly by a pause or a leap into the air to grasp an insect. Contact is maintained within the group by soft, frequently repeated calls.

Splendid Fairy-wrens are dynamic, active little birds of great beauty. However, they prefer to remain under cover, ready to scuttle into a more secure setting whenever disturbed. Annoyingly, they tend to follow each other, leaping from twig to twig or fluttering low between bushes, keeping an obstruction between them and their observer until they have reached a more secluded refuge. At such times, the coloured males are particularly good at concealment and are difficult to see clearly. Such was the case in Dryandra State Park.

Blue-breasted and Variegated Fairy-wrens

An even more challenging bird to study was the Blue-breasted Fairy-wren, more difficult even than its closely similar relative, the Variegated Fairy-wren. Persistently secretive, the Blue-breasted Fairy-wren only rarely ventures into the open. Confined to dry, open sandy woodlands with shrubby understorey, dense sandplain heath and mallee regions on the Eyre Peninsula and the south-west of Australia, it has lost much of its former habitat to agriculture, reducing its range substantially. Its similarity to the Variegated Fairy-wren, with which it shares parts of its distribution, has caused frequent confusion in both the identification and the taxonomy of the species. They are both slender birds with plumage patterns that are difficult to separate. Even the indigo-blue breast sported by the male birds is almost impossible to discern except in the very best light, which compounds the difficulty of correct dentification.

Fortunately, there are clues to help separate the two species. The Blue-breasted Fairy-wren has proportionally the longest tail of all fairy-wrens and variations in the colouration of the crown and ear patches of the nuptial plumage of the male also helps: in the Blue-breasted, the crown and the distinctive lanceolate ear-tufts that run from a rim surrounding the eye back over the ears, are of a similar rich violet cobalt, unlike the paler cerulean tufts of the Variegated group, which contrast with their darker crowns.

This would be more helpful were it not for the inordinate shyness of both Variegated and Blue-breasted Fairy-wrens, taken to extremes by the latter. When they were feeding, they almost never ventured into the open, foraging quickly within the security of dense heathy shrubbery in a typical fairy-wren hop-searching manner with their tails cocked vertically or held over their backs. Male birds at Dryandra were reluctant to show themselves at any time, but if disturbed they went to ground completely, remaining invisible until we had removed ourselves and they believed the coast was clear.

Red-winged Fairy-wrens

From Narrogin, we visited the Marri and Karri forests of the south-west to find the endemic Red-winged Fairy-wren (*Malurus elegans*). Those magnificent forests, including great stands of Jarrah, were

OPPOSITE *Red-winged Fairy-wren*, gouache, 33 × 24 cm
The plate depicting that species in Karri forest near Pemberton, Western Australia, for *The Fairy-Wrens*

still being cleared for agriculture. The Western Australian government of the time allocated land on condition that the country be cleared. We visited one gentleman who was visibly upset. He had applied for land and been rewarded with an allocation. He intended to start a native plant nursery, and the value of the land to him was in the native plants. Nevertheless, under his agreement, he was obliged to clear it. If he wanted an indigenous plant nursery, he was allowed to wait for the native vegetation to grow back; he could even plant it with the original vegetation, but it must first be cleared. We were stunned!

Nowadays I understand the implications of such a ruling. Opening the forest canopy was going to encourage the invasion of weed species, desiccate the ground and totally disrupt relationships within the ecosystem. It would take several lifetimes to rectify the destruction. I felt hugely saddened.

The Red-winged is the largest of the fairy-wrens and perhaps one of the most elusive. It is not so much shy as quiet and ponderous in its movements compared to the energy of other fairy-wrens. The Red-winged seems to materialise unexpectedly and vanish with equal alacrity. Their favoured habitat is the dense thickets of agonis, leptospermum or sword rush alongside creeks, rivulets or other damp areas, but they also venture further out on to the sides of gullies in the bracken and shrubby understorey of eucalypt forest.

Despite their size and the colouring of the males, they blend well with the vegetation. Their plumage is dull, and appears somehow softer and fluffier than the feathers of other fairy-wrens – for want of a better word, 'furrier'. This is offset by the light silvery blue of the crown and ear-tufts and on the back of the males, where the white bases of the feathers are visible, giving a pale, silvery effect. The chestnut shoulder-patch is broad and clearly evident. Their tail is much more obvious, being broad and long and carried erect and often slightly spread, in a manner reminiscent of a fantail. It is not apparently used for signalling, for we saw none of the restless agitation of the tail that is often seen in fairy-wrens, and the white tips to the retrices are so minimal that they quickly wear away. They can be difficult to observe as they forage quickly through their territory, mostly close to or on the ground, keeping to the cover of vegetation. If startled, the male bird will often seek a vantage point to inspect the source of the disturbance before again seeking cover and quickly dispersing with the remainder of his troupe.

Noisy Scrub-birds

Sadly, it was time to leave these magnificent forests and turn northwards towards Wiluna, but before we left, it seemed foolish to ignore the opportunity to visit Two People Bay just east of Albany and encounter a Noisy Scrub-bird (*Atrichornis clamosus*). This rare and extremely secretive species had been thought to be extinct until it was rediscovered in the dense, heathy, damp coastal understorey at Two People Bay in 1961. Swift action was taken to endeavour to protect the bird. A town had been planned for the site, but this was cancelled and a nature reserve established instead. It was to this reserve that we headed.

So secretive is the Noisy Scrub-bird that it is seldom seen. It runs with great speed and agility and moves through deep leaf litter in the thickest of cover, preferring moist vegetation that has been untouched by fire for a long period. Males occupy large territories, and these are defended throughout the year by singing, a song so loud that it can carry for over a kilometre. Noisy Scrub-bird numbers are evaluated by counting the number of singing males, a cogent reason

for ensuring that ornithologists eschew the use of 'playback' to try to see the birds. Although territories are defended by song throughout the year, singing increases at the start of the breeding season and remains at a high intensity until breeding is over. By 1970 it was estimated that numbers had increased to about forty-five birds.

We arrived at the reserve on a cold, damp, rainy morning, conditions under which most birds are difficult to find. Fortunately, Noisy Scrub-birds often follow similar routes through their territory, probably assisted by tunnels and runways pushed through the dense cover. They adhere to their routine quite punctually. Ornithologists at the reserve pointed out a likely spot. We could hear a male calling, moving rapidly through his territory, which was bisected by a narrow track. Selecting spots about thirty metres apart, Dick and I crouched down to wait. The calls became louder and closer, at times painfully loud, until the bird reached a spot close to the track. An uncertain silence descended. We waited. Then, with a mad, scuttling scramble, the Noisy Scrub-bird dashed across the track to the dense cover on the other side, where he shortly resumed calling. Not a prolonged study, and no sketches of a relaxed scrub-bird, but we did see him!

It was the spring wildflower season in the south-west and the countryside was gloriously covered in native blooms of pink, yellow and purple mixed with glaucous or green foliage: quite unforgettable. Along the roadside we found examples of the fascinating pitcher plant, which supplements its nutrition by trapping and dissolving insects. It favours the moist, boggy, acidic soils in the roadside table drains and its

modified leaves serve as highly refined pitfall traps. Nectar secreted from the underside of the lid attracts small insects to the slippery mouth of the pitcher. Once they fall into the liquid inside, there is little chance of escape over an array of downward-pointing spikes clustered just below the lip of the pitcher, which contain the struggling insect until the lid is closed and the prey is digested.

From this glorious, damp landscape we turned our faces towards Wiluna and our camp on Milbillillie sheep station. Prolonged drought had desiccated the land, and the country was almost unbelievably dry. The ground had been damaged by stock, which had an impact on finding some of the ground-dwelling birds that we sought, species like the Thick-billed Grasswren. Recovery from grazing in that climate, on those soils, could take as long as a century.

The area around Wiluna had been degraded since the discovery of gold in the early 1890s. The cessation of mining in 1920–24 had enabled eucalypts to regenerate, so that virtually every tree in the region was almost exactly the same age.

In April 1910, Frederick Bulstrode Lawson Whitlock had published a detailed survey of the Wiluna area birds in *The Emu*, and his records provided an accurate benchmark against which to compare the current state of the ecosystem and a useful guide as to the possible location of species of interest. The CSIRO had been commissioned to examine the effects on the environment of previous mining, and the likely effects of future uranium mining.

Striated and Thick-billed Grasswrens

I hoped to find, and to illustrate, the two species of grasswrens located there. Taxonomically, they represented two of the three probable evolutionary lineages emanating from a common

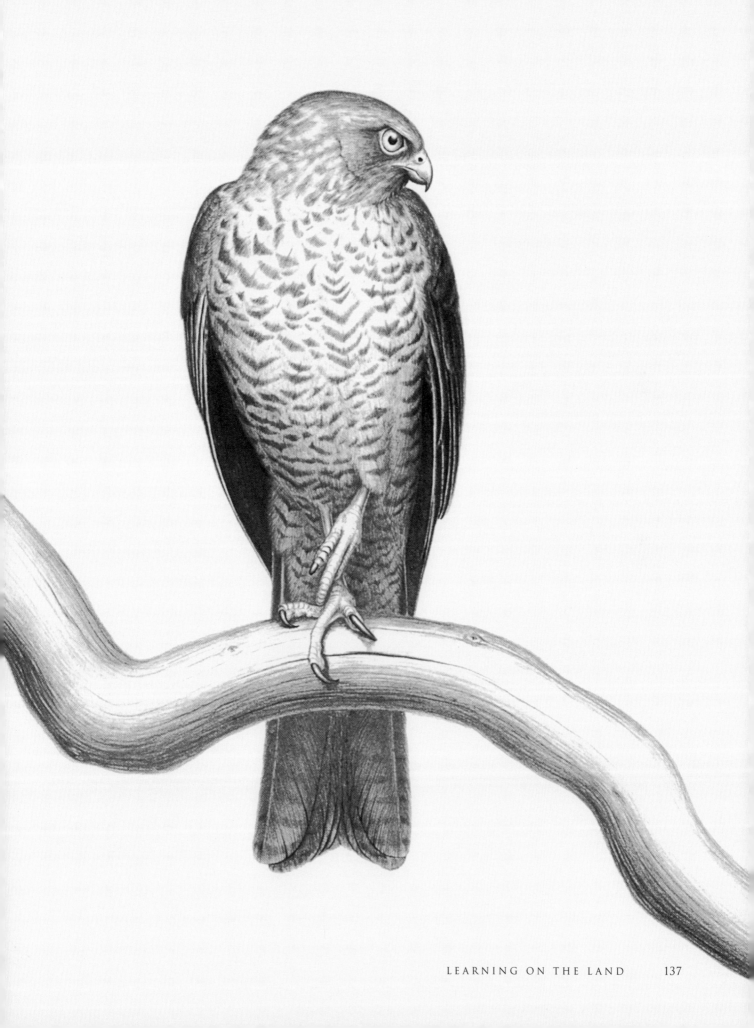

parental stock that seems
to have exploded, in an
evolutionary sense, out of an aridifying Australia
over the last ten or so million years.

One of these species was the Striated
Grasswren, adapted to mallee spinifex on desert
sands. The advent of genetic analysis has greatly
improved our understanding of relationships
amongst birds at all levels. Often it has led to
subspecies being given the rank of full species,
and populations of Striated Grasswrens around
Wiluna have proved to be one of them. They are
brighter russet over the back and creamier on the
breast than their relations in the east.

Near Wiluna, the nominate race of the
Western Thick-billed Grasswren (*Amytornis
textilis textilis*) was also present, a bird that
has been at the centre of confused taxonomy
since its discovery by Europeans. It was the first
grasswren to be found and described, as early as
1818, only to have dropped from sight for nearly
a century afterwards. Other similar species were
ascribed to this species from time to time, further
confusing the issue, until Shane Parker of the
South Australian Museum untangled the history
of misidentification and loss of specimens in
1972. He demonstrated confusion between three
species over many years, the western Thick-billed
Grasswren, the Dusky and the eastern Thick-
billed Grasswren.

Parker showed that the western Thick-billed
Grasswren (*A. textilis textilis*) was more closely
related to the eastern Thick-billed than it was to
the Dusky. He included them in a single species,

based largely on habitat, as both eastern and
western Thick-billed Grasswrens favour similar
saltbush or bluebush shrubberies, as opposed to
the Dusky's preference for the porcupine-grass-
clad boulder and scree slopes of the rocky ranges
of Central Australia and north-west Queensland.
The western Thick-billed has since been given
the status of a full species, the Western Grasswren
(*A. textilis*), based on genetic analysis. It is darker
and longer tailed than the eastern Thick-billed,
now separated as the Thick-billed Grasswren
(*A. modestus*), which is a more thickset bird
with a range extending no further west than
the Flinders and Central Australian ranges. The
most likely threats to the western sub-species are
the burgeoning numbers of feral cats in Central
Australia, big, strong and ruthlessly efficient
hunters. Intensive livestock grazing also robs the
birds of habitat and exposes them to predation.
So serious is this problem that the species may
be approaching extinction, having already
disappeared from Dirk Hartog Island and been
reduced to patchy distribution where it still exists.

To my delight, I found that we were based
not far from the beginning of the Canning Stock
Route, the track that runs from Halls Creek in
the Kimberley to Wiluna and is watered by some
forty-eight bores. The final droving run along
the track was in 1959, so the habitat was not
severely damaged by livestock. Number Two Bore
provided a wide variety of interesting birds.

Feeding flocks

One day we were
standing near a dense
patch of Mulga scrub when a
whirlwind of small birds came
through: it was a feeding party. These
are well known, particularly in rainforest,
where the commotion they cause

LEFT Pencil study of
a Western Bowerbird
(*Chlamydera guttata*),
from near the Rock
Pool at Wiluna,
Western Australia
BELOW A rare
opportunity to draw
a careful pencil study
of a Grey Honeyeater
(*Conopophila whitei*),
one of a mixed
feeding party near
Wiluna, Western
Australia
OPPOSITE Pencil study
of a Bourke's Parrot
(*Neopsephotus bourkii*)
from near Wiluna,
Western Australia

disturbs insects, grubs and other prey, allowing each bird to find food more easily. All species within the group benefit and can survive together because they glean their diet in different ways; they are more complementary than competitive. This, then, was a behavioural legacy from the origins of our Australian birds, adapted to aridity by gradual climate change as Australia drifted northwards and dried out, but still with behavioural traces of its rainforest origins.

In this mixed feeding flock were three species of thornbill, the Slaty-backed Thornbill (*Acanthiza robustirostris*), Inland Thornbill (*A. apicalis*) and Chestnut-rumped Thornbill (*A. uropygialis*). There was also a young Red-capped Robin (*Petroica goodenovii*), and I have a sketch of an adult male Splendid Fairy-wren from the same place. While they were not part of the feeding flock, other larger birds filled my sketchbooks: the attractive Western Australian variant of the Grey Butcherbird with a delicate necklace of black marks on its upper breast, a Spiny-cheeked Honeyeater and a useful sketch of a Western Bowerbird (*Chlamydera guttata*). Of course, such activity brings predators, and I also have a drawing of an adult female Collared Sparrowhawk.

Grey Honeyeaters

Amongst this feeding flock at Number Two Bore were Grey Honeyeaters (*Conopophila whitei*), rarely seen by ornithologists because of their cryptic colouration and remote distribution. This drab little honeyeater, discovered by Lawson Whitlock in 1901 and named *Lacustroica whitei* by North in 1910, shows faint traces of the plumage patterning of the Rufous-banded Honeyeater (*Conopophila albogularis*), with its pale throat and slightly darker upper breast; it also shows the faintest hint of yellow edging on the flight feathers, indicating its relationship with members of the genus *Conopophila*. The Rufous-throated Honeyeater (*C. rufogularis*) shows the same upper breast pattern in reverse, with a dark throat and pale breast, so the Grey Honeyeater has been included, somewhat tentatively, in the genus *Conopophila*, although in truth we have little idea of its origins and relationships.

Bourke's Parrot

One of the exciting finds for me was a nest of the beautiful little Bourke's Parrot in a hollow at the fork of a small Mulga (*Acacia aneura*), where one of the branches had snapped off. It speaks volumes for the adaptation of this hardy little parrot that it could breed in such a difficult, drought-ravaged season.

The nest allowed me to observe and draw the birds perching, relaxed, nearby. So often they can be difficult to observe, as they usually come to drink each day in very dull light or total darkness at dawn or dusk. Birds have very different postures and behaviour when they are disturbed and under observation. I would much prefer to depict them behaving naturally, even if they are seldom seen that way.

John McKean, an avid list-ticker and competitive accumulator of species lists, was very keen to see his first Bourke's Parrot. We knew of a particular place where they were coming in to drink, so the day before he had to leave to return to Perth he set off in the dark to watch their dawn arrival. Sadly, his alarm had failed to wake him sufficiently early and he mistimed his journey, arriving as the sun was rising, but after the parrots had finished drinking and departed. The next morning he was not to be beaten, so he

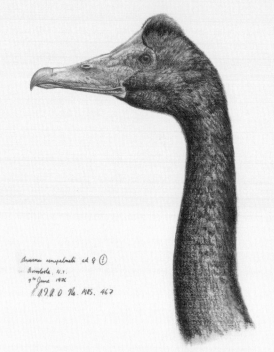

Anserana semipalmata, Juv. ♂ (?)
Borroloola N.T.
9th June 1976
£0920 No. MRS 468

Anserana semipalmata ad ♀ (?)
Borroloola N.T.
9th June 1976
£0920 No. MRS. 467

LEFT Pencil head studies of juvenile and adult Magpie Geese (*Anseranas semipalmata*), Borroloola, Northern Territory
OPPOSITE Pencil drawing of Magpie Geese in flight, Anbangbang Billabong, Kadaku; these birds are characteristic of Top End waterholes; originally drawn for the CSIRO publication *Wild Places of Greater Melbourne*, by Robin Taylor

got up really early and went out to the tank where they came to drink. Waiting, motionless, in the pitch dark, John fell asleep and awoke when the rising sun warmed him after the Bourke's Parrots had left once more. To say that he was frustrated would be to understate his mood. No wonder Bourke's Parrots are sometimes (misleadingly) known as night parrots or sundown parrots.

OUR RETURN TO Perth was on a passing semi-trailer. Our borrowed utility, which already had 51,500 kilometres on the odometer, proved never to have been serviced and had done well to travel as far as it had. It had been a long and exhausting trip, so we returned to our homes, Dick to write and I to complete some paintings for the plates for the wren book.

Work for each species in the wren book generally divided into three nearly equal sections: roughly three weeks each for fieldwork, drawing and design, and painting, although fieldwork and sketching are never quite complete, as I continue to learn about the birds the more I see and draw them.

Once I have captured the physiology and character of the bird, I then select a small number of the better sketches to keep working on,

redrafting them, developing them with further detail and interrelating them into an attractive construction for the painting. The same applies to the background, whether it be a landscape or a small piece of the bird's environment.

When I have a clear idea of what I am setting out to paint, sometimes from a detailed, full-sized black and white image, or a small coloured version of the work, I can start to prepare the final painting. First, I paint the background and then add the birds. This can be a laborious and disciplined process, with many pauses to research and portray intimate or tiny details. Each individual fairy-wren would take me about two to three days, if things went well, and each painting would require about three weeks of intense concentration.

IN 1978, DICK and I travelled to the massive sandstone outcrops of West Arnhem Land and the Kimberley. From the air, as we approached Darwin, we could see the havoc wreaked by Cyclone Tracy during the Christmas of 1974. Much of the infrastructure and housing had been repaired in the intervening five years, but higgledy-piggledy tree carcases bore witness to the enormous power of the winds and the devastated landscape.

Next morning, as we went in search of White-throated Grasswrens (*Amytornis woodwardi*), we were conscious of our error in attending a farewell party for a CSIRO ornithologist the previous night.

Turning east on the Kakadu Highway to camp at El Sherana, we proceeded along a dirt track narrowly bordered by sorghum grass, halting occasionally to watch birds like Pheasant Coucals (*Centropus phasianus*), or Partridge Pigeons (*Geophaps smithii*) with their embarrassed red faces, feeding on the wheel marks; these would vanish into the grass alongside as we approached. The increasingly rare Hooded Parrot (*Psephotus dissimilis*) nests in holes in the ant hills scattered amidst the tall sorghum grass in the woodland near Pine Creek, but on this occasion we searched without success.

We passed Kambolgie and Yurmikmik and stopped at UDP (Uranium Development Proprietary) Falls where Koolpin Creek plunges off the escarpment to a lovely pool below. Strolling over the sandbar and into the tall melaleucas, we were delighted to find a pair of beautiful Rufous Owls (*Ninox rufa*) in the branches. Typically, they did little more than open their brilliant yellow eyes to peer down at us with a look of astonishment at our intrusion. These imposing birds are surely one of Australia's most attractive owls, almost as large as the Powerful Owl (*Ninox strenua*) in the south, although with a broader head, and, as their name suggests, predominantly rufous. Their underparts are alternately barred with a sandy orange and chestnut; their dorsal surface is deep rufous with narrow buff and pale-ginger bars. As we watched they appeared to become discomforted and eventually flew silently deeper into the vegetation and out of sight.

Turning to retrace our tracks a short way, we set off on a steep climb up a magnificent rocky slope to the head of the Arnhem Land escarpment at El Sherana, the abandoned uranium mine that had closed

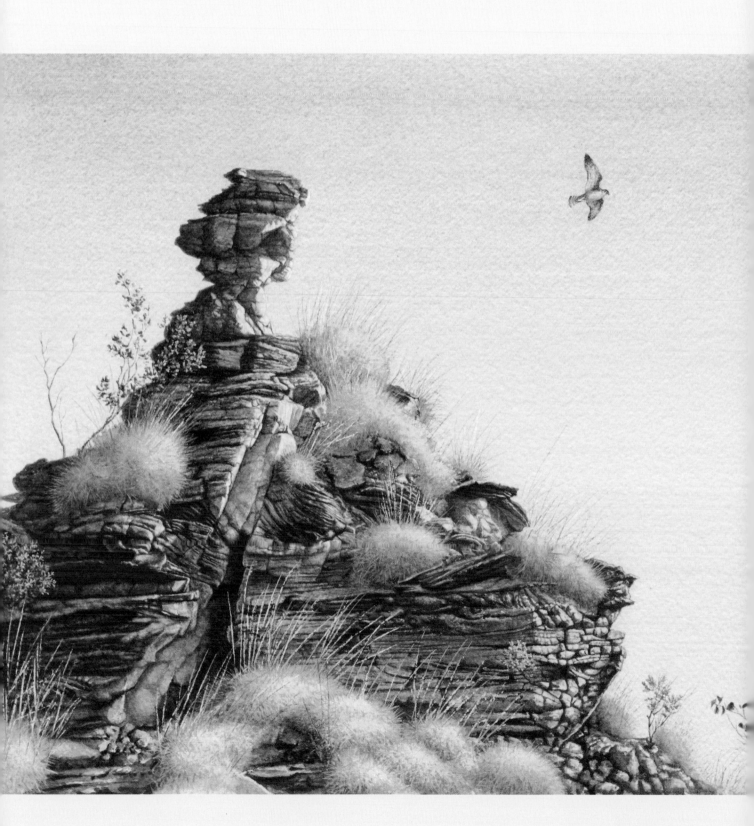

in 1959. The escarpment is now part of the spectacular soul of Kakadu National Park, which at that time had yet to open. At the top, the plateau is a chequerboard of chasms and gullies – testing country to traverse unless one is sensitive to the 'grain' of the land. Within the ravines grows an array of shrubs and trees, and the rocky plateau itself is interspersed with lines and patches of needle-sharp spinifex, shrubs and twisted trees.

White-throated Grasswrens

It is in these open rocky, spinifex-clad areas that the White-throated Grasswrens find a home. Perhaps the most confident of the grasswrens, and the largest, they are nevertheless shy and evasive, in the manner of all members of their genus. Their dark backs, bright chestnut or ginger flanks and brilliant white shirt fronts are strikingly beautiful as they forage rapidly, scrambling energetically over rocks and around vegetation, sometimes jumping to seize an airborne insect or a morsel from overhanging vegetation. If disturbed, they bolt, head and tail low as they disappear into a rocky crevice or over a stony rise.

Dick and I followed a pair of foraging birds through their territory; always, the male was in the lead, and occasionally he would sing from a vantage point. In general, though, they foraged in relative silence. Sometimes they would briefly hide and peer back at their observers, reminding us of the Carpentarian Grasswrens.

They would appear an hour or two after sunrise, then, as the day warmed, they would spend more time in the cool shade of rocky crevices or beneath vegetation. We allowed a few days to work with and sketch the White-throated Grasswrens, and to observe other escarpment birds.

Lavender-flanked Fairy-wren

A subspecies of the Variegated Fairy-wren, formerly separated as the Lavender-flanked Fairy-wren (*Malurus lamberti dulcis*), is restricted to rocky country with spinifex and shrubs typical of the escarpment. As with all Variegated Fairy-wrens it is a wary bird, sheltering for much of the time where it is difficult to observe. In beauty, the Lavender-flanked is equal to the Splendid Fairy-wren; the neat, clean-looking male has a clear white belly with deep lavender bordering its upper flanks, differing otherwise very little from the inland version of the Variegated, the Purple-backed Fairy-wren (*M. lamberti assimilis*). Subtle differences, such as a shorter tail or a larger bill, are difficult to discern in the wild. The female is very attractive; her dorsal surface is a dull greyish blue from head to tail, but her underparts and lores are a clean white. In rocky terrain, with open areas, it was a little easier to observe these beautiful birds as they foraged in the shrubberies of the escarpment, venturing onto open rock faces before plunging back under cover.

Banded Fruit-dove

Occasionally a fig tree in a ravine would carry sufficient fruit to attract a Banded Fruit-dove (*Ptilinopus alligator*). If stalked judiciously, these normally shy birds would sometimes allow us a close approach, especially when we were at the same level, the bird perched in a tree growing from far below.

The beetling cliff faces of the West Arnhem Land escarpment are a major feature of Kakadu. Except for inappropriate use of fire and the invasion of feral pests, much of the escarpment remains truly wild country. In more recent

LEFT *Sandstone Spirit*, watercolour, 28 × 38 cm An old Brown Falcon above a rock in Happy Valley, near Kununurra, where we searched for Lavender-flanked Fairy-wrens; the eroded shape suggested an ancient female guardian spirit and was irresistible as a subject; painting spinifex in watercolour was also a welcome challenge

times tourism has started to lure people to the escarpment, especially sites like Twin Falls and Jim Jim Falls, and the outlying outcrop of Nourlangie Rock with its magnificent Indigenous art.

Further north lies Cahill's Crossing, a ford over the East Alligator River, where escarpment birds may descend to a more accessible level. After the major effort to eradicate buffalo from this beautiful area in the 1980s, vigilance has relaxed, and these feral pests are increasing in number, leading park authorities to close some areas for safety reasons.

Chestnut-quilled Rock Pigeon

The elegant Chestnut-quilled Rock Pigeon (*Petrophassa rufipennis*) lives amongst the tumbled blocks of fallen sandstone and on the cliffs above them, perfectly camouflaged until it moves. When stressed they have the odd pigeon habit of flicking their head, as if to rid their mind of some unwanted idea, and often it is this movement that catches an observer's eye.

They can run swiftly over the rock ledges on their short legs, flicking their wings to reveal the rich chestnut primary feathers as they jump across clefts. They feed mostly in the cool of morning or evening, resting in shaded rock clefts during the heat of the day.

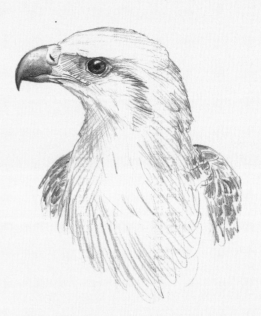

Sadly, the rock pigeons of these lower sandstone stacks are becoming increasingly scarce.

Rainbow Pitta

On the other side of Cahill's Crossing is a pocket of monsoon vine forest, in the darker and moister depths of which lives the beautiful Rainbow Pitta (*Pitta iris*). In behaviour these pittas are similar to the Noisy Pitta (*P. versicolor*), foraging in the leaf litter on the forest floor. The bright patch of electric blue on their shoulder blazes with colour in direct sunlight. However, they are adept at remaining in dark, shaded areas and rarely venture into direct sunlight.

Nearby, on the fringes of the Nadab Floodplain, is Ubirr, a group of rocky outcrops containing rock paintings dating back over forty thousand years. Of major significance for the Indigenous people, it holds a degree of mystique for the visiting tourist. One intriguing painting is of a Thylacine (*Thylacinus cynocephalus*), a marsupial predator considered to have become extinct on mainland Australia some two to three thousand years ago, and not a species commonly thought of as resident in tropical northern Australia.

Sandstone Shrike-thrush

A glorious call, echoing from the rock faces of Ubirr, reveals the presence of the Sandstone Shrike-thrush (*Colluricincla woodwardi*). This is a bird of the escarpments and gorges from the Kimberley across northern Australia to the McArthur River region of the Gulf of Carpentaria. Graham Walsh, the renowned expert on Bradshaw paintings, told me that there was an Indigenous belief that this was the bird ('Gwion gwion') that had painted those ancient paintings: that it would peck at the rock face until its bill bled and that the paintings are inscribed with its blood. It is an elongated, slender bird which is generally shy

and wary, but the constant stream of tourists at Ubirr has rendered this shrike-thrush much more approachable. It forages along the rock faces and ledges, ascending to vantage points on the clifftops to sing a rich, resounding song which bounces from the rock faces in cascading echoes.

White-bellied Sea Eagle

At dusk one evening, standing on the top of Ubirr, I watched with Jenny as wave after wave of flying foxes left their roosts in the vine forest at Cahill's Crossing and headed into the night to their feeding grounds. Suddenly they were joined by a vastly larger shape, a female White-bellied Sea Eagle (*Haliaeetus leucogaster*), which flew amongst them, snatching one out of the air like a hobby taking a dragonfly. Each night the flying foxes must run the gauntlet of the sea eagles, which have a nest on the riverbank not far from the crossing.

Little Woodswallows

On another occasion, Jenny, with her ever sharp observational skills, found a cluster of Little Woodswallows (*Artamus leucorynchus*) huddling together for security and warmth in a sheltered cleft of a rock face at Ubirr. Light rain was falling and the night was cold. Although the woodswallows were at eye level, they were superbly camouflaged, and so closely packed that it was almost impossible to count them, their wonderful soft plumage blended so well into a single unit, with sharp little eyes and beaks.

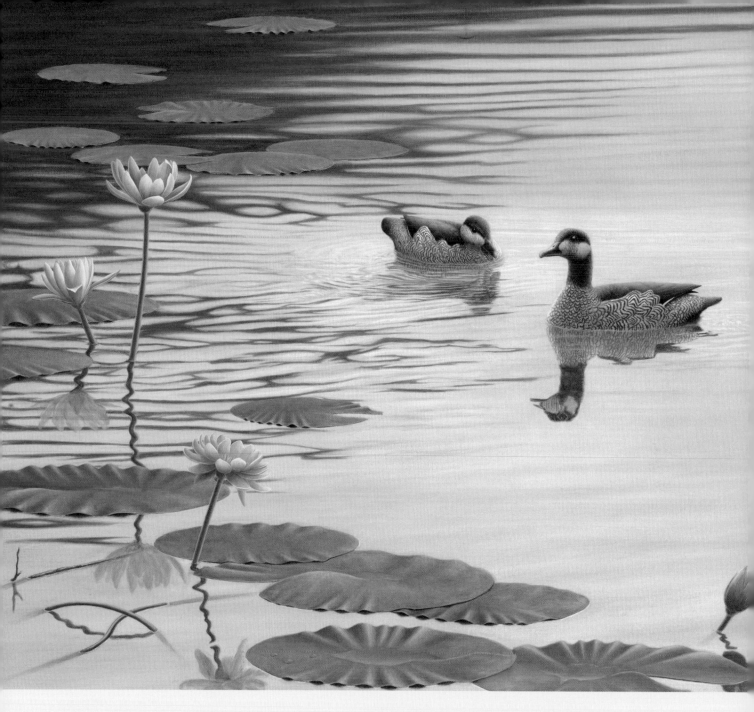

Green Pygmy-geese

Jenny and I witnessed a fascinating example of a non-mutually beneficial interaction between species in Kakadu. Both of us knew the country from before its declaration as a national park, when it was known as Woolwonga. We visited the bird hide at Mamukala, which we had known as a hotspot for birdwatching. Jenny noticed that every pair of Green Pygmy-geese (*Nettapus pulchellus*) appeared to have an association with another species, one that fed by diving. Watching, we saw that each time an 'associate' species dived – an Australasian Grebe (*Tachybaptus novaehollandiae*) or Wandering Whistling Duck (*Dendrocygna arcuata*) – the pygmy-geese would swim rapidly across to where they had last been, and immediately the associate they were shadowing popped back to the surface like a cork, the pygmy-geese would start to feed voraciously on the tiny organisms the diving bird had stirred up from the bottom and brought to the surface.

This interaction was not apparently mutually beneficial, but the turbulence created by the diving species, which must kick upwards when underwater to maintain submersion, was

BELOW Preparatory pencil drawing for *Yellow Waters*, done after spending a day there sketching in a boat

noticeable and clearly assisted the pygmy-geese in feeding.

Variegated Fairy-wren

Eventually Dick and I left Kakadu and travelled to Kununurra, in the Kimberley, first to the sandstone outcrops of Hidden Valley, where we hoped to find another subspecies of Variegated Fairy-wren, also referred to as the Lavender-flanked Wren (*Malurus lamberti rogersi*). This variant is confined to the rocks and spinifex of the Kimberley, similar habitat to that preferred by their Arnhem Land relative, *M. lamberti dulcis*. Indeed, the two subspecies are nearly identical, except that the white lores in the

female Arnhem Land birds are chestnut in the Kimberley bird, with other slight differences. Kimberley birds appear to have a brighter blue tint over their backs, compared to the duller greyish blue of the Arnhem Land birds, but both subspecies show intergradation with the inland Variegated Fairy-wrens where their ranges overlap, which we were able to check, because the birds proved relatively easy to find and co-operative to observe.

Dick had managed to arrange accommodation for us at a maintenance camp on the Mitchell Plateau, not far from Surveyors Pool, where we were to begin our search for Black Grasswrens (*Amytornis housei*).

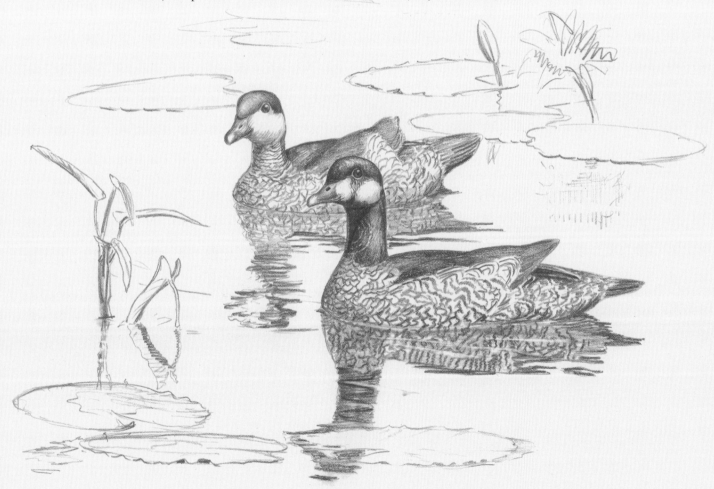

Black Grasswrens

When I was young, the Black Grasswren was a holy grail of ornithology, alongside the Night Parrot (*Pezoporus occidentalis*) and the Eyrean Grasswren. Discovered at the beginning of the twentieth century, it sank into obscurity until it was rediscovered in 1968 amongst the tumbled boulders along Manning Creek by the British Museum's Hall Expedition, working with methodical, almost forensic research to find the locality of the first sightings. This was on the southern margins of the bird's range, but naturalist Joe Smith found them near their northern limits on the Mitchell River shortly afterwards, and kindly guided Dick and me to Surveyors Pool. It was there, in the crags and clefts of jumbled sandstone clothed with spinifex, that we found Black Grasswrens. Like so many Australian birds, their supposed rarity had been due less to the disappearance of the birds and more to humans making insufficient effort to visit their habitat.

This was the final grasswren in our quest to see all species in their natural state. My first encounter with it was almost humorously anticlimactic. We left camp in the cold darkness of pre-dawn determined to find the birds while they were feeding in the early dawn, before the heat of the day drove them under cover. We arrived at Surveyors Pool at first light and started walking

quietly, alertly, through what we were certain was excellent grasswren habitat. For two hours we searched, with no result. By 8.00 am, we had separated to broaden the scope of our investigation; our shirts were wringing wet with perspiration and we had encountered not a single grasswren.

Discouraged, I sat down on a low rock and relaxed in the shade, my feet stretched out in front of me. I was roused from a light doze by a clear, sharp chirping. A movement just beyond my left foot had me instantly awake. Onto the rock on which my foot was resting hopped a male Black Grasswren, electric with curiosity, bowing, dipping, craning erect, flirting his tail this way and that, as he inspected this strange intrusion into his territory. Then he slipped back behind the rock and disappeared. Almost immediately he was replaced by the female, who, eschewing the rock, hopped onto the toe of my right boot. For several minutes they exchanged positions and inspected me, before deciding that I was not as terrifying as they had feared and slipping quietly away. I gave them a minute or two and then quietly followed them, observing their behaviour. I was bursting with excitement at my close encounter.

The birds were foraging actively for food, hopping or running energetically over the bare rocks and into deep clefts as they searched systematically for seeds and insects. The male was more vocal than the female, and Dick and I witnessed an odd little ritual in which, after singing from the crown of a rock, he would stoop forward, with wings spread and tail partly cocked and spread, and charge down the rock at the female below. We were unsure of the meaning of this demonstration, but wondered if it was associated with the defensive behaviour of 'rodent-running', when both parents, if threatened, will dash at an intruder to protect

LEFT Pencil drawing done at Surveyors Pool on the Mitchell Plateau after Dick Schodde and I had witnessed this curious little ceremony of the male Black Grasswren, flaring his tail, spreading his wings and running down the rock towards the female below; it required several attempts to clarify the posture before painting him, and we were unsure of the meaning of his actions
OPPOSITE *Black Grasswren* (detail), gouache, 33 × 24 cm The female bird; from the plate for *The Fairy-Wrens*

their young. Perhaps it had something to do with the male demonstrating his dominance. It was also necessary to consider that our presence might have influenced their behaviour.

For several days we visited Surveyors Pool at first light to watch Black Grasswrens as they started their feeding circuit, and each day they would keep us waiting until the sun had warmed the rocks and the insects had become active. They are large for a grasswren, almost as large as the White-throated, but dumpier and more compact. They normally held their tails low, which gives them a slightly more attenuated appearance, but they would raise their tails slightly and twiddle them about at times of greater excitement, when they were disturbed and hopped up to inspect their surroundings. Even as they scuttled along a crevice in the rocks, with head and tail lowered, they would occasionally raise their tails.

I found them to be quiet, curious and engaging, like the Dusky Grasswren. Certainly, they showed less of the shy reticence of White-throated Grasswrens, Carpentarian Grasswrens

and others of the 'striatus' group, which lends some weight to the lineages of evolution that Dick Schodde described.

Each day, Dick and I would cool off with a swim in Surveyors Pool, which we shared with a sizeable Johnstone's Crocodile (*Crocodylus johnstoni*). We would occasionally approach her end of the pool for a better view, but generally avoided disturbing her.

Back in Kununurra, as we bought supplies for the rest of our journey, I struck up a conversation with a young man heavily swathed in bandages. Had he been involved in a motor accident, I enquired. No, he'd been swimming in Surveyors Pool, where he was attacked by a freshwater crocodile!

We had suspected she was at the point of breeding, but she must have laid her eggs just after we left and chosen to defend her nest from this new intruder. Normally Johnstone's Crocs are so safe. Poor fellow; we commiserated with him.

Dick had chartered an aircraft to fly the length of the sandstone escarpment to Derby. He guessed that there was some divide that restricted Black Grasswrens from extending their range to the east, where apparently suitable sandstone habitat exists. And so it proved. Their region is corralled by the granitic Leopold Ranges to their south-west, and a broad belt of laterite and basalt that forms a barrier to the east.

Nevertheless, there are grasswrens in the sandstone and spinifex hills outside these barriers. Stockmen see them, and occasional reports come in, but the question remains: what are they? If, as Dick Schodde proposed, the speciation of grasswrens emanates from

LEFT Variegated Fairy-wren in pen and ink
BELOW Loose gouache study of a male Red-backed Fairy-wren sun-basking in the early morning near Walcott Inlet in the Kimberley; the crimson feathering becomes dominant from the rear when the feathers are flared
OPPOSITE Two of the many preliminary pencil drawings done during the years I worked with Dick Schodde on *The Fairy-Wrens*;
OPPOSITE ABOVE Striated Grasswren
OPPOSITE BELOW Dusky Grasswren

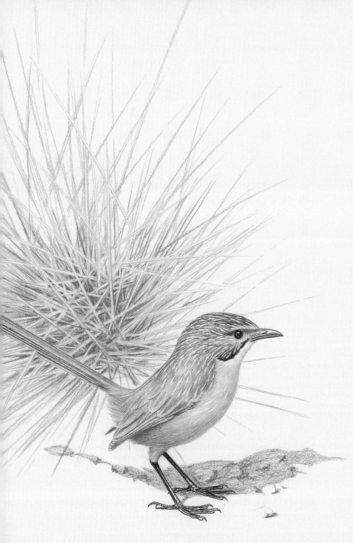

an ancestral form, and the Black Grasswren represents the lineage of stripe-throated species, while the Carpentarian and White-throated represent the lineage of the Striated group, could there be an equivalent to the Carpentarian or White-throated Grasswren in the hills behind Fitzroy Crossing? Or perhaps the birds seen there are a derivation, another subspecies of the Thick-billed, or an isolated subspecies of Dusky Grasswrens. More and more people are travelling to that region, so the question will be answered before long.

On the trip back to Kununurra, we stopped at Manning Gorge to check for Black Grasswrens at the site where they were originally collected, but the landscape had been so severely burnt that we found nothing.

Ten years after the publication of *The Fairy-Wrens*, I was back in the Kimberley watching Black Grasswrens along Bachsten Creek, between Mt Elizabeth Station and Walcott Inlet. It seemed that whenever we found Variegated Fairy-wrens,

they were associated with grasswrens, and this observation was confirmed by a local bushman.

In 1975, Dick Schodde published a paper which made a bold, but well-reasoned, decision to allocate the fairy-wrens to their own distinct family; despite criticism, our wren book followed the same taxonomy. It helped that it was not long before ground-breaking advances in molecular biology, led by Charles Sibley at Yale University, began to throw new light on the origins of Australian songbirds. He confirmed that the fairy-wrens were a close group with origins removed from their previously supposed relatives in Europe and Asia.

Dick surmised that for radiation of malurine wrens to have proceeded so far, they must have begun to diversify as long ago as the early or mid-Tertiary, at a time when Australia and New Guinea were a drifting fragment of the supercontinent Gondwana, located far to the south of where they are positioned now. Their interrelationships must be intimately connected with other early antecedents in the tree-wrens, russet-wrens and fairy-wrens of New Guinea.

It seemed that New Guinea held a key to the evolution of fairy-wrens, and so we planned our trip to the north.

PAPUA NEW GUINEA

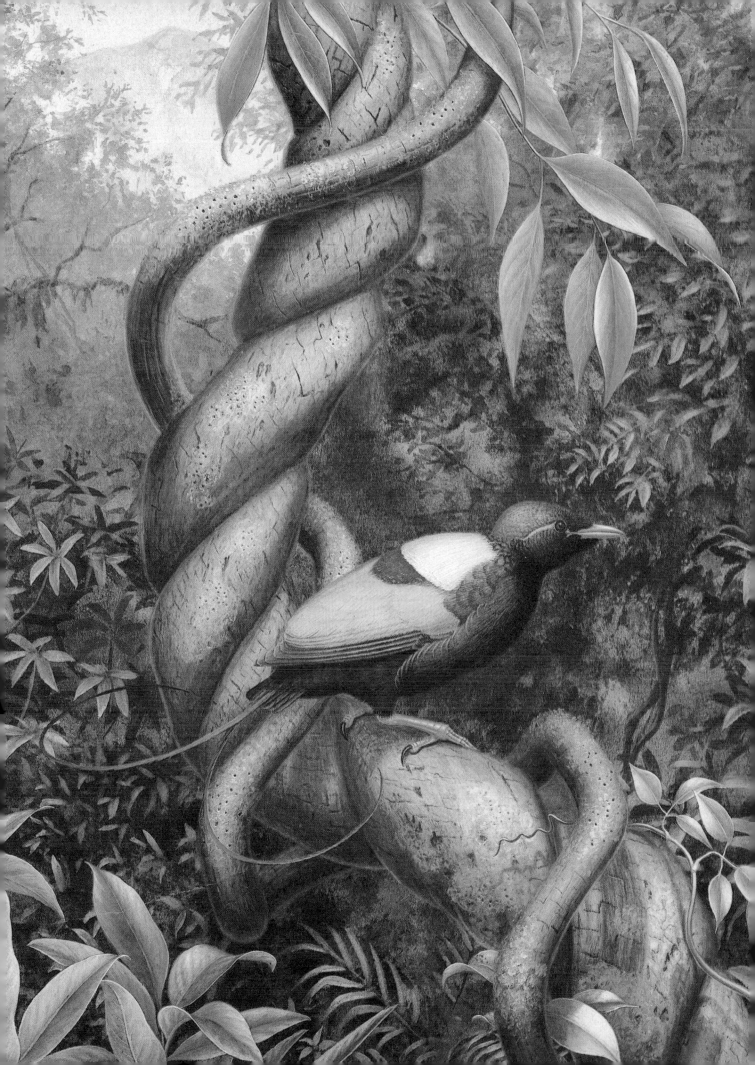

Pig-pen with totemic carving in human. Maprik - Wagri Road, Central Sepik, July 1981

DICK WAS GREATLY experienced in New Guinean ornithology, but I was an ornithological novice, having only been on a school trip to New Guinea in 1966. It was two years before we could travel there. We were fortunate to be collected and taken to Civic Guest House at Boroko by Brian Finch, the Secretary of the New Guinea Bird Society, which was well served by its office-bearers: President, Bill Peckover; Treasurer, Father Peter Heron; and Secretary, Brian Finch.

Next morning, while we waited for our hire car, we visited the Department of the Environment to speak with the Chief Officer in the Wildlife Division, Navu Kwapena, and clarify our plans with him before heading into the field.

Megapodes

To my great pleasure, we also met Karol Kisakou, the Director of the department, a most impressive man with a keen and dynamic intellect and enormous energy and charm. He willingly discussed his work on megapodes – medium to large birds, slightly reminiscent of rather dull-looking domestic fowls, with a pointed, triangular crest on the back of their heads. Of the many species and subspecies that range through tropical forests, mangroves and beach-side habitat, most incubate their eggs by building large mounds of earth and rotting vegetation and controlling the temperature generated. The megapodes that Karol Kisakou had been studying were a group that abounds along the coast of New Britain in a region of constant volcanic activity, where they utilise the warm soil of those volcanic areas for their incubation. The hen senses the temperature with her beak, laying the large egg at exactly the correct depth and maintaining the temperature at thirty-four degrees Celsius by scratching away volcanic soil or adding it, as necessary.

When the chick hatches, its eyes are protected from the soil by a thin membrane that remains in place until it has completed its struggle to the surface. During the one or two days that this might take, its feathers dry, so that when it escapes the soil it is fully fledged and self-sufficient, not only to forage for its own food, but also, almost miraculously, to fly if necessary.

Jenny had been in New Britain in 1974, making a film on megapodes for the ABC with the brilliant film-maker and photographer David Parer, and Karol Kisakou as an adviser. David was held in high esteem throughout Papua New Guinea, partly because of his gentleness and his careful portrayal of the people and their wildlife.

David would stay in a hide, often high above the forest floor and in acute discomfort, for as long as it took to get the perfect shot for the story. The film was as much about the human interaction with the megapodes as it was about the birds themselves. The New Guineans have harvested their eggs for generations, in a sustainable manner and often at considerable risk beneath the rumbling shadow of Mt Tavurvur, a dangerously

active volcano and part of the Rabaul caldera, which largely destroyed Rabaul in 1994.

It was early afternoon before we managed to leave for Brown River to search for the Emperor Fairy-wren (*Malurus cyanocephalus*). Initially we travelled through tropical savannah woodland similar to that found in northern Australia, dominated by grassland and white gum (*Eucalyptus alba*), but soon we were in rainforest with the additional interest of Raggiana Birds of Paradise (*Paradisaea raggiana*) flying across the road above us.

Emperor Fairy-wrens are inquisitive and easy to see, and in coastal rainforests around places such as Port Moresby they are noticeably abundant. Nevertheless, we were less successful than we had hoped.

Next day we eventually departed for Wau and Mt Kaindi at 6.30 am, on rough, muddy roads out of Lae, through crowded villages and their wandering dogs, chickens and pigs. Dick warned me that, should we hit anything or, God forbid, anyone, not to stop under any circumstances, but to speed off as quickly as possible. Fortunately, we travelled with due care and without incident.

On arrival at Kaindi, we went in search of the Bulldog Track, a remnant of what was once dubbed 'Reinhold's Highway', after W. J. Reinhold, the chief engineer responsible for its construction over nine months in 1943, using picks, shovels, crowbars and dynamite. The only vehicle track ever to cross the central mountains of Papua New Guinea, it has now fallen into disuse for anything other than foot traffic.

About a hundred kilometres west of the Kokoda Track, the Bulldog Track is reputed to be the steeper and more rugged of the two and is considered one of the more challenging tropical montane forest treks in the world. In those early sections, close to Wau, it was a benign haven of unspoilt jungle, which had recovered rapidly from the ravages of mechanical engineering.

Brown Sicklebill

In the low light and high humidity, the broad, open track provided good visibility and allowed us to move silently. Moss, orchids and other epiphytes clung to tree trunks and branches. A Brown Sicklebill (*Epimachus meyeri*) called, with its mechanical, machine-gun '*tat-tat-tat-tat*', an indication that we were in undisturbed primary forest. He was a large bird – nearly a metre long – racing on powerful feet through the branches with relentless energy, stopping to carefully pluck fruit with the tip of his bill and then, with a backward flick of his head, swallow it. Occasionally, he hung downwards to probe mossy crevasses for prey, presumably insects.

Belford's Honeyeater

This was also the place where I first encountered Belford's Honeyeater (*Melidectes belfordi*), a large, energetic honeyeater with a call reminiscent of the Australian Noisy Miner (*Manorina melanocephala*); it is indeed a close relative of the

LEFT Pencil sketch of a young Emperor Fairy-wren near the Veimauri River, Papua New Guinea, used in the final plate depicting that species in gouache for *The Fairy-Wrens*; 33 × 24 cm
OPPOSITE The *Emperor Fairy-wren* plate for *The Fairy-Wrens*; 33 × 24 cm

because we knew that the Orange-crowned Fairy-wren had been recorded there previously. Next day we left the Wau Ecology Institute at 5.30 am, but it was 7.00 am by the time we arrived.

Princess Stephanie's Bird of Paradise

We were almost immediately rewarded by encountering a Princess Stephanie's Bird of Paradise (*Astrapia stephaniae*), which allowed us excellent views. First, it settled down to preen thoroughly, sitting stolidly on a horizontal branch, fluffed out, head on shoulder, with its substantial tail held vertically below. In silhouette it appeared to have a protruding mass on the back of its head, where the feathers project.

When it began to feed, it ran through the branches swiftly and athletically, a kind of hopping, squirrel-like run, with the tail held low, similar to the attitude of a Squirrel Cuckoo (*Piaya cayana*) in South America. It was full of intense nervous energy and would periodically give an apprehensive flick of its wings. Its gait and carriage, and the wing-flick, reminded me of a disquieted lyrebird I had seen pacing its cage in Taronga Park Zoo.

Red-breasted Pygmy Parrot

Sometimes in my life I encounter a completely new bird, one of whose existence I had previously been totally ignorant. As we moved slowly along the track, I suddenly became aware of a bird, a tiny, elfin mite of a parrot, with enormous character. The surprise encounter with this little bird enchanted me. Dick, of course, without hesitation identified it as the mountain micropsitta, or Red-breasted Pygmy Parrot (*Micropsitta bruijnii*), but to me it was a breathtaking jewel of a bird, green on its back, bright and glittering with orange cheeks, blue nape and breast-band and bright red belly.

Manorina miners, although not as acrobatic. It assumes a multitude of miner-like poses, leaning forward with its head craning, just as a miner does. When preening or relaxed, its posture is similar, and it takes up miner-like threat postures. The submissive stance of a subordinate involves a hunched, deferential pose with head raised.

We decided to return to this beautiful, pristine rainforest in the early morning, not least

It was feeding head downwards, apparently on the mosses and lichens, and moving vertically as a sittella might, but more sedately, creeping up and down branchlets and small tree trunks, mostly on vertical stems, although this is contrary to the descriptions by Gilliard and Robinson, in Joe Forshaw's *Parrots of the World*. It was noticeably hunched in posture, with feet spread wide and toes pointed away from the body, its wingtips spread slightly either side of its tail.

The tail itself was as utilitarian as a woodpecker's, with stiff, projecting central shafts to the feathers, and used in the same way: always held towards the trunk of the tree and used as a prop when the bird was feeding upwards, but still touching, or nearly touching when it was facing downwards. The bird's body didn't move much, but its head was very active as it grazed, frequently breaking off to look around. It fed very actively, but moved slowly, nibbling and fossicking in grooves in the bark, where, I understand, it seeks a fungus on which it likes to feed. This delightful little bird spent about fifteen minutes methodically feeding up and down small vertical branches of a mid-stage tree, but we never once saw it transfer to a larger trunk.

When our book on fairy-wrens was eventually published, many of my field drawings were used to decorate the text, including wildlife other than fairy-wrens. Not surprisingly, our time was spent observing all the wildlife we encountered, other than just wrens. This allowed me to portray the character of the ecosystems in which the different species of fairy-wrens were found. In Papua New Guinea, Dick and I recorded 183 avian species in one day, and even in Australia, we saw over 160 species in a single outing. It would have been a great pity to ignore such opportunities simply because we were looking for wrens! So, I drew the pygmy parrot while I had the opportunity.

The New Guinean forests abounded in exciting birds; my notebooks are full of them. However, our hopes of seeing Orange-crowned Fairy-wrens were dashed. Our journey was tightly planned, so it was time to move on to our next location. This was to be further north and west, in the East Sepik region of Papua New Guinea.

After the excitement of the pristine mountain forests, our new surroundings seemed very quiet. There were numerous Varied Honeyeaters (*Gavicalis versicolor*) at Wewak, but along the road to Maprik, broad areas of Kunai Grass grew where forest had been felled for kau-kau (sweet potato) gardens. These depleted the soil and prevented regeneration of secondary forest. As most of the ecosystem is adapted to primary and secondary forest, the fauna in Kunai Grass areas is limited.

Post-and-rail pigpens, constructed to hold pigs overnight, often featured striking statues, carved from the trunks of forest trees and usually with their left arm raised, presumably to ward off evil spirits, particularly those spirits prone to stealing pigs.

In search of better locations, we turned down the road to Pagwi in the hope of finding an area of primary forest. Having found a possible locality near the village of Jama, we returned to our hut at Maprik to camp.

Next morning, we arose at 5.30 after a night in which rats had turned our hut into a playground. Our two local guides were late, but it was not until 8.00 am that the forest awoke and we began to see many more species than we had encountered the previous afternoon.

Unlike the forest of the Bulldog Track, this lowland rainforest lacked lichens and mosses in the upper canopy, and looked drier and more open; the numerous climbing vines and epiphytic orchids are present in both.

OPPOSITE The male Broad-billed Fairy-wren (*Malurus grayi*) is rarely seen and our search for it took us to the forests of the central Sepik region, near the village of Jama; a detail from the plate depicting that species in gouache for *The Fairy-Wrens*, 33 × 24 cm

King Bird of Paradise

Amongst the many birds we saw, it was a delight to watch a brilliant crimson male King Bird of Paradise (*Cicinnurus regius*) as he worked his way up the hanging vines of the canopy. He moved sluggishly, almost in slow motion, with none of the vibrant energy that I had previously associated with birds of paradise and bowerbirds. Reports of males on their display trees describe much greater energy and speed. I had expected his luminous crimson to glow in the darkened forest, but to my surprise, his lustrous blue feet outshone even his white belly.

Broad-billed Fairy-wren

By all accounts, the Broad-billed Fairy-wren is one of the genuinely rare New Guinean birds. Early records came mostly from north-western New Guinea, but this range was extended by D. L. Pearson, who found them in the early 1970s in the East Sepik Province where we were searching, along the Maprik–Pagwi road.

Whether they are truly rare, or just very difficult to observe, is hard to determine. There are only a few descriptions of them in the wild, and it seems that they feed in small parties, foraging rapidly in a manner similar to Orange-crowned Fairy-wrens, with their tails partly cocked as they flutter through the undergrowth, snatching insects disturbed by their passage.

White-shouldered Fairy-wren

Once I had completed the sketches for the background of my paintings, we began our retreat from the forest; the Broad-billed Fairy-wren for which we were searching was still eluding us. As we walked through the Kunai Grass, we suddenly found ourselves amongst fairy-wrens; these were a grassland species, the White-shouldered Fairy-wren (*Malurus alboscapulatus*) moving ahead of us and often hopping sideways up the grass stems to monitor our activities. The glistening black male, with his clean white scapular patch, frequently flew from one exposed stalk to the next, giving me an excellent opportunity to observe him. The group was composed of one nuptial male and three out-of-colour birds, which had blackish-brown backs, white throats and tail tips, and clear white 'spectacle' marks around their eyes.

A characteristic of these wrens was the constant flicking of their tails, not sideways, as we see so often with Australian fairy-wrens, but up and down. Mostly the tail was carried high or vertically,

ABOVE Pen and ink drawings of the White-shouldered Fairy-wren in the Kunai grasslands of the central Sepik region
LEFT Pencil drawing of Jama, where we camped while searching for the Broad-billed Fairy-wren
OPPOSITE *White-shouldered Fairy-wren*, gouache, 33 × 24 cm Plate depicting the species for *The Fairy-Wrens*

Jama, Maprik–Pagwi Road, central Sepik.

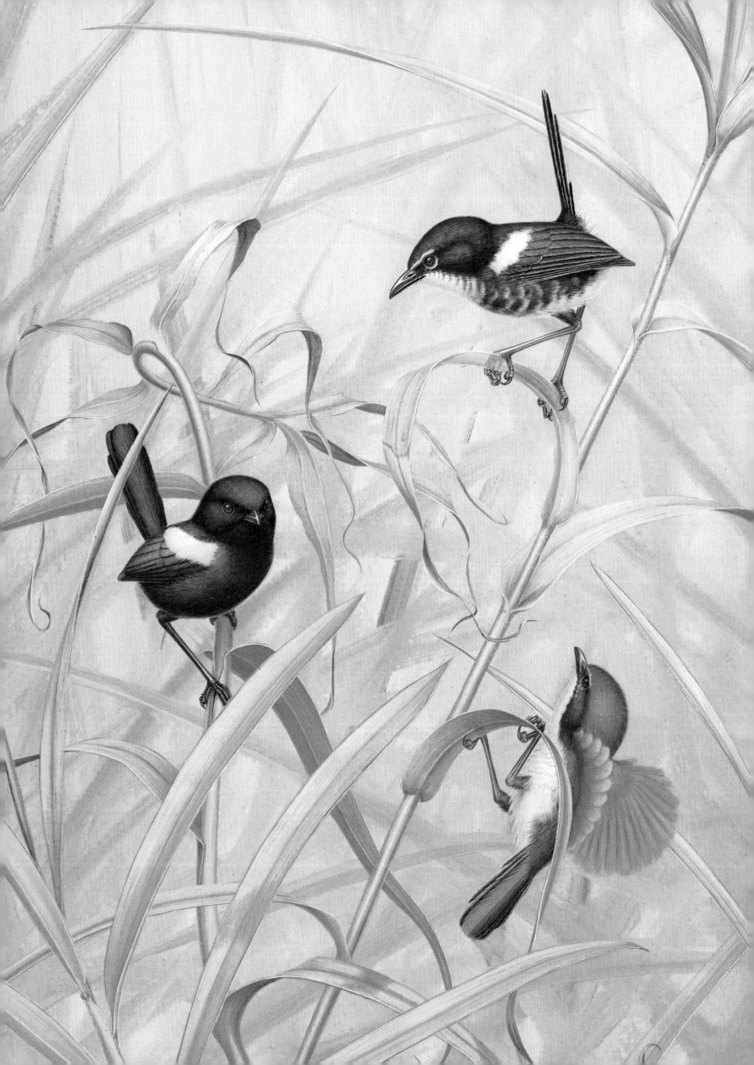

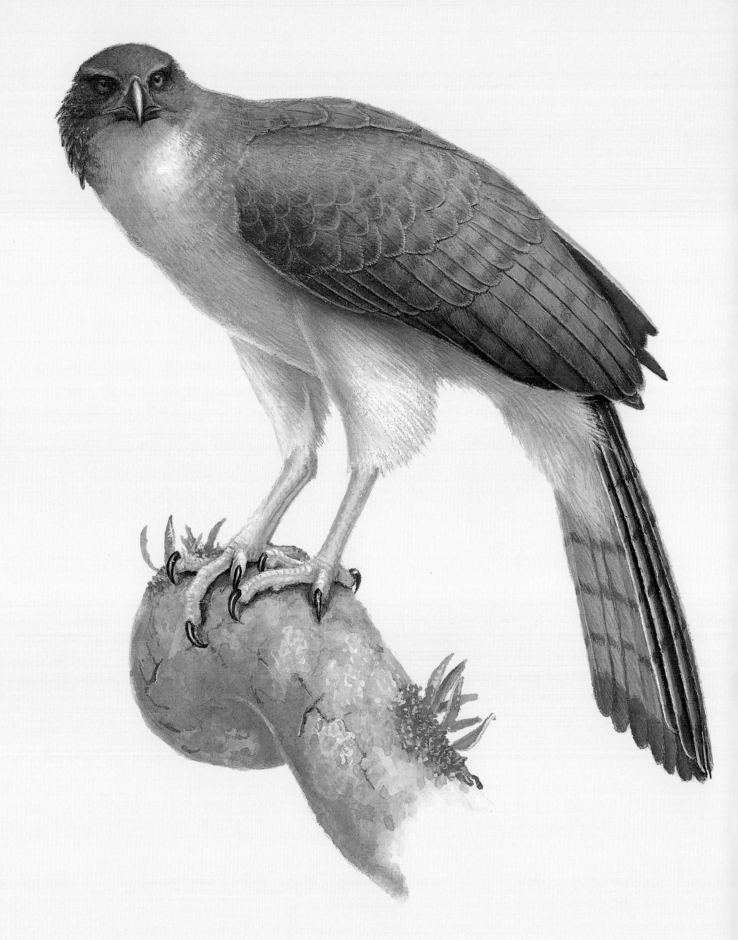

and it was distinctly shorter and broader than in Australian fairy-wrens. Their call was a rollicking version of the call of the Australian White-winged Fairy-wren, but more musical. It lacked the introductory notes of the red-shouldered group, such as the Variegated Fairy-wren.

In shape, the birds were of the compact, rounded appearance of the Red-backed Fairy-wren, except that their tail was very short and their bill was much longer and heavier, as were their tarsi. Clearly, the White-shouldered Fairy-wren is a relative of the arid-country grassland fairy-wrens of Australia, the White-winged and Red-backed, but is much more catholic in its choice of locality, frequenting tall grasses wherever it finds them, including cleared Kunai regions, old gardens or even swamps.

The following morning, we departed for Wewak, to fly on to Mt Hagen and the Baiyer River Sanctuary, in the heart of Papua New Guinea's Western Highlands.

Flying in the highlands always carries risks. By mid-morning there is frequently cloud hanging low over the mountains, drastically limiting visibility. Dick, with his lengthy experience of New Guinea, was desperate to get into the sky early. The plane stood ready, and an eager mob of impatient passengers milled around, but still we waited.

Eventually, a pilot – all of nineteen years old – emerged in a smart Alitalia uniform. Steam was hissing from Dick's ears, but I soothed him by pointing out that we were in experienced hands.

Full of trepidation we climbed aboard the aircraft. The pilot was exhibiting signs of uncertainty; as we taxied out onto the runway, he seemed to be shuffling through the pages of a slim volume, searching for something. Perhaps it was the *Boy's Own Atlas*. As we took off and flew out over the Sepik River, he finally turned to the

passengers and asked loudly, 'Does anyone know the name of that river down there?'

Fourteen passengers shouted, in several languages, 'The Sepik!'

We flew on stolidly towards the bank of clouds obscuring the mountains. At one point the clouds parted and our pilot identified a small settlement, incorrectly, as the Baiyer River Sanctuary. By this stage Dick was not a happy man, but as we descended through the mist and the Mt Hagen airport came into view, I said, '*You* know that this is Mt Hagen. And *I* know that this is Mt Hagen. But I wonder where the pilot thinks he's landing?'

There was no trace of a smile on Dick's face, although he brightened when Roy Mackay arrived to take us out to the Baiyer River Sanctuary, about forty kilometres away, with excellent forest and numerous bird species. The Australian administration had opened this nature reserve in early 1968, but it had since expanded.

Sadly, of recent years, there has been considerable unrest in the region and the main buildings have been consumed by fire. I would imagine disaster would have befallen the captive birds: too many were of an edible size. At the time we were there, the bird collection was of great interest, enabling me to sketch details of some of the shyer species.

New Guinea Harpy Eagle

It was here that I had the opportunity to see a New Guinea Harpy Eagle up close, and to observe what a remarkable bird it is.

I had seen a male New Guinea Harpy Eagle in a spectacular aerial display flight as we left the lowland forest and came out into the open on the previous day. The bird would half fold its wings, before rolling forward into a dive, at the bottom of which he would spread his wings and tail to

throw up into a stall, from which he would roll forward again. We observed three stoops of about twenty-five to fifty metres during a brief period, each dive sequence lasting about two to three seconds.

The harpy is a distinctive bird, with quite short, noticeably rounded wings, a very long, rounded tail barred with regular dark bands, the terminal one being the broadest, and long, bare yellowish legs. In many respects it is like a very large goshawk, built for hunting wallabies, possums and tree kangaroos in jungle conditions; also, according to the New Guineans, it hunts their piglets.

The term 'a formidable predator' seems almost too benign for such an impressive bird. When 'still hunting' (perched, searching for prey) it will crane its head horizontally forward or sideways in sometimes contorted attitudes, rather reminiscent of a huge goshawk, particularly the Red Goshawk (*Erythrotriorchis radiatus*). Prey species include cuscus, possum, tree kangaroo and wallaby, and possibly some of the tree rats. Occasionally they will land on a branch that has a hole in it, harbouring prey. The harpy will shake the branch or bang it, hoping to flush out a possum or other creature. Failing that, it may methodically rip the branch apart with its powerful feet to reveal its quarry.

The New Guineans report that it will crash blindly through the forest canopy seeking wallabies, sometimes landing abruptly on the ground beside a startled animal, then chasing the shocked wallaby on foot, assisted by sharp flaps of their half-folded wings. Having witnessed how agile they are on their feet, I believe that they can chase and catch animals on the ground.

Their flight is powerful and controlled, and they may be found soaring either in wide ascending circles or close above the forest canopy, but they more typically spend their time perched in the sub-canopy of forest or on tall dead trees, searching for prey.

From the Baiyer River complex we left in the early morning to camp overnight at Tomba in search of the Orange-crowned Fairy-wren. There was a little dip where they were known to occur at Mur Mur Pass, but we found that the country had been heavily cleared.

Birds of paradise

Close by our camp was a small fruiting sapling, an Umbrella Tree (*Schefflera actinophylla*), and into this flew a hybrid bird of paradise. It was a cross between a Ribbon-tailed Astrapia (*Astrapia mayeri*) and a Princess Stephanie's Bird of Paradise. On the eastern limits of the range of Ribbon-tailed Birds of Paradise, on Mt Hagen and Mt Giluwe, these Astrapia hybrids are not uncommon, being known as Barnes's

Long-tailed Bird of Paradise or Barnes's Astrapia. Jared Diamond has indicated that the hybrids at lower altitudes more closely resemble Princess Stephanie's, while at higher altitudes there is a closer resemblance to the Ribbon-tailed. Yet they are also very local, and elsewhere in the western Papuan highlands, on Mt Giluwe and the ranges north-west to Wabag and the Porgera, Ribbon-tailed and Princess Stephanie's birds of paradise replace one another altitudinally without interbreeding: they are separate species. Until the 1930s Barnes's Astrapia was itself thought to be a separate species and was classified in 1948 as *Astrarchia barnesi* by Tom Iredale, an English-born ornithologist of no formal training. Since then, it has been recognised as a hybrid, and no modern taxonomist has made any move to separate it as its own species.

These fruit-eating birds visit a series of food trees in rotation at set times of the day: a morning food tree may be totally neglected during the afternoon or vice versa. I waited nearby, watching the Umbrella Tree, and again an Astrapia bird of paradise flew in to feed. Its postures seemed crouched and exuded activity, but somehow less obviously energetic than the pure Princess Stephanie's that I had observed previously on the Bulldog Track. In silhouette, the shape was more Ribbon-tailed. The tail was of a Princess Stephanie's dimension, broader and shorter, but

white for two-thirds of its length with a black tip. All three of the males that we saw were equally hybridised, or at least of similar appearance; the females appeared very similar to a female Princess Stephanie's Bird of Paradise, but, again, with less nervous energy. Also, the flanks appeared to be less obviously barred. Both sexes scrambled like a squirrel around the branches, selecting berries to eat. When they flew, they swooped in huge loops from the top of one tree to the next, their tails streaming behind them. Over longer distances they flew fast and direct.

There were many other interesting birds on the Mur Mur Pass. Two species of honeyeater overlapped at the ridge: the green-eyed Rufous-backed Honeyeater (*Ptiloprora guisei*) and the Grey-streaked Honeyeater (*P. perstriata*). The latter is darker than the Rufous-backed, and larger, without rufous edging to the black feathers of the back. Both have bright, lime-green eyes, unique amongst honeyeaters.

There were also three species of scrubwren, one of which, the Mountain Mouse-warbler (*Crateroscelis robusta*), reminded me slightly of a reed-warbler. It feeds on the ground in dense undergrowth, climbing rapidly to a vantage point if disturbed.

The following day, we returned to Port Moresby, before leaving very early with Brian Finch the morning after, to be at Brown River before first light in our search for Emperor Fairy-wrens, one of the more familiar of New Guinean birds. I was still to sketch one for the wren book.

Emperor Fairy-wrens at last

By seven o'clock we had found the Emperor Fairy-wrens calling, a strong, reeling call. They were at the edge of the road beside a swamp, in low forest secondary growth, feeding in and out of grass stems and low shrubbery. There appeared

to be two males and a female present, behaving in very much the way one would expect from *Malurus*, which of course they are, although the males seemed to be longer in the body and much broader in the tail, which they held cocked. The female's chestnut back reminded me of the Variegated Fairy-wren, although this was probably naive autosuggestion. Each sex has an equally broad tail, the male's blue-black, the female's with a clear band of white at the tip of each feather. The bird's postures were crouched and relatively low, but with all the movement and energy of the Australian malurids.

They mainly gleaned insects from the low branches of small shrubs, leaping from twig to twig or fluttering between perches. They appeared to be searching for insects methodically in the bushes. The group was led by a brilliantly coloured male bird, and periodically he would emerge onto exposed perches. The female was much more discreet and difficult to observe, but appeared to keep contact with the group by calling and shaking her cocked, well-marked tail vigorously from side to side in the familiar wiggle of the Australian Superb Fairy-wren. At moments of excitement, when the males tended to congregate on partly exposed perches, she held her tail proudly upright. For nearly two hours we watched these gloriously bright fairy-wrens, yet they stayed within an area of about sixty-five metres, mostly along the bank of the road.

Wallace's Wren

With plenty of sketches to work from, we moved on to a timber reserve on the Veimauri River, to which Brian Finch had access, to search for another wren species critical to our book. Wallace's Wren, the smallest and perhaps least obvious of all the fairy-wrens, was named after Alfred Wallace, who almost pre-empted Charles Darwin with his

conclusions about evolution by natural selection. Somewhat like Wallace, the wren remained poorly recognised for many years. After its initial discovery by Europeans in 1860, another seventy years passed before its widespread distribution in Papua New Guinea was fully understood. The species occurs throughout the island in parts where rainforest veils the lower slopes of the mountain ranges, extending into rainforest on the plains and to an altitude of about eight hundred metres, even as far as twelve hundred metres, in the rainforests of the foothills.

Wallace's Wren inhabits the trees rather than the understorey, working within the vines and bamboos in glades where a tree has fallen or at the forest edge. Generally, they will work in the lower strata above two metres, but opportunism may take them anywhere from nearly ground level to the canopy.

A social bird, forming groups of four or five to ten, they favour feeding parties of other species. We encountered one at Veimauri River which included a drongo, whistlers, fantails, monarch flycatchers, gerygones and two genera of honeyeaters, all of which came through like a storm, followed by about six to eight Wallace's Wrens, which appeared to be feeding on insects disturbed by the forerunners of the group. They gleaned swiftly along twigs and vines, probing beneath leaves or fluttering like a gerygone beneath the foliage to snatch insects. Sometimes they leapt into the air like a flycatcher to grasp disturbed insects in flight.

Despite the speed and urgency of their passage, these little birds searched methodically through each patch of vines in the manner of the Acanthizidae, hopping steadily through the

OPPOSITE Pencil
sketch of a Wallace's
Wren, showing the
fluttering nature
of their progress
through the forest
as they glean insects
from twigs and leaves
BELOW Pencil study
of a Wallace's Wren
inspecting the lower
surface of a leaf for
insects

foliage, balanced with slightly spread wings and tails, which were carried straight behind them.

The next morning, Dick and I boarded a chartered aircraft to fly to a tiny, 'zero take-off' airstrip on the end of a cleared ridge in the Owen Stanley Range. It was Efogi, where Dick had worked previously, on the Kokoda Track, a bit over thirty kilometres from Kokoda and about as far south of the crown of the Owen Stanley Range as Kokoda is to the north.

As we descended in the aircraft, villagers gathered at the airstrip, and when we alighted, individuals came forward to greet Dick. Clearly they remembered him with affection, and we were shortly ensconced in our own 'guest' hut to prepare for the evening.

Brian Finch had drawn a very detailed map, marking places on the Kokoda Track where he had seen the Orange-crowned Fairy-wren. We had tried walking into their habitat without success; we had failed to mist net them in a known locality; this time, we would walk to a known territory and wait for them to find us. This wren inhabits different places from other wrens, the only one to occur at altitude, in the undergrowth and sub-stage of mountain forest, eschewing the interior of primary forest. With their sombre colouring, they are, it seems, often overlooked and are little known. They appear to live along both the north and south sides of the mountainous spine of the central cordillera in the dense forest

slopes above twelve hundred metres and up to three thousand metres. The birds are thought to remain in the same territory year after year, and it was on this behavioural trait that we were to rely.

As soon as we had sufficient light next morning, we set out from Efogi to walk the famous Kokoda Track. It was difficult not to feel overawed. It is steep; it is muddy; it is challenging. It is also beautiful, interesting and rewarding. The first part was very easy; at the outskirts of the village we plunged downwards to a rough crossing of stones and rocks over a small stream. Thereafter, there was a long walk through native gardens, all beautifully tended, but prone to revert to Kunai Grass cover. This brought us to a stand of scattered pandanus, which extended through grassland down a cleared hill below us. From this our pathway plunged into very open forest, then we slid down another steep descent. Passing through an old garden we came to a hut in a clearing, beyond which were some magnificent tree ferns.

On and on we walked, through forest and clearings to a huge kau-kau garden, where, in a dead tree, sat an Oriental Hobby (*Falco severus*), a beautiful, dashing little falcon with rich chestnut from his white throat to under his tail, and dark, slaty grey from his black hood to his tail tip. Shorter and more compact than an Australian Hobby, he radiated power and speed when he took off and sped down the valley.

Ornate Honeyeater

We were nearing one of the sites Brian Finch insisted was Orange-crowned Fairy-wren territory, so we each chose a position inside the forest and settled down to wait. This was no easy task, for several reasons. Foremost was the welcome distraction of other birds calling all round us. The lovely Ornate Honeyeater was extremely vocal

*Vaimann River,
25th July 1981*

near the edge of the rainforest. This striking bird has a bright yellow patch of bare skin around its eye, above which is a small patch of rufous cinnamon feathers highlighted in stark relief by a dark hood, broken only by the eye-patch and a broad white band across its throat, which extends to the gape as a line of rufous cinnamon. Its breast is banded black, then a yellowish cinnamon below, with even black marks along its flanks. Its back is dark grey, almost black, with clear white margins to the feathers, and its grey-brown wing feathers have margins of buff along the fringes, giving the impression of a yellowish patch on the folded wings.

Also calling was a Superb Bird of Paradise (*Lophorina superba*), with a drawn-out, riflebird-like rasp. It was further back into the forest but occasionally came closer, visiting a tall shrub to feed on fruit. The silhouette of a Superb Bird of Paradise is distinctive, with its arrow-shaped breastplate and black cape. It seemed to move quite slowly when feeding, picking carefully over the fruits.

Quite suddenly, the quiet of the forest was disrupted by a yell from Dick, calling me to come to see what he had caught. He was shouting that he had a python by the tail; why, I had no idea.

When I arrived, I found him struggling to hold a large snake of over two metres. He had a firm grip around the tail, while the other end was making a determined effort to leave. However, our identifications differed. To me his snake looked particularly like a taipan, and when I suggested this to him, and that he might like to relinquish his grip and run very fast somewhere – anywhere – he took less persuasion than I had feared he might.

In fairness, Dick says he has no recall of this incident and that he is normally cautious with snakes. I have an alternative recollection clearly etched on my memory!

Lawes' Parotia

We returned to our long wait on the track, slightly less relaxed than previously. A movement caught my eye further back in the forest, and a dark bird, apparently black, glided down to a tall shrub from which it began selecting fruit. After a fairly long interval, it dropped to the ground, where its stance and gait were reminiscent of a pitta. As it hopped on the forest floor, brief glimpses of its bronze-green breast shield declared it to be Lawes' Parotia (*Parotia lawesii*).

Orange-crowned Fairy-wrens

Suddenly, all this was forgotten. There was a disturbance in the forest sub-stage on one side of the track just downhill from me. A group of russet-looking birds were coming swiftly through the undergrowth, hopping and fluttering from one stem to the next, gleaning from the undersurface of the leaves.

This was what we had been waiting for. A party of Orange-crowned Fairy-wrens was on the move, darting from side to side as they advanced, a tiny cyclone of avian activity, passing

BELOW *Oriental Hobby*, gouache, 21 × 30 cm
This hobby was perched on a tall dead tree in a huge kau-kau garden as we ascended the Kokoda Track
OPPOSITE *Orange-crowned Fairy-wren*, gouache, 33 × 24 cm
Plate depicting the species for *The Fairy-Wrens*

through so swiftly that only the shaking leaves of the understorey were left to mark their passage. They were like bulky emu-wrens, their tails held half cocked, but not agitated or quivered in any way; they moved laterally to make contact with each other frequently. Arriving at the walking track to Kokoda, they hesitated, but then fluttered across on their tumultuous way, disappearing as swiftly as they had arrived.

Following in their path, and no doubt benefitting from their passage, was a loose agglomeration of species that represented a feeding flock: whistlers, fantails and a range of insectivores that were capitalising on the disturbed insects left by the fairy-wrens.

This, then, was what we had come to find. We were stiff from sitting motionless for so long, and itchy, very itchy, as the renowned bush mites made their presence felt, but we had achieved

what we needed and it was time to retrace our steps to Efogi before night fell.

We had an aircraft chartered to collect us the next morning, and in gratitude for the hospitality of the villagers, we offered the spare seats to any of them who needed to travel to Port Moresby. One villager was eager to take advantage, for as it turned out he had trapped some Musschenbroek's Lorikeets (*Neopsittacus musschenbroekii*), which can be common around such villages, and wished to trade them in the market in Port Moresby. After some soul-searching on the ethics of such a venture, we felt that it was going to be extremely complex to withdraw our offer on moral grounds, and so he boarded the plane with us.

For Dick and me, it was time to return to Australia. We had gathered the information we had come to New Guinea to seek. Now we must put it together as a book.

The Maluridae

DICK SCHODDE HAD observed fairy-wrens in the wild in both Australia and New Guinea, examined specimens in major museums all over the world, researched the published literature and thought deeply on the origins of fairy-wrens. In 1975, he had first published his concept that not only were they completely distinct from northern-hemisphere wrens and warblers, from which a Eurocentric vision had perceived that they had evolved, but they held greater affinity to some other groups of indigenous Australasian birds.

Dick recognised the success of various passerines in a similar niche to the fairy-wrens, their general way of life being so apt for small insectivores that it has emerged in a number of unrelated groups of birds. He identified four of these groups: in Eurasia, in the Americas, in New Zealand and in Australia and New Guinea. Their common behavioural characteristics – of rummaging through undergrowth for insects, their reluctance to fly far, permanently inhabiting the same territory, defending it with a luxuriant portfolio of song – he recognised as being probably convergent evolution.

Dick had identified a number of anatomical structures that were unique to the Maluridae, as he called them. He recognised the evolutionary trends in their bill shapes and the arrangement of their rictal bristles; he examined the underlying structure of their skulls, noting a characteristic form in the bones of the palate and the development of auditory bullae behind the ears to enhance hearing with shifts in environment; he classified differences in their plumage patterns, some for camouflage and others for signalling;

and he recorded how some markings are common to the development of all plumage patterns, such as the dark pectoral girdle that terminates at the gape, and the jewellery of the erectile blue ear-tufts of the fairy-wrens, which emanates from the lower eyelid and is present in at least vestigial form even in emu-wrens and grasswrens.

These features, and more, he recognised not only as evidence of interconnections amongst all the malurine wrens, but also as traits that separate the malurines from all other wren- and warbler-like birds. Their distinctively cocked tail is one, having two or more feathers fewer than the twelve that make up the tails of almost all birds. Emu-wrens have only six, near barbule-less, long plumes that resemble the feathers of an Emu. Another is the interscapular gap. In most birds, body feathers are not attached randomly to the external surface, but arranged in lines or tracts of follicles as constant and predictable as the position of our fingers, and from there the feathers are spread out to cover the body. One of these tracts runs all the way down the spine, to protect the back – except in malurine wrens, in which it is broken between the shoulders, leaving feather tufts arising on scapulars at the sides to cover the back instead.

Long consideration led Dick to conclude that these singular birds should be given the status of a separate family, the Maluridae. 'As so often happens,' said Dick, 'questions of origin become questions of relationship.' His ideas were being confirmed by the development of molecular biology: pioneering American ornithologist

Charles Sibley's work on egg-white protein at Yale University supported Dick's reasoning that the fairy-wrens were a close group with origins far removed from their previously supposed relatives.

Within the malurids, Dick identified five groups of wrens that were ostensibly dissimilar, three of them in Australia. He suggested how the birds evidently originated in the rainforests of Australasia when it was an island offshoot of the great southern supercontinent Gondwana, and how they evolved, either by adapting to drier conditions or by retreating north with their original habitat as it withdrew to New Guinea, then arising from the sea. Birds that remained in Australia developed slender bills to help them survive on the smaller insects in the drying, open Australian landscape, taking on brilliant contrasting male plumage only at the time of breeding. But birds that kept to habitat similar to their jungle origins, in the rainforests of New Guinea, retained their broad bills, flanked by stiff rictal bristles, and kept brilliant blue plumage throughout the year. They continued to occupy their niche in the forest understorey, except for one, which moved to a life in the trees.

This reorganisation of the wrens led to a further question: what was their common ancestor and what did it look like? Dick had recognised that two of the New Guinean species fitted easily with Australian species into the genus of the fairy-wrens, *Malurus*. Another, Wallace's Wren, which had previously been grouped with one of them in the genus *Todopsis*, he segregated in a monotypic genus. But somewhere, Dick surmised, there was a missing link in the phylogeny of the malurids which was, well … missing. He thought that, at some point, there had been an archetypal New Guinean wren in which the sexes were alike, with brown in their blue plumage, a dark central cap on their blue

crown and a broad, heavy bill. He described it with blue ear-tufts and a black malar stripe and predicted a tawny mantle and scapulars. In his mind he could see a bird that was the rough equivalent of the Broad-billed Fairy-wren, but with hints of the Variegated group. He asked me whether I was willing to try to paint it from a description put together by him as a frontispiece for our book. I explained that I did not normally paint a bird that I had not seen, but the idea was so interesting that I would accept the challenge. Dick verbally described his bird to me in detail, but I suggested to him that he would need to provide me with a detailed written description from which I could work.

In the event, his description never arrived. Instead, he sent me a photograph!

A MISSING LINK

This is how it happened.

In the Southern Highlands Province of New Guinea and south of the central cordillera is the solitary collapsed cone of an extinct volcano. It sits on the Great Papuan Plateau, a massive crater about four kilometres wide and a kilometre deep. On 4 February 1980, Robert Campbell landed in a light aircraft on a remote airstrip on the slopes of Mt Bosavi. He was a member of the Australian Bird-banding Scheme, and had arrived to mist net local birds and to band them for study.

He walked down the track from the end of the airstrip to the mission house to drop his gear, passing through the dense secondary regrowth where primary rainforest had been cleared. The regrowth was filled with an undergrowth of Sago Palm (*Cycas revoluta*), tangled with rattan and other vines, excellent habitat for small scrub-loving insectivorous birds.

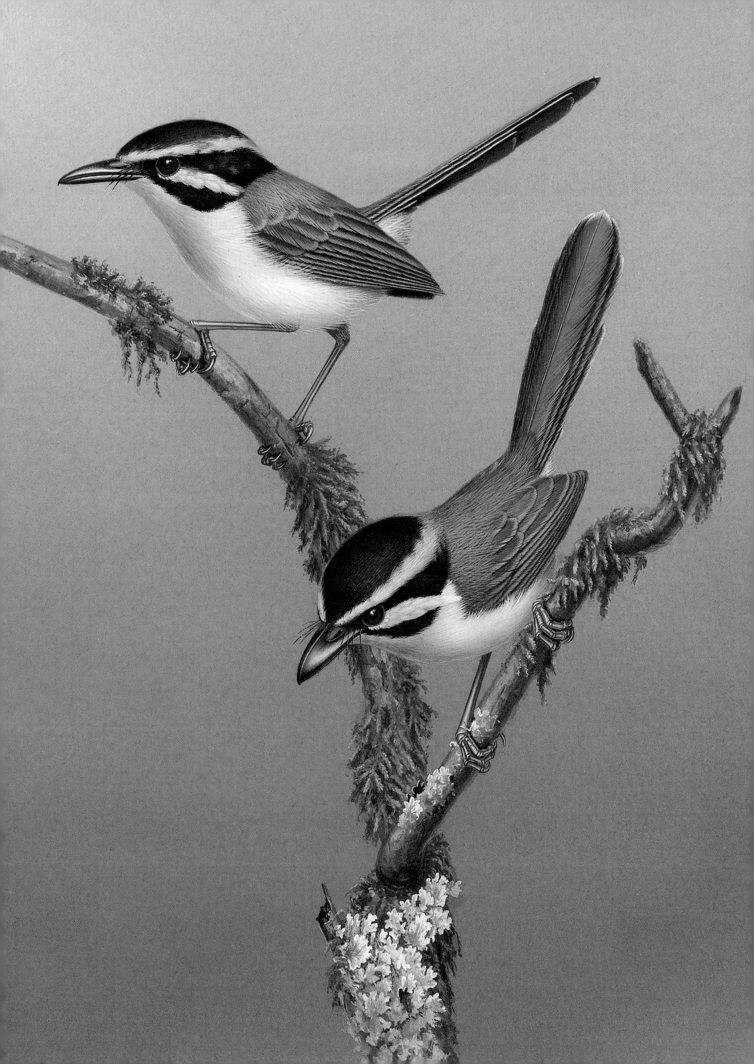

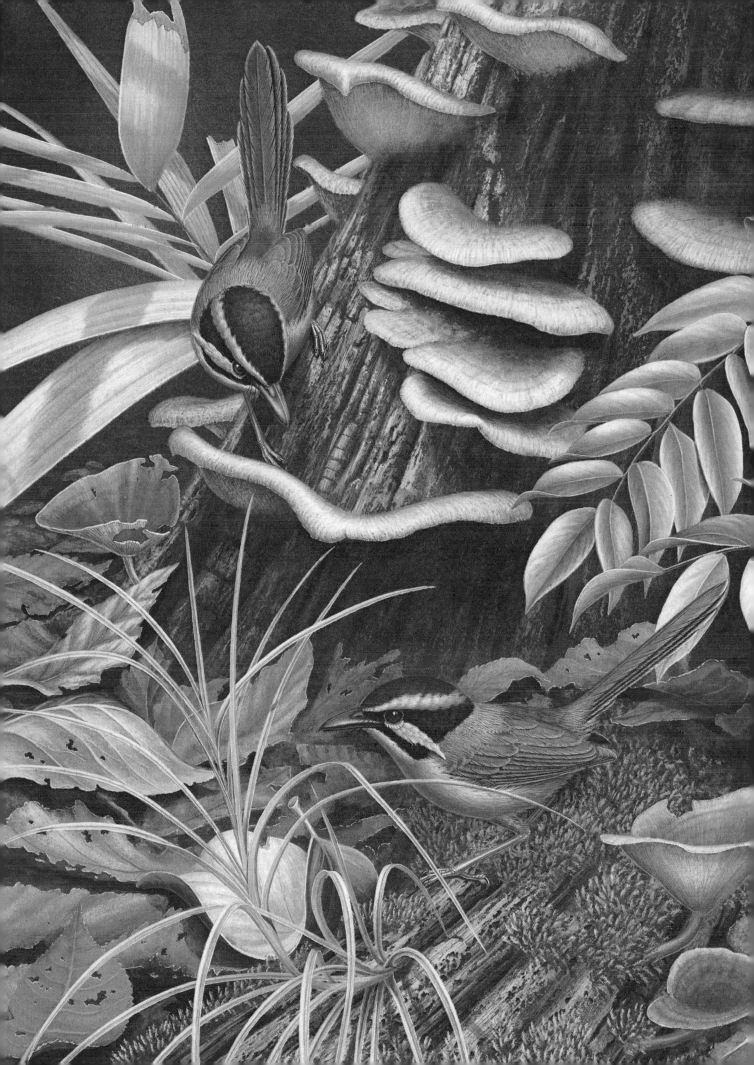

Returning, Rob quietly erected his mist nets. When he checked them later, he found in their lower shelves two tiny gems of birds, each a soft powder blue with a black cap edged with a brilliant blue ring. They were unlike anything he had ever encountered or heard of previously, but they matched Dick's description of his missing link to perfection.

Methodically, Rob placed numbered aluminium bands on their legs, weighed them and took precise measurements. He then photographed them carefully before gently releasing them back into the undergrowth.

In February 1981, Rob caught another of these strange birds, and, returning with Roy Mackay of the Baiyer River Sanctuary in the following November, trapped two more. Eventually the photographs that Rob had taken found their way to Dick, who forwarded them to me. This was the bird that he had described to me and asked me to paint! Clearly, it was closely related to the Broad-billed Fairy-wren on the other side of the central cordillera. There are many species of birds that have been separated by that massive landform, some as subspecies, some having become full species.

After long consideration and examination of traits that were unique to this new bird, and conscious of the important contribution that Rob Campbell had made to our book, we took great pleasure in naming the bird after Rob – *Malurus campbelli* – the first new species of bird described in New Guinea for thirty-two years. There had been argument about whether Campbell's Fairy-wren was just a subspecies of the Broad-billed Fairy-wren north of the cordillera, but DNA distance has now shown that it ranks as a good species – which Dick had regarded as obvious from its divergently contrasted back pattern. No other male fairy-wren sports tawny

scapulars alongside the bluish grey of its back. Nor does any other have the distinctive black head delineated with pale blue over the brow and cheek.

The bird was illustrated, as it was always intended to be, for a paper describing it in *The Emu*, and also as a plate for the book. By a quirk of fate, the paper in *The Emu* was delayed, and eventually appeared after the publication of our book, which also preceded the collection of a specimen, so that technically the painted study of the male and female for the description in *The Emu*, which was published as the frontispiece of *The Fairy-Wrens*, are illustrations of type specimens, now lost. Dick had arranged for Rob to collect a type earlier, but he had demurred at the brink when advised by Roy Mackay that it was 'only a subspecies'. Next time we paid for Rob's flight to Bosavi, and he honoured us with three specimens – but it was too late.

PUBLICATION

In August 1982, *The Fairy-Wrens* was finally published in two formats: one a limited edition, bound in leather, numbered and signed by author and artist, with a 'tip-in' plate of the new species of fairy-wren from New Guinea described within its pages. The other was a cloth-bound version on lighter paper and unsigned. The timing was good, with Christmas impending.

Unfortunately, the binding was faulty, and even in the warehouse books started to 'butterfly' as the cardboard warped. Both editions were withdrawn and rebound but all the advertising and publicity were squandered as the book was unobtainable over Christmas and the new year.

Nevertheless, it was immensely well received and swiftly sold out of the less expensive, cloth-bound copy. It received a coveted Whitley Award for making a significant contribution to new information relating directly to Australasian ornithology.

In September 1982, the original artwork for the book was exhibited as a single collection in an exhibition held at the Victorian Artists Society in East Melbourne. There were thirty-seven paintings depicting all the species and important subspecies of malurine wrens, together with a hundred sketches and finished drawings that had enhanced the text. The exhibition was well attended, particularly on the opening night, when competition for individual works occasionally flared into conflict.

I remembered a comment by the engineer and author Neville Schute Norway, after he had designed and built an airship in competition with a government service. 'You must feel very proud,' someone suggested.

'I suppose I should,' he answered, 'but somehow I just feel too tired!'

The research and fieldwork for the fairy wren book had kept me painting and travelling in Australia and New Guinea for eight years. I had seen an enormous variety of habitats and scenery and sometimes been to places where few white men had been before. I had an enormous number of sketches of places and birds that were becoming important to me to record as paintings. Two years after the exhibition of 137 works from the wren book I had a collection of thirty-three paintings and drawings completed for exhibition at Australian Galleries in Collingwood.

I had a homemade, metal-covered, airtight box that I could use to transport pictures with a modicum of safety on the back of my utility, and so the paintings were carefully wrapped and packaged for transport. For my previous

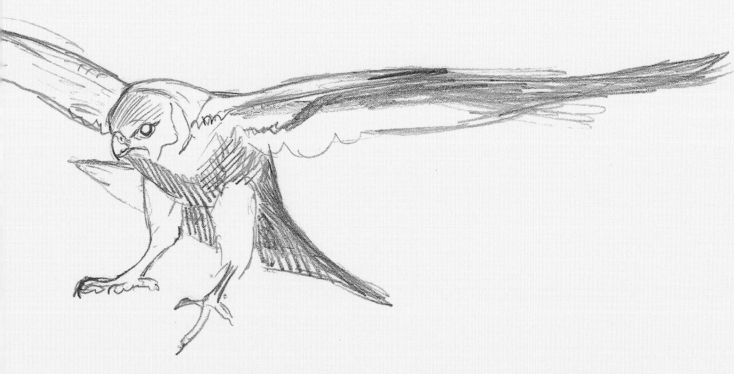

exhibition, two years before, I had left home in my ute with considerable trepidation as to whether it would allow me to return from Melbourne. Certainly it was clear that, with a wife and family, I would have to sell enough paintings to buy a new car.

My utility had done some rough miles. It had delivered me safely to the places in which about a quarter of the wren paintings had been done, so it never occurred to me that it would not deliver me and the full exhibition of paintings to the gallery without complaint. My route took me over the towering hump of Westgate Bridge, nearly within sight of my destination; and then, just as I was relaxing, and very nearly at the pinnacle of the bridge, the engine cut out. I felt rising despair. I could not push the vehicle uphill with that weight on the tray, and I dared not leave it without security for the artwork. The first mobile phone service in Australia was still three years away. With me in the vehicle was my favourite Peregrine tiercel, and I detected a reluctance on the part of others to meddle with my vehicle in the presence of a bird of prey. However, Tambuti was inside and hooded to prevent him moving about, and the artwork was outside. I had no choice but to

give expression to my very limited mechanical skills, which thankfully proved adequate. It was with great relief that I arrived outside the gallery and unloaded the paintings.

In the gallery at the time was one of their more famous exhibiting artists, John Olsen. John was immediately interested and came and sat with me to draw Tambuti as I fed him. It was fascinating for me to watch John's style of sketching and to see his reaction to, and interpretation of, the bird. Sadly, I lacked the confidence to suggest that we swap drawings!

Tambuti achieved fame with another well-known artist the next morning. The exhibition opened on Saturday 1 December 1984, the morning of the federal election between Bob Hawke and Andrew Peacock. The sight of a hawk feeding on a bird (not in fact a peacock, but a surplus day-old chick) proved too much for the great cartoonist Ron Tandberg, who drew Tambuti ripping into his obviously avian prey, with the caption 'You'll be sorry in the morning!' This appeared on the front page of *The Age* along with a reference to the arts page and an article on the exhibition. Wonderful publicity, and again I wish I had suggested we swap drawings!

OPPOSITE Pencil sketch of a Peregrine in flight, throwing back up to gain height after a 'stoop' at prey
ABOVE Pencil sketch of the delightful little Australian Hobby Captain Beaky, who used to perch on the lid of my paintbox to watch me paint

America

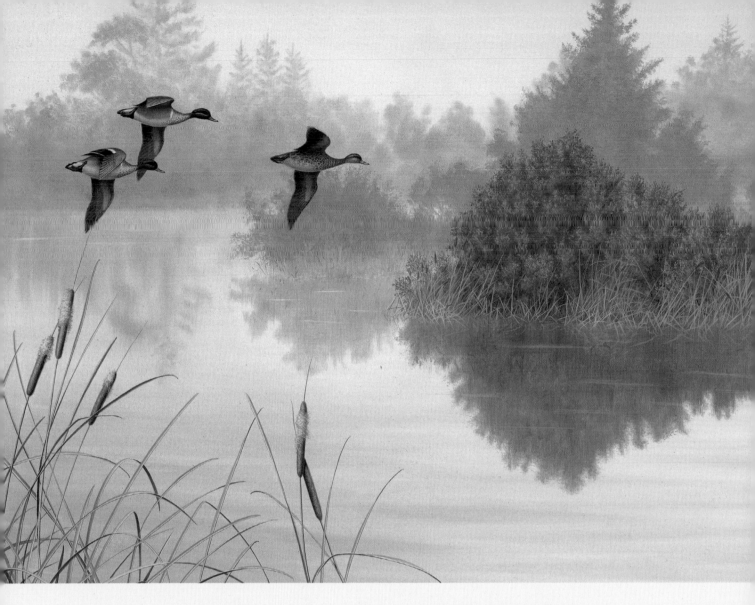

AT THIS TIME, in late October 1985, I was invited
to join a team of artists commissioned to produce
a portfolio of the waterfowl of North America
in the format of John James Audubon's elephant
portfolio, to raise money to protect the four major
migratory flyways for waterfowl in North America.
A number of artists were being commissioned to
paint one or two of the plates each. I was the only
artist from the southern hemisphere invited to
participate. The opportunity was too interesting
to decline, so I arranged to travel to the US and
Canada to do the initial fieldwork.

American Wood Duck

The species that I had been allocated was the
American Wood Duck (*Aix sponsa*), one of the
most ridiculously splendid ducks imaginable. The
Wood Duck is closely related to the Mandarin
Duck (*A. galericulata*) and must have been the

bird that God made on Christmas Day. It is a
retail duck, lavishly packaged in bronze, green
and purple sheens with white flashes, constantly
changing in the light like an over-decorated
Easter egg. It is small, kitsch and might easily
be made from plastic. It has a flamboyant
occipital crest delineated with white stripes and
a marking like a white bridle on its head. It is
appropriately American.

Wood Duck are, as one might expect from
the name, a woodland duck, much dependent
on the oak forests of the Midwest, but extending
down the western and eastern coasts of North
America. Those from the cold, northern parts of
its range migrate into Mexico during winter. They
have sharp claws, which enable them to perch
in trees, climb easily and nest in tree hollows.
They like to be close to sheltered rivers, ponds
or swamps surrounded by trees, and often spend

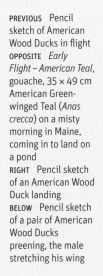

time roosting on fallen logs on the fringes of water. While the male is amazingly colourful, the female is duller and has much in common, in colour and bill shape, with the Australian Wood Duck (*Chenonetta jubata*), except that instead of the double lines through the eye of the Australian bird, the female American Wood Duck has a large, horizontal 'teardrop'-shaped marking running through her eye and shows hints of a purple sheen through the grey plumage of the dorsal surface. It interests me that two birds of such different behaviour and habitat could have evolved to be so similar. They both have short, goose-like bills, but while the Australian Wood Duck feeds by grazing, the American bird feeds along the water margins on seeds and berries, or finds nuts and acorns on land. Even in flight, the call of the female American Wood Duck and that of its Australian counterpart are curiously similar.

From the outset, American people were very hospitable and helpful. My field trip coincided with the centenary celebrations of the American Ornithologists Union, which fortunately I was persuaded to attend. I made lifelong friends there, who, in some cases, became travel companions and shared field trips for many years into the

future. Ducks Unlimited Canada were supportive, and while many of their members enjoy hunting ducks, they proved to be strongly focussed on conservation and habitat maintenance. Usually, they had either a strong interest in a species associated with waterfowl habitat, for example Sandhill Cranes (*Antigone canadensis*), or a local habitat restoration project designed to help a single type of bird, such as a local subspecies of crake or rail.

My fieldwork started at Vancouver, a city that held many surprises. The first was how warm it was, with almost tropical vegetation. This, I believe, is because of the North Pacific Current, an extension of the Kuroshio Current, which forms part of the North Pacific Subpolar Gyre and moves warmer water emanating from the subtropics into the subpolar regions. In the eastern North Pacific it separates, one current (the slightly greater portion) flowing southwards as the California Current, and the other going north as the Alaska Current, delivering warm surface water onto the south-west coast of Canada and keeping it far warmer than I had anticipated.

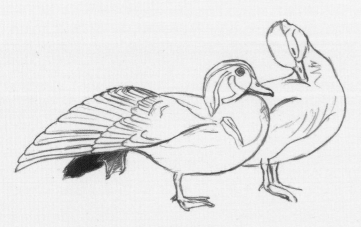

My second surprise was the number of bears that would come into the city to raid rubbish bins. At the time I was there, council policy was to shoot these bears and in the previous year they had eliminated over seven hundred Black Bear (*Ursus americanus*). Better solutions with more sustainable outcomes have since been implemented, using a bear-proof catch on the top of the bins.

On every continent that I visit, I am reminded how safe Australia is. Despite a reputation for terrible danger – perhaps because snakes and spiders cause irrational fears – Australia has very few hazardous native animals other than crocodiles and sharks, and one must become aquatic to meet them. It is much more dangerous to drive a car.

I have only been in close proximity to a Black Bear once, and it was more concerned with evading than confronting me. It wasn't looking where it was going and dropped onto the path I

ABOVE *Harlequin*, oil on linen, 40 × 50 cm A beautiful Harlequin Drake walking upstream in the shallow glacial waters of Lizard Creek, near Fernie in Alberta, Canada

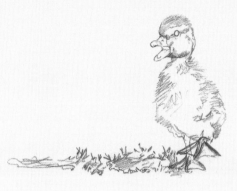

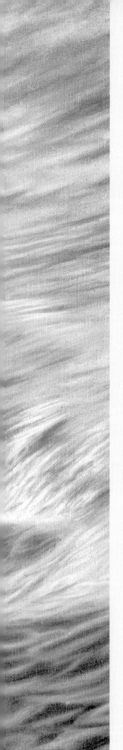

was taking about three metres in front of me, then swiftly retraced its tracks! Nevertheless, I did learn to be cautious about Black Bears, Grizzly Bears, Moose and Elk (*Cervus canadensis*), although I was always tempted to stalk them, to the concern of my hosts.

I began my work on Wood Duck in the broad, fertile Fraser Valley near Vancouver, on the banks of the Alouette River, a tributary of the Pitt River. I was based at a small multifunctional farm which had a series of ponds for waterfowl, at one of which they provided feed for the ducks. The farm was divided into numerous tiny fields surrounded by levee banks so that they could be irrigated from the Alouette River. Each year, in rotation, one or two of these fields would be sown with a barley crop and, just before harvest, they would run a roller over the crop to flatten it before flooding it with about 200 millimetres of water. The amount of waterfowl that this attracted was astonishing. Wood Duck were plentiful and I had ample opportunity to sketch and observe them at close range.

Harlequin Ducks

However, this was not natural habitat for Wood Ducks, which I needed to visit, but before I began this search I was asked to paint a picture of Harlequin Ducks (*Histrionicus histrionicus*), another small but ridiculously attractive American duck of great agility, with a preference for wildly turbulent waters. They breed in the rapidly flowing grey, glacial waters of the highest alpine streams, where they nest close to water, sometimes in the hollow left in an eroded vertical stream bank where a boulder has been dislodged by floodwaters, leaving a snug, duck-sized cave. After hatching, the ducklings are nurtured carefully downstream to an alpine lake, where they join others in large creches under the supervision of a

few adults. Their winters are spent at sea, usually near the white water of pounding surf on the rocky shorelines of the east and west coasts. We sought them in their beautiful breeding quarters, high in the Rocky Mountains of Alberta, in truly wild country.

Their food is predominantly crustaceans and molluscs or insects, obtained by diving. Being small and vulnerable to the intense cold of their habitat, they have tightly packed feathering that traps air next to their bodies. This gives them a typical buoyancy, so that they bob around in rough waters like a toy duck and swim high in the water, jerking their head backwards and forwards like a moorhen as they paddle. They are a delight to observe, the brightly patterned male having a base colour of dark blue-grey, elaborately patterned with black, white and russet chestnut. The females are much less colourful and are well camouflaged, as they do more of the incubation than the males.

Richard Trethewey, my host at Coniagas Ranches in the Fraser Valley, guided me to Harlequin Duck habitat, and we spent several days in some of the most rugged and spectacular country on Earth. For the first time, I watched Rocky Mountain Goats (*Oreamnos americanus*), which have an extraordinary double woollen coat

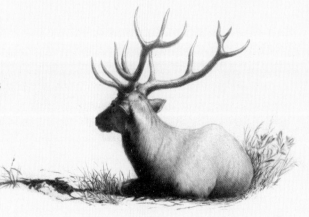

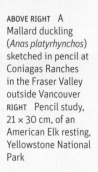

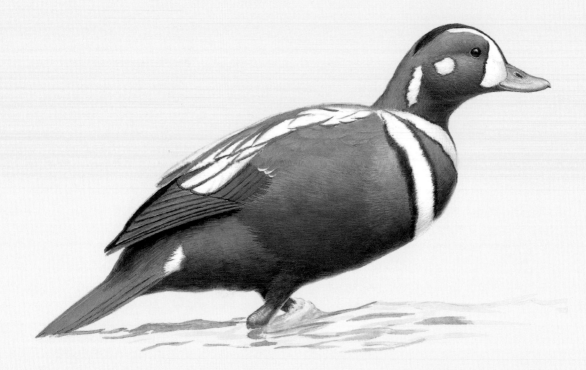

to enable them to survive at chilling altitudes up to four thousand metres. Their cloven hooves, also, are specially adapted to give them balance and grip on the rocky cliffs and ice that they favour.

There was a huge scree slope in the valley and onto this would occasionally come a Grizzly Bear with two cubs, offering me a unique opportunity to observe, but one that left my stalking impulse deeply repressed. There is enormous power in the way they move and a very strong maternal instinct comes into play if their cubs are threatened.

We found numerous Harlequin Ducks, which turned out to be mostly placid and confiding. They would not, even in flight, forsake the security of the stream, following each twist and turn of the watercourse with few deviations. They were unconcerned by the depth of the water in which they fed, diving in furiously fast, deep runs or paddling in the shallows, retiring to little backwaters along the rocky edges if they became fatigued, when they were more approachable than I would have expected.

With such easy and enjoyable fieldwork, it took determination to tear myself away, but I had to travel south to the oak forests where I could watch and draw Wood Duck. To my great good

fortune, I had been given an introduction to a wonderful man, gentle, kindly and widely talented Robert M. Mengel, Professor of Ornithology at Kansas University. A widely respected scientist, teacher, writer, historian, enthusiastic fly-fisherman and gifted artist, Bob Mengel was the ultimate modern Renaissance man. There was so much I could learn from him, but I was young and only vaguely appreciated my opportunity.

Bob and his family invited me to stay in his house in the typical oak woodland preferred by Wood Duck, at Lawrence, near Kansas. He was very busy, but steered me towards some excellent habitat, one site of which became the background for my eventual painting. He also guided me to some interesting birds, such as the brilliantly coloured Red-headed Woodpecker (*Melanerpes erythrocephalus*), a species that can be easily overlooked due to its quiet and inconspicuous nature, but which I was eager to see, given a keen interest in woodpeckers.

I had a further contact at Charleston in South Carolina, a delightful and very interesting couple called Peter and Patti Maningault. Peter and Patti had visited us in Australia when Peter was the President of the Spoleto Festival, an arts festival

ABOVE Gouache study, 21 × 30 cm, for *Harlequin*, one of many sketches and studies done on Lizard Creek
OPPOSITE Careful pencil study in preparation for *Autumn Gold*, a painting of American Wood Ducks

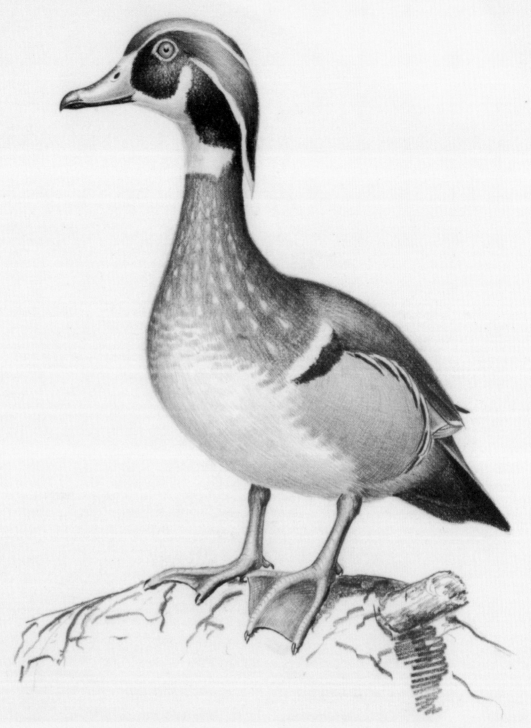

founded in Charleston in 1977 by the composer Gian Carlo Menotti, as a companion to the Festival dei Due Mondi in Spoleto in Italy. Peter came to Melbourne to instigate a similar 'companion' Spoleto Festival there, in which he succeeded. The Melbourne version has since been renamed the Melbourne International Festival of the Arts.

Peter and Patti were interested ornithologists and when they came to Connewarran they brought their good friend John Henry Dick, an American naturalist and artist who specialised in birds. Unfortunately, their visit coincided with copious rainfall, and attempts to drive around Connewarran usually ended in the use of a shovel before we walked home. However, Patti had been a professional artist based in Paris in her younger days, so we spent an enjoyable day, trapped inside, discussing various art forms.

Peter and Patti owned a property outside Charleston which they referred to as 'the Rice

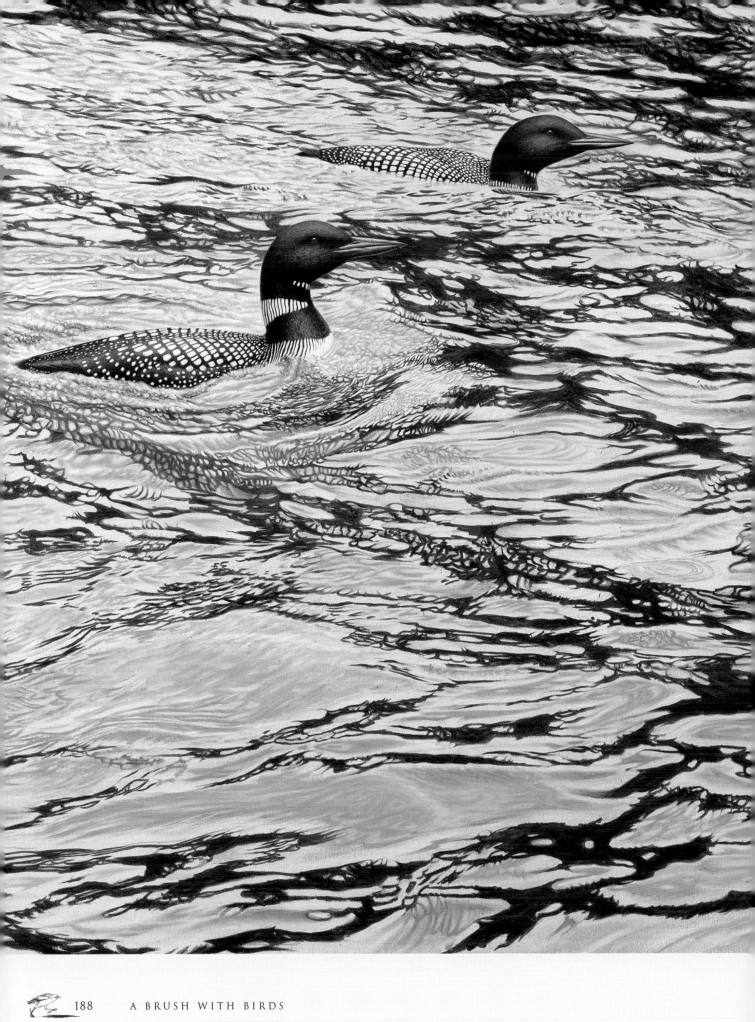

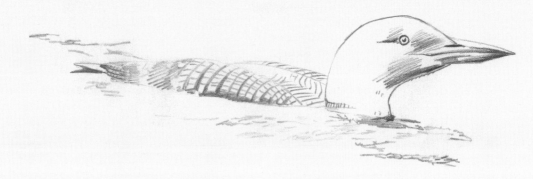

Farm', about four thousand acres containing irrigated ponds originally for rice production but now run entirely for the benefit of wildlife. They employed a past director of the US Fish and Wildlife Service to run it and were generous in allowing me access to its facilities. Water levels could be controlled for each pond by adding or removing boards in the spillways. Thus, Peter might discuss over breakfast the high number of scaup – the Lesser Scaup (*Aythya affinis*), a diving duck that prefers deeper water – and mourn the low numbers of the lovely Pintail (*Anas acuta*), an attractive, elegant dabbling duck; the decision would be made to remove boards to drop the water 200 millimetres, so that the next day there would be more Pintail than scaup.

Peter had also designed programs to nurture the Wild Turkeys (*Meleagris gallopavo*), mostly by sowing alfalfa crops (which I knew as lucerne) along rides and glades near well-sheltered woodland to assist the chicks to develop quickly. In addition, he did what he could to protect and preserve the rare and declining Red-cockaded Woodpecker (*Picoides borealis*), a diminutive species that can be found only in mature pine forests. It was a wonderful opportunity to see this species.

The Wood Duck on the Rice Farm were as wild and natural as I could possibly have hoped. I was taken out to see them as they left their dawn roosts and later moved back to roost for the night. I saw them feeding, flying, swimming – everything I needed – and filled sketchbooks with drawings.

Common Loons

Later, in Maine, Jen and I were walking beside a lake called Jordon Pond when we found a pair of Common Loons (*Gavia immer*), known in Europe as the Great Northern Diver. These are a bird of great mystique, and a recurring figure in some Native American myths. Normally found on large lakes in wild country or on coastal waters, they have a distinctive yodelling call, which once heard is seldom forgotten.

They are larger than a Great Cormorant (*Phalocracorax carbo*) and intricately patterned with geometrical squares of white or linear black and white patches on the very dark, glossy green back and neck. I had long wanted to watch loons, but the only other one I had ever glimpsed briefly was from a bus as I was driven into Kansas airport. Astonishingly, there was one on a small pond next to the road!

The sky was low and grey, the water dull and wind-ruffled. For the next three-quarters of an hour, Jenny and I strolled along the banks of the lake watching this pair of loons, sometimes close to the shore, sometimes moving further out, but always quietly swimming onwards, diving regularly. Then, quite suddenly, they swam into a broad inlet of calmer water, the far bank of which was clothed in conifers of one kind or another. In an instant, I understood the evolution of the colour and patterning of loons, which matched the intricate pattern of reflections from the pine forest beyond. They looked wonderful and became the model for one of my early transitions from gouache and watercolour to oil painting.

LEFT *Loon Patterns*, oil on linen, 73 × 105 cm This painting emerged from our wonderful sighting of Common Loons on Jordan Pond in Acadia National Park, Maine; exhibited in Leigh Yawkey Woodson Art Museum's *Birds in Art* exhibition, 1990, and at Australian Galleries, 1989
ABOVE One of the pencil sketches of the Common Loons in Maine

Birds of Mexico

EVENTUALLY I DEPARTED to join a trip into Sonora, Mexico, south of the border, with Emeritus Professor Dr Stephen Russell, the Associate Professor of Ecology and Evolutionary Biology at the University of Arizona. A gentle and gifted teacher, Steve had spent forty years studying the birds of Sonora and, together with co-author Gale Monson, was in the final stages of completing a book of that name. Ruth, his wife, is a brilliant ornithologist and a charismatic leader within the Audubon Society. The trip cemented our friendship, and they have remained some of my closest friends ever since.

There had been a prolonged drought in Sonora. Spring was coming, and hence the breeding season, but drought conditions persisted, meaning that the tropical thorn-scrub, which covers much of Sonora, and the tropical deciduous forest were defoliated and sparse. Would the birds wait until conditions improved, bringing them into breeding condition, or would they be stimulated to breed by the changing photoperiod?

To answer this question, Steve had assembled a group of his brightest graduate students to do a kind of 'bird blitz'. In the plane heading south to join them, I came across a fascinating article in the in-flight magazine about the Creosote Bush (*Larrea tridentata*). This extraordinary American desert shrub is widespread across the southern US and well south into Mexico. So efficient is it at harvesting water that it is normally surrounded by areas of bare soil, as seeds are unable to accumulate sufficient water to germinate.

As the bush ages, new ones are produced clonally, expanding the plant's size in a ring of genetically identical plants. A single plant in the Mojave Desert had been recently dated as 11,700 years old, indicating that it could be one of the oldest living organisms on Earth.

Native Americans use Creosote Bush as a medicinal herb for ailments as disparate as chicken pox, snakebite, intestinal complaints and tuberculosis. Not surprisingly, it is in popular use in Mexico. However, US government authorities warn against its consumption due to the associated risk to the liver and kidneys.

I read this article thoroughly on the flight, and on landing at the airport at Tucson was met by Steve and Ruth Russell. 'We were just heading out into the desert to try to find a Bendire's Thrasher,' Steve said, as he loaded me into the back of his van. Bendire's Thrasher (*Toxostoma bendirei*) is similar to the more common Curve-billed Thrasher (*Toxostoma curvirostre*), but smaller and with a shorter and straighter bill. They have a much more limited distribution than the Curve-billed Thrasher, but who was I to know? I had never seen one, so readily agreed to join in the search.

Steve drove us out of town to some scrub behind the military airport, where he stopped and opened the sliding door on the side of his van to release us. I stumbled out and fell into the branches of a desert bush. 'Hah,' I exclaimed in triumphant recognition, '*Larrea tridentata*.'

'How did you know that?' Steve asked in surprise.

'Oh, it's always good to do a bit of homework before going into the field,' I wickedly replied. A few days later, I was at a barbecue at the University of Arizona, speaking with a small group of students. Recognising my accent, one of them asked where I came from. When I replied, she said, 'Australian? So, you're the bastard!' Apparently, Steve had been chastising his students for laziness over their preparatory research. He had told them of his guest

Ruth and Steve -
Mexican memories
10th - 15th May, 2005

who had flown halfway around the world from Australia and still took the trouble to know his plant species, I felt it was only fair to confess.

Soon after, we were heading down the road to Mexico. There was some trepidation about the trip, as not long before a university group of six people had been murdered in the region which we were intending to survey and no one had any idea why. We planned to keep moving and never spend a second night within a couple of kilometres of where we had been the night before.

That first night in Sonora was amazing. We were camping amongst the typical, but to me exotic, vegetation of the Sonoran Desert – cholla (*Cylindropuntia* spp.), prickly pear (*Opuntia* spp.), Saguaro (*Carnegiea gigantea*), Senita (*Pachycereus schottii*), and Organ-pipe Cactus (*Stenocereus thurberi*) – a harsh landscape of great beauty only softened by the occasional mesquite (*Prosopis* sp.) or paloverde (*Parkinsonia* sp.) tree. A golden and pink dusk was falling, silhouetting the arching arms of the giant cacti. I meandered out of camp, picking my way cautiously between the prickles (Jumping Cholla (*Cylindropuntia fulgida*) does not earn its name because it jumps – although it did sometimes behave more like an ambush than a bush). I had not gone far when I surprised a Black-tailed Jack Rabbit (*Lepus californicus*), also known as the American Desert Hare, an animal of whose existence I had been blissfully unaware.

For those unprepared for them, these apparently common creatures appear enormous, especially in the low light. Its ears were huge, and glowed in the evening light, exaggerating their size. Briefly, every rabbit that I had attempted to annihilate on my farm flashed before my mind, each with gnashing teeth and glowing eyes; I quietly retreated to our camp.

Not everything was as sharp or as daunting as on that brief excursion. I enjoyed the delightful little Cactus Wren, which is of course no relation to our unique fairy-wrens. The wrens are camouflaged by plumage that could be reminiscent of a desert grasswren, but shy they are not. These cheeky, sociable birds rely on their ability to dart through dense barriers of cactus spines. Active and noisy, they are always enjoyable to watch and have been the state bird of Arizona since the 1930s.

The desert was mostly well stocked with a variety of doves: Mourning Dove (*Zenaida macroura*), White-winged Dove (*Zenaida asiatica*) and the diminutive Inca Dove (*Columbaria inca*). There were also Gambell's Quail (*Callipepla gambelii*), a similar bird to the better-known California Quail (*C. californica*), and with the same ridiculous-looking comma shaped crest flopping forward from its forehead. Attractively patterned in shades of grey, ochre and chestnut, with a chestnut crown and black face delineated with white markings, they are mostly seen in flocks, running across open ground or scratching around the base of cacti in search of food. They enjoy the cover of thickets of the deep-rooted, leguminous mesquite trees along drainage lines.

From our desert camp, we headed into lowland country near Hermosillo along a dirt track through fields of maize. As we approached a cross-track, a very beaten-up vehicle suddenly dashed across our bows and skidded to a halt in a cloud of dust. Steve slowed his van and stopped, as two exceptionally scruffy Mexicans got down from their truck, one with long, greasy

black hair and a sawn-off shotgun, the other with a classical, drooping Mexican moustache and a .44 Colt revolver. Swiftly, they moved to either side of our van, covering Steve with the shotgun and poking the revolver at my right ear. Cocked. They seemed to be unhappy, and it took little inspiration for us to assume that we were unwittingly heading into a marijuana crop, a navigational error on my part.

In the back seat was Arnie Moorhouse, an employee of the Mexican Department of Agriculture and fluent in Spanish. Making no sudden movements, I suggested to Arnie that he explain to these gentlemen that I came from Australia and that the reason it was referred to as 'down under' was that everything was, indeed, upside down. Perhaps, I suggested, this might explain why I was holding the map upside down and that in fact, we now realised with startling clarity, we were really wanting to go in the opposite direction!

Slowly, a broad smile spread over the Mexicans' faces and they stepped back to watch us do a U-turn and disappear back the way we had come. There were many complex reasons – sociological, economic, religious – for the sudden rapid increase in growing drugs in Mexico at that time. From our point of view, it meant that we must be alert to the possibility of stumbling into a marijuana crop at any time. From their point of view, we looked like 'the authorities' with our binoculars and cameras, and therefore represented danger.

Paradoxically, this was the safest of several trips I have taken to Mexico with Steve and Ruth. In later years, the small-time growers we faced were brought under the control of drug cartels and the controlling drug barons faced much more than a slap over the wrist from the authorities. For them, a bullet was the usual way to protect their illicit empire. There were many wonderful places that I was taken on that first trip which no sane person would now enter.

In Sonora, some sparse foliage was struggling to burst through on the oak trees, but visibility in the forest was remarkably unimpeded: ideal for watching birds, less so for the birds' breeding.

Squirrel Cuckoo
Birds like Squirrel Cuckoo, normally so difficult to see, became more observable. When disturbed it runs swiftly along branches, leaping boldly from one to another or plunging from one canopy to another in a manner reminiscent of a squirrel, an

image enhanced by its outlandishly long tail and russet plumage. This cuckoo is a large and active species that favours dense thickets in tropical deciduous woodland, where it skulks deliberately along branches in search of caterpillars and spiders. Because it is mostly silent it can be difficult to find, a characteristic shared with many cuckoos.

Lineated Woodpecker

The Lineated Woodpecker (*Dryocopus lineatus*) is an unusual species, rarely seen easily in the tropical deciduous forests of Sonora. Woodpeckers fascinate me, as they are exotic for an Australian observer, eschewing our hardwood forests. The

Lineated Woodpecker is spectacular, a large black and white bird with a fiery red crest and strongly barred underparts. A strong white line runs from its bill down the side of its neck, beneath which the male carries a red moustachial stripe. They actively chip out holes in the branches of trees, sometimes quite large holes, in search of insects, mainly ants and beetle larvae, and excavate large cavities in dead trees for nests. Active and diligent in their fossicking for food, they fly swiftly and directly, so it can be difficult to remain in contact with them for long periods of observation, although the open foliage due to the drought made observation much easier.

Rufous-bellied Chachalaca

Another bird that inhabited the densely wooded hillsides was the Rufous-bellied Chachalaca (*Ortalis wagleri*), a loudly vocal, long-tailed, turkey-like bird with a deep rufous belly. Chachalacas are in the family Cracidae, along with

curassows and guans. My only experience of this group of birds was watching David Reid-Henry develop a painting of an extinct species of guan. I still possess his drawings, and it was interesting to watch something so novel, yet so vaguely familiar in its resemblance to a big chicken, being recreated in paint. The Rufous-bellied Chachalaca is the most richly coloured of the chachalacas, which are mostly fairly bland. Confined to Mexico, they have strong legs and a long hind toe, which assists them in perching and climbing. They are not easily seen, but have a very loud, piercing call, which may break out spontaneously and then cease abruptly. This call carries for a considerable distance, usually sounding much closer than the bird actually is. Chachalacas mostly call as a small group, from a perch well above ground and often near a ridgetop. If they can be seen at such times, slanting sunlight may make their distinctive frontal

ABOVE Gouache study, 21 × 30 cm, of a Military Macaw (*Ara militaris*), from the birds seen at San Rafael in Sonora
OPPOSITE ABOVE Pencil sketch, 21 × 30 cm, of an Elegant Trogon (*Trogon elegans*) in the oak woodlands at San Rafael
OPPOSITE BELOW *Canvasback* (*Aythya valisineria*), a diving duck with a distinctive head shape; oil on gessoed board, 29 × 40 cm

crest and bare, red throat distinctly visible. While they will feed on the ground, often they are well hidden high up in fruit-bearing trees, running along the branches before vanishing from sight. For such a large edible bird in a hungry country it pays to be wary!

Elegant Trogon

My favourite part of the trip to Mexico was the mountains of the Sierra Madre Occidental, particularly in the pine–oak woodlands or, higher still, in the pines. The altitudinal change in avifauna is clear, from the tiny Tufted Flycatcher (*Mitrephanes phaocercus*) and the many species of hummingbirds of the Trochilidae family to the magnificent Military Macaw. Possibly my favourite was the Elegant Trogon, a bird that is so jewel-bright that its degree of camouflage can scarcely be believed. Their shining bottle-green head and back are neatly complemented by a crimson belly

and under-tail coverts, separated from the green by a neat white band across the breast. Wing coverts are finely vermiculated black on white, as is the under-tail, which is crossed by three broad white bands. Both wing coverts and tail blend to a soft grey at a distance. The upper side of the tail is a glossy copper, so that they are frequently referred to as the Coppery-tailed Trogon. The female is duller than the male, being grey-brown where the male is green, and paler where he is red. She also has a white spot behind her ear.

Typically, these magnificent birds are found perched upright and motionless on a horizontal branch on their small, weak legs, often in deep shadow. They prefer forests of oak and sycamore near canyon streams, but I found them often in the scattered oaks in high-country forests. They may give their position away by calling, a series of hoarse *oik, oik, oik, oik* notes. In fact, that is the most frequent means by which they are

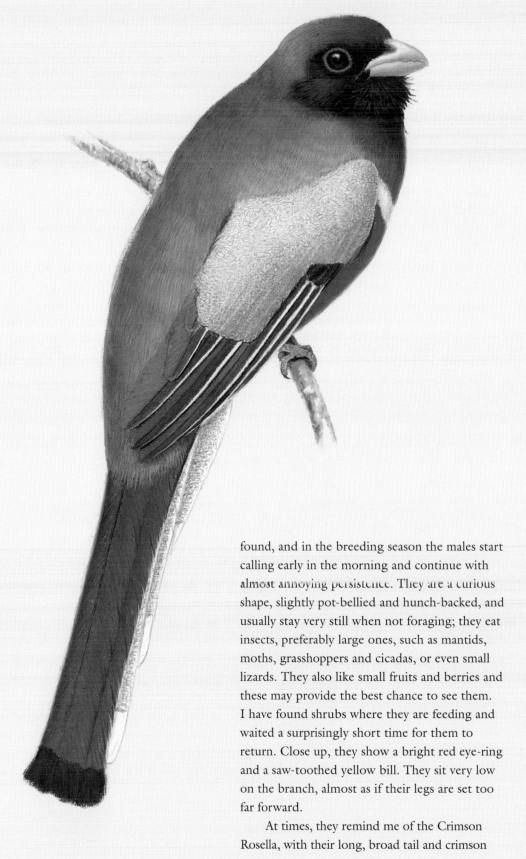

found, and in the breeding season the males start
calling early in the morning and continue with
almost annoying persistence. They are a curious
shape, slightly pot-bellied and hunch-backed, and
usually stay very still when not foraging; they eat
insects, preferably large ones, such as mantids,
moths, grasshoppers and cicadas, or even small
lizards. They also like small fruits and berries and
these may provide the best chance to see them.
I have found shrubs where they are feeding and
waited a surprisingly short time for them to
return. Close up, they show a bright red eye-ring
and a saw-toothed yellow bill. They sit very low
on the branch, almost as if their legs are set too
far forward.

At times, they remind me of the Crimson
Rosella, with their long, broad tail and crimson

LEFT Gouache study
of an Elegant Trogon,
21 × 30 cm

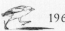

bellies, particularly when they drop from a tree and flit, with their undulating flight, to the next chosen perch. If genuinely disturbed they can fly very strongly.

When I first saw trogons, part of the attraction was the glorious surroundings in which they lived. The view from the hilltops looked out over range after range of spectacular mountains, stretching to the horizon as apparent wilderness, which, of course, it is not. On each range and at each streamside, peasant families are scratching out a meagre existence with tiny crops of whatever will grow, often peanuts. Oxen and small, lean horses pull at simple, single-furrowed wooden ploughs to prepare the ground for planting. No wonder the sale of a cash crop like marijuana appears so attractive to these mountain people.

Nothing can be more spectacular than to look out on this glorious view and see a small flock of noisy Military Macaws flying with their slow, heron-like wing-beats from one ridge top to the next. Their brilliant plumage, stentorian, echoing calls, long tails and huge bills are becoming an unusual sight in Sonora. They favour the ridge tops and cliff faces of barrancas and are mostly heard long before they are seen.

These mountain ranges are fissured with barrancas, deep gullies with steep or vertical sides, often with small fertile areas at the bottom. Many support habitat for birds not commonly seen elsewhere, so on early mornings we would often pick our way carefully down a narrow track on a towering cliff face, eager to reach the bottom while the birds were still active in the dim light of the deep arroyo.

On one such morning, I was descending a narrow path when, from within a shallow recess in the cliff face, emerged a stern-looking Mexican gentleman, dressed predominantly in ragged khaki clothing, wrapped in a bandoleer, possibly two,

containing high-calibre ammunition. Held slanted across his chest was a heavy, military-style rifle. He stepped out and stood astride the path, blocking my way.

I was heavily armed with a pair of old binoculars and a camera bag; I looked him in the eye. He returned my gaze, unflinching, so I nodded to him in my most off-hand Australian style, turned on my heel and nonchalantly wandered off back up the path. Perfect negotiation should leave both parties slightly unhappy, so we had communicated well. Something indicated to me that there might be a small piece of cultivated ground at the bottom of that barranca. In fact, there was, but only about half a hectare. I stumbled upon it on another day, simply fenced with a single strand of barbed wire to discourage wandering cattle.

Raptors

The group of ornithologists on this field trip had to assemble the distributional, behavioural and ecological information of the avian species in Sonora. Steve Russell's book on the birds of Sonora was based on personal observations and those of his colleagues and trusted observers. Each record was necessarily scrutinised, assessing the relative expertise required to identify the bird, the competence of the observer and the likelihood of the bird's occurrence. How difficult it must have been, then, when rare birds were reported at the limits of their territory.

One morning, we were each surveying our chosen habitats and recording sightings of the birds we found. I was at the bottom of Barranca las Colas near Sahuarivo. Suddenly I was aware of a very large bird of prey circling above me, to my eye an eagle, which had just taken off from a perch low in the canyon and was searching for a thermal as it gradually ascended from the barranca and

disappeared behind the tree canopies and towering cliff face. From below, the only angle from which I saw it, it seemed to be very large, with obviously broad wings that appeared generally dark. I saw no markings on the underside of its wings. Its legs were obviously yellow and there was a broad white band across the middle of its distinctively short tail. With my limited knowledge of Mexican birds, I thought it to be a Solitary Eagle (*Buteogallus solitarius*). This eagle, sometimes referred to as the Montane Solitary Eagle, is native to Mexico and central South America and inhabits mountainous forests. It is frequently confused with the Common Black Hawk (*B. anthracinus*), which is much smaller and has a white patch at the base of the primaries. It is responsible for many of the reports of Solitary Eagles in lowland regions. The Great Black Hawk (*B. urubitinga*) also shows many similarities. Smaller than a Solitary Eagle, it would have had a greyish pale area at the base of its primaries and two white bands across its tail, although one band, near the tail coverts, is not always visible. Both these keys to identification could be overlooked by a careless observer.

On returning to camp, it emerged that the same bird had been seen by three other observers, and these sightings constituted the only probable record of the Solitary Eagle in Sonora since 1958. Poor Steve, how tantalising it must have been to want to record this bird for his book. What were the alternatives that it may have been?

Each of the four of us was carefully and separately interviewed by Steve to ascertain the basis on which we had determined our identification. The Solitary Eagle has been an extremely rare resident of the very southern part of Sonora, nesting there in 1947 and in 1949 and recorded there in 1948. It is a rare bird anywhere in Mexico and only appears in that country at the northern extreme of its range. It was important that such a tantalising sighting should be documented, but ultimately it remains uncertain what, in fact, we saw.

Rosy Thrush-tanager

Many years later, with Steve and Ruth at El Tuito, in the state of Jalisco and nearly 1100 kilometres further south, the difficulty of sight records emerged again. I returned from an outing one afternoon when I had been seeking the furtive and extremely elusive Rosy Thrush-tanager (*Rhodinocichla rosea*). Excitedly, I described to them a close encounter and excellent views of this difficult bird. I also mentioned seeing a Wood Thrush (*Hylocichla mustelina*) nearby. To my surprise, it was the Wood Thrush that interested them most. Indeed, I was met with total disbelief

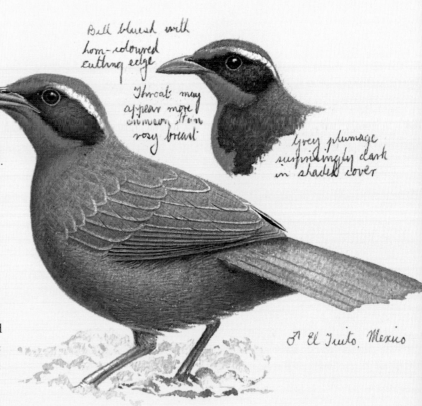

Bill bluish with horn-coloured cutting edge

Throat may appear more crimson than rosy breast

Grey plumage surprisingly dark in shaded cover

♂ El Tuito, Mexico

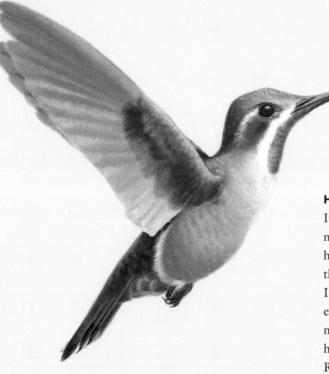

Hummingbirds

It would be difficult to leave Mexico without mentioning those brilliant avian gems the hummingbirds. There are at least sixteen species that have been reported in Sonora, some of which I have only seen in other places. Ruth Russell is an expert on hummingbirds, trapping and banding many birds throughout each year. In my case, I had not encountered hummingbirds before I met Ruth and had been inclined to regard them almost more as insects than as tiny birds. However, through Ruth's instruction, I came to see what fascinating birds they are, with spectacular flight displays in the breeding season. Nearly all the main structure of the wing is actually enclosed within the body, so that instead of flapping the whole wing, from the shoulder outwards, the bird flaps only the part beyond the wrist, which allows it to flap with extraordinary rapidity, and to twist to enable hovering, flying backwards and even flying upside down.

Their colouration and use of metallic reflection are both fascinating and beautiful, and some of their display flights can be spectacular. In Sonora, yuccas were flowering and these would

and advised to scan the field guide thoroughly to find what it really could have been.

The Wood Thrush is distinctive in both shape and plumage and the only other bird that could possibly be considered similar, despite many obvious differences, is the Brown Thrasher (*Toxostoma rufum*), a gangly bird with a pale eye that is so obviously different that it would be difficult to confuse. The thrasher is normally found in the eastern US and has only been recorded as wandering into Sonora, in Mexico's north, on four occasions.

Admittedly, much the same is true of the Wood Thrush, also a bird of the eastern states of the US, for which there was only one record in northern Sonora, within about fifteen kilometres of the border with Arizona, although it migrates for the winter into Central America, south of the Yucatan Peninsula. Numbers have been declining since the late 1970s, mainly, it is thought, due to loss, by destruction and by fragmentation, of its favoured habitat, broad-leafed forests with low-level shrubs, leaf litter, shade and moisture.

This was a mystery that was destined to remain unresolved, but the report of the Rosy Thrush-tanagers attracted Steve and Ruth to visit the location the following day. In the evening, when we met again, they seemed very pleased. Yes, they had seen the thrush-tanagers – good views – but they had also seen another bird: a Wood Thrush.

OPPOSITE Sketch studies, 21 × 30 cm, in gouache of a Rosy Thrush-tanager at El Tuito, Jalisco, Mexico; a study that is not right first time can still be valuable with corrective notes
ABOVE AND RIGHT Gouache studies of Plain-capped Starthroats (*Heliomaster constantii*), 21 × 30 cm

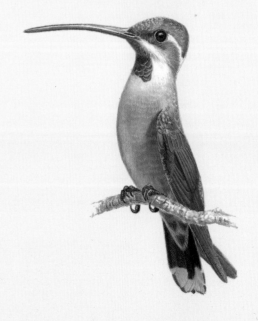

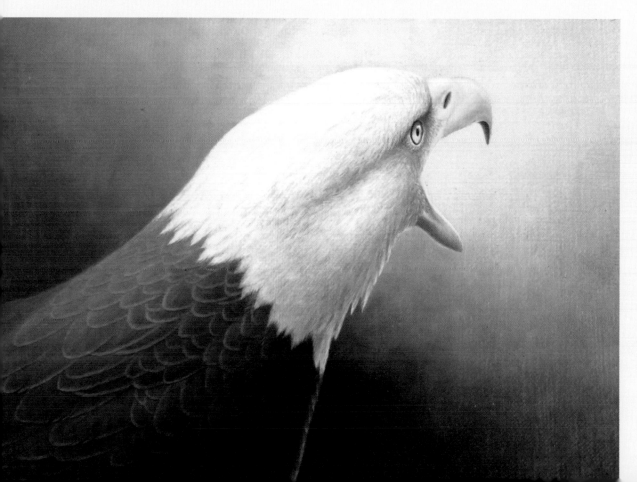

bring a variety of hummingbirds to feed on their nectar, from the smallest, the Calliope (*Stellula calliope*), weighing only a couple of grams, to the larger Blue-throated (*Lampornis clemenciae*), a giant eight grams.

The colouration of hummingbirds frequently relies on iridescence, changes in colour depending on the angle at which the feathering is viewed or illuminated, effects that are produced by multiple thin layers of light reflecting from melanin and keratin in the barbules of the feathers. The greater the number of thin multiple layers within the barbules, the brighter the colouration may become, for light bouncing off additional layers is combined to become more brilliant than the colours created by any single layer.

The cool colours of blue, violet and indigo are invariably structural colours, rather than pigments, and hummingbirds carry the greatest array of structural colouration of any group

of birds. They display an extraordinary range for which the basic mechanisms are still poorly understood and are the subject of ongoing research. Their instinctive use of the angle of light to show their colours in display is amazing to watch. I found it easier to enjoy than it was to understand.

The experience of working with Steve and Ruth Russell and some of their associates was an amazing opportunity for me and has, perhaps, been as important in my understanding of ornithology and ecology as any other opportunities I have had in life. Since my several experiences in Mexico, we have accompanied each other on such varied field trips, some extensive, as Thailand, Bulgaria and Romania, as well as examination of Anasazi culture in America and short trips in Australia.

ABOVE Gouache and pencil studies of Plain-capped Starthroats 21 × 30 cm
LEFT *Bald Eagle* (*Haliaeetus leucocephalus*) *Study #1*, oil on linen, 23 × 30 cm
This head study was painted at the time of the theft of Munch's painting *The Scream*, a title that could have been applied to the Bald Eagle painting; after the Twin Towers catastrophe, it could equally have been called *9/11 – The Scream*: a title can be used to make an emotional point and change the meaning and impact of a painting, although the painting remains unchanged
OPPOSITE Pencil and gouache sketches, 23 × 30 cm, developing an idea for a very small oil painting of a Bald Eagle fishing, called *Breakfast*

ANTARCTICA

MY ADVENTURES IN America had given me numerous subjects for paintings, but I was aware of an impending journey to Antarctica that would require a transition from watercolours to oil paints. Some of my paintings in oils were already finished, and Australian Galleries offered me an exhibition, to open on 2 November and run until 21 November 1989. This would give me just a month after the exhibition closed to prepare for my departure south.

Looking back I am astonished how many of my works were oil paintings, but the Australian Galleries, in a burst of wisdom, arranged to hold the exhibition in their Works on Paper gallery.

Fortunately, the paintings sold well, so within a month I was back in fieldwork, with Jenny generously running my affairs at home.

I was extremely fortunate to work in Antarctica. The program was part of the CCAMLR Ecosystem Monitoring Program (or CEMP) developed by the Commission for the Conservation of Antarctic Marine Living Resources, known more familiarly as CCAMLR. It was devised in response to the perceived threat to the Antarctic ecosystem by commercial harvesting of species such as krill and whales, and was intended to be an early-warning detection for changes in the health, abundance and distribution of creatures that, although not harvested themselves, could be affected by the harvesting, or protection, of other species. An example would be the flow-on effects of a proposed international ban on whaling, with an expected consequent increase in the number of whales. If this occurred concurrently with the increase in the commercial harvest of krill, then the excessive consumption of krill would depress the quantity available for krill-dependent species.

Given the immense task it would be to monitor all species and their interrelationships simultaneously, it was proposed to monitor a select group of 'indicator species' to give a valid reflection of the wider picture. Parameters suggested were reproduction, growth and condition, feeding ecology, behaviour, abundance and distribution. Changes in any of these could be caused by either aberrations in environmental conditions or alterations in food supply, so concurrent monitoring of the abundance of krill became important to assess the likely source of any problem.

PREVIOUS Adélie Penguins (*Pygoscelis adeliae*) and Emperor Penguins (*Aptenodytes forsteri*)
BELOW LEFT *Going Fishin'*, watercolour, 76 × 57 cm Adélie Penguins leaving the colony to head back into the ocean, although the surroundings of a nesting colony are seldom as pristine
OPPOSITE *Still Flying*, oil on linen, 41 × 50 cm Painting commissioned as a gift for Max Brookes in gratitude for his successful work on Gyrocast; sadly, he died of cancer just prior to its completion

My involvement with the project came through the Australian Antarctic Division, which was undertaking research in support of CEMP. My task was to instigate the initial research. The species on which I was to work was the Adélie Penguin. Adélies are known to be susceptible to disturbance, so a small colony was selected to study, situated on Béchervaise Island, near Mawson Station in the Australian Antarctic Territory. I was to work with a much younger person, Grant Else, who possessed the many technological skills that I lacked. The even greater advantage for me was that if anything went drastically wrong and it could not be obviously blamed on me, then it must be the fault of somebody else. There would only be two of us on the island!

Clearly, once CEMP was in full operation, to ensure comparable data from separate sites and seasons, it would be essential that identical methods be used by each participating experiment. However, at this early stage, that standardisation was for the future. The initial task was to prove the feasibility of the underlying concept.

Our tasks were numerous, but interrelated. We were to design a system whereby the birds in the colony weighed themselves automatically, recorded their individual number and spontaneously transferred the information to a computer in Hobart via an electronic signal radioed from a transmitter on top of the small hill on the island. The system would be required to sustain its operation without fault for periods of at least ten years to avoid humans disturbing the

colony. The technological aspect was very much Grant's field.

We were also to allocate numbers and fix radioactivated tags to about a hundred birds selected as a core study group, monitor the rate of recruitment of the juvenile penguins to the colony's creche, determine that the breeding adults were, indeed, dependent on a diet of krill, and develop an accurate visual means of telling the sex of each penguin. This more practical part of the project was more within my capacity.

The prospect of the sea journey from Hobart to Mawson Station in Antarctica was hugely interesting for me. I had not before sailed the open ocean and so was innocent of any knowledge of seabirds. Entertainment on the *Icebird* was provided to keep expeditioners occupied, for while there were many hardened old hands amongst us, there were younger, fitter and more restless men and women. Games of volleyball in the hold were popular for a while, until the open sea gave independent movement to the ship, and as many passengers as volleyballs were cannoning off the bulkheads before queueing at the door of the ship's medical office. Then it was banned, although shuttlecock survived. Whereas many passengers enjoyed conversation, games or videos in the warmth and security of the rooms below deck, I had resolved to spend

ABOVE *Against the Light*, oil on linen, 40 × 50 cm
A celebration of the colours in the Antarctic ice and the flying skills of the Light-mantled Sooty Albatross (*Phoebetria palpebrata*), the supreme aerialist of the southern oceans; the challenge was to paint facing the prevailing light source

LEFT Colour sketch in gouache, 21 × 30 cm, of a Light-mantled Sooty Albatross; it would be very difficult to capture their magnificent flying skills in a static painting

every possible moment on deck, keeping my eyes open for any Antarctic wildlife.

Initially I was disappointed. Four days out of Hobart the sea was perfectly calm, very clear and blue, but with few seabirds. I speculated that even though we were below 57°30' south, the water temperature remained high, at 5.7 degrees Celsius, and perhaps there was little in the water on which seabirds might feed. Day after day, the sea was oily calm and an eerie mist hung low.

Of course, there was important survival training for us to do, which I both welcomed and enjoyed. Subjects such as crevasse evasion and escape, with rope climbing and knots, seemed to be a sensible use of our time. Other aspects included building temporary shelters, glacier rescue and advanced navigational training.

Seabirds

After five days steaming southwards I was gradually becoming familiar with some of the birds. The first Wandering Albatross (*Diomedia exulens*) arrived on the second day and was an inspiring sight; shortly afterwards a Southern Royal Albatross (*D. epomophora*) was following the ship, dominating the smaller mollymawks, the Black-browed Albatross (*Thalassarche melanophris*), Shy Albatross (*T. cauta*) and Grey-headed Albatross (*T. chrysostoma*). Sooty Albatross (*Phoebetria fusca*) and the lovely Light-mantled Sooty Albatross had joined us early on, sooner than I had expected. We were also followed by Northern Giant Petrel (*Macronectes halli*), White-chinned Petrel (*Procellaria aequinoctialis*), which became almost boringly common later in the trip, Providence Petrel (*Pterodroma solandri*), Fleshy-footed Shearwater (*Puffinus carneipes*), Sooty Shearwater (*Ardenna grisea*) and Short-tailed Shearwater or 'Mutton Bird' (*Puffinus tenuirostris*).

Most of the time there would be an albatross or petrel of some kind following the ship, sometimes a long way behind, occasionally close behind the stern. They have learnt that ships may throw offal overboard, but beyond that, the churning propeller must damage sea life as it ploughs through the water and the turmoil of the wake tends to swirl food items to the top. Albatrosses, petrels and their ilk are opportunistic feeders, taking advantage of any dead fish or crippled squid that emerge on the surface. It is this behaviour that makes longline fishing so damaging to their survival.

Longline fishing

In commercial longline fishing a main line trails from a ship or a buoy with branch lines attached to it, each carrying a baited hook and stretching up to one hundred kilometres in length. On such longlines, many fish might have been dead for hours or even days when retrieved.

The capture of non-target species – 'bycatch' – can include sharks, dolphins, turtles and, of course, birds. Longlines may be set at any depth, but those near the surface put seabirds at risk. Baits can be weighted to sink faster as they are released from the back of the ship, but when they hit the water, they bob to the surface again in the wake and seabirds seize them, become hooked and are dragged under to drown.

Nigel Brothers, a committed marine biologist, was an Australian government observer on Japanese longline fishing vessels and could see that the method of launching baits was leading to reduced fish catch. He was also desperately concerned about the bycatch of seabirds leading to serious decline in numbers of albatross and pushing some species close to extinction. Longlines were contributing to upwards of

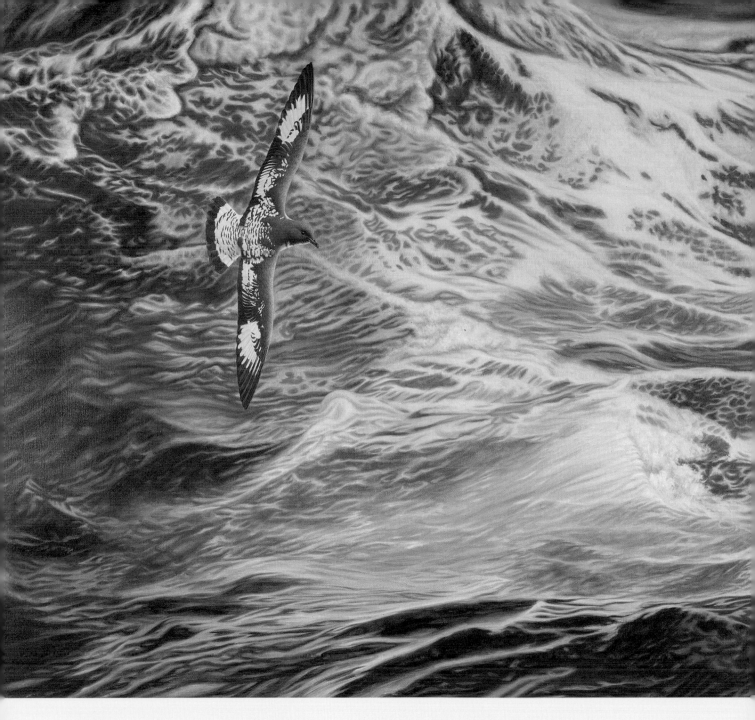

300,000 seabird deaths each year, many being shearwaters and petrels.

Today, the Norwegians, who fish for toothfish in the southern Antarctic Ocean, have the largest fleet, but in the early 1990s the Japanese fleet was the largest and considered to be the second-worst damaging fleet in the world for bycatch and the worst for deaths of albatross. Nigel Brothers' conservative estimate was 44,000 albatross lost annually, over twenty per cent of which would be Wandering Albatross. Seventeen of the twenty-two species of albatross were in danger of extinction, and their slow rate of

reproduction was incapable of compensating for losses of this magnitude.

Fortunately, Nigel Brothers and the Japanese fishermen were able to look for solutions co-operatively. If the baits could be launched mechanically from the side of the ship and flung forty to fifty metres beyond the turbulence behind the ship, they would sink promptly, reducing the opportunity for albatross to grab them. Initial results were encouraging, but they would need to design a mechanical launching device.

Back on land they adapted a clay pigeon trap, but the mechanism frequently broke down

ABOVE *Pintado Patterns*, oil on linen, 75 × 100 cm
A celebration of the evolution of plumage to blend with habitat, similar in intent to *Loon Patterns*, page 188; Cape Petrels (*Daption capense*) frequently accompany shipping in southern oceans and are a delight to watch as they sweep backwards and forwards behind the ship

under tough oceanic conditions. Nigel Brothers wrote an article for the Melbourne *Age*, explaining that the device would most likely have to be designed and manufactured in Japan.

A small manufacturing company in Ballarat responded and discussions soon resulted in patent applications and development of an early prototype. Munro Engineers were to manufacture and market the device and develop a commercial export market.

Retired engineer Max Brooke proposed the application of novel hydraulic principles to withstand the harsh conditions. Field testing led to upgraded trial models. Fishing masters on various test vessels responded positively and knowledge of the new technology spread swiftly by word of mouth. Gyrocast Pty Ltd was established in Ballarat to produce bait-casting machines for longline fishing, designed specifically to substantially reduce seabird bycatch.

Sadly these devices are no longer in production; Japanese companies began manufacturing bait-casting machines and Munro Engineers was involved in costly patent litigation proceedings in Tokyo. However, when their insurer declared insolvency, the cost of litigation became prohibitive and they could no longer fight to protect their patent. Modern longline fishing increasingly uses bait-casting devices, but the current technology is focussed more on improving fishing efficiency and less on protecting seabirds.

BY THE SIXTH day our ship, the *Icebird*, was feeling its way through brash ice, often at trivial speeds, before eventually we returned to clear water. At about lunchtime on the tenth day we were suddenly surrounded by about three hundred birds, most of them Antarctic Prions (*Pachyptila tutur*). They were massed astern and would make long, sweeping runs along the side of the ship, jinking suddenly from one tack to another or racing along, flush with the level of the waves, before arcing high into the air to sweep back to their starting point. Several of the lovely Light-mantled Sooty Albatross were present, along with Antarctic Petrels, Snow Petrels (*Pagodroma nivea*) and a Cape Petrel and then, in the evening, a Blue Petrel (*Halobaena caerulea*), not dissimilar to a prion, but noticeably darker over the head, longer and narrower in the wings and more direct in its flight. It was keeping pace alongside the ship, giving me an excellent view. The white terminal tip on the tail was very clear.

Sightings of whales were satisfyingly frequent, particularly Minke Whales (*Balaenoptera bonaerensis*), and with experience it became much easier to identify them. One pod had a calf and we could see Killer Whales (*Orcinus orca*) manoeuvring to intercept them, but gradually the heavy fog and scattered snowflakes concealed the outcome of this interaction. Other whales were infrequently visible – a single Fin Whale (*B. physalus*) and some Sei Whales (*B. borealis*) – but by the end of a day I would have no idea of the total number we had seen, having not made the effort to keep a record. There were plenty.

And then, quite unexpectedly, the sun shone through. I had found the days of continual mist and, sometimes, sporadic snowfalls increasingly depressing. Craving sunlight to display the colours of the icebergs, I was surprised to find that the colours that had been on display in dull light were perhaps more intense than when the bergs were fully lit. The intense brightness tended to subdue their colouration, but not so

ABOVE RIGHT *Chasing Down the Wind*, detail, oil on linen
An Antarctic Petrel (*Thalassoica antarctica*) racing down the face of a wave at full pace with the wind under his tail

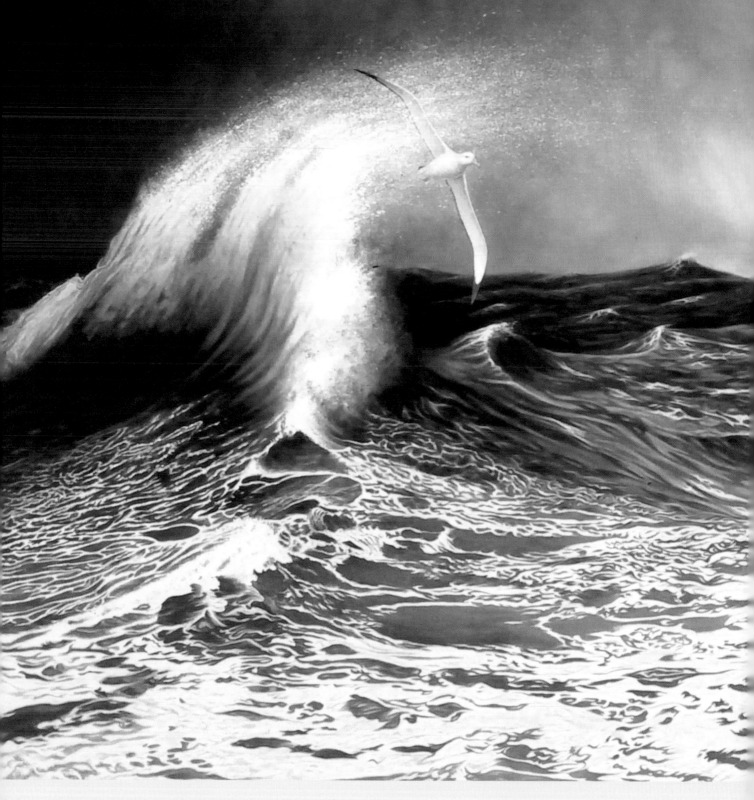

ABOVE *Ancient Mariner*, oil on linen, 122 × 183 cm

One of a pair of large oil paintings about conservation and preservation of marine resources, alluding to the epic works of the Old Masters and Coleridge's *The Rime of the Ancient Mariner*. It explores the relationship between violence and peace, depicting an adult male Wandering Albatross, whose white plumage may evoke uneasy associations with the white dove of peace. So long as the albatross follows, the voyage is free of troubles – 'And a good south wind sprung up behind; The albatross did follow' – but when it is killed, there are terrible consequences. All is resolved when the mariner blesses the beauty of the water-snakes and the albatross falls from around his neck: 'He prayeth well, who loveth well/ Both man, and bird and beast.' The composition echoes Hokusai's *Great Wave off Kanagawa*, from his series Thirty-six Views of Mt Fuji (represented by a wave in my painting) and evokes the relationship between the ocean and the Japanese influence on our marine environment. The albatross, almost obscured by the Great Wave, emerges from the darkness of threatened extinction, escaping the near Biblical wrath of the stormy sea, a powerful natural force that cannot be controlled by humanity, and flies into the light and calm of the foam in the foreground, now protected from the hazards of longline fishing by the advent of Gyrocast

By the following morning we were in heavy pack ice in an alley of icebergs at 66°48' south. Adélie Penguins were hunched mournfully on many of the icefloes or lying idly on their bellies in tobogganing postures. The open areas of water were constantly quartered by Wilson's Storm-petrels (*Oceanites oceanicus*) in the manner of swallows, except that swallows dip down to snatch morsels in their bill, whereas the storm-petrels would alight on the water, still holding their wings erect, and, almost dancing, pick the food from the surface.

By 7.30 am we were quietly reversing, backtracking out of what had proved to be a dead-end to search elsewhere for a weakness in the ice that would allow us to move closer to Mawson Station. Heavy weather was closing in, reducing visibility; it was unlikely we would be able to go ashore. Clear weather at both the take-off and the landing site is a basic requirement for helicopter transport. While the waiting was frustrating, it was all founded on safety.

We spent much of the day enclosed by the pack ice that was keeping us at bay around eighty-eight kilometres from Mawson, although we did get within about seventy-seven kilometres at one point. We broke through the barrier finally and pushed through to open water, cruising down an alley of icebergs in deteriorating weather conditions to arrive at the ice edge at about 9.00 pm in a total white-out, with the wind careering off the plateau, picking up fragments of ice and flinging them into our faces. In these strong winds, the flying skills of the Cape Petrels really stood out. They were very fast, with wings swept back, taut as a bowstring, almost vibrating as the wind whistled through them – wonderful to watch.

We could not reach land until the weather cleared. All next day we sat, moored to the ice, waiting. Strong winds and snow persisted and

their shapes. Brighter light showed a degree of structural beauty as the extraordinary, infinite variety of their sculptural shapes was revealed. Never were two the same, and seldom were they similar, ranging from rippled surfaces with deep creases to immense Gothic shapes with arches and domes; there was an intriguing spiritual quality in their silent splendour.

visibility was poor. Various kinds of petrels put on
a constant display of aerial agility, circling the ship
or arcing from water level to the sky, strung taut as
they shone brightly against a leaden background.
Antarctic, Snow, Cape, Southern Giant
(*Macronectes giganteus*) and Wilson's Storm-petrels
were all around the ship, but the show was stolen
by the Adélie Penguins. They were languishing by
the edge of the ice all day, or tobogganing around
in forlorn little groups; some came porpoising in
from the ocean to spring like a jack-in-a-box out
of the water and onto the ice. Occasionally they
would meander up to solemnly inspect the ship
before ambling away again on some half-forgotten
errand. Frequently, blocks of ice would break
away, carrying little parties of penguins aboard. It
was then that I could see how much they preferred
not to be isolated and alone. A single penguin will
almost always make its way to join a group, rather
than to stay alone, despite the frequent bouts
of quarrelling that break out amongst a group.
Adélies are pugnacious little penguins.

The following morning was, at last, beautiful
and sunny. It was time to disembark and see
Antarctica firsthand. Now we were within sixty
kilometres of land, each helicopter could operate
independently, whereas further out they must
fly in groups of three. Suddenly, I had fifteen
minutes' notice to prepare to be flown ashore. It
was an excellent feeling to be in the air with the
Antarctic vista spread beneath. There was nothing
with which to establish scale, so the immensity of
the landscape was not immediately apparent. The
eye is distracted by geographical features, dark
shapes protruding through the ice cap: the North
Masson Range, Rumdoodle, Mt Henderson and
Fang Peak in the David Range. Straining my eyes
for my first view of Mawson, the base for my
activities for the next few months, and knowing
from photographs what it would look like, I saw

ABOVE *Wolves of the Sea*, oil on linen, 122 × 183 cm

The second large work exploring peace and violence, it also refers to Christianity with the Gothic cathedral-like arch of the iceberg, intended to remind us of Genesis and the instruction to humans to 'have dominion over ... every living thing that moveth upon the Earth'. It is only later, as we emerged from the Church's domination, that we began to reconnect with nature, although we are yet to understand how intimately we are connected to the natural world. I have attempted to give a sense of the immensity of nature and our powerlessness in the face of it. Killer Whales disturb the peaceful scene, dark shapes that strike fear into most species, even our own.

it suddenly, unexpectedly spring into view. The sensation was extraordinary: imagine looking at your surroundings and having a telescope, held the wrong way round, thrust before your eyes. I was astonished at how tiny, how vulnerable, how inconsequential Mawson appeared. The landscape was huge, immense, totally dominating those little red buildings below! Horseshoe Harbour seemed to be a tiny pond and Béchervaise Island the bleakest barren rock imaginable.

That afternoon I was free to wander the station and learn its layout. The huskies were there, lovely, friendly dogs with a very important role in the station. Always, there will be someone in any camp who feels lonely, depressed, rejected or sad. Mawson had fewer psychological difficulties than any other Antarctic station, because when someone felt down, there were always the dogs to talk to, especially a friendly young dog called Bear, who had a special relationship with all the expeditioners.

They were cheerfully eager to fight each other, and were energetic and active on their chains when a person came near. Huskies can bed down and conceal their nose within their tail to weather a blizzard. A film of ice forms over the guard hairs of their fur, retaining warm air in the dense soft fur near their skin. It is important not to pat them or disturb them in such conditions, lest the ice layer be broken, allowing the wind to penetrate and robbing them of thermal energy.

How remarkable that those dogs were removed from Antarctica in the 1990s and sent to Canada on the grounds that they were a damaging exotic influence, polluting the continent. The fact that the penguins carried traces of PCBs (polychlorobiphenyls), the ozone layer was thinning and the seabirds were choking on plastic was not enough to encourage humanity to look after our planet, but the bloody dogs were a problem!

Down at Horseshoe Harbour there was a sobering row of three white crosses, marking the loss of three expeditioners who had not lived to board the ship homewards. In front of each cross is a pile of stones, covering the bodies of the men who died. The graves stand on the west arm of the harbour, always present as a reminder that life in Antarctica can be challenging and dangerous.

Each of Australia's Antarctic stations has suffered deaths, but the memories of those lost are more obviously displayed at Mawson. (In fact, there is now a fourth grave at Mawson, containing the ashes of Dr Phillip Law and Nelle, his wife, after whom the *Nella Dan* was named. Mawson Station was established by Dr Law on 13 February 1954.)

The following day, in the early afternoon, we were given on-site survival training and a demonstration of crevasse rescue. It left a lasting impression. Joined by ropes, we set off into the ice field, skirting an obvious crevasse, which we stopped to inspect, peering carefully over the edge to see as far as possible down into the depths.

Suddenly, there was a loud noise and one of the trainee expeditioners vanished. Chris had moved forward to see the crevasse and stood on an overhang, which promptly collapsed. He had plunged out of sight. Our trainer, Nic Deka, was lightning quick. Realising that the fallen man must be tied to someone who might be unprepared for the twang at the end of the rope and could be pulled into the crevasse himself, he leapt back, plunged his ice axe into the ground and tied off the rope in an instant. The lost man's fall was arrested. There we were, all deeply shaken, with one of our number dangling in a cold, confined crack in the ice, terrified that if anything further went wrong he could have another sixty metres to fall.

The next exercise was to remove him from his predicament. This was not as easy as it sounds. The rope was running over the edge of the lip of the crevasse and buried in snow. Approaching the lip would be dangerous, lest it give way further, or drop a second person into its confines. Setting up rope retrieval systems and extracting Chris took over two hours, by which time he was extremely cold and very, very frightened.

That evening we skied across to Béchervaise Island to assess the work to be done at the penguin colony. The sea ice was still relatively resilient, but the snow and ice and slush on top were beginning to break up and make travel difficult. The sledges we would have to use to transport our gear were going to sink in and make towing them very hard work. Some of the tide cracks were beginning to expand, so we needed to get organised quickly.

Béchervaise Island proved to be the bleakest spot on Earth. It is no more than a rock with no topsoil and, unsurprisingly, no plant life larger than a lichen. Wilson's Storm-petrels use the security of the ledges formed by cracks in the rocks to rest, to roost and to nest and were swirling about like bats, accompanied by the occasional Snow Petrel. There was a penguin colony located at the north-east tip of the island, with a landing point nearby at the mouth of the channel separating the island from the mainland. There was a single main colony, with two subsidiary colonies and many eggs and young chicks in the nests. The Adélies seemed relatively unconcerned by our presence, so long as we remained on the periphery of the colony. Always, there were South Polar Skuas (*Stercorarius maccormicki*) in attendance, searching for any opportunity to steal an egg or snatch an unprotected chick. It was therefore imperative that we not disturb the adult penguins.

Returning to Mawson, we organised survival supplies and food rations, in preparation for our move to Béchervaise Island. Two miserable days ensued while we waited for a weather report clear enough to fly by helicopter to our camp site. I seized the opportunity to ski out to East Bay to sketch Emperor Penguins. There were fifteen Emperors clustered together close to the shoreline awaiting their moult. Ten were beginning to look shabby as the first feathers fell. They did not appear to be alarmed by our presence and allowed us to approach to within about three metres without showing any signs of nervousness or desire to move. They had obviously been camped there for some time, as the ice was becoming heavily marked by their presence. There was little aggression between any of them.

Weather was going to delay the start of our project longer than we could tolerate, so we reassessed our baggage and pulled out the absolute essentials for the first few days. This brought our kit back to 195 kilograms, so we procured two man-haul sledges, packed them and prepared to ski to Béchervaise Island. There was only a narrow window of time in which we could operate. The sea ice was still sufficiently firm to support our weight, we had skis and harnesses for four people and sought assistance from other helpful and interested folk. After dinner, at 8.00 pm, when the sea ice might be expected to be a bit firmer, we set out for the island, towing the sledges. We arrived at the north-west corner of the island without too much difficulty. Each time the sledges broke through the surface it was only into fresh water about a foot deep, lying on top of the sea ice. It took all of us to lift a bogged sledge back to the surface ice and get it moving again. On arrival, we were faced with carrying the gear across

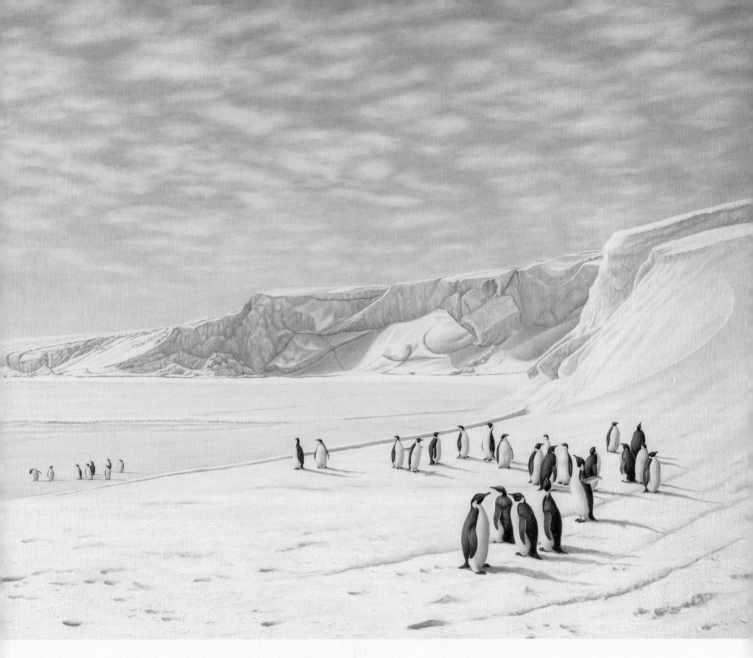

to the north-east corner of the island, beyond the channel and beyond the colony of penguins. We were hopeful that, once the weather improved, a helicopter could air-lift the remainder of our gear to the island, although it was important that it did not disturb the Adélie Penguins. We still had to transport our food, tent, radio gear and plenty of alternative fencing materials to develop fencing concepts for penguins. As a farmer, that was my job. The ice was expected to melt swiftly very soon, trapping us on the island until such time as a helicopter could lift us off. Helicopter time was scarce and expensive, so we could be there for months, not days.

There were two pairs of skuas next to our selected camp site, one with two young and the other with a single chick. The parents were very aggressive, the pair with only one chick more so than the other. They viciously attacked our heads, occasionally resting on top of a nearby rock to recover from the exertion. They never actually made contact with us, but we gave them little encouragement to do so. The chicks, meanwhile, would scurry away with heads held low to hide near or behind a rock.

We had landed on part of the island nearest to Mawson Station, probably about two kilometres from our chosen camp site near the penguin colony. To give some perspective, one of the fencing materials that we were to test – galvanised rabbit netting, nine hundred millimetres high and one hundred metres long –

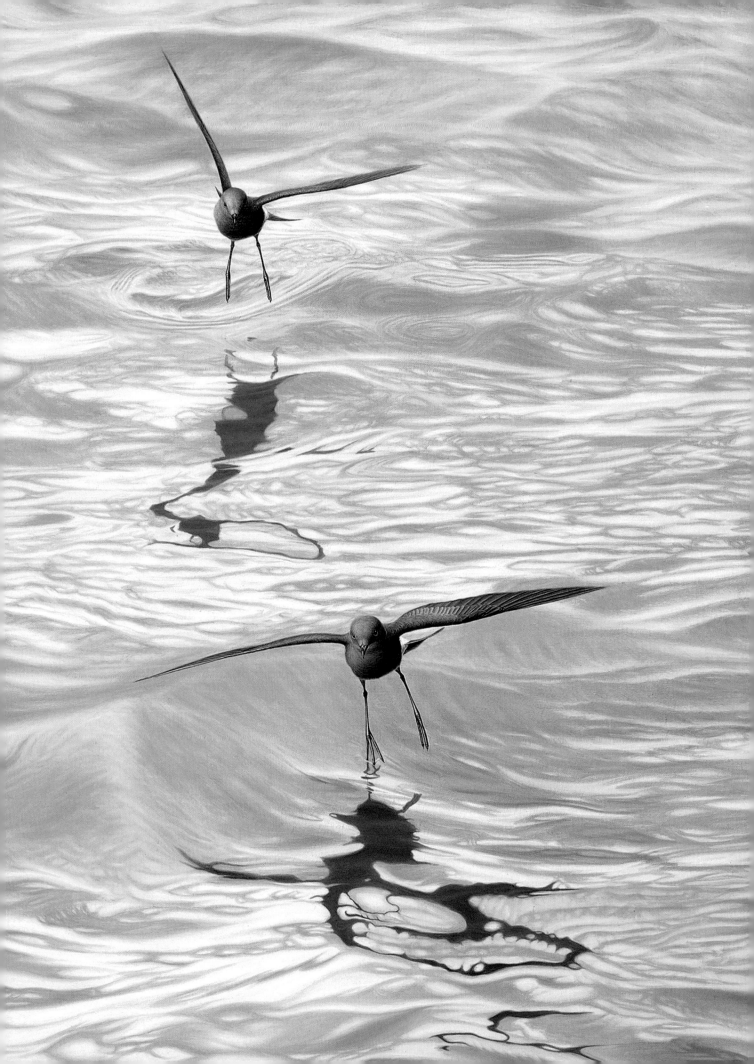

weighs seventy-five kilograms per roll, no joy to carry over rough rocky terrain for over a kilometre. Eventually we managed to transfer all our gear to the camp site, erect our polar pyramid tent in the approved manner and begin our work. Quietly, Grant and I agreed that we would work as hard as we could to accomplish our mission in the minimum time possible, so we could ski off the island while there was still ice to carry us.

After setting up camp, one of our first tasks was to ascertain whether penguins could be influenced or controlled by fencing and, if so, could they be induced to cross a weighbridge in single file to reach the colony? Prior to leaving Hobart, Grant had been working on the conversion of an automatic weighbridge, invented for cattle by Dr Knowles Kerry and Charles Tippendale, that would function in the infinitely adverse conditions of Antarctica without breakdown. He had emerged with a completely new concept which I am unable to explain, but which I am sure was brilliantly innovative!

Adélie Penguins

Adélie Penguins are cute little guys to look at. I first encountered them as I was carrying a roll of netting over my shoulder and passing about six metres from the breeding colony. One of these charming little birds, a male, rushed out, grabbed my leg in his very powerful bill and proceeded to beat it with a flurry of strong blows from his tough little wings. He left a bruise like a grapefruit which persisted for several days.

Having begun our relationship with such affection, we needed to develop a means of capturing individual birds to number, measure and tag. In my youth I played rugby, and the odd

shape of the ball seemed designed to make it more difficult to secure in adverse conditions, like wet mud. As always, nature's design was better than man's, and whoever designed Adélie Penguins made them almost impossible to catch in icy conditions. They look easygoing, even placid, but they can leap, skid, twist and turn like a weasel, before they bite, struggle and flap. They are amazingly strong.

I hasten to add that, prior to leaving for Antarctica, our project had to receive the seal of approval from an ethics committee and one of their requirements was that I develop expertise in handling penguins. To this end, I helped band 100 Little Penguins (*Eudyptula minor*), close but diminutive relatives of Adélies, on Phillip Island. However, that experience bore no resemblance to attempting to catch Adélie Penguins.

To identify individual birds we used sheep-marking dyes, which, to satisfy the wool industry, must be scourable and would therefore wash off soon after our research. We needed to select a colour that was unlikely to alter the behaviour of the birds: red was obviously inappropriate, as it could resemble an injury and prompt an attack from their own or another species. We chose blue, and, capitalising on their glistening white shirtfronts, and their tendency to turn to face any threat, we painted numbers across their breasts.

The next morning, Grant went to set up a weather station, while I observed the penguins to establish what route they habitually used to enter the breeding colony. It immediately appeared to be more daunting than we had hoped. Much of the colony and subsidiary colonies seemed to come ashore at random and would not be possible to guide with fencing. A lot of the birds nesting at the top of the little hill on which Grant would erect the communications signal used a main route for access, which narrowed at one point, giving a possible site for the automatic weighbridge. Unfortunately, the

OPPOSITE *Wilson's Storm-petrels*, oil on linen, 60 × 90 cm Detail from a painting of storm-petrels emerging from shelter after three days of blizzards; there were tiny birds everywhere, dancing on the oily water, casting wonderful reflections as they picked morsels of planktonic minutiae from the ocean surface
ABOVE Gouache study of an Antarctic Prion; they have an indirect flight pattern, constantly weaving or abruptly turning in a manner quite different from most other seabirds

birds tended to use
several routes back to sea.
More concerning was the fact that
many of the penguins from the group on the hill
were landing at a different place and reaching their
nests by an alternative route.

Whether each bird's route was consistent
each time, or whether they alternated between
routes, we were unable to tell until we had
sufficient identifiable birds. I was also concerned
that their behaviour could well change once the
sea ice melted in a week or two, as the position of
the ice seemed to affect their approach to land.

However, the penguins seemed amenable to
suggestion, and on land appeared reluctant, or
unable, to jump anything over which they couldn't
see. However, it was possible to see through most
of our fencing materials. Whether this would alter
their behaviour we did not know.

The wind had been increasing in strength to
about seventy kilometres per hour and had become
tiresome. It was very cold, so we were reluctant to
handle birds in those conditions, lest they became
stressed. Instead, we ascended to the trig point to
assess whether we had a good enough view of the
penguins to establish a census of the colony. As it
turned out, our hopes were completely dashed,
because we could not see a single penguin.

The following morning, after a good sleep,
I slipped out very early, leaving Grant sleeping.
I started at the western end of the channel and
using this point of the island as a datum point,
began drawing a map of the penguin colony.
Instead of counting nests, I counted birds. I found
it difficult to ascertain what a nest contained
without forcing birds to stand up, thereby
disrupting the colony. And what constituted a
nest? Many of the Adélies were using stone nests,
but appeared to be inexperienced or non-breeding
birds. Some birds were still incubating eggs and

there were plenty of young
chicks, but none of
them was ready to
move into a creche,
probably not for a week or more. I arrived at a
final count of 2169 birds.

Overwintering expeditioners commented
that everything seemed late that year and
suggested that the birds had not arrived until late
October and early November. It was already the
second week in January and there were birds still
copulating, although they were not necessarily
breeding birds.

There also seemed to be unoccupied
outlying 'mini-colonies'. These would probably
have been used by inexperienced or non-
breeding birds anyway, but I felt that the
previous year might have been a bad one, or that
some influence was depressing the breeding in
the year we were studying. To be really scientific,
it just didn't 'feel' right!

After Grant arose, we set about measuring
penguins. It took us some time to develop a
system, but then we settled into a rhythm. We
were having great difficulty with the calipers
losing adjustment. There seemed to be a tooth
missing in the calibration that created an error
of 0.5 millimetres at regular intervals. We were
also disappointed to find that our scales were only
sensitive to fifty grams, instead of the twenty-five
grams that we would have preferred. Measuring
the legs of the birds caused us great difficulty, as
the bone is cushioned by so much flesh that it
was difficult to isolate the tarsus for measurement,
particularly with recalcitrant and struggling birds.

One reason for measuring was to try to
identify a reliable method of telling the sex of the
Adélies. It appeared that we were finding similar
dimorphism to that in Little Penguins, which
really seem to be only a tiny, neotenous form of

LEFT Pen and ink
with wash sketches
of Adélie Penguins on
Béchervaise Island
OPPOSITE Loose
study in pen and ink
with watercolour,
21 × 30 cm, of an
Emperor Penguin
that came ashore
behind the dog lines
at Mawson; it was
very approachable,
providing great
opportunities for
observation and
sketching

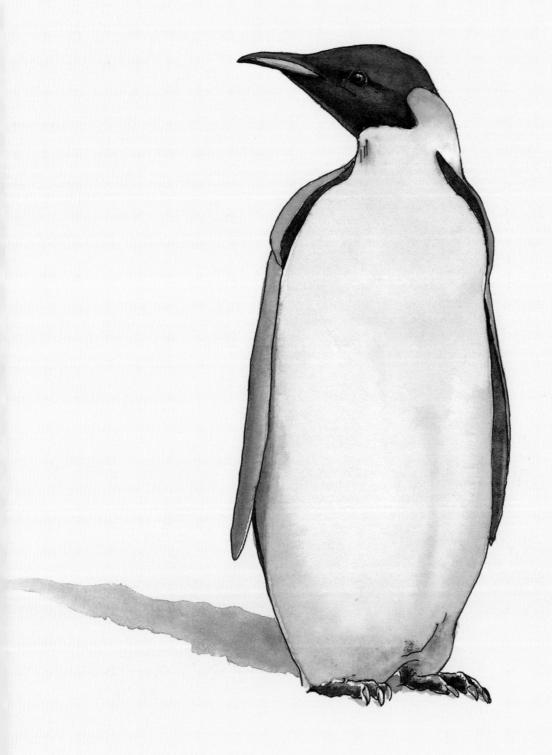

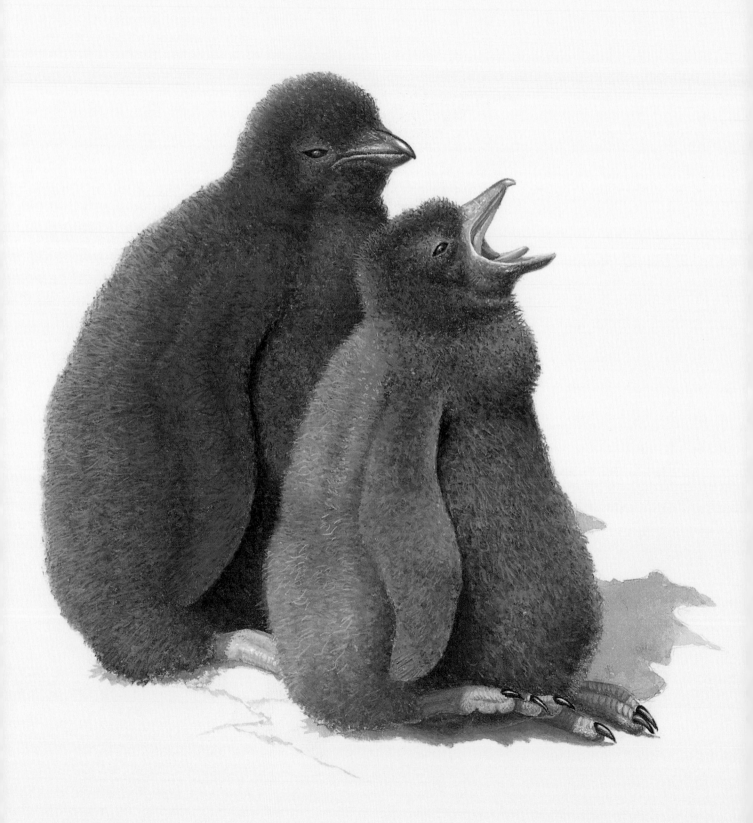

the Adélie. In each species, as it turned out, the females' bills are slender with a shallow hook, while the males' bills are deep and heavy, with a more distinct hook. We were measuring width and depth at the nares, but our difficulty was to find a set of measurements that expressed sexual difference clearly; the length of exposed culmen (the upper ridge on the beak) seemed to show promise.

Our measurement of flipper size showed extraordinary uniformity. Every bird seemed to have flippers of nearly the same size and width.

We had numerous radio sessions with Mawson during the day to ascertain whether the helicopters were in service. Eventually, at 3.45 pm, we were informed that we could do the aerial survey of the penguin colony at 4.25 pm. Immediately we packed up our gear, walked to the south-east corner of the island, donned our skis and fled back to Mawson. Fortunately, the sea ice was stable, and if anything in slightly better condition than when we skied out to the island.

Once at the station, we packed the remainder of our kit in nets and air-lifted everything out to Béchervaise with two Squirrel helicopters. After we landed and unloaded, we removed the door from one chopper so that I could sit on the floor with my feet on the skids; we did two steady runs down the channel flying at sixty metres taking aerial map photographs of the penguin colonies for massive enlargement to allow me to count individual birds on my return to Australia. To say that it was cold sitting outside the helicopter is something of an understatement. The wind-chill factor from the aircraft's downdraught was astonishing. Chill subdued my fear of plunging sixty metres into icy water, or onto rocks or ice. I was pleased when we had finished.

Following the return of the helicopters to Mawson, we moved through the penguins trying to establish to which position our marked birds were returning, before building a rock wall across the path of departure for penguins leaving the colony, attempting to funnel them through the point at which we intended to establish the weighbridge. By measuring places where we had seen penguins jumping obstacles naturally, we were confident they were unwilling to jump any obstacle above their eye level, which translated to a height of 450 millimetres.

Armed with this observation, we began to erect our fencing. There could be no thought of driving any vertical structure into the rock to support it, so we constructed uprights from steel mesh, to which we attached rabbit netting, supporting the uprights with rocks on their base. The ground was uneven, so gaps beneath the wire needed to be addressed. We found that Adélies were unwilling to duck under the wire; two did so, but only when under pressure and where there was a gap of 260 millimetres. Their normal reaction was to stop well back from the fence, before turning along the line in search of a way through the barrier. Some birds (we observed four do this) would rush the fence and push at the wire with their breasts, but these were half-hearted attacks and nothing came of them.

OPPOSITE Gouache study, 21 × 30 cm, of two penguin chicks in the nest; I nicknamed them Optimism and Pessimism
RIGHT Gouache study, 21 × 30 cm, of an Adélie Penguin chick, colloquially known by expeditioners as a 'shmoo'

Grant did report one bird that went over the fence where it was loose and flexible and where the supports were too widely spaced. Other than that, one bird pecked at the wire in an exploratory fashion and none attempted to jump or climb over it. We constructed a 'pseudo-weighbridge', using the aluminium tray from our tuckerbox, and set it in a suitable site for the weighbridge, concealing the edges with rocks to make it slightly more acceptable. Most birds resisted the obstacle and when we removed it the traffic flowed more freely, especially uphill, which gave us pause for thought.

In the early afternoon a Southern Giant Petrel visited the colony and was immediately chased by the skuas, which effectively evicted it from their nesting territory. It meandered off up the channel and loitered around the island for a time, before returning and being attacked by the skuas again. Eventually it left and disappeared completely, leaving us erecting an extension to our fence on the Mawson side of the weighbridge gap to try to prevent birds running up the hill from an alternative route and to encourage them to use the main track. Initially, they continued to duck around the end, but when it was further extended, it worked well. With our fencing in place, I went round all the sectors of the colony, plotting the position of our numbered birds.

Our next task was to fit birds with radio tags. These were stock-handling tags encased in black plastic and about half the size of a box of matches. Our intention was to glue them to the feathers on the back of the penguins, where they would not inhibit their activities in any way, until they were shed on the beach at the next moult and could be recovered by searching with an Amscam receiver. In the cold temperatures, the glue took too long to dry, so we could only tag when conditions were warmer than normal. Penguins are very strong, and their flippers, with which they fight, can give a fearful beating – I was still suffering from my first encounter. Their bills are also efficient weapons and my hands were beginning to accumulate numerous injuries where I was bitten while measuring them.

Conflict between birds was frequent, and their attitudes reminded me of being in a pub! Their normal response was to push at one another with their breasts ('What was that you said? You come outside and I'll sort you out!'). Further antagonism would result in whirring flurries with their flippers, before the loser turned tail and fled.

They seemed to operate within a capitalist system. Their currency was pebbles and small stones, rare on the barren surface of the island. Stones were highly valued in the construction of their nests, and morality was low amongst some birds. Theft of stones was common, and they looked ridiculous waddling along, happily carrying a good stone in their bill. Within the confines of the colony, such theft received communal retribution, as each nesting bird pecked and bit the culprit as he rushed between them, weaving to avoid the attacks.

Once we had tagged birds, the Amscam system appeared to be working quite well. It was the birds who were unco-operative. The first bird

LEFT Every penguin colony is supervised by a pair of South Polar Skuas, relentless predators forever on the alert for an unguarded egg or chick; this 16 × 21 cm pencil drawing depicts their greeting ceremony; published in *Conserving Antarctic Marine Life : CCAMLR the Commission for the Conservation of Antarctic Marine Living Resources – its origins, objectives, functions and operation*, 1991
OPPOSITE Pencil drawing from an Antarctic sketchbook of Rumdoodle from the hut, done on a 'jolly' from Mawson
BELOW Pen and ink with wash sketches of Adélie Penguins at Mawson

we tagged was moving downhill, so we ambushed him before he reached our weighbridge and released him again on the uphill side, hoping to test the tag as he went over the scales. Instead, he immediately rushed back uphill and was soon afterwards to be found in colony 'P' incubating two chicks. The next bird we caught going uphill, so we tagged and released it before it reached the gate, whereupon it shot off downhill. Some judicious shepherding induced it to retrace its tracks and step through the gate, giving us our first reading of a correct number.

Meanwhile, we had re-caught our first bird and encouraged it to go through the gate twice. In each instance we achieved no reading. The first time it ducked through very low and managed to get under the infra-red beam without triggering it. The second time, it held its wings back in a 'swallow dive' posture and the signal was occluded by its flippers. We realised we must glue the tags to the nape of the neck rather than to the mantle so that they could be clearly read.

There were two inexperienced, non-breeding birds with a nest near our weighbridge

gate. The male had been carrying stones for the nest for a couple of days and we saw them copulating. Given they would be likely to use the gate more frequently, we tagged and measured these two birds, having identified their sex. We took them down to our coastal measuring site to band them, hoping to prevent them becoming fearful of the weighbridge site, as others had appeared to be. Both became extremely agitated after measuring and tagging. Upon release, the male left in a hurry on an oceanic voyage of great urgency. The female loitered off along the shoreline, looking hurt and dispirited.

Both were back on the nest by the evening, having given valid readings at the weighbridge, although the female was still shy. Clearly, the birds did not enjoy being handled, so we allocated time that evening to trace birds that were known to us and could be readily identified to assess whether they had suffered any ill effects. Almost immediately we found number 46 in colony 'P' happily incubating two chicks, and number 35 in colony 'Q' attending to its incubating mate. Others we found were behaving naturally and seemed to have fully recovered from

their experiences, so it seemed that they could be safely tagged.

We had instructions to take stomach samples from five penguins, to assess whether they were fully dependent on krill, a much more severe intervention we approached with great reluctance. Of those we captured, the stomachs of young, non-breeding birds contained small amounts of krill only, whereas the older birds with chicks to feed were full of food: krill, worms, squid and various fish.

These results raised some interesting questions. Do older birds, having more experience, manage to capture a wider variety of species? Or, because they have families to feed, must they forego the luxury of preferred food and be content with whatever they can find in the least possible time before relieving their partner of nest duties? It may have been that to travel to the areas where krill could be found used too much time and energy, so that they hunted only the food items that were closer to their nests. It is a delicate balance to survive a breeding-cycle in Antarctica. Whatever the answers, Grant and I were most reluctant to force penguins to regurgitate and

ABOVE Gouache study, 21 × 30 cm, of an Adélie Penguin stealing pebbles for a nest
OPPOSITE Having procured a pebble, there is the run home, chastised by every other Adélie Penguin if it comes within reach of their nest; gouache study, 21 × 30 cm

were relieved when we had completed our task. It is tough on the penguins and objectionable for the biologist, a point made clearly in our final report. The birds show evidence of shock from the treatment and suffer from hypothermia as a result. They appear weak and dejected and totter off to sit shivering in isolation. I think our enforced use of unheated water made it much worse.

We spent time locating the birds that had been tagged the previous day and found all but one in the upper colonies, where they would have crossed the weighbridge. One had a tag that was malfunctioning, having leaked seawater, but otherwise the system appeared to function well. Leaking tags did become a bit of a problem for the program, as did batteries fading in low temperatures, but that was what we were on Béchervaise Island to test. It forced a change to a different, subcutaneous tag with a protruding aerial for subsequent years.

It was time to assess our efforts, so we sat near our weighbridge to watch the penguin parade. Approximately seventy birds per hour were going through the gate with a leakage to other points of access of about ten per cent, or up to fifteen per cent at its worst. This encouraged us to extend the top and bottom of the western fence to bring in more birds.

Penguins evidently react negatively to being handled, becoming much shyer than birds that have suffered no interference. Some seemed to become quite paranoiac. They appear to remember where they were measured, and possibly even by whom.

Penguins react well to being fenced. They seem to be mentally attuned to circumnavigating physical barriers and accepted the presence of a fence without testing it. Mostly they could be induced to turn along it in the direction required. Occasionally, just like Emus, they would get

almost to the gap and then turn back, having not recognised it, or deciding it must be in the other direction.

They responded best to rabbit netting. With sheep mesh, the gaps were just wide enough for them to try to push through instead of turning and following the line. One interesting point that arose from living with the birds for a time was the fallacy that Adélie Penguins move in groups. We never saw more than five to seven emerge together from the water, and normally only one to three. Having made landfall, they tended to behave individually. They would preen themselves dry after moving only a short distance ashore and then proceed uphill to the colony. Sometimes they seemed to lose their train of thought, or their confidence, and if they met a group of birds coming back in the opposite direction, they might

turn and follow them back down for eight or ten
metres, before regaining their resolve and turning
to face uphill again.

They are very reluctant to enter the water
alone, and try not to be the first in a group to
do so. This is perfectly reasonable, as the first in
is the most likely to fall prey to a Leopard Seal
(*Hydrurga leptonyx*) or a Killer Whale. It was
this instinctive desire to be second, or third, that
enabled us to separate them at the weighbridge.
We needed to ensure that multiple individuals
did not cross the plate simultaneously, as we
would not be able to separate their numbers or
their weights. By raising the weighbridge plate
to a level at which it became an obstacle, we
induced their naturally courteous behaviour.
Three or four birds might arrive together, but
they would stand aside, muttering, 'Après vous,
George!' 'Non, non, après vous, Henri,' until

one took the plunge and the others followed in single file.

We had finished our requirements, so, in the evening, we dismantled the fencing, carefully marking its position, and started to pack up the camp. There being no pressing reason to stay on the island, it was best that we got off quickly while (or if) there was sufficient strength in the sea ice. Otherwise we would probably be dependent on a Zodiac to pick us up after the ice had cleared completely, which could take months. It was unlikely we would be allocated a helicopter for non-urgent transport, so it was 'get away quickly or be prepared to stay.'

We arose very early the next morning hoping to capitalise on cooler temperatures, packed the camp and walked across the island, carrying our skis. The ice across to Mawson was reasonably

sound, although Grant disappeared into a tide crack at one point. There were eight Weddell Seals (*Leptonychotes weddellii*) lying out on the ice, presumably having come through the tide crack in the opposite direction, and one was 'singing', with a series of warbles and trills a bit like a whale's song. The variety of sounds that it could make was astonishing.

So, we left Béchervaise Island. It had been a fascinating experience and I had managed to fit a good deal of drawing into any gaps that I could find in our scientific program.

DRAWING EN PLEIN AIR

Drawing in Antarctic conditions imposes a few challenges. Normally, it was compulsory to be roped together when we were outside the station

limits, lest one should blunder into a crevasse. It is
not easy in such conditions to survey the landscape
and to suggest to one's companions that here,
right here, would be a good place to do a drawing.
People don't enjoy waiting around in sub-freezing
conditions, humouring an artist who feels moved
to draw the landscape. In such conditions, one
works with increasing speed, with a greater
certainty of line and clearer understanding of
the key features to be recorded. Added to the
urgency is the acute discomfort of immobility in
intense cold. I found that, quite quickly, a drawing
that might have taken me ten minutes when I
first arrived at Mawson would take me only two
or three minutes under these constraints. The
freedom of Béchervaise Island had allowed me to
draw or paint alone. I found early on that sitting
still was only tolerable for a time. After an hour,
or perhaps an hour and a half, I would start to be
acutely aware of the discomfort. Two hours was
very painful and three hours was intolerable, so my
painting and drawing speeds improved.

In preparation for my time in Antarctica, I
had experimented with the media I intended to
use by wrapping the paints, canvasses and brushes
in a towel and placing them in a deep-freeze for
over three hours to find out how they would
respond. They remained surprisingly normal and
proved excellent once I was using them on the ice.

Most of my sketches were in either ink,
pencil or oil paints; water-based paints were less
feasible for obvious reasons. I had made up a
whole series of sketch canvasses for oil painting
prior to my departure. These I used for recording
the colours of the landscape, which proved to
be extremely difficult. The 'white' of Antarctica
is made up of many brilliant clean colours, blues
and greens and pinks, but they are difficult to
record because of the intense light. Mostly, when
I looked at an oil sketch back at base, under

artificial light the colours were so exaggerated
that it appeared ridiculous.

The island was a fine home for many, many
Wilson's Storm-petrels and I had had plenty of
opportunities to draw them. In the evenings,
right on dark, they would come in to their nests,
fluttering in front of the ledge and sometimes
landing, but frequently veering away to fly back in
again, or landing on the rocks above and resting.
We found many nests, some of Snow Petrels, and I
was able to observe the South Polar Skua often, as
well as Antarctic and Cape petrels, and, of course,
the Adélie Penguins and other Antarctic birds.
It was a privilege to have visited what was still,
nearly, a pristine wilderness.

The rest of my time at Mawson was
wonderfully interesting. Our job was finished, so I
was in limbo until such time as the ship returned.
When it did, it was the krill research voyage, as
part of the round tour to transfer passengers to
and from Davis and Casey stations. While still at
Mawson, I could spend time anywhere on the
station, which allowed me to accumulate sketches

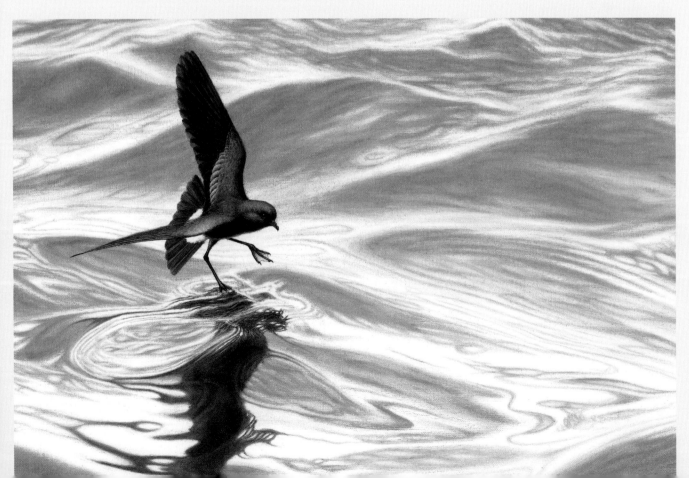

and paintings at will. To move outside the station required a permit and company willing to be roped to me.

There were often people seeking journeys further afield, the Masson Range, Rumdoodle and Mt Henderson always being popular. Such journeys normally used a vehicle known as a Hagglund (the Hagglund BV206D tracked carrier) and required a minimum number, so there was always an invitation. Grant and I, being available, were fortunate in the number of trips we took and I even climbed Mt Hordern, accompanying the infinitely more experienced Nic Deka. The peak was little more than a narrow ice ridge, less than a metre wide, but the view along the David Range to Mt Coates and Mt Lawrence was superb. To the east of us lay the Masson Range

and southwards a very interesting mountain decorated with beautifully coloured scree slopes.

That was our last day at Mawson. When we returned to base, there lay the *Polar Queen*, anchored offshore and waiting to come into harbour. However, the next day we awoke to filthy weather conditions, a white-out with a temperature of –5.8° Celsius and winds of fifty knots, gusting to sixty. It was not a full blizzard, but it was still nasty to be outside. From the West Arm the ship looked spectacular and inviting in the white-out. No one was visible on board. While I was watching, I became aware of a Weddell Seal breathing at a small hole in the ice in the lee of a rock nearby and set out to stalk it. It moved while I was approaching, but came into a more open stretch of water where it rose to breathe more regularly, about every

six to ten minutes. When it came up it would breathe rhythmically, but put its head under water between breaths. Eventually it came up to breathe about one and a half metres away, saw me and very quietly sank, tail first, leaving hardly a ripple or a swirl to disclose its presence. It never came back.

As the wind continued to moderate, we waited for the ship to enter harbour. The day was clear, and had been from the beginning, but still we waited. Eventually she started to move and circled to line up on the entrance to Horseshoe Harbour. Once in, she used her bow thrusters to position herself before dropping a LARC to run lines to the bollards. This done, our mail was brought ashore and a deep silence settled on the station as each expeditioner retired to read his or her news from home.

Soon Mawson swarmed with new faces bedecked in bright, unsullied polar gear as they wandered off to visit the graves, or pat the dogs or look for penguins. We were about to leave, but the cycle was to begin again.

At 5.00 pm the next evening we boarded the ship. As we ascended the gangplank, we could see over to East Bay, where there was a long line of penguins, both Adélie and Emperor, all in single file, marching out towards the sea. The seals were on the move also, and I recall turning to the person behind me on the gangplank and asking, 'Do you think they know something we don't?' Three days later, the ship's radio bulletin published an account of what had occurred:

NEWS FROM MAWSON: During the final throws [sic!] of dinner we heard the low growl of ice crashing from the cliffs near the station. There was a virtual mass exodus from the mess as we all congregated on the vantage points at East Arm. To our utter amazement the ice cliffs on East Bay, and further eastward, were all cascading into the sea. The spectacle lasted for approximately 15 minutes ... The desire to capture such a unique image on film was tempered by the indecision of not wanting to lift your eyes from this superb demonstration by mother nature ... The water level in the bay, to the east of the station, rose up to six feet (1.8 metres): with water flowing up the slopes of the adjacent islands 20 feet (6 metres), vertically. In Horseshoe Harbour the water rose in excess of four feet (1.2 metres), on an abnormally high tide (due to a recent solar eclipse) and rushed up into 'market square' engulfing 'store Klippe' and the surrounding bollards and climbing the walls of the old power house.

My time on board ship was filled with watching the krill research, and trying to help whenever I could. Unfortunately the super high-tech underwater camera proved inoperable, so the research team dropped back to more primitive technical aids, a krill net: a gauze drum net tied to a rope, which was wound round an old electrical cable drum, through which was poked an old broken plank. I smirked inwardly when I witnessed the degree of adjustment from the high-tech to the low-tech. Initially, they had little success, but around midnight numbers caught began to grow. At first the catch was composed of juveniles, but

232 A BRUSH WITH BIRDS

then there were increasing numbers of adults, until
we had caught some females with eggs. The final
score for the night was between five and seven
thousand, far exceeding expectations, and the krill
crew were generous in allowing me access to the
krill to make sketches and drawings.

There were numerous Snow Petrels coming
in very close to the ship, sometimes in flocks of
up to two hundred, as well as a tight squadron of
about 250 Antarctic Petrels. These were joined
by the occasional South Polar Skua, Southern
Giant Petrels, Wilson's Storm-petrels and,
sometimes, a Light-mantled Sooty Albatross.

The sea became very much rougher overnight
and remained so the following day. Onwards
we steamed, followed by increasing numbers of
Southern Fulmars (*Fulmarus glacialoides*), Snow
Petrels and Southern Giant Petrels. Wilson's
Storm-petrels were frequently present, flying

like swallows, as fast as or faster than the ship,
occasionally stopping abruptly to hover with feet
trailing in the water before picking some tiny
morsel from the surface.

When I awoke the following morning it
was to find the ship stationary and enshrouded
in mist. Snow was falling heavily. The captain
thought that we were at Davis Station. I asked
whether I could go ashore were I to forego
lunch, and boarding the next LARC managed to
get a spare seat on a helicopter heading for Hop
Island, where two scientists were studying Adélie
Penguins and skuas.

Petrels
Hop Island supported colonies of Cape Petrels,
Antarctic Petrels and Southern Fulmars, and it was
to these areas that I made tracks. The route took
me through an Adélie Penguin colony, and these

birds were well in advance of those breeding on Béchervaise Island. Chicks were well grown and in creches, and there was even a first-year bird ashore to moult.

There were about twenty Cape Petrels in their colony, all very tame and quiet. They were brooding half-grown young and the nests were widely spaced. The parent birds were not very active, but they looked superb in the snow. More common in the breeding colonies were Southern Fulmar, which seemed to be nesting on many areas of the island. Activity within their colonies was greater, with more interchange of adults and more pairs in attendance. Their breeding was less advanced than the petrels', with many still incubating eggs. They have a bill-gaping greeting ceremony which is similar to their threat display when their territory is invaded.

Antarctic Petrels were nesting next to the fulmars just below the camp, with nests packed tightly together. All their chicks were of a uniform age, about half grown, and many were unattended. The adults are very docile and delicate, and if disturbed most merely turn their head obliquely away before giving ground. From close up they are very beautiful, with exceptionally soft colouring.

Returning to the base, we were greeted by the sight of a Chinese ship, from their station the other side of Law. Despite her size, she was no ice-breaker and had been unable to get to her base because of the ice. In the oblique light, coming quietly through Iceberg Alley, she looked fantastic, glowing as if she were made of burnished gold. It was a great disappointment when she came closer and the light changed to reveal that she was a rusty old hulk with no visual appeal whatsoever. Such is the magic of good lighting!

On shore, or just offshore from the station, we saw a Leopard Seal take an Adélie Penguin, a brutal performance. The seal would swirl up beneath it, grasp it in its jaws and fling it five to ten metres across the sea, before repeating the process. The penguin becomes weaker and weaker and dies quite early, but the process continues to strip the skin from the bird and make it more palatable for the seal.

I managed to secure another helicopter ride out to Hop Island, where I spent more time with the penguins and the fulmars. There were two areas where the fulmars were nesting closer together and they spent a lot of time gaping their bills at each other as a form of intraspecific threat, although in general they are quite peaceable. Many were sitting on empty nests or attending incubating mates, and there were always birds arriving and departing.

The return journey was a real bonus because we had on board The Man from the Ministry, a representative from the Ministry of Finance, assessing the wisdom with which our taxes were being spent. We were given a clear and detailed tour of the region around Davis Station. The landscape is much more complicated than the surroundings at Mawson. The station nestles on the edge of the Vestfold Hills, a low outcrop of rolling, rocky knolls with frequent intrusions of black rock,

ABOVE AND OPPOSITE
Pencil sketches,
21 × 30 cm, of
Antarctic Petrels on
Hop Island

cleaved by fjords and tarns and bounded on one side by the ice plateau and on the other by the Sørsdal Glacier. This glacier is very heavily fractured by crevasses and we circled low over an Imax film crew working on filming one of these. There must be tremendous tensions in the ice to create such an effect; sometimes the splits are in a chequerboard pattern and occasionally the whole ice mass is gnarled and twisted. It was spectacular to view this landscape from the air. Davis generally experiences milder conditions, and the heat absorbed by the black rock surrounding the station must moderate temperatures greatly.

After a buffet dinner in the Davis mess we boarded the ship and by 10.00 pm were sailing out through Iceberg Alley towards Casey Station. The amount and variety of bergs were magnificent. On our journey to Casey we were again followed by seabirds, and had Cape Petrels with us all day in varying numbers. They fly fast on great swirling tracks backwards and forwards across the stern, occasionally riding the wake to venture alongside the ship before lifting, kite-like, up and behind again, or alternatively advancing round the bow and back again. The wind was strong and they arced high over the stern, with shallow wing-beats, or with wings set in a taut 'W'. They are dumpy birds that give the impression of short, straight wings with a high wing-loading, but they are lovely to watch, and astonishingly well camouflaged, considering their bright patterning.

Occasionally they were joined by White-chinned Petrels, large, dark petrels with a gleaming pale bill and a small white patch of feathers on their chin, gliding effortlessly on long, broad wings. Usually they flew stolidly some two hundred metres behind the ship, but occasionally they ventured closer, particularly if they saw a Cape Petrel drop into the water for food. With their greater size, broad bodies and bull-necked appearance, it is not difficult to see them as potential robbers.

After some days of filthy weather (one night the ship was forced to stop and hold position, facing into the wind, for five hours) we eventually arrived at Casey. However, the weather remained poor, so it was not possible to go ashore. The third day was much calmer and there were seabirds gathering on the water behind the ship, seeking some microscopic organism or phytoplankton on the surface. Half a dozen Cape Petrels were swimming around pecking food from the water's film. There were also numerous Wilson's Storm-petrels 'walking the water', heading into the wind at near stalling speed, treading the water with both feet simultaneously as they bend to snatch each morsel. The motion is quite rhythmic, and the poor little guys must have been ravenous. The torrid weather conditions of the past few days must have had them cringing under rocks and in burrows to keep warm, and now was their chance to satisfy a voracious hunger. The sea temperature was close to freezing, around −3.5° Celsius, so the slow movement of the water was placid and oily. The birds created the most intriguing reflections.

ABOVE *Ice Edge*, oil on linen, 50 × 65 cm
View from the ship *Icebird* as we waited for a blizzard to clear at Mawson to allow us to fly ashore; conditions where we waited were dead calm, but the blizzard caused beautiful colouration over Mawson

RIGHT Pencil view of Casey Station from near the new station, looking over the melt lake below and to the vacated dongas beyond

The next morning was a dead calm, grey day, with the sea like a mirror. Immediately I boarded a LARC and gained the shore, taking the opportunity to walk around and do some sketching of various views. I walked up through the old dongas, due for demolition, and peeking inside was saddened by what a huge slice of history was to be removed. They were still much the same as when people moved out of them, with cutlery and crockery on the tables.

Not far from Casey is the abandoned American station at Wilkes on the Clarke Peninsula. I was interested to visit the site and see what remained. It had been a research base built by the US in January 1957, and taken over by Australia in February 1959. Having been built as a temporary station, it swiftly began to deteriorate. Seeping fuel turned the buildings into a fire hazard and drifting snow entombed the structures for most of the year.

By 1969, a new station, Casey, was commissioned for the other side of the bay and Wilkes was closed. That old tunnel station was in turn superseded by the new Casey Station. Gradually the site has been covered in ice from drifting snow. A group of us skied round to

inspect the station. A number of the buildings and objects were visible, but the overriding memory is of storage dumps and rubbish from twelve years of occupation. When the division pulled out, it took nothing with it, and left a shambles. There were dead huskies piled on a pallet and partly burnt. Another pallet carried dead seals (for dog food?). There were cases of jam, soap, iron filings and bicarbonate of soda (used in making gas for meteorological balloons), waste tar paper, old machinery parts – everything, just lying scattered about where it was last used. It was both beautiful and disgusting at the same time. Everyone in our little skiing party was deeply affected by the shame of what we saw.

Around the fringes of little Newcomb Bay are SSSI (Sites of Special Scientific Interest), yet the evolution of habitation on this astounding continent is a grim reminder of how slow we have been to alter our attitude to the removal of waste from Antarctica and the protection of its environment. Even the new Casey Station has been guilty of a diesel spill into the melt lake below.

From this clear day the weather progressively deteriorated, but eventually the Jetranger helicopter aboard was able to fly us out in adverse

RIGHT Pencil drawing, 19.0 × 25.5 cm, of a pair of Crabeater Seals (*Lobodon carcinophagus*) resting on a bergy bit at Casey Station; *Conserving Antarctic Marine Life*, CCAMLR

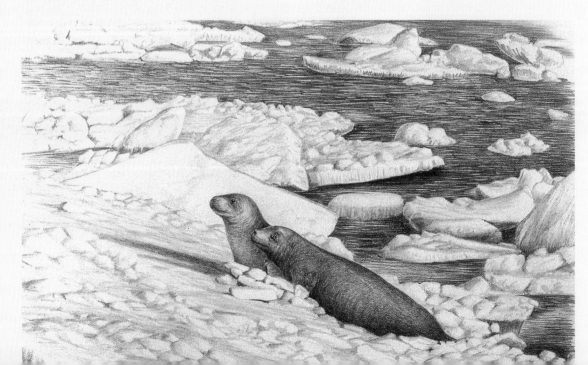

conditions and we could weigh anchor. As we got into open water, we were joined by Great-winged Petrels (*Pterodroma macroptera*), smaller than a White-chinned Petrel and with a black bill, and a less stolid means of flight, jinking and arcing high. At one time a lovely White-headed Petrel (*Pterodroma lessonii*) passed us briefly, flying in the manner of a fulmar, a beautiful well-marked bird with more obvious contrast than guidebooks would have us believe. The dark wings and pale body were decisive and its white head showed the dark eye-marking and black bill very clearly. Sadly, it took no notice of our ship and disappeared into the mist ahead.

At night, as we headed towards Hobart, we were treated to a glorious aurora. While not particularly bright, or even colourful, it was like a soft visual symphony, ever changing in subtle ways as now the woodwind dominated, now the strings, quietly changing shape and character all the time. One almost expected it to ascend in a crescendo, but eventually it just faded away, leaving a dark sky and an air of sadness. Thus finished my Antarctic journey.

When I returned from Antarctica, I made an error which I suspect is not uncommon. I arrived home, full of stories of adventures and wonderful sights, and spent scant time listening to Jenny and thanking her for all that she had done to enable me to be away. Single-handedly, she had been running our businesses, our finances, our home, while raising two young children in isolated circumstances. She had juggled all these responsibilities with flair.

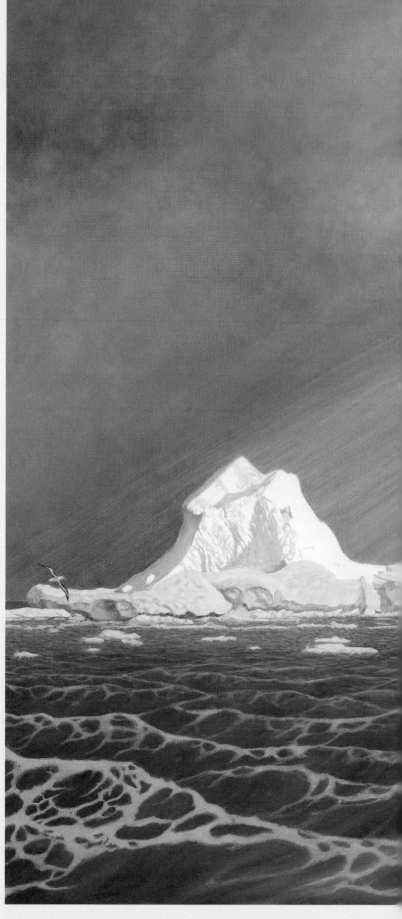

ABOVE LEFT Tiny gouache sketch of a Wilson's Storm-petrel in flight, no bigger than a twenty-cent piece; such sketches are a valuable record of attitudes and character

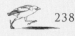

238 A BRUSH WITH BIRDS

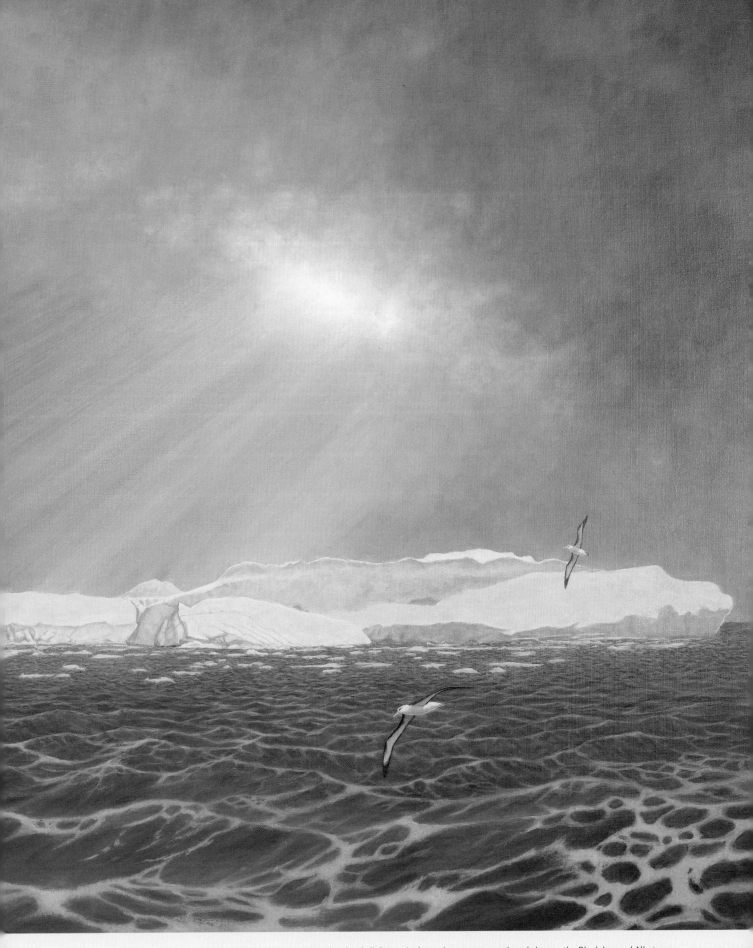

ABOVE *Southern Light*, oil on linen, 60 × 90 cm A shaft of light penetrating the clouds lights an iceberg; the seas are rough and choppy, the Black-browed Albatross seek shelter from the wind in the lee of the iceberg – not every day in the Southern Ocean is benign

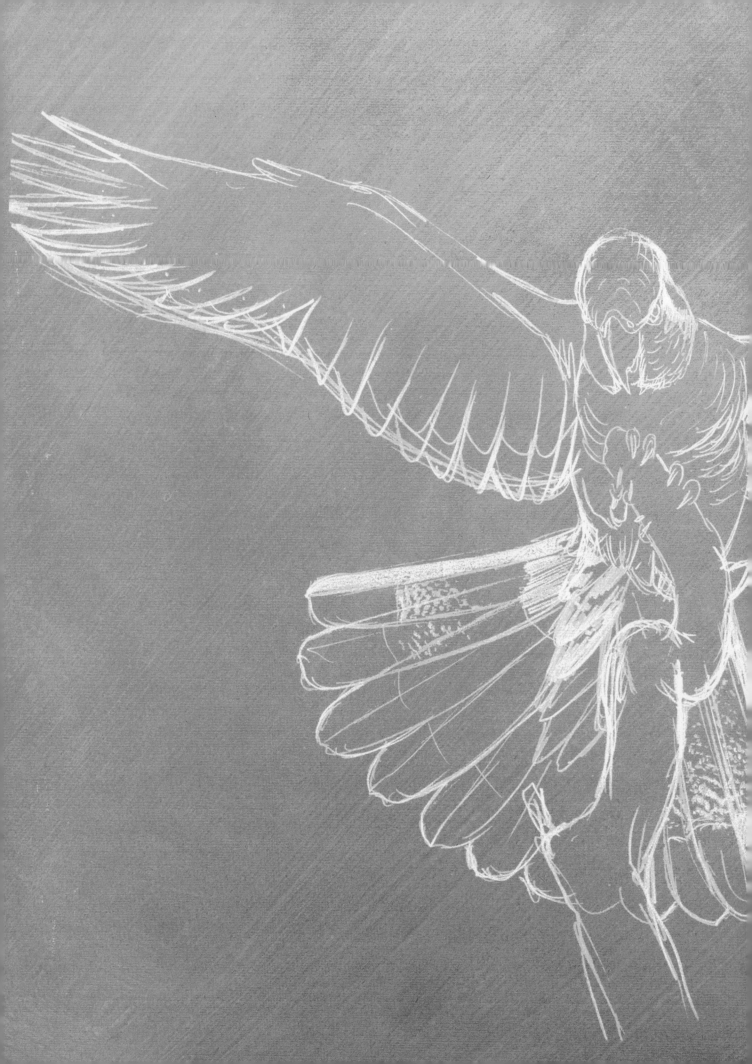

Fire and Water

THE GRAMPIANS – GARIWERD

ONE OF THE under-recognised aspects of farming in Australia is that the family is living in the business, day in, day out and all day. There is no respite; there are books to keep, phone calls to make, plans to be drawn up. It can become increasingly claustrophobic.

It was Jenny's idea that we should buy a place in the Grampians, a mountain range in western Victoria, so that we could escape to a nearby paradise to relax. It would be easily accessible, and would fulfil our respective interests in natural beauty and the environment. So, we began to search for our ideal retreat. Our budget was limited and our requirements specific, so there were few places that appeared suitable. One that we liked was sold, to our great disappointment, just as we were inspecting it, but given that we were in the Grampians anyway, we went off to look at another place that we knew we couldn't afford: Mirranawarra, a lovely combination of bush and heathland, bounded on two sides by the Grampians (Gariwerd) National Park.

Well, what a surprise. It was perfect, but, as we knew, unaffordable! We spent a lot of the day walking through this property, relaxing near its large wetland and enjoying what it had to offer. Then we went home, in silence. That oppressive silence hung over our household for two or three days, until we decided that, if we ever did buy a property in the Grampians, it would be difficult to enjoy it, as it would always seem second best.

Ultimately, we negotiated the purchase, but for less than the original asking price. The night

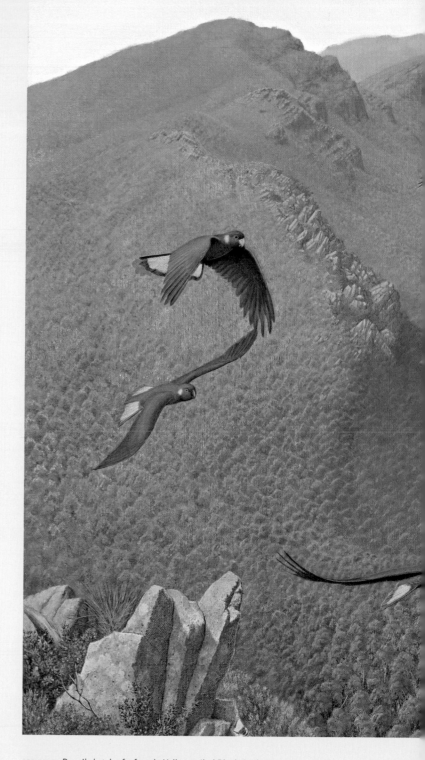

PREVIOUS Pencil sketch of a female Yellow-tailed Black Cockatoo
ABOVE *Over the Range*, oil on linen, 60 × 90 cm
When I first sketched this wonderful landscape in the Serra Range in the Grampians in January 1974 it had suffered from fire only once since European settlement. Now it has been burnt more often and has become dryer and more flammable. The first drawing was from the ridge for a painting of a Peregrine Falcon about to leave her perch on a rock and dive at a pair of Crimson Rosellas crossing through Serra Gap. After the country was burnt again in 2007, I changed to Yellow-tailed Black Cockatoos, resilient birds that appear to recover well from fire. I wanted to portray the sense of flying with them, so I redrew the landscape from an imagined point one hundred metres above the ground. As a focal point in the foreground I included some rocks sketched on the site as a kind of dolmen, a gravestone in memory of a landscape consumed by fire. I finished the painting in 2016, forty-two years after I started.

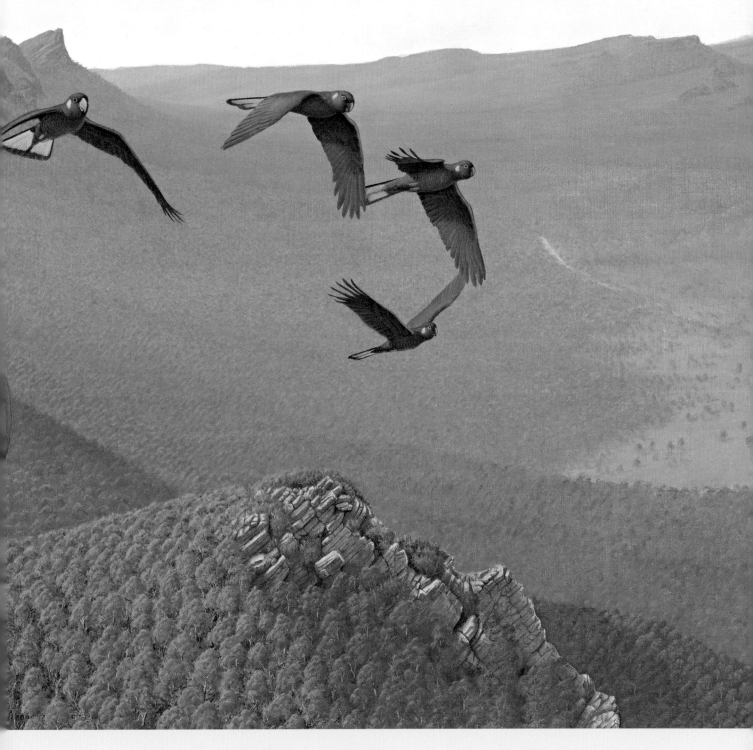

we moved in was early in November 2005 and there was a massive electrical storm. The house has huge windows, and we felt warm and secure while revelling in the wild storm that was raging outside. Intense flashes of lightning were illuminating the mountain cliffs looming above us. The hummocks of Club Rush (*Ficinia nodosa*) swayed and tossed in the wind, almost like the breaking waves of a rough sea. We felt part of the place; it was a fantastic welcome to a new abode.

In the morning, the wetland in front of the house was calm, with an eerie mist rising from the Spike Rushes (*Eleocharis sphacelata*) as multitudes of swallows and martins left their night-time roosts amongst the reeds. The water became alive with ripples where the swallows were drinking or snatching insects from the surface film. As the day warmed, the insects rose higher and with them the birds, until they were circling tightly some sixty metres above us.

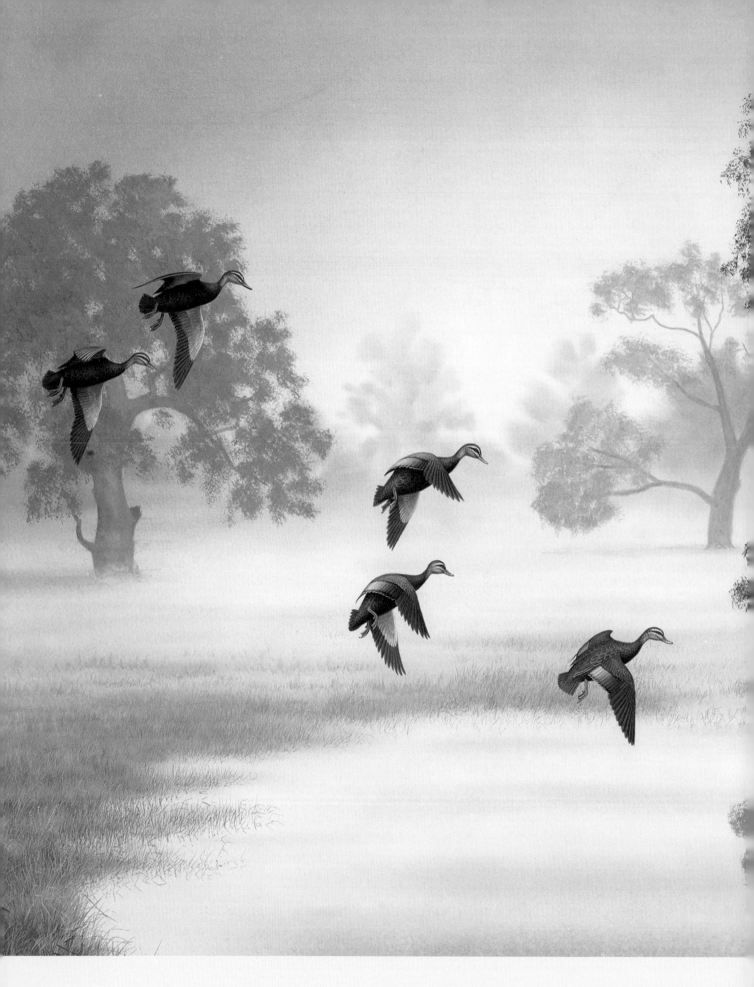

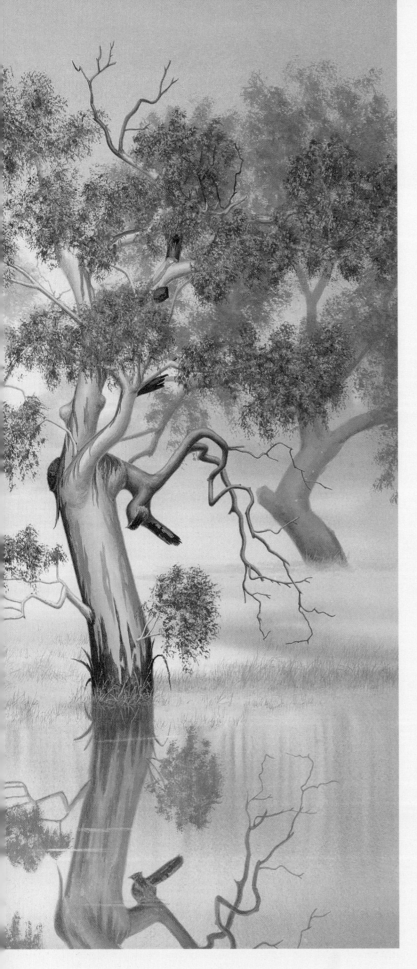

An area of water gives an excellent focus for a dwelling. All day, the dam would attract interesting birds to use it. A regular was the Swamp Harrier, which wafted in on upswept wings, hoping to surprise some unfortunate and defenceless prey trapped out in the reeds and at its mercy. Normally it would begin its search where one of the springs fed the waterway in the north-west corner and saunter erratically across the dam towards the house, so there were often wonderful opportunities to watch its behaviour. It would baulk and turn, then drop into the reeds, before scrambling back into the air and resuming its unpredictable search.

There was a young male Musk Duck (*Biziura lobata*) that lived on the dam for a couple of years. His was a nervous existence; he was constantly checking under the water, I suppose to monitor for the presence of large Murray Cod (*Maccullochella peelii*). Sometimes he would see something and run, splashing across the surface for ninety metres or more before settling down again. At other times, when he was feeding underwater, he would pop up from a dive like a cork and run frantically to a safer place. I always believed he must have encountered some predatory monster lurking down there to terrify him.

His concerns were well founded, for, as we held a barbecue one day, a young girl caught a Murray Cod, and while cleaning it, suddenly called out, 'Hey, look, Mum. There's a duckling inside!' and, sure enough, there was a little Black Duck that had been taken by surprise from below. I believe that this may have happened more frequently than we knew. I was impressed by that girl, as she was an enthusiastic breeder of poultry and ducks, but was totally pragmatic about the predation of a duckling by the fish.

LEFT *Black Ducks Landing in the Morning Mist* — this early gouache painting, 56 × 76 cm, portrays Black Ducks flying in to the flats of the Hopkins River during a flood, something I had grown used to seeing since I was a child

Sitting relaxed on the verandah and beside the water one lunchtime, I heard a sudden commotion and a male Eastern Spinebill (*Acanthorynchus tenuirostris*) tumbled out of the air and plummeted to our feet, hotly pursued by two New Holland Honeyeaters intent on beating it into submission. The New Hollands swiftly realised the situation and fled, but the spinebill lay there resting for so long that our son gently bent down and picked it up, perching it on his finger. Still it stayed there, so eventually I went to get a camera. When I returned, it hadn't moved, so I photographed the situation, the bird held close in front of our son's face as he examined it, a shot that I value greatly. Eventually, the spinebill roused itself, preened some displaced feathers and flew off into the scrub.

I always enjoyed the Yellow Robins (*Eopsaltria australis*) whizzing along the verandah, swerving at the last minute to narrowly miss our heads. They fed on the lawn immediately in front of the house and sometimes nested just outside a window, where they could be readily observed. They enjoyed visiting the birdbath less than a metre from where we sat, sharing it with the spinebills, fairy-wrens, scrubwrens and fantails, and seemed little concerned by our presence. The rosellas liked to bath using a dish at greater distance, and the bronzewings – both Brush (*Phaps elegans*) and Common (*P. chalcoptera*) – came in to drink very cautiously, even further removed from where we sat.

In the evening, there were a couple of places where the Yellow-tailed Black Cockatoos (*Calyptorhynchus funereus*) preferred to come for their evening drink. They settled and posted their sentries before the first one or two birds descended to the water's edge. It must seem very dangerous for a large bird like that to be caught at ground level where visibility is restricted, and it takes time to scramble into the air if a threat

appears. The Gang-gangs preferred to find a drooping branch that hung down to the water, where they could clamber down to drink before ambling back up again. Mostly they spent their time relatively immobile in the denser acacia trees, quietly stripping the seeds on which they feed and gently conversing amongst themselves with gravelly growls and squeaks, like an old oak door on unoiled hinges.

There are nearly 120 hectares of heathland and bush to enjoy on this property. Most, particularly the heathland, is far too dense for a person to force their way through, and if they could, it would be so noisy that everything would be frightened away before it could be seen. For this reason we slashed walking tracks in a pattern throughout the area. The first we created is a generally circular track circumnavigating near the boundary. At intervals, 'spokes' run from the house to the exterior track so that people can choose which wedge they wish to walk, or, for variety, trek over a number joined

together to make a larger wedge. All the tracks deliberately meander to conceal what is just ahead. This achieves two aims: one is to enable close and unsuspected approach to avoid disturbing the wildlife until we are near enough to observe it; the other is to make the journey seem longer, the property larger. This was a trick shown me by a wonderful little game park in Zimbabwe, only about the same size, but in which I kept on seeing the same animals again and again, until I began to wonder whether Sable Antelope always rested in groups of three, or zebra universally grazed in herds of seven, and why Giraffe eschewed company to be always alone.

There is a downside to slashing tracks. It opens the country to exotic animals and feral pests. There is no doubt that foxes and Red Deer utilised the easy access, but we never saw a rabbit, and only one cat. We didn't observe any weed invasion, but it did give us emergency access throughout the property, if it were ever to be required.

Walking the tracks, one soon became familiar with the environment and developed a good sense of where certain species were to be found: the places where the Powerful Owls roosted, the breeding territory of the Southern Emu-wrens and the roosting hollow used by an Owlet-nightjar. Some species were less certain, but there were places where one knew one was more likely to encounter Blue-winged Parrots (*Neophema chrysostoma*) or Crested Shrike-tits

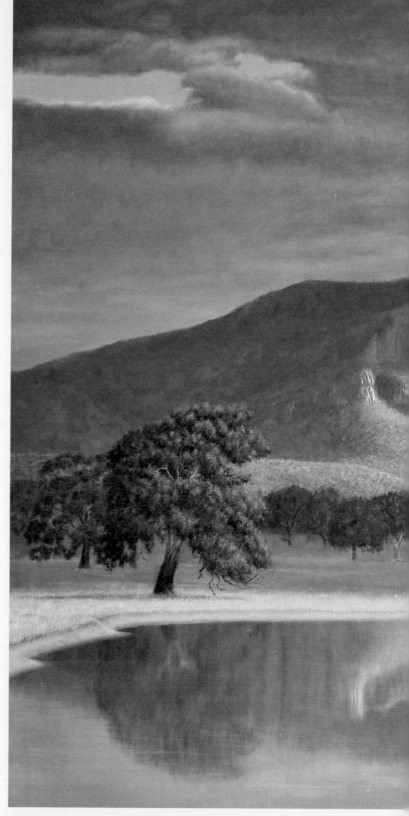

ABOVE LEFT Pencil drawing of a male Eastern Spinebill feeding in Common Heath (*Epacris impressa*), sketched in the Grampians

ABOVE *Grampians Wakening*, oil on linen, 60 × 90 cm
View of Mt Abrupt and the Mt William Range, which we often passed on our way to Mirranawarra. One day, it was displayed by this wonderful light effect. The ephemeral lake doesn't exist, but the mountains needed balance, so I added it from imagination, allowing me to introduce the arriving Brolgas. I made many visits back to the same spot and sketched it numerous times, but never saw the same light effect again.

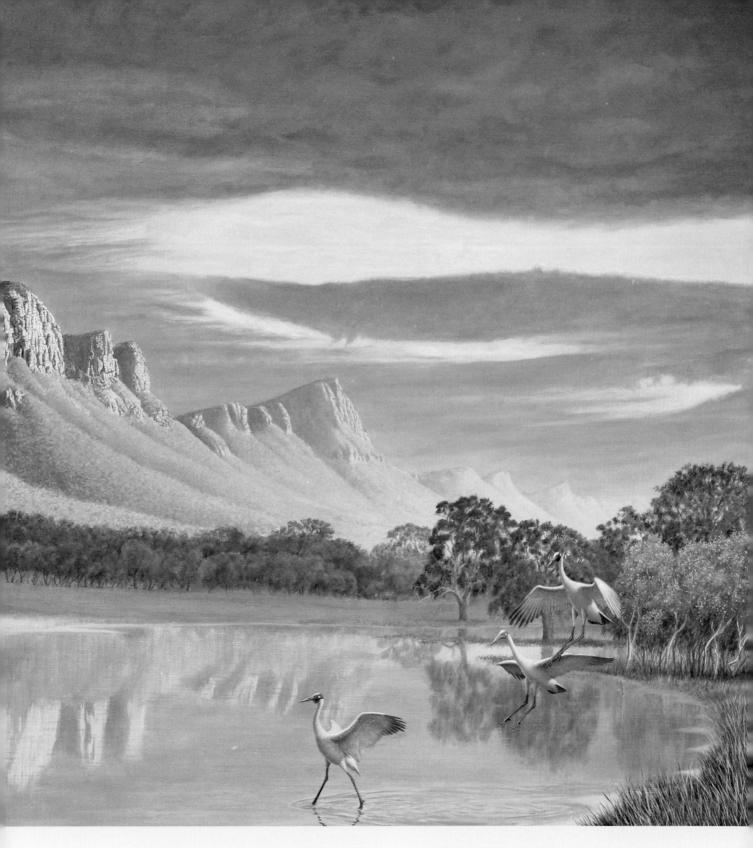

(*Falcunculus frontatus*). A pleasant sense of familiarity gave a much closer relationship with the area.

We became increasingly familiar with the landscape and the events that affected it. When we first arrived, although the seasons had been drier than normal, it had a sense of dampness, even marshiness. There were parts where one could not walk without getting wet feet, even in the early summer. There were numerous reliable springs and the country seemed wonderfully healthy.

Then there was a fire.

FIRE

The first was lit by lightning at Mt Lubra. In the past, a local would have saddled a horse, ridden up into the mountains and put it out. However, the property was surrounded by national park and so this is no longer allowed. Very slowly the small fire grew, and grew, spreading into some rugged country and consuming vast areas of bush. This, apparently, was of little concern as there was no 'property' lost. One wonders who the bush belongs to. It was all national park, to my mind the property of the people.

I was a volunteer in the local fire brigade. As it happened, most of our time was spent sitting around doing nothing, waiting for someone in the command centre to approve what we knew had to be done. Often, approval would come through too late for the task to be effective, and decision-making would have to start all over again.

The original lightning strike was left unattended on the grounds that it was too unsafe to travel into it. There is always a degree of danger, of course, but mathematically, the danger of having over two hundred trucks and their crews fighting a fire for sixteen days over 80,000 hectares is more likely to produce casualties than two or three people tending to a fire of half an acre for half a day.

Despite threatening for a fortnight, this fire never reached our property. However, it focussed the attention of the authorities on the region around our place and it was decided to burn a large area adjoining us the following year. We watched, aghast, as several thousand hectares were burnt. We were concerned because initially the area was lit manually along the road at the foot of the range, forcing the wildlife up the slope. Then, a helicopter was flown in and incendiaries dropped in the national park at the head of the slope, trapping the fleeing wildlife between two walls of fire.

The purpose of the burning was 'hazard reduction', though no fire had emanated from that section of bush to damage local assets in living memory. It was labelled an 'environmental burn', and I can only agree that it consumed the environment. For the first time in my life I was on the spot to observe the repercussions for the ecosystem, not only on the day of the fire, but for years afterwards. A cheerful young girl from the department, pale-faced from her urban existence, informed me that 'the xanthorrhoeas will love it,' meaning, I suspect, that *Xanthorrhoea* has evolved over millions of years to tolerate and mostly survive fire, frequently responding by flowering, as do many plants in a last-ditch attempt to reproduce prior to their demise under abnormal stresses.

The area burnt was selected because it had been unburnt for many years. I have been unable to locate any prior survey to evaluate the targeted area. Sadly, the ecosystem is devoid of any innate affection for fire, as burning wreaks many important changes. Forest Wire Grass (*Tetrarrhena juncea*), which burns violently, can be sparsely represented in the bush and responds with enormous vigour after fire, growing back with increased density, choking out many of the more delicate indigenous plant species. This tends to render the environment increasingly flammable each time it burns.

Depending on the ferocity of the burn, organic material in the soil can be destroyed in the surface levels. This natural mulch of leaf-mould, mosses or ground-lichens is consumed, leaving the soil vulnerable to erosion. Normally, the leaf-mould, acting as a barrier, would slow the speed of rainfall run-off, allowing greater water penetration

ABOVE AND OPPOSITE Overnight, many Welcome Swallows (*Hirundo neoxena*) would roost in the reeds at Mirranawarra, and each morning they would take wing to feed, starting at water level and gaining height as the day became warmer and the insects rose; gouache, 21 × 30 cm

to the soil and helping to keep the forest damp and the springs recharged. The deprivation of moisture is compounded by the resulting germination of primary colonising plants. Melaleucas, leptospermums, acacias and other responding seedlings tend to be shallow-rooted and highly competitive for moisture. Eucalyptus seedlings germinate with a tap-root that drives deep into the soil below to secure copious moisture, for eucalypts are highly evaporative in their younger years, transpiring astonishing quantities of water. When they are about fifteen years old, this tap-root begins to atrophy as it is replaced by far-reaching feeder roots.

The effect is that the ground becomes drier than it should be in its natural condition, covered by many brittle understorey plants, highly combustible because of the flammable oils for which some are commercially favoured and which most have present in their leaves. In the surrounding catchment, the flow of natural springs is reduced or disappears, and the bush becomes desiccated and more combustible.

In the wake of calamitous fires in Australia over the spring and summer of 2019–20, there have been loud cries for increased hazard-reduction burns. However, the result of these burns is often extremely deleterious to both the wildlife and the ecosystem; because the regrowth tends to be so flammable, and because of the post-fire desiccation of the bush, fire danger can increase greatly in areas that have been burnt, probably worst in the fourth to sixth year. The recent fires have emanated from a prolonged drought, believed to be of anthropogenic cause, but the human activity that I believe makes the forest most likely to burn may be the politically popular practice of hazard-reduction burns.

There are calls to revert to Indigenous fire practices, and these I fully support, provided that the knowledge still exists. Fire-stick farming is a much gentler and more sensitive operation than flying a helicopter along a range and dropping incendiaries from the sky to burn areas of up to 5,000 hectares in a day. My understanding is that Indigenous people were very sensitive in their use of fire, that they burnt small areas with small fires and had a good understanding of weather conditions, the likely changes that would turn the fire back on itself, or down to a waterhole or other break to control it. There is also considerable evidence that most of their burning occurred on the plains country.

Indigenous fires were slow, cool burns, with flames seldom exceeding knee height, whereas many of the modern hazard-reduction burns

ascend into the crowns of the trees, burning with great heat.

The other feature of the Indigenous method of burning was its well-planned regularity. Through frequency of burning they created more open areas to promote the procurement of food supplies. It was repeated burning rather than the scale of the burns that made them effective.

I can see why, politically, it is popular to call for more burning. Most votes come from the cities, where the population has less direct knowledge and experience of fire. It seems inherently logical that, if something burns, it will not burn again. But, if burning is making the bush drier and the fires worse, as I believe, it becomes a self-perpetuating problem and a closed cycle. As someone, not Einstein, once said, 'Insanity is doing the same thing over and over again and expecting different results.'

There are enquiries into major fires. Inevitably, they are held shortly after the event, when those involved are still in some degree of shock and undergoing the classic stages of recovery, grief, anger, blame and other unproductive mindsets. Recently, a short article was written by Richard Thornton, the CEO of the Bushfire and Natural Hazards Cooperative Research Centre. In it, he paraphrased the American scholar Henry Mencken, saying, 'There is always a simple solution for every complex problem that is neat, plausible and wrong.' Such solutions are likely to arise in the current circumstances of political opportunism and fear.

The implications of widespread hazard reduction for the wildlife of the lower storeys of the Australian bush are concerning. Many, many of our bird species have evolved to utilise that habitat and its removal would inevitably push many species towards extinction. Spring burning, in an attempt to widen the window of safe weather for burning,

would have dramatic effects on the breeding success of the small birds of the understorey.

Bush that has for many years remained unburnt seems to become damper and safer than areas that are burnt regularly. The character of burnt areas changes substantially as the understorey becomes sparse and open and the natural refuges of hollow limbs, logs or trees disappear. Many species, of birds and beasts and reptiles, are dependent on hollows for shelter or to breed.

A common misconception is that when a controlled burn consumes a forest, the birds and animals move into the unburnt regions and life carries on. This exodus to undamaged habitat is well recognised. For a period, the overstocked habitat preserves its immigrant population, but as Tom Lovejoy showed in his research, the numbers decline swiftly until the ecosystem returns to its natural equilibrium; either the newcomers must move on or perish, or the residents must go. There are not sufficient resources for both.

Fire has a secondary effect. By opening the canopy of the bush it allows direct exposure to the sun, causing further desiccation. The changed habitat allows exotic species, pests and weeds to penetrate and some of these become established in the changed environment, inhibiting its recovery. We found that there were many species that had been present prior to a 'controlled burn' which never reappeared. A male Boobook called long into that first night after burning, but remained unanswered by his mate. He has not been seen or heard since, twelve years later. Other changes in species also occurred. Red-necked Wallabies (*Macropus rufogriseus*), common on our lawns before the fire, were replaced by Swamp Wallabies (*Wallabia bicolor*) and have not returned since.

There were seven years of recovery after this departmental burn. Seven years of quiet regrowth and recolonisation. Then, I was painting in my studio at Mortlake in 2013 when Jenny came in to tell me that a lightning strike had started a fire to the north-east of our block in the Grampians. She had discovered it on the internet almost as it happened.

Immediately, we grabbed our bags of fire-clothing and some basic equipment, scrambled into a utility with a small tank and fire unit on the back and drove as quickly as we could to our Grampians home. Once we were there, we watched as a pattern was repeated. Fire authorities refrained from attending what was, at that time, a small fire, so it fizzled and struggled, growing incrementally for a few days as the local country fire brigade captain spent much time on the radio beseeching support to go to the spot and douse it. Then, as it began to pose a more obvious threat, water-bombing aircraft – helicopters and fixed-winged – were brought in to attend to it. For periods of up to an hour, the S-64 Aircrane built by Erickson and affectionately known in Australia as 'Elvis' would fill at our dam in front of the house every few minutes. Hanging in the air behind was its sibling, waiting to fill when Elvis had moved away. Each load was 9500 litres of water, taking about thirty seconds to suck on board. Every minute or two, one of the Skycranes would move in to fill. This was successfully suppressing the fire, but then' … for some reason, all would stop. We watched as the smoke was almost extinguished, the aircraft would be recalled and the fire would flare up to full strength again. This frustrating pattern was oft repeated; we took it as a serious warning of things to come.

LEFT *Fighting Emus*, watercolour, 74 × 56 cm Rehearsing the colour balances in watercolour for a much larger oil painting
ABOVE Pencil and watercolour sketch of a Red-browed Finch (*Neochmia temporalis*), 13 × 9.5 cm

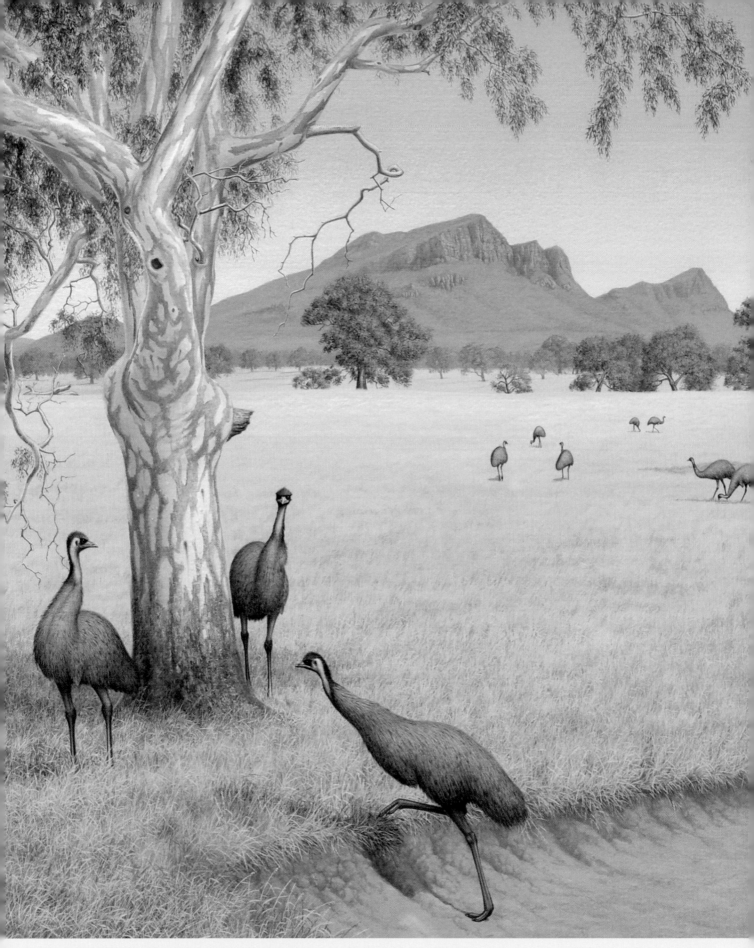

ABOVE *Emus on the Western Plains*, gouache, 56 × 74 cm Commissioned by the Hamilton Art Gallery Trust, it depicts a scene not far from Dunkeld that can be seen from the Glenelg Highway; for some reason quite large flocks of Emus often gather on the grazing country near the Grampians

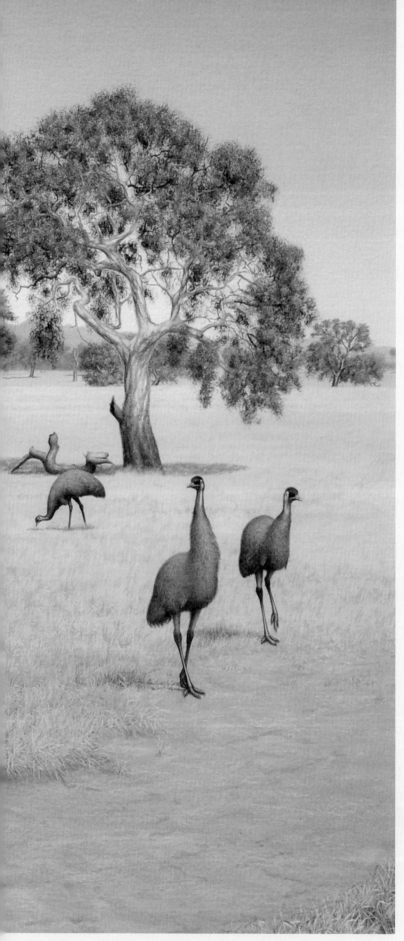

Meanwhile, we prepared. The house and its surrounds were well protected with sprinklers. We turned off the ones on the house and concentrated on dampening the surroundings until the fire came, and I used the fire unit on the utility to extend this influence as far as I could. We intended to run sprinklers on the house once the fire reached us. We agreed that, if the fire crested the hill to our north, we would move into action.

We were sitting at dinner when the fire topped that hill. By that stage we were sufficiently prepared to be able to walk down to the pump house, start the pump and the reserve pump and … wait for the fire to arrive. In the preceding period a low-pressure system had developed immediately to our north, so intense that it was off the meteorological scale. A gale-force wind had picked up the fire and exploded it across our northern landscape, giving it an enormous, threatening front of several kilometres.

Then the wind turned to the north. The whole mass of the fire turned towards us and, with flames towering from one and a half to two times the height of the forest trees, swept down the hill at enormous speed with a roar like several jumbo jets combined. On it rushed, and we were directly in its path.

Fortunately, there was a dammed wetland immediately to the north of the house. This water had several lovely old dead trees standing like sentries some forty to fifty metres from the shore. These disappeared, vaporised by the radiant heat and burnt to the water-line.

The fire then split, racing down each bank of the wetland. Oddly, the western side reached

us some minutes before its counterpart. In retrospect, I think the eastern side was delayed because of water accidentally spilled by the helicopters as they left the dam after each filling.

Then it was upon us, and we were intensely busy, dashing hither and thither, dousing spot-fires and flickering fronts, holding its advance in any way we could. A portion of scrub would burst into flame and the fire would advance towards the house. It would be doused, but then, shortly afterwards, burst into flame again. So the job of fighting the fire became bigger and more complex by the minute.

We fought the fire alone. We had no wish, no expectation, that other people, either professional or volunteer, should risk their lives on our behalf. We had a good water supply and pumping systems, were well-prepared, and were well-served by our utility and slip-on fire unit, equipment that became critical in saving our house.

Gradually, the threat of the fire was reduced as the main front swept on up the hill behind us, but there remained an area of unburnt ground around and between the buildings which was at great risk from cinder attack. We found that trees would spontaneously burst into flame, way above the ground, and we would need to find an extension ladder to reach the fire in the crown, using the utility fire unit to provide water at pressure. The worst of these was less than four metres from, and overhanging, the house.

Eventually, it was all over. We were exhausted after two and a half hours of toil, but jubilant that we had prevailed. We were unable to relax, as we needed to keep patrolling the smouldering remains and burning logs. Across the lake on the far shore, the flickering glow of flames running up eucalypt trunks was like being in Hong Kong or Singapore at night, with a city lit beyond the bay, a sense increased by the reflection of the lights in the water. If we could have ignored the emotion, it would have been very beautiful. Late that night we fell into bed.

In the dawn next day, the landscape was silent. The only movement was the curling wisps of smoke rising from the ashes. We wandered around, probably in a degree of shock. Everything seemed unfamiliar; landmarks, from the most trivial to the tallest tree, were obliterated or changed. Injured animals were struggling to remain alive. An old Swamp Wallaby was standing

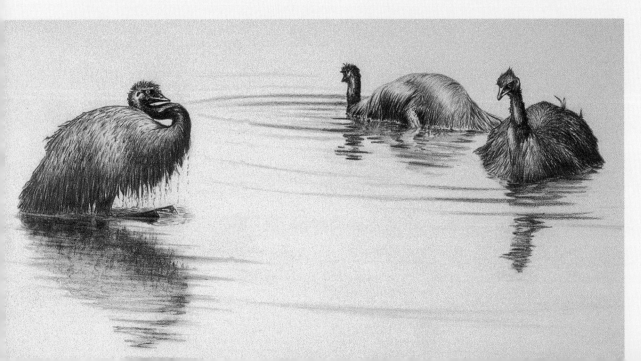

in the water of the dam to ease the pain in her burnt feet. Her fur was singed and her ears blistered. It would have been kind to euthanise her, but we had no firearms or drugs. Anyway, we felt huge empathy that she had survived.

Other animals had not been so lucky. Standing in one place, we could count nineteen little burnt carcasses lying in the ash. One or two had their heads down a hole, where they had been struggling to get underground in an aperture too tight to access. A Stumpy-tailed Lizard (*Tiliqua rugosa*) appeared to be fine, until we realised that he was but the shell of his scales.

The next few days were horrible. The fire still raged in country nearby and fire crews needed constant access to our water. Each crew that arrived to fill its tank was full of questions. What was the state of the fire? Where was the front of it now? What other brigades were involved? As time passed, we saw more and more trucks from New South Wales and the Australian Capital Territory and they seemed to be better equipped and better informed.

Our household water supply was lost, the concrete tank split and the buried pipe perforated by the heat. We managed to get some water to keep us going and hiked through some of our burnt country. Birds were virtually absent; occasionally a raven or a Wedge-tailed Eagle would pass overhead, but little else survived. Bill Middleton, a much

loved and respected botanist and ornithologist who worked for the old Forestry Commission, made calculations of avian mortality following the horrific bushfires in north-eastern Victoria in 2003. Using figures of average bird densities in forest habitats, largely derived from estimates made by Richard Loyn of the School of Life Studies, LaTrobe University, Bill allowed fifty per cent for any overestimation of numbers, and for factors such as seasonal variation, effects of drought and variations in habitat, as well as the assumption that all birds perished (later research tends to indicate a survival rate in unburnt areas like gully vegetation and because the mobility of birds assists their escape). Nevertheless, he calculated that, after allowances for variance, 4,820,050 birds perished in the 2003 fires.

Worldwide, bird numbers are plummeting. Recent research reported by the *New York Times* from the journal *Science* suggests that, since 1970, about 2.9 billion birds in total have been lost in North America. This is referred to by David Yarnold, the President and executive of the National Audubon Society, as a 'full-blown crisis'. The majority of species have declined, as indicated by data derived from long-term birdwatching records, backed by figures provided by weather-monitoring radar towers that also record migrating flocks of birds.

The most important causes are considered to be habitat loss and high levels of pesticide use in agriculture, as grassland birds are, by a clear margin, most affected. In America, many of the small birds, warblers and such, are migratory, and pesticides like neonicotinoids (neuro-active chemicals similar to nicotine) can inhibit their capacity to gain weight prior to migration.

Neonicotinoids have been widely linked to adverse effects in both insect and avian populations, including the loss of honey bees. Three of the main brands are now restricted in their use in Europe, and they have also been restricted in several states of the US out of concern for bees and other pollinators. Some species are managing to move against the majority trend and increase in numbers: vireos are increasing, although the reason for this is not understood. Other groups, like waterfowl and some birds of prey, are increasing because they are coming from a low base through good conservation measures.

Europe has been suffering a similar decline in bird numbers and it is thought that the cause is similar. I am not aware of any study so complex and analytical being completed in Australia, but, anecdotally at least, it would seem that bird numbers are in decline, exacerbated by climate change, habitat fragmentation and loss, and a series of droughts.

We should not be too casual about avian decline. Throughout the world there have been notable collapses in insect numbers, which, along with bird losses, will disrupt ecosystems with serious flow-on effects.

So what happens after a fire? Is there a swift recovery? Prior to the Grampians fire of 2013, I had fought fires on many occasions, but never lived on-site through the recovery. It was a new experience to be associated with the changes that are forced by a wildfire, the recovery from utter destruction. A place with which we were so familiar was changed beyond immediate recognition.

It was obvious that recovery would take a very long time and would be uneven throughout the landscape. In parts, the heat had been so severe that organic matter in the soil had been destroyed. Alarmingly, large areas had collapsed by about 200 millimetres, leaving the burnt roots of plants sitting proud of the remaining earth. In other parts there was the stirring of fresh germination as soon as rain had wet the ground.

At first we struggled to identify the seedlings that were sprouting. Frequently they were not the species that had been there previously, but were

ABOVE LEFT Sketched outside our house in the Grampians, a Superb Fairy-wren always makes a good model; gouache, 21 × 30 cm
OPPOSITE *After the Fire*, gouache, 20 × 16 cm Scarlet Robins (*Petroica boodang*) are amongst the earliest birds to return to burnt country, and they seemed to fit well with the colours of the freshly opened fruit of the hakea

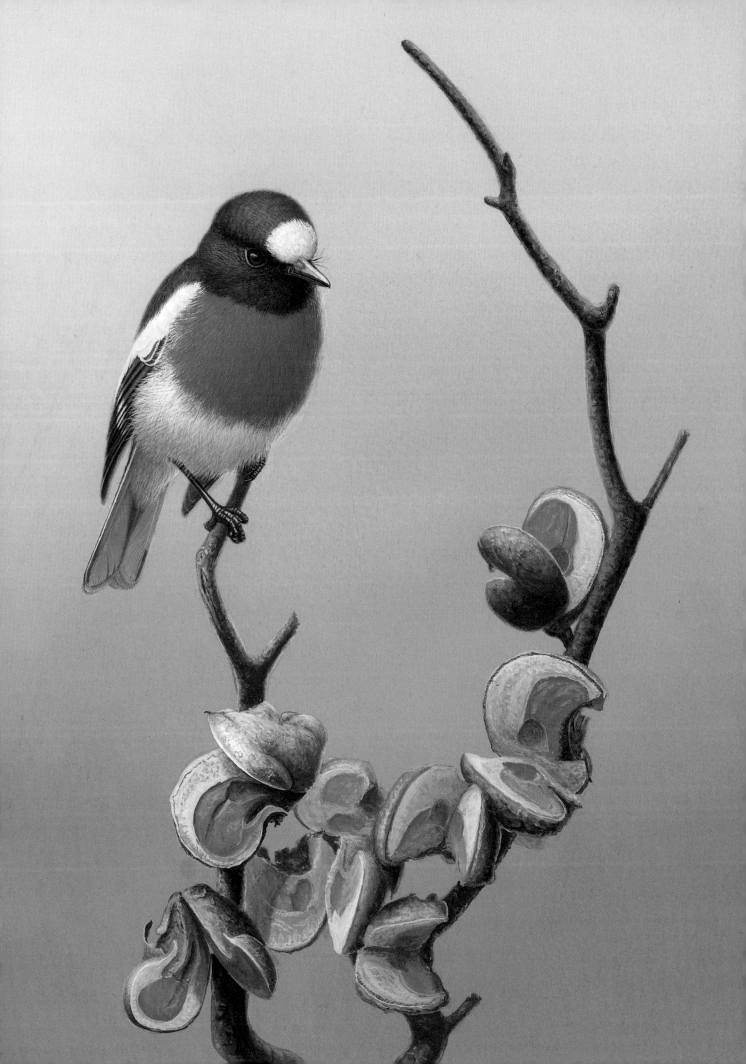

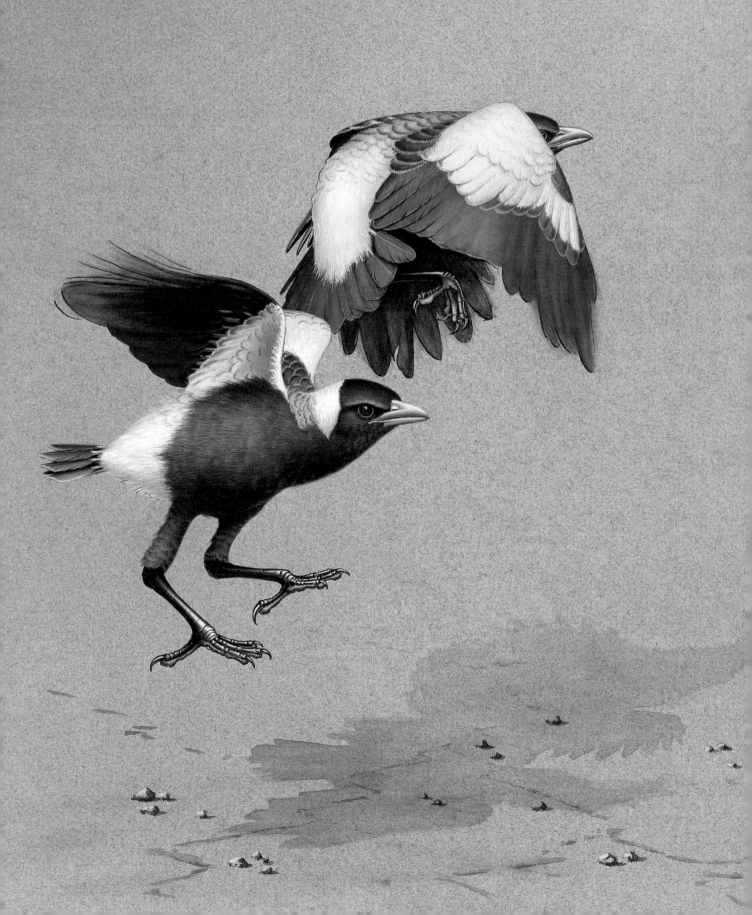

short-lived primary colonising species that would prepare the ground for their replacements. Some of these emerged at a density that was scarcely believable, as we had known only one or two specimens of those plants on the property prior to fire. Allocasuarina, leptospermum and hakea plants were gone, replaced by extremely thick growth of *Acacia retinodes* and *Viminaria juncea*.

We were prepared for a reduction in animals, as there had been a special post-fire review following the Mt Lubra fire in 2006 when over 80,000 hectares, or forty-six per cent of the Grampians National Park, was burnt by severe wildfire. The earliest analysis had found indications that there had been an initial fifty-eight per cent reduction in the fire-affected area and a forty-seven per cent reduction overall in the study animals captured, with zero captures of some target species. The trapping trial had been running since 2003, so it was compared with good baseline data. In the shock of the immediate post-fire period we were resigned to similar effects in birds. We had access to a study from near the Grampians that indicated any recovery would take about six years.

Interestingly, there was an excellent literature review compiled by Matthew Vinicombe of Deakin University, Melbourne, which drew together post-fire responses from a wide range of localities, both within and outside Australia. In 2009 he submitted his thesis, 'The recovery of bird communities after a severe, landscape-scale wildfire', which demonstrated an immediate point that may have been obvious, but was easy to overlook: that different birds and different environments respond in their own ways. Essentially, some bird species favour open environments, eschewing densely vegetated areas, and these species tend to be the ones that first colonise sites that have been burnt.

Other birds, which rely on more closely packed habitats, such as understorey vegetation or dense grass, are more severely affected by fire and become scarce or absent following burning, as their normal feed supply is interrupted, particularly for insectivorous birds, and they are more exposed to predation once their protective cover is removed.

Sedentary species, provided they can survive the ferocity of the initial fire, will tend to show a high degree of site-fidelity and remain in situ, but most studies of this behaviour are from places that have suffered fires of low intensity. However, the genera associated with this behaviour, birds like fairy-wrens and thornbills, are small, tiny even, and may be adept at seeking temporary shelter below ground in any available hole they can find. Certainly, I was both surprised and gratified at the speed with which Southern Emu-wrens returned, the first of which I saw just twenty-six months

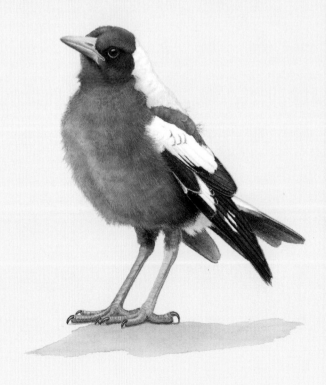

LEFT *Crested Pigeons*;
these birds nervously
came in to drink in
the evening; oil on
board, 22 × 28 cm
OPPOSITE *Edge of
the Dunes*, gouache,
43 × 59 cm
View from Point
Ricardo in East
Gippsland looking
along the Ninety
Mile Beach, past
the mouth of the
Snowy River towards
Melbourne. Each
plant species is
carefully painted
and identifiable
and I have used the
parallel bending
shoreline and the
sand dunes to
lead the eye to the
parallel streams of
Yellow-tailed Black
Cockatoos in a
curving double helix
to suggest the DNA
that binds all species
together. I returned
to the site twenty-
five years later
and it is no longer
recognisable due to
bushfire damage.

after our fire. Emu-wrens have previously been recorded as taking refuge in small crab or yabby holes, and these tiny, delicate little birds may have used the same means to survive.

Mirranawarra was a complex of many environments, but Matthew Vinicombe's research was more concerned by the proximity of these ecosystems to areas that had remained unburnt, parts that had escaped burning because of prescribed burning prior to the fire and their degree of isolation. He found that patches of long-unburnt vegetation were important in recovery as they could provide the source for recolonisation of the habitat we had lost. Sadly, we had little unburnt environment in close proximity, and we found that this appeared to retard the rate at which our recovering environment was ecolonised. We watched for six years, and rejoiced in the

recovery, but the fire had robbed us of much that had attracted us there originally. The Red-necked Wallabies that used to feed their joeys on the lawn were largely replaced by Swamp Wallabies; we saw few of the three species of antechinus that had been so common previously; the bandicoots seemed much reduced; our owls were gone, both the Powerful Owls and the Southern Boobooks; and we never again heard or saw an Owlet-nightjar there. The character of the bush had changed and, perhaps, so had we. Mirranawarra will hopefully return to its former diversity, but in September 2019 we sold it and transferred our interest in local avifauna to the coastal regions of the Bellarine Peninsula, where soon we fell under the spell of the amazing East Asian – Australasian migratory waders and their astonishing annual journey to the northern hemisphere.

BELLARINE PENINSULA

IN MARCH 2015, Jenny and I retired from Connewarran and moved to a house we had bought at Wallington, on the Bellarine Peninsula, east of Geelong. Our new abode overlooks the Barwon River estuary and is close to Lake Connewarre, and has some great advantages for a birdwatcher. Being located in any single spot gives a great sense of security, as one becomes familiar with the region, the types of birds that inhabit it and where they are to be found. It is easy to become habitual and complacent, so I was surprised by the richness of opportunity near our new home.

Birds with which I had previously had only limited contact were suddenly in abundance all around me and often more easily approachable. Many of these species had occurred with regularity on Connewarran, but never in such abundance. Bronzewing pigeons are common, mostly Common Bronzewings, but also occasional Brush Bronzewings, and many, many Crested Pigeons.

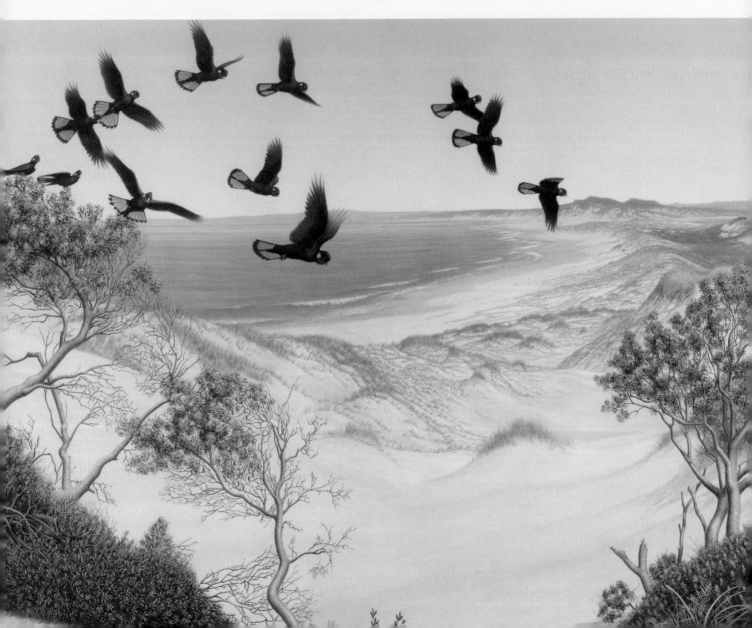

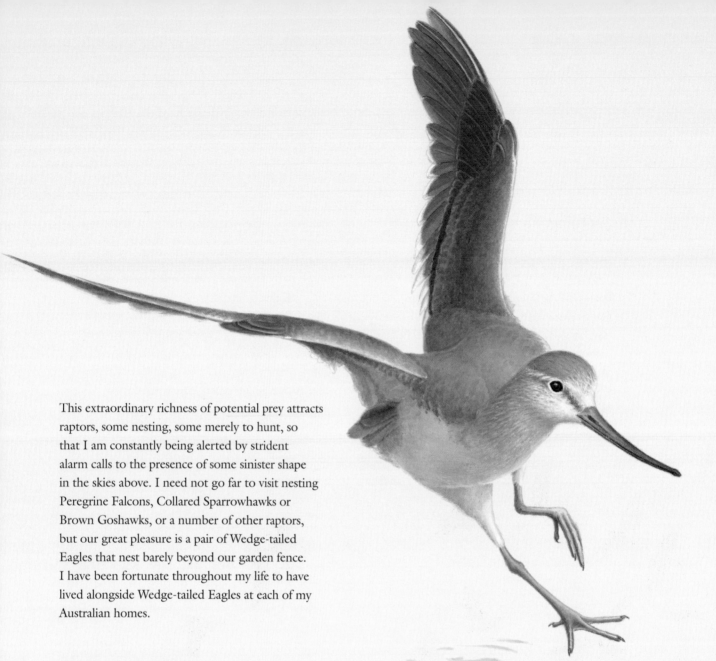

This extraordinary richness of potential prey attracts raptors, some nesting, some merely to hunt, so that I am constantly being alerted by strident alarm calls to the presence of some sinister shape in the skies above. I need not go far to visit nesting Peregrine Falcons, Collared Sparrowhawks or Brown Goshawks, or a number of other raptors, but our great pleasure is a pair of Wedge-tailed Eagles that nest barely beyond our garden fence. I have been fortunate throughout my life to have lived alongside Wedge-tailed Eagles at each of my Australian homes.

WADER MIGRATION

In Australia, we are not so directly conscious of bird migration as are residents on continents in the northern hemisphere. When I visited Bulgaria, I found it strange to realise that the birds that were arriving in groups and flocks to land there had taken to the air in Africa, beyond the Mediterranean Sea to the south, and were on a major migration route. To see swirling mobs of raptors circling in the skies above felt alien, and I was unused to seeing the groups of small passerines, from warblers to thrushes, migrating urgently across the country. Other than the extraordinary migration of the waders on the East Asian – Australasian Flyway, our

birds in Australia migrate in a seemingly more subtle way, as there may often be many that stay behind and numerous species are inherently nomadic anyway. However, I now find that in my new home I have access to a migration of small passerines across Bass Strait for the winter. The species well known for its migration between Tasmania and the mainland is the Silvereye, but it is not alone. Swift Parrots and Orange-bellied Parrots (*Neophema chrysogaster*) migrate each year, having bred in Tasmania, crossing to the mainland for autumn and winter. Some surprisingly small birds, Grey Fantail (*Rhipidura albiscapa*) and even the tiny Striated Pardalote

ABOVE Gouache study, 21 × 30 cm, of the attractive Terek Sandpiper (*Xenus cinereus*) landing, perhaps on its return from its breeding grounds in the northern hemisphere

(*Pardalotus striatus*), make the perilous crossing each year. A number of other birds undergo a similar journey, arriving on the mainland around Cape Otway and then dispersing. Many emerge from the Otway Ranges and cross Lake Connewarre to the Barwon estuary, where numbers can be seen using a gully to move into the Ocean Grove Nature Reserve. That gully crosses just below our garden, so we are privileged observers of a small portion of the migration. The increased numbers of birds tend to attract raptors, notably Grey Goshawks (*Accipiter novaehollandiae*), to follow their passage, particularly as the weather cools in late April to May, at a time when hungry young goshawks are being evicted from their parents' territories in the Otway Ranges in preparation for a new breeding season. These young goshawks can be very hungry, so hungry that they are sometimes quite tolerant, or lethargic, about disturbance, allowing people to approach them.

A great advantage of our new location is the extraordinary number of Ramsar Sites in the close vicinity. As of 2019 there were 2341 Ramsar Sites, which had been selected throughout the world because of their international significance. To find myself living within ten minutes' drive of seven of these was a significant incentive for me to learn much more about a group of birds with which I had previously had only limited acquaintance.

Along the beaches scurry small, grey birds, urgently probing the sand with their bills in a way that reminds me of the needle on an electric sewing machine: stab, stab, stab. Tiny shapes, they run before the surging foam of the spent waves rushing up the beach or take to the air in groups, sharp as arrows, their white under-wings flickering as they turn this way or that, swirling like a wisp of smoke, shimmering now bright, now dark as the

light catches them, always in unison like a shoal of small fish. They may race out to sea before wheeling back to the shoreline, abruptly landing close to where they departed moments earlier.

There can be larger sombre silhouettes along the shoreline, warily stalking the mudflats at low tide and easing ridiculously long bills into the mud. And there are robust, rotund birds, decked in patterns of black and white and chestnut, striding the rocky outcrops on sturdy, orange legs. Waders come in a variety of shapes and sizes, each built to feed on a specific food resource in a specific manner. Their size, the length of their bill or the shape of their bill is dictated by the food they have evolved to harvest, so masses of birds of different species may not be competing for the same resource.

To see the tiny Red-necked Stints (*Calidris ruficollis*) rushing apparently randomly on their urgent feeding mission is to witness an avian athletic champion, for these little birds, only three or four times the size of our familiar blue wren, and not much heavier than a House Sparrow (*Passer domesticus*), migrate to breed in the Arctic regions of the northern hemisphere and may fly the equivalent of fourteen times around Earth's equator in their lifetime. During their stay in the southern hemisphere, they, and other migratory waders, must replenish the condition they have lost flying from the Arctic, accumulate fat to provide energy for their return journey and have sufficient reserves to fuel successful territorial defence, courtship and breeding in the north. They will almost double their weight before departure and undergo extraordinary physiological changes to gain flight efficiency, so the wetlands they use at the southern end of their journey are critical to both their individual survival and their persistence as a species. Each time they are disturbed and leap

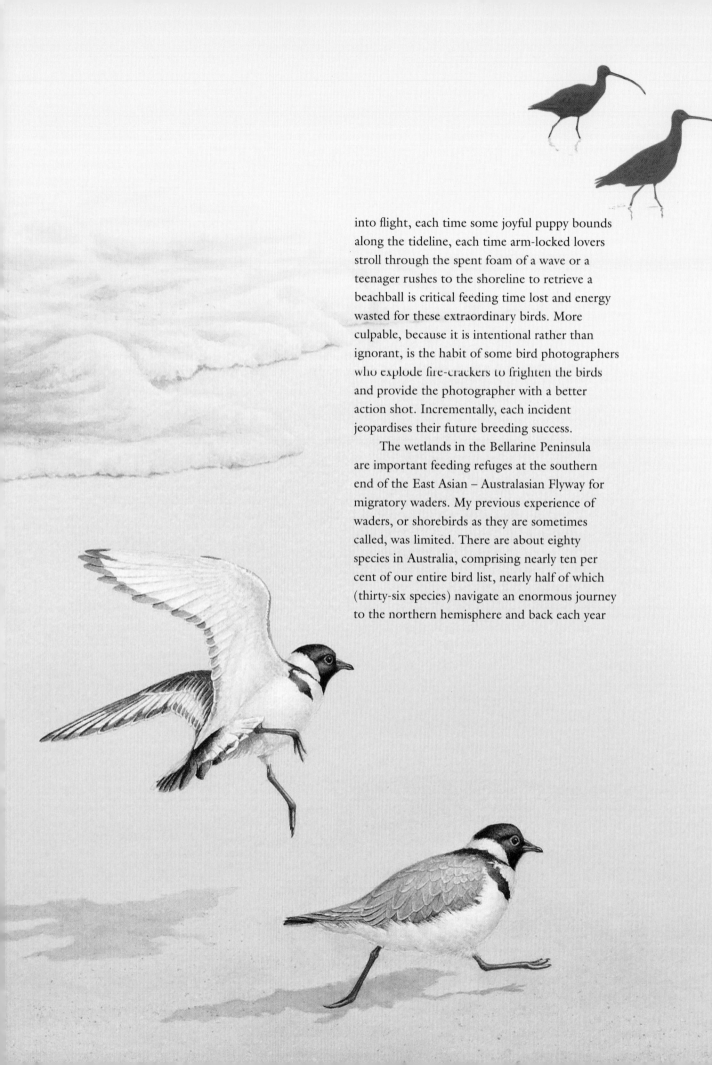

into flight, each time some joyful puppy bounds along the tideline, each time arm-locked lovers stroll through the spent foam of a wave or a teenager rushes to the shoreline to retrieve a beachball is critical feeding time lost and energy wasted for these extraordinary birds. More culpable, because it is intentional rather than ignorant, is the habit of some bird photographers who explode fire-crackers to frighten the birds and provide the photographer with a better action shot. Incrementally, each incident jeopardises their future breeding success.

The wetlands in the Bellarine Peninsula are important feeding refuges at the southern end of the East Asian – Australasian Flyway for migratory waders. My previous experience of waders, or shorebirds as they are sometimes called, was limited. There are about eighty species in Australia, comprising nearly ten per cent of our entire bird list, nearly half of which (thirty-six species) navigate an enormous journey to the northern hemisphere and back each year

OPPOSITE ABOVE AND
ABOVE Silhouettes
of Eastern Curlews
(*Numenius
madagascariensis*),
foraging warily far
out on the mudflats,
sketched at Albany
in Western Australia;
gouache, 21 × 30 cm
OPPOSITE BELOW Detail
from a watercolour
painting, *Running
Ahead*; it took me
years to get the
drawing of the
left-hand bird to my
satisfaction before
finishing the painting

of their adult life. While some of these species also frequent freshwater marshes further inland, many of them are predominantly found in, or are restricted to, our coastal regions, a habitat to which I had previously been little exposed. There are others that do not migrate at all, but live their lives in paddocks and swamps and deserts, or breed on the inland lakes of Australia, and I was more familiar with many of these.

Migration tends to follow prescribed routes deeply embedded in the instincts of these birds, albeit with some degree of variation. Around the world there are nine other recognised migratory shorebird flyways, all but one of which stretch from the Arctic tundra to the intertidal flats of the southern continents.

Typically, the long journey for Australian waders of eight to twelve thousand kilometres is broken into stages, with one or more resting points to recuperate, feed and gain weight. The prime location for this recovery is the Yellow Sea, the shallow waters between China and the Korean Peninsula, in Taiwan or Japan. Different species may leave at slightly different times and travel by slightly different routes; some will be going to different destinations, but all must be precisely programmed to arrive at their breeding grounds at exactly the right time and will fly, non-stop, regardless of terrain for about five days. They cannot glide or soar, for their wings will not allow that, and must power their progress by flapping their wings, every inch of the way. None but the very largest and strongest birds can accomplish the journey non-stop.

Australian waders arrive in the northern hemisphere, inside the Arctic Circle, to breed as the land warms, just as small invertebrates start to multiply in the warm summer air. After May, there are twenty-four hours of daylight fuelling their activity for a short time before darkness

begins its gradual but inevitable return. The breeding period is short, squeezed within the far northern-hemisphere spring and summer, before the weather cools and frost descends on the ground again, forcing birds to migrate to the rich coastal feeding grounds of the southern hemisphere. There they replace their flight feathers and build weight before the long journey north is repeated, to breed again in the northern summer the next year.

Every year some eight million waders fly from one end of the Earth to the other, a saga of enormous courage, strength and resilience, completing some of the longest migration routes on the globe. Why do they do it? The origins of this behaviour must be deep-seated in their instinct from long, long ago.

One hypothesis is that this behaviour originated in the last ice age, at a time when the two destinations were much closer than they are today. The tundra in those days, which provided rich breeding grounds for waders in the short northern summer, would have extended further south than it does now, and when the winter frosts returned and feeding became difficult, the journey to the rich food sources further south would have been shorter.

As the ice receded, the tundra would have retreated northwards, and with it would have gone the feeding bonanza on which the waders depended to breed. The southern feeding grounds would also have retreated as southern parts of the continents grew warmer, gradually increasing the distances between the two destinations that had become embedded in the breeding strategy of the birds. As the distances incrementally increased, the waders' instinctive strategy would have evolved to cope with today's gruelling marathons, for only the ones that survived would have reproduced.

Particularly for the smaller shorebirds, resting and refuelling refuges would have become increasingly important to their migration strategies over increasing distances, and these stop-over points remain critical to their success today.

Shorebirds feed on a variety of marine invertebrates – crabs, snails, clams and worms – but their precocial young, which hatch as tiny fluff-balls, all legs, feet and beaks, require a rich food supply to grow quickly, and something more readily obtainable than marine invertebrates. Chaperoned by their fathers, they must feed themselves, a task they could not possibly undertake on scarcer food than the copious quantity of protein-rich insects available in the Arctic. Migration is timed to bring the parent birds to their breeding grounds at the optimum time to court, lay eggs and hatch chicks, capitalising on an extraordinarily abundant food supply, almost ideal for the purpose, an enormous surge in breeding invertebrates, midges, mosquitoes and crane flies. This, then, allows the chicks to thrive and grow. The insects are in millions, clouding visibility and dense in their larval forms in every pond, puddle or pool. However, soon the winter frosts clamp down, the tundra hardens into ice, and food is scarce. Counterintuitively, it is the adult females that leave first, for they have carried the greater burden of egg-laying on their energy resources. The males stay with the hatched chicks, not to feed them, but to guide them and guard them against a multitude of dangers of which they must rapidly become aware.

Then the males leave, and the juveniles must grow and fatten on their own resources until some instinctive trigger leads to their departure for the richer, warmer feeding zones to which their migratory schedule takes them, guided solely by instinct and navigating by means that are not yet properly understood. This is Darwin's 'survival of the fittest' in raw terms, and mortality has driven the evolution of a deeply embedded instinctive knowledge. The instinctive route taken has determined the fate of countless previous generations, influencing which bird survived to breed or which perished on the journey.

BELOW Watercolour sketch, 21 × 30 cm, of Hooded Plovers at Blue Rocks, Thirteenth Beach, Barwon Heads OPPOSITE Gouache study, 21 × 30 cm, of a Ruddy Turnstone (*Arenaria interpres*) in non-breeding plumage

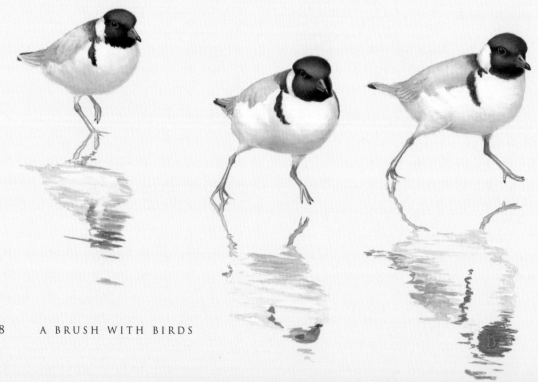

Far, far to the south are the long, safe, sloping shorelines with copious food and all-round visibility which allow the shorebirds to build strength, muscle and fat for their future lives. It is a journey fundamental to the survival of each individual and to each species as a whole, but is also the time in their life-cycle when they suffer the greatest mortality. For most of the juvenile birds that survive, there lies ahead a protracted recovery of a year or more, depending on their size or species, before as adults they will resume the journey for every year of the remainder of their lives.

Probably the region of the Yellow Sea and the eastern coastline of Asia has always been an important feeding ground, and then, as now, some birds remained instead of travelling on, but it is unlikely that sufficient resources were available to feed all the birds resting there permanently. It was a place where waders could rest, feeding with enormous success to replenish the reserves required to carry them through the rest of their journey. These resting and refuelling zones have now become fundamental to the success of wader migration along the East Asian – Australasian Flyway.

For millennia, the two great rivers of China, the Yellow River and the Yangtze Kiang, have washed nutrient-rich sediments into the shallow Yellow Sea, creating large swathes of intertidal mudflats. Waders are constantly moulting to keep their feathers in airworthy shape, but feather growth requires huge amounts of energy. The Yellow Sea can provide sufficient resources for worn feathers to be replaced before the journey is resumed.

However, the refuge provided is under threat from anthropogenic changes. The Three Gorges Dam on the Yangtze River in central

China is the world's largest hydro-electric scheme. Creating a huge reservoir some 660 kilometres long to stabilise water flow in the river has reduced the flow of sediment that would otherwise be deposited in the Yellow Sea. At the mouth of the Yangtze, in a broad estuary, there sit three alluvial islands. One of these contains the Chongming Dongtan Nature Reserve, China's only wetland park and a migratory bird reserve only about fifty kilometres from Shanghai. Prior to the construction of the Three Gorges Dam, deposited silt was extending Chongming Island on its eastern side by about two hundred metres each year; this is now reduced to less than one hundred metres annually.

Not only waders prefer long, sloping shorelines; these areas also attract development and industry. In South Korea, at Saemangeum, habitat for some 350,000 birds has been destroyed, despite a long conflict between the South Korean Government and environmental activists. Saemangeum is the most important resting point on the East Asian – Australasian Flyway, for birds flying either north or south, but in 1991 the government began to construct the longest artificial barrier in the world, to exclude tidal flow and reclaim mudflats in the estuaries of two rivers, to be used either for agriculture or industry. The seawall was erected just south of the mouth of the Geum River and incorporates the estuaries of the Mangyeong and Dongjin rivers, effectively removing over one hundred kilometres of coastline in one of humanity's largest ever land-reclamation efforts. By April 2006 the project was complete. The birds had nowhere else to go and recorded numbers of migratory waders arriving back in Australia began to collapse. While some of the migrating birds had managed to relocate to other sites, most had simply died. Waders are

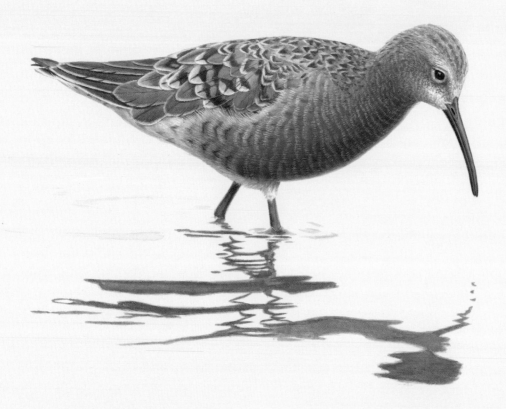

birds with great site-fidelity; they like to return to the same place time after time. Relocation is an additional stress which drains energy reserves and can lead to migratory failure. As a result of the land-reclamation work at Saemangeum migratory wader numbers began to diminish rapidly, particularly for the Great Knot (*Calidris tenuirostris*). In addition the Eastern Curlew has been moved to the Critically Endangered list by the International Union for Conservation of Nature and the critically endangered Spoon-billed Sandpiper (*Calidris pygmaea*) put at further risk.

Sadly, the four hundred square kilometres of land that had been reclaimed from the tidal flats soon became stagnant and polluted, so that the initiative ultimately received little interest from potential businesses and investment declined. The project was an economic failure; it achieved little but destroyed much, a stern warning as new technology makes land reclamation easier and easier. But it also echoed the changing nature of South Korea; land reclaimed for agriculture was required for industrial development as the surging economy became increasingly industrial.

While there are dramatic changes occurring in the Yellow Sea, not all blame can be laid at the feet of South Korea. China, also, has been attracted by the temptation of land reclamation; in the decade between 2003 and 2013, over 1.3 million hectares of tidal zone was reclaimed, and two-thirds of the tidal flats in the Yellow Sea have disappeared in the last fifty years. In fact, nearly three-quarters of China's entire coastline is now walled, a huge linear construction that is over twenty per cent longer than the Great Wall of China.

However, there remain beacons of hope. Korea Bay lies at the north-eastern corner of the Yellow Sea, at the mouth of the Yalu River, which marks part of the border between China and Korea. Much of Korea Bay is bordered by North Korea, but here it is in close proximity to one of China's major ports, with the attendant industrial activity that one would expect. This contributes to the disturbance of feeding waders.

Fortunately, because of North Korea's impoverished economy, it has little capital and therefore little inclination to reclaim or develop tidal mudflats. At present, the terrestrial fringes of

ABOVE LEFT A Curlew Sandpiper (*Calidris ferruginea*) moulting into breeding plumage and nearly ready to leave on its long migration flight northwards; gouache, 21 × 30 cm
OPPOSITE Pencil sketch, 21 × 30 cm, of Red-necked Stints feeding near Blue Rocks on Thirteenth Beach, Barwon Heads

Korea Bay are more agricultural than industrial, and low-input agriculture at that.

Even in China there may be the stirrings of change. Much of the reclamation of the tidal mudflats that were wader feeding zones has been funded by grants from the central government to local councils, grants allocated as incentives to increase construction, irrespective of whether it will be beneficial or sustainable, but mostly offered as rewards for increases in each local government area's GDP. However, a new awareness is creeping in, the concept of the value of 'ecosystem services'. The past drive for economic growth is being modified by a concept described as 'ecological civilisation', which may be reflected in regional funding.

Wader migration on the East Asian – Australasian Flyway is in crisis, with some species rapidly declining towards extinction, predominantly due to anthropogenic influences. Many very dedicated scientists, ornithologists and volunteers have done excellent work to achieve a much better understanding of the influences on wader survival. Increasingly efficient methods of identifying individual birds, tiny geolocators that can record the locality of a bird during migration, and breeding and satellite tracking devices that can be carried by the larger species are incrementally adding to the knowledge we have of these migrants of the East Asian – Australasian Flyway. But the basic tenets of migration – that the bird must leave and arrive at precisely the correct time and that to do so it needs to undergo physiological change, such as dramatically increasing weight, bulking its breast muscle, shrinking its gizzards and intestines and increasing the size of its heart and liver to

gain flight efficiency – remain amongst the great avian wonders of our world. I am humbled by the strength and determination of these diminutive birds on their long migrations.

In China and South Korea, the growth of the middle class has encouraged an increased interest in natural history. Birdwatching clubs and societies are being formed and young enthusiasts are doing more research in ornithology. Perhaps the preservation of the East Asian – Australasian Flyway and the simple act of watching birds can be the glue that binds a common interest in the future of birds. The concept of a shared purpose lending unity to a chain of nations on the flyway is irresistible.

Recently, I was walking near my home along a narrow dirt track flanked by tall tussocks and low shrubs, between old 'borrow pits' where sand and shell-grit had been mined. Only a few metres away, waders were urgently feeding. A Curlew Sandpiper cocked an eye at me, stepped to its right and continued feeding with a group of Sharp-tailed Sandpipers (*Calidris accuminata*). How can this little bird, so threatened by the actions of humans, have such trust?

Walking towards me were three gentlemen dressed in camouflage clothing and carrying

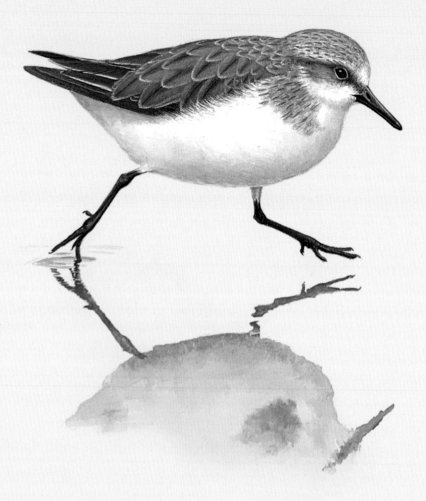

huge camera lenses. They enquired about one or two species and talked about their local bird club in South Korea. They were knowledgeable, enthusiastic and friendly and they had come a long way to see specific species of birds. Is this a glimpse of the future?

Each autumn at Roebuck Bay, near Broome on the north-west coast of Western Australia, flocks of waders may be seen amassing in growing numbers. This seems to be a marshalling point for departure, and birds from Tasmania, Victoria and the east coast, as well as South Australia and south Western Australia, gather here, feeding voraciously in final preparation. Many kinds of wader intermingle: curlews, wild and wary; stints, restlessly active, pulsating, mercurial; tattlers and godwits; Terek, Curlew and Sharp-tailed sandpipers, with many others. Not all would travel together, as each species chooses its own timing, adapted to its own route and routines.

A restlessness increasingly pervades the flocks as they approach departure and gather in groups of their own species, awaiting the moment. And soon they are gone, flying strongly, seeking the formation that gives each bird the maximum protection from the buffeting winds by shadowing a bird in front: a peloton of athletes settling for a long, controlled journey.

Their difficulties are great, but there seems to be a growing awareness of what those difficulties are. Co-operation is improving between governments along their route. In the countries concerned, the rise of an extended middle class is spawning a growth in interest in birds and social clubs that service those interests. I am optimistic that the damage that human beings have done to our planet, our increasing population and overconsumption, will be resolved and that future generations may have the leisure and beautiful surroundings to take pleasure in the beauty and fascination of birds.

ABOVE LEFT A Red-necked Stint running along the shoreline as it feeds voraciously; gouache, 21 × 30 cm
OPPOSITE Gouache study of a Flame Robin (*Petroica phoenicea*), 21 × 17 cm, used by the National Trust as a Christmas card, an Australian red robin!

CONCLUSION

I have been fortunate to have a career that has allowed me to travel extensively. Now, I am able to concentrate increasingly on my work as an artist and live a more relaxed life near many areas of interesting habitat, with numerous birds. I can reflect on a lifetime of painting.

Each artist develops a style of their own, and ultimately that is a reflection of their character. I don't necessarily paint the way I do because that is the way I prefer to paint; it is my way of pictorial expression, the DNA of my art.

A strong interest in science and in art has caused me some intellectual conflict. The discipline of science and the creativity of art are odd bedfellows, but without discipline, creativity can be frittered away, and without creativity, discipline becomes wooden and unproductive. They should be mutually beneficial, but I find them mutually restrictive. I have too much

creativity to be a genuine scientist, although the visual acuity of an artist aids observation and the discovery of details. I have too much discipline to be as creative as I would like to be in my art. I find it difficult to throw away the shackles of inhibition and explore the limits of my imagination. I have nearly always worked alone, never with an agent and seldom associated with a gallery.

I remember an eager client asking David Reid-Henry how long it had taken him to execute a seemingly very detailed work. His reply was illuminating. 'Oh, about three days. But with forty years of experience.' I too have learnt my art for a very long period.

With that experience, my aims have changed. The desire to portray an underlying message is stronger, and I am more interested in depicting character and light. I have a wealth of memories, and filing cabinets full of sketches and drawings. I have learnt a little about birds, their habitat and the creatures that share their surroundings as part of the ecosystem, and perhaps achieved that most elusive element of all: contentment.

INDEX

Bold page numbers refer to illustrations.

ACKNOWLEDGEMENTS

THIS BOOK IS in no way a personal achievement. Many people, in many countries, have contributed to it by befriending me and providing generous encouragement and assistance. Some are no longer alive, but I mention them as if they were, for they deserve to be recognised and the memory of their support is as strong as ever.

In my early years, my parents gave me encouragement and opportunity. As the youngest child, I benefitted from the enthusiasm of my brother and sister. A guest, Mrs Gredler from Wisconsin, can never know how much she piqued my interest with her gift, Our Amazing Birds, by Robert Lemmon, beautifully illustrated by Don Eckleberry, together with two delightful Inuit carvings of Great Auks. I was five years old.

Mr Claude Austin, Mr Sandford Beggs, Dr Norman Wettenhall and our neighbour Robert Hood gave enormous encouragement, as did Peter Edwards, my primary-school art teacher.

In England, I enjoyed the hospitality of my godfather, Richard Stratton; the Luckock family, particularly Mr Richard Luckock, Andrew, Tom and Tessa; Sir Owen Wansbrough-Jones; and Hugh and Sally Mellor. Harry and Jane Horswell, David Reid-Henry and Robert Gillmor nurtured my interest in art.

In Africa, the Christie family warmly took me into their home, almost as a member of their tribe. Their friend John Condy did more than he could know to help me. Bob Collins found me a home, lent me a car and gave me much more. I valued immensely my friendship with Peter Johnson and his wife Claire, and with Chris Halliwell, Dave Rushworth, Rob Hughes and Geoff Sutchbury.

I owe gratitude to Brian Finch, Roy MacKay, Rob Campbell, Karol Kisakou, Navu Kwapena and Longe Iria from Papua New Guinea.

Robin and Betsy Dening, Richard and Elizabeth Trethewey and Sandy Foss made possible my time in Canada. Americans, renowned for their generosity, did not stint in their assistance. Dr Lester Short, Don Lamm, Dr Steven Russell and his wife Ruth, Linda and Dr Steve Sherrod, Dr Clayton White, Johnathon and Mary Twiss, Frank Graham Jnr, Anne and Jake Faust, Peter and Patti Maningault, Bob Mengel, Mardi Gieseler and Susan Soland all provided hospitality or help at critical times. George Allen Jnr and Lincoln Allen gave me generous access to their collection.

Back home in Australia, I received help, guidance and friendship from Allan McEvey, Charles and Pat McCubbin and family, Graham and Sue Pizzey and their family, and Dr Knowles Kerry. Alfred Dunbavin Butcher and Phillip Du Guesclin supported my falconry and Fergus Beeley spent months assisting. Dr Richard Schodde helped tremendously in the early development of my knowledge of ornithology and Dr David Hollands has been a frequent companion in the field over many years.

Recently, Karen Spreadborough and The Hive Gallery have been supportive and I thank Dr Richard Schodde, Craig Morley and Penny Mansley for proofreading the text; Sally Percival and Gretel Sneath for their help; the team at Splitting Image; and Sandy Grant and the team at Hardie Grant for helping me to create this book. Particular thanks must go to Nan McNab, who has patiently, gently, courteously edited the manuscript and guided the book to fruition.

Finally, but foremost, I wish to thank my wife Jenny for endless support in every aspect of this book and the life it describes. She supported even those projects of which she strongly disapproved, to my great advantage. I also thank our children, Hamish and Skye, particularly for the times when I should have been there but was not. They have remained most tolerant and helpful, even though their lives have been dominated by birds.

ABOUT THE AUTHOR

RICHARD WEATHERLY IS well known as an artist, conservationist and innovative farmer. His love of birds and the natural world was fostered during a rural childhood. His parents and grandparents had kept lists of the bird species on the family property, but it was under Richard's stewardship that the numbers of species almost doubled. He and his wife Jenny established over twenty wetlands and revegetated the denuded habitat with more than half a million trees and a rich selection of understorey plants.

While studying history at Cambridge, Richard had carved two sculptures from a broken walnut gunstock. These were spotted by a London gallery, exhibited and sold. Richard followed this up with two solo exhibitions of his paintings, having taken the opportunity to study with some renowned British artists. The die was cast: to the dismay of his parents, he decided to become an artist.

A year in Africa, sometimes assisting in wildlife research, enhanced his bushcraft, biology and tracking, and his introduction to falconry began a lifelong fascination with birds of prey, which he studied, sketched, painted, trained and rehabilitated until they were fit for release.

Richard has exhibited his paintings on five continents, in some of which he has also worked as a biologist and naturalist. In the US and Mexico he participated in ornithological surveys and was the only artist from the southern hemisphere invited to paint a plate for the prestigious Waterfowl of North America. In Antarctica he studied Adélie penguins as part of a ground-breaking ecosystem monitoring project, and assisted in CSIRO environmental surveys throughout Australia. These, with surveys in Papua New Guinea with Dr Richard Schodde, were the fieldwork for The Fairy-Wrens, which won a coveted Whitley Award.

Photo courtesy Cormac Hanrahan

Richard's outstanding contributions to conservation, restoration of the environment, and global sustainability, his services to rural community through Landcare, and his contributions to the visual arts, have all been acknowledged with prestigious awards, including an OAM.

But Richard is far from earnest. His wit never deserts him, even when out on a limb many metres from the ground and confronted by a deadly banded cobra, or when observing the struggles of a tiny thornbill wrestling with a feather almost as big as herself to line her nest. Richard is a gifted storyteller and his eventful life has provided him with a rich source of anecdotes and insights.

Richard's greatest legacy may well be his paintings, which are held in collections around the world, but his ability to share his love and deep understanding of the natural world and its remarkable inhabitants – whether feathered or not – will inform, enrich and inspire his readers.

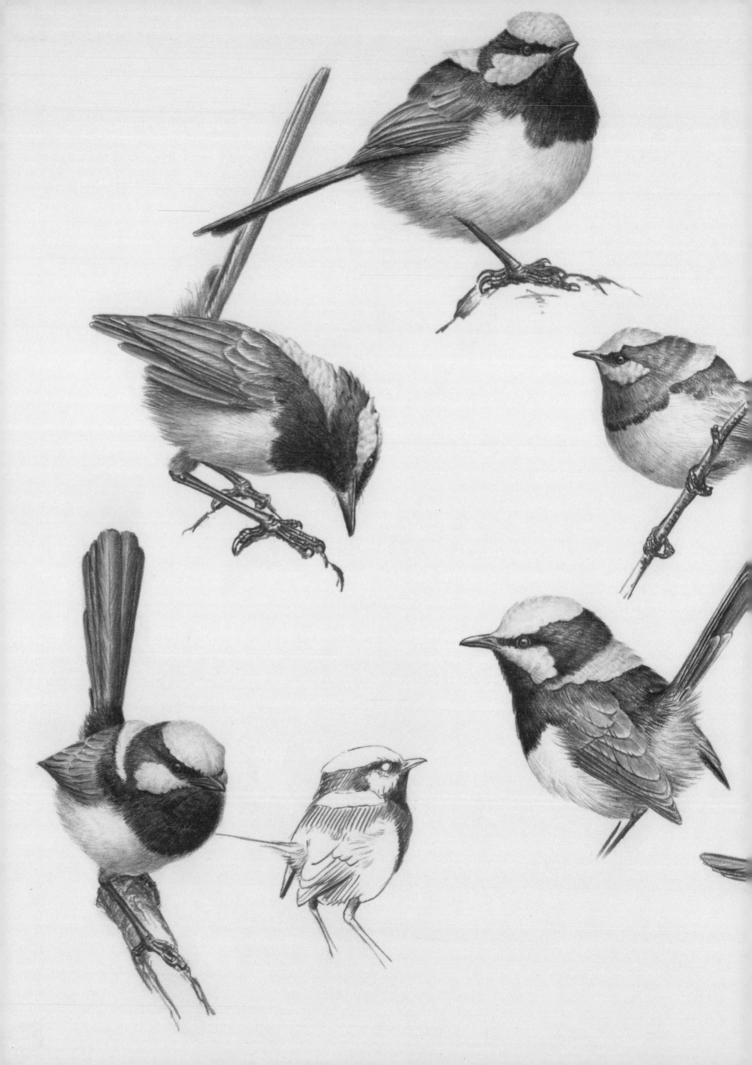